RUSKIN ON ARCHITECTURE

His Thought and Influence

RUSKIN ON ARCHITECTURE

His Thought and Influence

KRISTINE OTTESEN GARRIGAN

The University of Wisconsin Press

Published 1973
The University of Wisconsin Press
Box 1379, Madison, Wisconsin 53701

The University of Wisconsin Press, Ltd.
70 Great Russell Street, London

First printing

Printed in the United States of America

For LC CIP information see the colophon

ISBN 0-299-06460-3

I seem born to conceive what I cannot execute, recommend what I cannot obtain, and mourn over what I cannot save.

Ruskin to his father, from Abbeville, August 9, 1848

Contents

Figures

Preface

At a time when Victorian art and architecture are being newly examined with
an objectivity and lively interest that only the sufficient passage of time makes
possible, John Ruskin, with his formidable reputation as an "art dictator" of
the period, looms inescapably large. Perhaps no author has ever been more
thoroughly identified with the aesthetic currents of his time—or blamed more
indiscriminately for its artistic failures. It is difficult, then, to reevaluate either
Victorian art or architecture without studying Ruskin's imposing works care-
fully, establishing both what he actually preached and, equally important,
what he did not.

Appropriately, therefore, Ruskin's theories of art have in recent years be-
gun to attract renewed scholarly attention; his architectural thought, however,
has remained largely neglected. This is not to imply that no one remarks on
Ruskin's architectural ideas, but such commentary rarely extends beyond the
boundaries of a single chapter and more frequently is limited either to passing
allusions or to generalizations which are not only left undocumented but are
by no means so obvious as they appear. As recently as 1967, the distinguished
historian of nineteenth- and twentieth-century architecture Henry-Russell

Hitchcock admitted, "Only those writers who, like myself, are concerned with mid-nineteenth-century architectural developments pay much attention to him as a critic of architecture, and, in our writings, the references are quite likely to be no more than recurrent use of the vague term 'Ruskinian.'"[1] In this area, at least, Ruskin seems still to be remembered best for his more conspicuous stylistic and philosophical extravagances, and the temptation to ignore him or simply to perpetuate time-hallowed judgments is correspondingly great. Perhaps Robert Furneaux Jordan sums up the problem most accurately when he says:

> All Ruskin is in his work. One must take him whole or not at all. And that is precisely what neither the Victorians nor we have ever done. The nineteenth century devoured his glowing and purple prose, and then—in his name—committed every kind of architectural vandalism. The twentieth century has ignored his teaching which—with its vast apparatus of Biblical allusion—it would not have understood anyway, has attributed to him opinions he never held, as well as buildings he never built—for he was not an architect. It has preferred the minutiae of his miserable marriage and heart-breaking love affairs.[2]

"Taking Ruskin whole" is complicated, however, not only by the intimidating bulk of his canon but because his positions on many subjects developed by accretion—as Gothic cathedrals did, in fact. Ruskin uses a typically organic metaphor to demonstrate that the shifts in opinion found in the five volumes of *Modern Painters* (1843-60) are more apparent than real; the figure applies equally well to his writing on architecture:

> These oscillations of temper, and progressions of discovery, extending over a period of seventeen years, ought not to diminish the reader's confidence Let him be assured of this, that unless important changes are occurring in his opinions continually, all his life long, not one of those opinions can be on any questionable subject true. All true opinions are living, and show their life by being capable of nourishment; therefore of change. But their change is that of a tree—not of a cloud.[3]

The major task in studying Ruskin is to focus steadily on his "tree" rather than on the constantly mutating and far more spectacular "clouds." One of

1. Henry-Russell Hitchcock, "Ruskin and American Architecture," in *Concerning Architecture*, ed. John Summerson (London, 1968), p. 168.
2. Robert Furneaux Jordan, *Victorian Architecture* (Harmondsworth, 1966), p. 170.
3. Preface to *Modern Painters V*, par. 8, in the Library Edition of *The Works of John Ruskin*, ed. E. T. Cook and Alexander Wedderburn, 39 vols. (London and New York, 1903-12), 7.

Ruskin's most sensitive interpreters, Graham Hough, explains: "His individual judgments are so capricious that to establish his real and substantial view is always a matter of sifting and collating: to quote any one passage as final lays one open to the charge of being as arbitrary as Ruskin himself." For "Ruskin's thought has a way of accumulating around a few focal points";[4] it is the sheer *persistence* with which an idea appears rather than the brilliance or extremity of its expression that is crucial to establishing these focal points and evaluating Ruskin's thought justly. Quantity becomes more important than chronology— even than quality. My method, therefore, has been to do as Hough suggests, to sift and collate. When in the following chapters I make a particular point I am asking the reader to assume that the supporting evidence offered consists only of the most memorable or concise statements Ruskin makes on that subject, since to cite all the relevant evidence would be impossible (though in footnotes I occasionally add references to other especially cogent examples). And when I draw from Ruskin's lesser-known or seemingly less important works, it is either because that quotation is a particularly apt formulation of an oft-repeated idea, or because it seems an apposite pinning-down of ideas consistently implied elsewhere.

My systematic sifting and collating have produced somewhat unexpected results. If I have confirmed a number of generalizations made by previous critics, I have also rooted them in detailed contexts so that they take on new shadings and in surprising ways grow or diminish in relative importance. Above all, I have demonstrated that Ruskin formulated no coherent body of architectural doctrine to be neatly abstracted from his books; instead, his writings simply reveal certain significant clusters of perceptions and preoccupations. This finding may strike some readers as disappointingly negative; certainly it forces a rethinking of the nature and extent of Ruskin's influence, a general process I undertake myself in chapters 4 and 5. It is not within the bounds of my study, however, to discuss at length those Victorian architects whose designs embodied "Ruskinian" characteristics. "Ruskinian" architecture was precisely that: inspired *by* Ruskin, yet *not* Ruskin's, and, in fact, derived partly through misinterpretation—a problem that plagued him in all his endeavors.

But although Ruskin's architectural writings are significant in themselves and provide a fascinating perspective on the aesthetic temper of the nineteenth century, their most fundamental importance extends much beyond these limits. For, as I show in my concluding chapter, they constitute a valuable key to Ruskin's mentality—his attachments, his methods of study, his way of apprehending the external world—and therefore they interrelate with and illuminate the entire range of his works. In the end, this remarkable Victorian must indeed be taken whole or not at all.

4. Graham Hough, *The Last Romantics* (London, 1949), pp. 18-19, 37.

I wish to thank Robert B. Doremus, Professor of English and Associate Dean of the College of Letters and Science at the University of Wisconsin—Madison, whose Victorian prose course marked the beginning of my investigation of Ruskin, for his supervision of the doctoral thesis on which this book has been based and for his continuing kind interest; Professor Frank R. Horlbeck of the University of Wisconsin—Madison Department of Art History for his gratifying encouragement and for sharing his expert knowledge of medieval art and architecture so generously; the readers of my original manuscript for the University of Wisconsin Press, John D. Rosenberg, Sir John Summerson, and Francis G. Townsend, for their valued suggestions; Arletta Renneberg for being the most dependable and cheerful of typists; and Larry Lundy for skillfully rendering my illustrative figures. My debt to my husband for his support and patience over the long years of my study cannot adequately be expressed in a few short phrases.

<div align="right">KRISTINE OTTESEN GARRIGAN</div>

Madison, Wisconsin
May 1973

Note on Documentation
of Ruskin's Works

The standard edition of Ruskin is, of course, E. T. Cook's and Alexander Wedderburn's splendid thirty-nine-volume Library Edition of *The Works of John Ruskin* (London and New York, 1903-12). The reader is far more likely to have convenient access, however, to some of the increasingly numerous reprints of Ruskin's individual books or to various late-nineteenth-century editions available through used book dealers. I therefore give most citations of Ruskin's works by chapter and paragraph, with the Library Edition volume number following in parentheses, to allow the reader to locate my quotations— at least approximately—in the widest range of editions possible. If the reference is *only* readily found in the Library Edition, I provide the appropriate page numbers. I am convinced that a main reason for Ruskin's being so often misinterpreted is that he is quoted out of context; I hope that my somewhat unusual method of documentation will enable the reader to place my own excerpts quickly and accurately in their larger settings, and will thereby encourage him to "take Ruskin whole."

RUSKIN ON ARCHITECTURE

His Thought and Influence

1

The State of the Gothic Revival and Victorian Architecture before Ruskin's Appearance

When one thinks of John Ruskin's writings on architecture, his eloquent appreciation of the Gothic style and his impassioned defense of its adaptability to modern purposes come immediately to mind; he is popularly identified still as the unveiler of the glories of medieval architecture to the industrial age and as the ideological leader of the Gothic Revival in mid-Victorian England. Yet Ruskin was hardly the innovator that to the casual modern reader he may appear; indeed, many of the ideas he so fluently propounded had been current for some time. In order to gauge accurately the originality of his approach, therefore, it is essential to have freshly in mind the historical backdrop against which Ruskin preached his architectural aesthetic.

The Gothic tradition had never wholly died out in England; well through the sixteenth century, in fact, the style "had no name; it was the only way of building."[1] Not until the classical revival crossed the Alps could Northern builders even comprehend that alternatives to their traditional methods might exist: before 1600, "there were obvious distinctions such as new and old,

1. Kenneth Clark, *The Gothic Revival* (New York, 1962), p. 13.

3

elaborate and rough, but men were more aware of continuity than of change; and had—and could have—no idea of evolution in style."[2]

By 1700, however, many of England's Gothic buildings had been either abandoned, vandalized, or destroyed—first because of the dissolution of the monasteries, and next during the Puritan Revolution. Deserted church buildings were frequently rifled for materials, particularly the lead of their roofs; once that was gone, structural decay was almost immediate. In those monuments still used, medieval stained glass, if it had not been destroyed during insurrections, might be pulled out and disassembled to admit more light, while private boxes and other "improvements" could block out whole sections of the original buildings.

That so few people were concerned about this deterioration at the time was attributable mainly to the state of English taste in the late seventeenth and early eighteenth centuries. Gothic architecture violated all canons of the then fashionable neoclassical style and was viewed, in John Evelyn's contemptuous phrase, as "crinkle crankle," the product of a barbarous race ignorant of classical truth to nature and Vitruvian proportions. Obviously if Gothic buildings were measured strictly by Greek and Roman standards, they would necessarily be regarded as aesthetic disasters. And it was this inability to view medieval architecture as the product of completely different yet equally valid aesthetic and structural principles (the same inability, ironically, that the Gothic Revivalists would later demonstrate in regard to Renaissance architecture), that made Gothic such a distasteful style to the classicists. Hence, by the eighteenth century, the very term "Gothic" was being used broadly and pejoratively as a synonym for "barbaric and tasteless."[3]

But it would be a distortion to assume that derogatory opinions like Evelyn's were altogether universal. Generally outside the realms of fashion and of letters stood the antiquarians, methodically compiling county histories and catalogues of local monuments. Admittedly, their work could be dull and pedantic. Horace Walpole, for example, eventually resigned his own membership in the London Society of Antiquaries; he had to grant that their prints were valuable—but as "for their volumes, no mortal will ever touch them but an antiquary."[4] Nonetheless, during the early decades of the eighteenth century, these scholars, by accumulating more and more facts, dry or otherwise, helped to foster interest in England's medieval heritage and to provide a reliable foundation for its objective study. By the closing quarter of the century,

2. E. S. de Beer, "Gothic: Origin and Diffusion of the Term; the Idea of Style in Architecture," *Journal of the Warburg and Courtauld Institutes* 11 (1948): 157.

3. A. O. Lovejoy, "The First Gothic Revival and the Return to Nature," *MLN* 47 (November 1932): 421.

4. Horace Walpole to William Cole, September 1, 1778, in *The Yale Edition of Horace Walpole's Correspondence*, ed. W. S. Lewis et al., 34 vols. (New Haven, 1937–71), 2: 116–17; hereafter cited as *Correspondence*.

an impressive number of profusely illustrated volumes on the Gothic antiqui-
ties of the whole British Isles were appearing.

Generally, though, as the eighteenth century wore on, interest in Gothic
outside antiquarian circles, with the exception of a few poets such as Thomas
Gray and Thomas Warton, was shallow and completely unscholarly, a product
of the desire for novelty in a world beginning to grow cloyed with Vitruvian
monumentality. "Gothick" was employed mainly in frivolous outbuildings
such as gazebos or sham ruins, and was simply one of several alternative styles
from which the Augustan becoming sated with classical grandeur might choose.
At midcentury, the rage for *chinoiserie* was reaching its height, a style which
depended for its charm not merely on exoticism but, like Gothic, exploited
such unclassic qualities as lightness, variety, and movement, and at its most
fanciful could assume perversely labyrinthine patterns. Moreover, these styles
were frequently mixed, since each exemplified the same basic quality: free-
dom from classical regularity. The most important architects worked in several
styles, sometimes simultaneously. Mastery of one mode was not thought to
preclude achievement in another, nor was the designer's artistic integrity com-
promised by such shifts in allegiance—hardly the view of the more devout mid-
Victorian Revivalists. But the ultimate absurdities of this eclectic search for
the exotic can be imagined from a mere glance at the titles of available plan
books like "Grotesque Architecture for Rural Amusement; consisting of Plans,
Elevations and Sections, for Huts, Summer and Winter Hermitages, Retreats,
Terminaries, Chinese, Gothic and natural Grottos, . . . Mosques, Moresque
Pavillions, . . . etc., many of which may be executed with Flints, Irregular
Stones, Rude Branches and Roots of Trees."[5] Obviously, then, none of these
styles was being taken very seriously, and Gothic, except for its patriotic over-
tones and its availability (after all, many English estates already had real
Gothic ruins), was not necessarily regarded as a logically, much less philosophi-
cally or aesthetically, preferable form of building. Gothic architecture needed
a respectable *imprimatur* to encourage its revival.

This Horace Walpole provided when he acquired his Twickenham villa,
Strawberry Hill, in 1748, and began remodeling it three years later in the
Gothic manner, a process that continued till his death in 1797. Like Ruskin,
Walpole has received a great deal of not wholly deserved credit for promoting
interest in Gothic and its revival. In 1872, Charles Eastlake, the first historian
of the Gothic Revival, called Walpole's house one of the chief causes of the
movement,[6] and this notion has been echoed rather uncritically by both art
and literary historians to the present. Doubtless, as B. Sprague Allen suggests,
part of the significance attributed to Strawberry Hill is due simply to Walpole's

5. This was advertised to builders in 1767, according to John Steegman, *The Rule of
Taste from George I to George IV* (London, 1936), pp. 85-86.
6. Charles Eastlake, *A History of the Gothic Revival* (London, 1872), p. 42.

having written voluminously about it[7] (as well as opening it to literally thousands of visitors), so that we know more about his Gothic villa than any others of that era. Probably the most just assessment, however, is Kenneth Clark's contention that Walpole "did not so much popularize as aristocratize Gothic."[8] Antiquarians of earlier decades may have included some distinguished members of the nobility, but they were not famed for their taste, discrimination, and wit as Horace Walpole was. Since he first catalogued his father's magnificent pictures in *Aedes Walpolianae,* published in 1747, he had been recognized as a knowledgeable critic of art; his *Anecdotes of Painting in England* (treating English architecture as well), first printed in 1761, further helped to establish him as the "English Vasari."[9] His judgments on Gothic restorations were sought by the Dean of Westminster and the Bishops of Ely, Rochester, and York; he advised a host of influential friends on Gothic additions to their estates.[10] And, finally, beyond his preeminence as an aristocratic connoisseur of art and architecture, Horace Walpole was the celebrated author of that progenitor of Gothic novels, *The Castle of Otranto* (1764). In Walpole, the antiquarian and romantic elements of the early Revival met.

At first glance, Horace Walpole and John Ruskin would appear to have nothing in common, the one an irreverent, witty Augustan dilettante, son of England's powerful first prime minister; the other, an earnest, deeply religious offspring of a solid Victorian sherry merchant and his devoutly Evangelical wife, who were both painfully cognizant of their undistinguished origins. Indeed, Ruskin once actually bemoaned a possible connection with Walpole.[11] Yet there are some rather unexpected parallels, not only in their credibility as proponents of Gothic (which with both men stemmed in part from their knowledge of painting and the repute of their books on that subject) or in their "services" to the Revival (just as Walpole made Gothic respectable to the eighteenth century by giving it an aristocratic cachet, so Ruskin made it respectable to the nineteenth by freeing it from Roman Catholic associations), but in the very nature of their emphases.

In remodeling Strawberry Hill, Walpole's approach to Gothic was basically serious and scholarly, at least by early Revival standards. Admittedly, the uses

7. B. Sprague Allen, *Tides of English Taste,* 2 vols. (Cambridge, Mass., 1937), 2: 80.

8. Clark, *Gothic Revival,* p. 61.

9. W. S. Lewis, *Horace Walpole* (London, 1961), p. 157.

10. Ibid., p. 113.

11. Writing to his father from Scotland in 1853 that he feels ashamed of his "self indulgence" in purchasing Tintorettos, Turners, casts, and missals, Ruskin frets, "I shall get to be a mere collector, like . . . Sir W. Scott, or, worst of all Beckford or Horace Walpole" (September 23, 1853, in the Library Edition of *The Works of John Ruskin,* ed. E. T. Cook and Alexander Wedderburn, 39 vols. [London and New York, 1903-12], 12: lxviii); hereafter cited as *Works.* Although Ruskin disdained Walpole's tastes, he was delighted to secure in 1865 a fine set of *Anecdotes of Painting* for £105 (*Works,* 36: 483).

to which his researches were put were totally, even absurdly, un-Gothic: for example, in the most spectacular addition to Strawberry, the gallery, completed in 1763, the portals were taken from a door of St. Albans and the canopies over the recesses in the north wall from a tomb at Canterbury, while rising from the seventeen-foot walls to the ceiling and running the full fifty-six feet of the room were the fan vaults of Henry VII's Chapel at Westminster Abbey. Moreover, the materials chosen could hardly have been less appropriate. The stone ribbing of the original Gothic canopy was transformed into "gold net-work over looking-glass"; the lath-and-plaster fan vaulting sprang out of walls faced in crimson damask.[12] But the patterns of these motifs were archaeologically correct, and if this phenomenon can be regarded merely as misguided antiquarian purism, it also connotes a respect for the inherent beauties of Gothic *line*. For Walpole had the un-Augustan ability to free himself sufficiently from Vitruvian strictures to see that medieval architecture proceeded out of a valid aesthetic system, that its builders knew what they were doing, and that Gothic was worth studying for its own sake. In *Anecdotes of Painting,* he actually becomes defensive on this point, noting that the Gothic architects "had much more knowledge of their art, more taste, more genius, and more propriety than we choose to imagine": "It is sufficient to observe, that Inigo Jones, Sir Christopher Wren, and Kent, who certainly understood beauty, blundered into the heaviest and clumsiest compositions whenever they aimed at imitations of the Gothic—Is an art despicable in which a great master cannot shine?"[13]

But Walpole had little appreciation or knowledge of Gothic structure; what attracted him to medieval architecture was its ornamental detail. Consequently, he overlooks soaring multi-shafted piers and lofty vaults in favor of tombs and pew carvings; hence he can say that Gothic reached its perfection during the reign of Henry IV by citing as evidence the tombs of the archbishops of Canterbury,[14] and can call Archbishop Warham's tomb (c. 1532) in that cathedral "the last example of unbastardized Gothic." According to Walpole, "the great delicacy and richness of Gothic ornaments was exhausted on small chapels, oratories and tombs."[15] It is thus quite consistent that so many of the Gothic details at Strawberry Hill are derived from basically extraneous objects like doors and screens, which might have been added or substituted decades, even centuries, after the building itself was complete. This explains too why it was easy for Walpole and others to gothicize their houses: the style was defined as

12. [Horace Walpole], *A Description of the Villa of Mr. Horace Walpole . . .* (London, 1964), p. 47 (facsimile of Walpole's 1784 edition).

13. Horace Walpole, *Anecdotes of Painting in England,* ed. James Dallaway and Ralph N. Wornum, 3 vols. (London, 1862), 1: 120-21.

14. Ibid., pp. 126-27.

15. Walpole to William Cole, August 11, 1769, in *Correspondence,* 1: 190-91, 191n.

a series of ornamental patterns which could be pasted on an existing structure. "Gothic" detail could be prefabricated, therefore, and Walpole could tell his friend George Montagu with a perfectly straight face, "a barge-load of niches, window-frames and ribs is arrived."[16] It also follows that Walpole would see nothing wrong in substituting stucco and wallpaper for medieval stone; Clark is more witty than exact when he accuses him of having been "instinctively opposed to anything made of its right material."[17] For Walpole, materials were not even at issue; what counted was the *surface pattern*—this was what made a building Gothic.

It would be inaccurate, of course, to overstate Walpole's devotion to Gothic. Although he could appreciate medieval architecture better than most of his contemporaries, he seems to have viewed it mainly as a source of decorative motifs for his own use. (Ruskin would have shuddered over Walpole's remark to Mary Berry—"Canterbury I know by heart. It was the chief fund of my chimney-pieces, and other morsels"[18]—in the same way he lamented Sir Walter Scott's underlying insensitivity to Gothic at Abbotsford: "he reverences Melrose, yet casts one of its piscinas, puts a modern steel grate into it, and makes it his fireplace."[19]) Walpole in no way seems to have considered the faith and humanity of the Gothic builders in the impassioned manner of Ruskin, though he was fully aware that he was plagiarizing from religious buildings; he referred with whimsical irreverence to his house as the "last monastery in England," and to himself as "Your beadsman, the Abbot of Strawberry."[20] Certainly Walpole's notions of Gothic were utterly devoid of the strong moral bias the Revival would take during the nineteenth century, especially in Ruskin's advocacy.

Furthermore, Walpole had no desire to see the style adopted universally; rather, the charm of what he called "Gothic gloomth" was to be limited to smaller buildings like private residences. Indeed, Walpole's remarks on Gothic in *Anecdotes of Painting* and in his journals and letters (apart from those relating directly to Strawberry Hill) are far exceeded in quantity and quality by commentary on the glories of the classic era, that "age when architecture displayed all its grandeur, all its purity, and all its taste."[21] In motivation, there-

16. Walpole to George Montagu, August 20, 1761, ibid., 9: 385. Walpole's friend Gilly Williams once joked that Strawberry's owner "had already outlived three sets of his battlements" (Lewis, *Horace Walpole*, p. 107).

17. Clark, *Gothic Revival*, p. 64.

18. Walpole to Mary Berry, September 24, 1794, in *Correspondence*, 12: 105.

19. *Modern Painters III*, pt. 4, ch. 16, par. 33 (*Works*, 5).

20. See, for example, *Correspondence*, 1: 325, 10: 379, 11: 127, 168.

21. Walpole, *Anecdotes of Painting*, ed. Dallaway and Wornum, 3: 786. For a detailed discussion of Walpole's attitudes toward classical and Gothic architecture, see my unpublished Ph.D. minor thesis, "Horace Walpole and Strawberry Hill: an Expression of Self," in the Kohler Art Library, University of Wisconsin—Madison. I have found no refer-

fore, Walpole and Ruskin could scarcely be farther apart. But in the characteristics of Gothic design which attracted them, they were surprisingly at one. We will see the same concern for surfaces and ornamental details appearing, albeit from a very different perspective, in John Ruskin's work.

Probably the most fabled eighteenth-century "Gothic" structure, however, and the one epitomizing the essentially romanticized, dilettantish view of Gothic in that era, was William Beckford's Fonthill Abbey. The statistics surrounding this extraordinary venture are as charged with unreality as the conception itself: Fonthill, as projected in 1796, was to be "a ruined convent of which the chapel parlour, dormitory, and part of a cloister alone should have survived."[22] Sited in a picturesque Wiltshire landscape and enclosed by approximately seven miles of twelve-foot high wall, the "Abbey" had a central tower at least 276 feet high; Beckford himself estimated the project's cost at £273,000. The whole undertaking had an air of megalomaniac fantasy, and indeed the construction proved as insubstantial as Beckford's dream: in 1825, the gigantic tower, inadequately supported in the haste of its erection, collapsed, and Fonthill lay in real, not stage-managed, ruin. Structural considerations were of negligible importance anyway compared to the effect of "gloomth" Beckford had sought; further, Clark demonstrates convincingly that Beckford was no dedicated medievalist, that in fact he probably chose Gothic simply because it seemed to provide an exotically dramatic setting. In other words, Fonthill Abbey was an incredible piece of stage scenery. It is irresistible, and not entirely inaccurate, to equate the collapse of Fonthill with the demise of the romantic phase of the Gothic Revival, although the association of Gothic with melancholy decay can clearly be found in Ruskin's writing.

In the first forty years of the nineteenth century, the embryonic Gothic Revival received impetus from various quarters. It would be impracticable to discuss any but a few representative instances, but in all cases the effect was basically the same: to popularize the taste for Gothic and make available greater means and more occasions for building it as a revived style. The romantic associations of Gothic were conveyed most effectively to a broader public by Ruskin's beloved Walter Scott, who larded his Waverley novels with accurate archaeological detail, bringing Gothic to life by associating it with real historical events and believable characters. As Eastlake puts it, "With the aid of his magic pen, . . . Kenilworth becomes once more the scene of human

ences to Strawberry Hill in Ruskin although he does mention indirectly the great Strawberry Hill Sale of 1842 (*Works*, 4: 395) at which Walpole's collections were dispersed.

22. Clark, *Gothic Revival*, p. 87. My account is based upon Clark's (pp. 86-91) and Eastlake's (*History of the Gothic Revival*, pp. 62-65).

love, and strife, and tragedy; the aisles of Melrose echo again with a solemn requiem." Interestingly, the grandiloquent Eastlake overtly connects Scott and Ruskin as servants of the Revival:

> The time may perhaps have now [1872] arrived when the popular mind can dispense with the spell of association, and learn to admire Gothic for its intrinsic beauty. But in the early part of this century, England could boast of no such author as Mr. Ruskin [F]ifty years ago, in the darkest period British art has seen, we were illumined by one solitary and flickering flame, which Scott contrived to keep alive. It was the Lamp of Memory.[23]

A more immediately practical encouragement to revival was the increasing number of relatively inexpensive books of engravings of England's Gothic buildings, the best known and certainly the most numerous being John Britton's highly successful series, including *Beauties of England and Wales* (1800-16), *Architectural Antiquities of Great Britain* (1805-14), and *Cathedral Antiquities of Great Britain* (1814-35). They combined surprisingly careful renderings (England's Gothic monuments, major and minor, claims Eastlake, were depicted for the first time with "something like accuracy, as well as artistic power"[24]) with historically reliable texts. Of special usefulness to practicing architects, however, were editions like Auguste Charles Pugin's and E. J. Willson's two-volume *Specimens of Gothic Architecture* (1821-23). Such works made accessible precisely copied sections and measurements of Gothic buildings. But it is important to note that these plates were generally illustrations of parts, frequently minor, of such structures; that is, details separated from their contexts. Eastlake regards the publication of practical and accurately illustrated books on Gothic architecture a main turning point in the progress of the Revival even if their immediate effect was rather baleful: "An age of ignorance was succeeded by an age of plagiarism."[25] It is easy to see why Ruskin would later so unremittingly attack Victorian architects for their incapacity to design beautiful Gothic detail. Obviously the use of copy-books encouraged good draftsmanship at the expense of creative invention.

Another thrust to the revival of Gothic, and specifically as a style suitable for churches, derived, oddly (or perhaps typically) enough, from quite utilitarian motives. The Church Building Act, passed in 1818, granted one million

23. Eastlake, *History of the Gothic Revival*, pp. 113, 115. Clark points out in his own history that Scott's influence has been generally overrated, noting the relatively late dates of the Waverley novels (*Gothic Revival*, pp. 71-72, 80). Nonetheless, their vast popularity undoubtedly caused them to reach segments of the public untouched by the archaeological engravings of Britton, for example (discussed below), while Scott's effect on Ruskin was profound and lifelong.

24. Eastlake, *History of the Gothic Revival*, p. 84.

25. Ibid., pp. 91, 89.

pounds for the construction of new churches; 214 were erected, and of these 174 were "Gothic."[26] This style was preferred mainly, however, because brick was cheap compared to the expense of stone for classical porticoes; the important thing was to provide as quickly and inexpensively as possible churches for manufacturing districts. "Commissioners' Gothic" soon became a term of opprobrium because of the perversely practical meagerness of the new structures; un-Gothic but economical materials like cast iron were widely used, while such medieval features as vaulted crypts might serve double duty as coal cellars.[27] At the same time, though, Commissioners' Gothic did help accustom the public to the idea of Gothic being employed for modern ecclesiastical purposes, and concurrently provoked a reaction among more sensitive Englishmen to return to the "purer" forms of the style.

A source which did much to legitimize Gothic by freeing it from the utilitarian considerations of the Commissioners and declaring it a noble expression of a pious former age was the ecclesiological movement, which was in part related to the Tractarian cause; if the old liturgy were to be revived, churches would be needed in which it could be properly performed, and the bare, boxy halls which were then common would never do. Hence, in 1839 at Trinity College, Cambridge, the Camden Society was founded "to reform church architecture and revive ritual arrangements"; in 1841 the society began publication of its influential journal, *The Ecclesiologist*.[28] In their magazine the Camdenians emphasized numerous ideas later promulgated by Ruskin, including the beauty of natural forms, the "honest" use of materials, and particularly the deep faith of the medieval builders. A more dictatorial body can scarcely be imagined; stringent, pedantic rules on correctness were set up, and church architects were expected to submit their plans for the society's approval. Moreover, for a variety of not completely intelligible reasons, they exalted the "Decorated" middle period of English Gothic (as Ruskin was later to recommend halfheartedly in *The Seven Lamps of Architecture*), which led to some ruthlessly procrustean restorations of England's cathedrals. The group had its vicissitudes—its propinquity to Catholicism was suspect—and as a result was dissolved in 1845, but it immediately reappeared under a different name.[29]

26. Clark, *Gothic Revival*, p. 95.
27. Eastlake, *History of the Gothic Revival*, pp. 188–89.
28. Clark, *Gothic Revival*, p. 155. A similar but less stentorian group was founded at Oxford.
29. Ibid., pp. 165, 168; in chapter 8, "Ecclesiology," Clark gives a full version of the controversy. Cf. Eastlake, however, who maintains the society simply moved to London because so many of its members had graduated. Eastlake claims that the Camden and Oxford societies "did immense service in popularising the Gothic cause among men of refinement and education, who were young enough to acquire a taste, and had leisure to cultivate it without seriously encroaching on the business hours or professional duties of life" (*History of the Gothic Revival*, pp. 201, 205). Such a description aptly fits Ruskin,

By 1849 the "Ecclesiological Society" had commissioned William Butterfield, its favorite architect, to construct in London All Saints' Church, Margaret Street, as a model of proper Gothic ecclesiastical architecture; that this building, though not completed until 1859, antedated in its projection by two years the first volume of *The Stones of Venice* and by four years the second and third volumes is significant, since many of its characteristics were those Ruskin prescribed. Nevertheless, its interest being solely in church architecture, and in "correct" as opposed to merely beautiful church architecture at that, the group had little to say regarding the appropriateness of Gothic for civic and domestic uses.

The Camdenians' success in imposing their dogmatic prescriptions was clearly related to the confused state of taste in the early Victorian era. Ruskin himself maintained in his 1849 preface to *The Seven Lamps:* "And I have been the less careful to modify the confidence of my statements of principles, because, in the midst of the opposition and uncertainty of our architectural systems, it seems to me that there is something grateful in any *positive* opinion, though in many points wrong, as even weeds are useful that grow on a bank of sand."[30] Such opposition and uncertainty had a multitude of interwoven causes. In the broadest sense, Victorian aesthetic anarchy can be traced to the new awareness of architecture as history that came into being in the eighteenth century—an awareness of which the frivolous indulgence in Gothic and *chinoiserie* was a shallow sign. In a brilliant chapter, "The Influence of Historiography," in his *Changing Ideals in Modern Architecture, 1750-1950,* Peter Collins, using Voltaire's historical writings as symptomatic, shows how the phenomenon of change came to be viewed during the eighteenth century as more typical of nature than permanence, and how, as a corollary, change could be seen either as gradual, that is, a matter of evolution; or as direct, a result of human agency and will, that is, a matter of revolution. Consequently, architects began to think of architecture as a sequence of forms which evolve, but which might also be experimented with in radical ways. It was at this time, too, Collins contends, that history began to be defined as a series of periods, with the consequence that architecture resolved itself into a succession of styles related to time and place. The result was that the element of morality now became an architectural factor, because *choice* was required:

> . . . as soon as architects became aware of architectural history, and of the architectures of exotic civilizations (and hence of architectural "styles"); as soon as they became uncertain as to which of a wide variety of tectonic

who Eastlake states belonged to the Oxford group (ibid., p. 203n), but I have been unable to locate evidence of his membership.

30. Par. 1 (*Works,* 8).

elements they might appropriately use; they were obliged to make basic decisions involving moral judgements, and to discuss fundamental problems which their more fortunate forbears had disregarded because in their ignorance of history, and the security of their traditions, they did not know that these fundamental problems existed[31]

With the introduction of moral criteria, it followed, of course, that a particular style would eventually find justification to the extent that its forms and associations embodied or correlated with the architect's, or the architectural critic's (for the relation to Ruskin's approach is obvious), or the client's conception of human nature.

But this underlying abstract phenomenon that Collins describes was specifically complicated in the Victorian period by numerous dislocations of traditional architectural practice imposed by the rapid spread of the Industrial Revolution. First of all, an entirely new set of architectural needs came into being, which could not adequately be met by traditional solutions. Some new building types, such as large factories, railway stations, warehouses, and gas works, resulted very directly from industrialization; others indirectly, like office buildings, exhibition halls, and large stores. Through government legislation, too, a wide assortment of institutional structures became necessary, many of them posing complex new planning problems. And with rising populations and burgeoning cities, even buildings for which historical prototypes existed, such as inns or town halls, were now required on a far larger scale, both in number and size. The diversity of these new architectural needs was so great, Nikolaus Pevsner asserts, that a survey of Victorian architecture might best be made by types of buildings rather than biographically or chronologically.[32]

The industrial age also presented an array of new materials to Victorian architects. Today it is easy to fault these men for their reluctance to employ materials like iron and glass (especially since a nonprofessional exploited them so successfully in the Crystal Palace), or, when they did use them, for foolishly forcing them into anachronistic shapes. Considerable justification exists for this view, and, as we shall see, no one was more willfully blind to the implications of new materials or argued more vituperatively against their use than John Ruskin. But the availability and practicability of these materials at mid-century has probably been overstressed. Up until 1845, for example, England had a heavy excise duty on glass, while the Crystal Palace required fully one-third of the total British glass production of 1842 and employed the largest

31. Peter Collins, *Changing Ideals in Modern Architecture, 1750-1950* (London, 1965), pp. 40-41.

32. Nikolaus Pevsner, "Victorian Prolegomena," in *Victorian Architecture*, ed. Peter Ferriday (London, 1963), p. 23.

panes available in 1851, four feet in length.[33] Similarly, iron was not nearly so versatile a building material as it may appear to us now. Cast iron was too brittle for many architectural uses, but the stronger, more malleable, fire-resistant wrought iron was extremely expensive to produce; although the Bessemer process for making steel was developed in 1856, only in 1879 was an inexpensive way of removing phosphorous from iron devised.[34] Such data also shed light on the employment of reinforced concrete as a building material; although it "emerged to maturity" in the 1870s, the first patents of François Hennebique, who substituted steel for iron reinforcements and "introduced the bending of the steel reinforcements near the supports," date from 1892 and 1893.[35] Finally, the development of the mechanical services that were to permit full exploitation of skeletal construction came largely in the last quarter of the century with the practical harnessing of electricity for heating, ventilation, lighting, and elevator systems.[36] It is basically understandable, therefore, that the revolutionary architectural possibilities of new materials were going largely unrecognized at the time of *The Seven Lamps* (1849) and *The Stones of Venice* (1851-53), while with the dominance of architectural historicism, the potential for incongruous, even hideous, misapplications of such materials was immense—which only helped to obscure their real value and further delay their creative exploitation.[37]

Meanwhile, industrialization was bringing into being a new species of architectural client as well: commercial and manufacturing committees, often divided and insecure in their tastes but sternly united in their overriding concern for costs.[38] The character of the private client was likewise beginning to change; the aristocratic patrons of the eighteenth century were being super-

33. Christopher Hobhouse, *1851 and the Crystal Palace* . . . (London, 1937), p. 32; Sigfried Giedion, *Space, Time and Architecture*, 4th ed., enl. (Cambridge, Mass., 1962), p. 249.

34. Collins, *Changing Ideals in Modern Architecture*, p. 197.

35. Nikolaus Pevsner, *Pioneers of Modern Design*, Pelican ed. (Harmondsworth, 1960), pp. 144, 146.

36. See Collins, *Changing Ideals in Modern Architecture*, pp. 238-39, and Giedion, *Space, Time and Architecture*, pp. 207-8.

37. It should be remembered, too, that the logical employment of new materials required an entirely new aesthetic response, particularly because of the revised relation of load and support such materials brought about. (Ruskin's writings contain a number of references to the painfully insubstantial appearance of glass and iron shopfronts.) Thus we find in nineteenth-century architecture contradictory effects like the masonry shell enclosing the iron construction of Henri Labrouste's Bibliothèque Sainte-Geneviève, Paris (1843-50), or, on a less masterful level, the juxtaposition of Gothic exterior with iron and glass interior roof in the Ruskin-inspired Oxford Museum (see chapter 4) and the masking of railway sheds by pretentious Greek facades.

38. See Frank Jenkins, "The Victorian Architectural Profession," in *Victorian Architecture*, ed. Ferriday, pp. 40-41.

seded by yet another product of industrial England: a prosperous upper middle class desirous of making their economic achievement obvious through conspicuous consumption. With no clear canons of taste to direct them and a congenital tendency toward what Matthew Arnold would eventually label "doing as one likes," it was inevitable that in their own residences they should be drawn to the novel, the exotic, and the gaudy: "*laissez-faire* economics encouraged *laissez-faire* aesthetics."[39] In his earliest architectural papers, collected as *The Poetry of Architecture* (1837-38), Ruskin wryly satirizes a supposedly typical private patron's eclectic tastes as conveyed to his architect: his magnificent new abode should include Italianate statues of dancing nymphs; "wigwam" details from the "Cannibal Islands"; Egyptian sphinxes to support the conservatory door, "holding scrapers in their fore paws, and having their tails prolonged into warm-water pipes, to keep the plants safe in winter"; Gothic window mouldings mimicking those of Fountains Abbey; and great octagonal towers patterned after Kenilworth's, with "machicolations for boiling lead, and a room at the top for drying plums" "The architect is, without doubt, a little astonished by these ideas and combinations; yet he calmly sits down to draw his elevations; as if he were a stone-mason, or his employer an architect; and the fabric rises to electrify its beholders, and confer immortality on its perpetrator. This is no exaggeration"[40]

To complicate matters more, amid such aesthetic confusion was repeatedly heard the demand for a new style, a cry that reached its height about mid-century, or at the time of Ruskin's major architectural writings. This desire was less the result, however, of an awareness of new needs and materials per se than it was the product of the historical notion of architectural styles that we have already examined. For if every other age had had its style, why then should not the Victorian age be marked by a distinct species of architecture? Progress was the byword of the Victorian age; why was architecture not progressing too? Collins's distinction between change as revolution and change as evolution is extremely useful here: on the one hand, in an era characterized by a series of revolutionary mechanical inventions, was it not also possible for a new architecture simply to be invented, like the spinning jenny or the steam engine? On the other, if styles evolved naturally through time, did it not follow that a new style would consist of subtle adjustments of established forms? Thus the revivalist ideal, at least among the more creative practitioners and proponents, was to free an historic style from mere archaeological accuracy and to adapt it freely to modern requirements—hence the paeans to Gothic "flexibility" so central to the rhetoric of that particular revival. But as Collins aptly observes, this kind of aesthetic self-consciousness controverted the very

39. Jerome Hamilton Buckley, *The Victorian Temper* (Cambridge, Mass., 1951), p. 132.

40. "The English Villa—Principles of Composition," pars. 168-69 (*Works*, 1).

idea of an evolutionary style: "Once architects became aware of the historical process by which evolution took place, their architecture was as incapable of evolving naturally as they themselves would have been incapable of eating naturally by following a textbook explanation of the movements of the epiglottis."[41] Geoffrey Scott states it more pithily: "the architect, with nothing but his scholarship, set out to restore a style that had never been scholarly."[42]

In *The Seven Lamps* Ruskin addressed this problem, if only to deny that it should even exist:

> A day never passes without our hearing our English architects called upon to be original, and to invent a new style: about as sensible and necessary an exhortation as to ask of a man who has never had rags enough on his back to keep out cold, to invent a new mode of cutting a coat. Give him a whole coat first, and let him concern himself about the fashion of it afterwards. We want no new style of architecture.[43]

A decade later, in a lecture to the Architectural Association, he exposes what he considers the absurd implications of the notion with brilliant, jabbing disdain:

> Perhaps the first idea which a young architect is apt to be allured by, as a head-problem in these experimental days, is its being incumbent upon him to invent a "new style" worthy of modern civilization in general, and of England in particular; a style worthy of our engines and telegraphs; as expansive as steam, and as sparkling as electricity. But, if there are any of my hearers who have been impressed with this sense of inventive duty, may I ask them, first, whether their plan is that every inventive architect among us shall invent a new style for himself, and have a county set aside for his conceptions, or a province for his practice? Or, must every architect invent a little piece of the new style, and all put it together at last like a dissected

41. Collins, *Changing Ideals in Modern Architecture*, p. 143. That the Victorians themselves recognized this contradiction can be seen in the writings of the prolific Gothic Revival architect Gilbert Scott. Explaining in his *Remarks on Secular and Domestic Architecture, Present and Future* (London, 1857) that "the peculiar characteristic of the present day, as compared with all former periods, is this—that we are acquainted with the history of art" and thus "know better whence each nation of antiquity derived its arts than they ever knew themselves," he confirms: "It would be absurd to imagine that [this] knowledge . . . will be without its influence upon that which we ourselves generate,—it is impossible that it should be so. Influence it must exert,—it is for us to guide that influence by subjecting it to our intellect" (pp. 259, 261).

42. Geoffrey Scott, *The Architecture of Humanism*, 2d ed. (New York, 1924), p. 42. Robert Furneaux Jordan (*Victorian Architecture* [Harmondsworth, 1966], p. 137) makes a quite defensible point, however, when he argues that the Victorians, by the very nature of their adaptations, actually *had* established their own style.

43. Ch. 7, par. 4 (*Works*, 8).

map? And if so, when the new style is invented, what is to be done next? I will grant you this Eldorado of imagination—but can you have more than one Columbus? Or, if you sail in company, and divide the prize of your discovery, and the honour thereof, who is to come after your clustered Columbuses? to what fortunate islands of style are your architectural descendants to sail, avaricious of new lands?[44]

For just as the misapplications of new materials helped to postpone their logical development, so the confused, vulgar novelties which the demand for a new style could foster tended to becloud and discredit the real need for one.

In any event, the Victorian architectural profession, taken as a whole, was by no means equipped to deal with new materials, needs, or clients, much less to produce "a style worthy of our engines and telegraphs." Architectural training was generally very informal; the system of articled pupilage that prevailed through most of the Victorian period was inefficient and subject to abuse. (The first Master of Architecture at the Royal Academy was appointed in 1870, and a full-time course in architecture was not established at the university level until 1892 at King's College, London.[45]) Martin Chuzzlewit's situation was thus not entirely fictional, nor was the immortal Pecksniff altogether a caricature; clients were often misled by doctored drawings and underestimated costs. The well-publicized controversy and backbiting that surrounded most architectural competitions, from that for the first major "Gothic" building, the Houses of Parliament (1835), to that for the last, the New Law Courts in the Strand (1867), hardly fostered public respect for the profession. (Some architects, such as the Ecclesiologist Butterfield, declined to enter competitions at all; Ruskin thoroughly disapproved of them. Ironically, too, Paxton's Crystal Palace became possible because of the unsatisfactory results of the original competition in 1850.)

The Institute of British Architects had been founded in 1834, but it did not become the "Royal" Institute until 1866. Its membership was distinguished and subscribed to a strict code of professional ethics; by 1841, however, only 9 percent of the nation's architects belonged, while those outside could indulge with impunity in a variety of dubious practices, such as fee-cutting and collusion with builders and speculators. Statutory registration and examination of architects, by contrast, was vigorously fought to the end of the century by many eminent designers—joined by nonarchitects with Ruskinian connections like Edward Burne-Jones, Holman Hunt, and William Morris—on the grounds that the capacity for architectural design could not be fairly tested, and that rigid professional accreditation would therefore compromise architecture as an art.[46]

44. Collected in *The Two Paths*, lec. 4, par. 101 (*Works*, 16).
45. Jenkins, "Victorian Architectural Profession," p. 47.
46. Ibid., pp. 41-42, 47-48. Statutory registration was not achieved in England until 1938 (ibid., p. 49).

In fact, the conflict between architecture as an art and architecture as a profession is germane to an understanding of why the "Modern Movement" was so late in being born. For it was the best Victorian architects' sense of their aesthetic mission that caused them to distrust and eventually become alienated from the group which could help them most in developing a new style to meet new needs, the engineers. The isolation of architect from engineer has probably, in the interests of a tidy explanation, been overstressed by historians, just as the practicability of new materials has been. Collins cites evidence that the architects officially deplored the schism and that the assistance the engineers could offer, for that matter, lay not so much in the exploitation of new materials as in their rationalistic, abstract approach to structural elements. In reality, he suggests, the architectural profession was overwhelmed by a sense of inferiority in the face of the public acclaim the engineers were receiving for their daring structural feats.[47] On the other hand, the archaeological emphasis inherent in all Victorian revivalism obviously fostered a concern for ornament as opposed to structure, and especially new structural forms, at the same time that it invested the architect with the aura of a scholarly man of culture. This also helps to explain why many of the better architects unfortunately took little interest in designing new building types, and why, while the engineers were vaulting larger and larger spaces in their glass and iron market halls, a major technical challenge facing the Gothic Revivalists should be how to accommodate Gothic tracery to modern sash windows (which they actually did find a vexing difficulty). But for whatever complex reasons, by midcentury, architects were coming to view engineers as threatening opponents rather than as valuable partners.

It can be seen, therefore, that just when unique and problematic challenges with far-reaching consequences had most urgently to be met, divisive confusion and lack of communication prevailed both within and without the architectural profession. Ruskin was not necessarily exaggerating when he claimed that the dicta of *The Seven Lamps* possessed the virtue of weeds stabilizing a bank of sand.

No review of the state of early Victorian architecture and the character of its practitioners would be complete, however, without reference to the architect Augustus Welby Northmore Pugin (1812–52). Of all the English writers on architecture before Ruskin, only Pugin approached him in the force of his personality and the vigor of his arguments for the revival of Gothic. More important, Pugin's published architectural writings antedate all of Ruskin's by five years or more (except for *The Poetry of Architecture* [1837-38], which dealt with villas and had virtually no Gothic bias), a fact which caused Ruskin to be dogged for years by charges of plagiarism.

47. See Collins, *Changing Ideals in Modern Architecture*, pp. 190-91, 188, 197.

The relationship between Pugin and Ruskin is a revealing one. Although they were not personally acquainted, they shared many attitudes: their disdain for restorations and eclecticism, for classic, Renaissance, and nineteenth-century architecture; their sense that the Victorian social structure was the root of all architectural evils, and that only pious men in a healthy society can build good buildings; their scholarly, lifelong interest in Gothic art; their belief that Gothic was the only truly Christian architecture. The very turn of mind of the two men—their assurance, enthusiasms, and inconsistencies—was similar, even to the disabling madness in which each tragically closed his life.

It was Pugin who stressed, far more than Ruskin did later, the functionalism of Gothic. He firmly believed that Gothic was suitable for every variety of building; this assumption was inherent in the "two great rules of design" that he enunciated in *The True Principles of Pointed or Christian Architecture* (1841):

> *1st, that there should be no features about a building which are not necessary for convenience, construction, or propriety; 2nd, that all ornament should consist of enrichment of the essential construction of the building.* The neglect of these 2 rules is the cause of all the bad architecture of the present time. . . .
>
> Strange as it may appear . . . it is in *pointed architecture alone that these great principles have been carried out* Moreover, the architects of the middle ages were the first who *turned the natural properties of the various materials to their full account,* and made *their mechanism a vehicle for their art.*[48]

These principles were restated and further applied in *An Apology for The Revival of Christian Architecture in England* (1843). The modernity of such tenets was to some extent belied in his practice. Pugin's real love was not Gothic construction but its ornament; *The True Principles* and *An Apology* are as full of delicate plates of Gothic metal- and woodwork as Ruskin's *Seven Lamps* and *Stones of Venice* are with infinities of intricately sculpted Gothic capitals and mouldings. In his buildings, he was accused by *The Ecclesiologist* of "starving his roof-tree to deck his altar";[49] Ruskin advises sarcastically: "Employ him by all means, but on small work. Expect no cathedrals of him; but no one at present can design a better finial."[50] It is fitting that in his

48. A. W. N. Pugin, *The True Principles of Pointed or Christian Architecture* (London, 1841), pp. 1-2. Nikolaus Pevsner points out, however, that Pugin's ideas were not startlingly original but rather "the direct continuation of the principle of French seventeenth and eighteenth century rationalism" (*The Sources of Modern Architecture and Design* [London, 1968], p. 9). See also Phoebe Stanton, "The Sources of Pugin's *Contrasts*," in *Concerning Architecture*, ed. John Summerson (London, 1968), pp. 120-39.

49. Quoted in Clark, *Gothic Revival*, p. 137.

50. *Stones of Venice I*, app. 12 (*Works*, 9: 439).

uneasy—and at the time, shamefully under-publicized—collaboration during the thirties and again in the late forties with Charles Barry on the controversial Houses of Parliament, Pugin was responsible for designing the entire quantity of ornamental detail, inside and out, right down to the inkwells and hat racks.

At the same time, though, his experience as a staggeringly prolific architect ("My medical man tells me that I have lived an hundred years in forty," he wrote before his premature death at that age[51]) gave him insights into the practical problems of reviving Gothic of which Ruskin was totally ignorant. Hence, scattered through his books are plates of pleasingly chaste sample adaptations of Gothic to Victorian uses, including railroad bridges, shops, and private homes; he built himself two Gothic houses. Nor would he reject machinery and new materials out of hand in the manner of Ruskin (to be discussed in chapter 5), but could envision legitimate uses for them in freeing money and labor for the nobler aspects of a building: "The whole history of Pointed Architecture is a series of inventions *It is only when mechanical invention intrudes on the confines of art, and tends to subvert the principles which it should advance, that it becomes objectionable.*"[52] And in a very direct if limited way he was able to raise standards of Victorian craftsmanship, fully two decades before Morris and Company, by building up his own small workshop for the making of stained glass, textiles, metalwork, wallpapers, and tile.

Pugin also predated Ruskin in his strong moral bias, first marked in his powerful volume *Contrasts: Or, A Parallel between the Noble Edifices of the Middle Ages and Corresponding Buildings of the Present Day; shewing the Present Decay of Taste. Accompanied by appropriate Text* (1836, with an expanded second edition in 1841). In a series of eleven pairs of his own drawings —fifteen in the second edition—he juxtaposed with devastating effect medieval scenes and their Victorian counterparts. Especially interesting in view of Ruskin's later social criticism is a plate such as "Contrasted Residences for the Poor": the "Antient Poor House" is a beautiful Gothic complex of church, cloister, and gardens; the "Modern Poor House" is a stark, windowless, high-walled polygonal enclosure with a ponderous neoclassic pediment, in a setting bereft of greenery. The smaller accompanying frames are still more damning: for example, "The Master" in the "Antient" plate is a priest in flowing robes distributing alms; the "Modern" Master is a shiny-buttoned Bumble type, clutching handcuffs and a cat-o'-nine-tails.

Yet Ruskin completely denied Pugin's influence on his own ideas, attacking him with savage, tasteless vehemence as "one of the smallest possible or

51. Quoted in Alexandra Gordon Clark, "A. W. N. Pugin," in *Victorian Architecture*, ed. Ferriday, p. 139.

52. Pugin, *An Apology for The Revival of Christian Architecture in England* (London, 1843), p. 40.

conceivable architects" in an appendix to *The Stones of Venice I*. The quality that rendered Pugin so repugnant to Ruskin was also that which prevented the architect's theories from gaining wider currency than they did: Pugin had become in 1834 a zealous convert to Roman Catholicism, and in his writing from *Contrasts* on, he unabashedly identified Gothic architecture with a Catholic society, claiming that the successful revival of Gothic was inextricably tied to the return of England to her ancient religion. Although his later works were somewhat more moderate in tone than the editions of *Contrasts* (which included such charges as "everything glorious about the English churches is Catholic, everything debased and hideous, Protestant," and references to "that female demon, Elizabeth"[53]) they were all clearly intended as propaganda pieces.

Pugin is important not only in himself, however, but because of his effect on Ruskin's work. For Ruskin had to deal with Pugin, if only to belittle him, and Ruskin's reaction to Pugin doubtless helped determine the tone and emphases which we will be investigating in his own architectural writing. He fervently denied any debt in Appendix 3, "Plagiarism," to *Modern Painters III* (1856), surely smarting from such remarks as an *Ecclesiologist* reviewer made in reference to *Stones of Venice I*: "Mr. Pugin himself might learn from Mr. Ruskin, had not (as is not improbable) Mr. Ruskin learnt it from him, to loathe all that is false and mean and meretricious in art."[54] He claimed to have glanced at *Contrasts* "once, . . . during an idle forenoon," and to have seen Pugin's "Remarks on Articles in the *Rambler*," "brought under my notice by some of the reviews. I never read a word of any other of his works, not feeling, from the style of his architecture, the smallest interest in his opinions."[55] In 1855 he declared privately to Dr. Furnivall: "I certainly owe nothing to Pugin, —except two *facts*, one about Buttresses, and one about ironwork. I owe, I know not how much, to Carlyle, and after him to Wordsworth, Hooker, Herbert, Dante, Tennyson, and about another dozen of people. But assuredly *Nothing* to Pugin."[56] Ruskin also belittled Pugin's buildings, unmercifully attacking the pro-cathedral of St. George's, Southwark (1840-42) in *Stones of Venice I*: "St. George's was not high enough for want of money? But was it want of money that made you put that blunt, overloaded, laborious ogee door

53. Pugin, *Contrasts*, 2d ed. (Leicester, 1969), pp. 51, 65. I have based my descriptions on and taken all quotations from this valuable photographic reprint of the 1841 edition.

54. August 1851; quoted in *Works*, 5: 428n.

55. *Modern Painters III*, app. 3 (*Works*, 5: 429).

56. *Works*, 5: 429n. John Unrau points out that neither work Ruskin confesses to reading contains the *"facts"* he acknowledges, but *True Principles* does, as well as numerous other ideas echoed in *The Seven Lamps* and *Stones of Venice*; therefore, "it seems highly probable that Ruskin read at least this book in addition to the two he admitted reading" ("A Note on Ruskin's Reading of Pugin," *English Studies* 48 [August 1967]: 335-37).

into the side of it? . . . Was it in parsimony that you buried its paltry pinnacles in that eruption of diseased crockets?"[57] He detested the Houses of Parliament, maintaining, for instance, in *Modern Painters V* (1860) that "for the millions of money, we got a mouldering toy."[58]

Beyond such direct reactions, however, Ruskin's emphases also seem dictated at least partly in response to Pugin. The intentional antifunctionalism of some of Ruskin's architectural pronouncements, and particularly those denying the logic of ornamented construction (to be examined later), would certainly seem to be aimed at discrediting Pugin's second "True Principle." In addition, although Ruskin appears always to have disliked English Gothic in every form, Pugin's eloquent respect for it probably further encouraged Ruskin's vituperative use of it as a source of bad examples throughout his writings. But the most crucial, indisputable effect Pugin had on Ruskin can be discerned in the ugly, strident anti-Catholic tone that mars so much of his major architectural writing, especially *The Stones of Venice*.

The early Victorian period was, of course, strongly influenced by Evangelicism—ironically, Pugin was reared by a mother quite as sternly Evangelical as Margaret Ruskin—and many English still feared and hated Catholicism. The hostility encountered by High Church Anglicans like the Tractarians and Camdenians was symptomatic, while the earlier passing of the Catholic Emancipation Act (1829) roused fears of a Romanist takeover of England, fears which were partially reactivated when the Catholic hierarchy was restored in 1850.[59] The ecclesiastical associations of Gothic were consequently very strong, the more so because a leading Revival architect was zealously, openly urging national apostasy. Both *The Seven Lamps* and *The Stones of Venice* are obviously directed to a perfervidly Protestant audience, and Ruskin's eagerness to sever for his readers Gothic architecture from the Church of Rome led him into symbolic interpretations just as extreme as Pugin's, when he reads, for example, heathen Papacy and Protestant dissent into the various carvings of Venetian Gothic cornices.[60] His debunking zeal surely drove him to his wrongheaded assertion of the domestic rather than ecclesiastical origins of Gothic, a position he did not officially abandon until his 1882 lecture "Mending the Sieve; or, Cistercian Architecture," when he begged the audience's pardon for the narrowness of the position into which he had been thrust by, among other

57. App. 12 (*Works,* 9: 438-39). This passage was withdrawn in later editions, assumedly because of Pugin's confinement in Bedlam and subsequent death (see *Works,* 9: 439n).

58. Pt. 9, ch. 12, par. 10 (*Works,* 7). Pugin himself derogated the complex as "all Grecian, Sir; Tudor details on a classic body" (quoted in Michael Trappes-Lomax, *Pugin, a Mediaeval Victorian* [London, 1933], p. 87).

59. A strong statement against Catholic Emancipation is found in *Seven Lamps,* note 1 (*Works,* 8: 267-69).

60. *Stones of Venice I,* ch. 27, pars. 22ff. (*Works,* 9).

causes, "dread of ritualist devotion."[61] Nonetheless, as Clark suggests, "The dissociation of Gothic architecture and Rome was, perhaps, Ruskin's most complete success": "for the majority of readers Ruskin succeeded in disinfecting Gothic architecture; and it is because he was the first person consciously to attempt this, because his work could be read without fear of pollution, that he is remembered as the originator of Gothic Revival doctrines."[62]

But, paradoxically, the identification of Gothic and *modern* Catholicism was actually a false issue. The recently emancipated English Catholics had neither money, power, nor a plethora of aristocratic patrons to erect magnificent churches. Thus the new Catholic structures proved to be a kind of Commissioners' Gothic in themselves since funds had to be spread so thinly, and Pugin, who designed a number of these churches, often had to compromise his grand conceptions. In fact, it was Pugin's laments over this situation in "Remarks on Articles in the *Rambler*" (1850) that prompted the *Stones of Venice* attack on St. George's just noted, in which Ruskin assures him, "no difficulty or restraint ever happened to a man of real power, but his power was more manifested in the contending with or conquering it."[63]

Furthermore, some old Catholic families, still worshiping privately in their own chapels, resented upstart converts like Pugin, while the treasuries of the small group of wealthy patrons who did support him were hardly inexhaustible. By contrast, the tastes of many converts tended to be totally opposite to Pugin's; they favored Renaissance and Baroque designs of what Eastlake calls "a quasi-Italian character." The 1850 restoration of the Catholic hierarchy under Wiseman encouraged this trend, for, sighs Eastlake, the Cardinal's "private tastes were directly at variance with Mediaevalism, and during the latter part of his life he made no secret of the fact." He regretfully concludes: "It is well known that Pugin's views on ritual and ecclesiastical usage . . . gave offence to many who shared his faith, and after his death there was a reaction in the artistic predilections of the Romish clergy from the influence of which they have never been thoroughly relieved."[64]

Part of Ruskin's aversion to modern Catholicism plainly stemmed from the condition of the great medieval Continental churches as neglected or, worse, "improved" by their nineteenth-century clergy: "I can most strongly and faithfully assure you that I have no hidden leaning or bias toward Popery," he affirmed to his mother-in-law in 1852; "that on the contrary I hate it for abusing and destroying my favourite works of art."[65] His writings, especially *The*

61. Par. 23 (*Works*, 33).
62. Clark, *Gothic Revival*, p. 196.
63. *Stones of Venice I*, app. 12 (*Works*, 9: 438).
64. Eastlake, *History of the Gothic Revival*, pp. 347, 346.
65. From a letter to Mrs. Gray published in Mary Lutyens, *Millais and the Ruskins* (London, 1967), p. 20.

Stones of Venice, are filled with caustic references to the "coarse and senseless vulgarities" with which modern priests "upholster" their churches; indeed, "so far from Romanism now producing anything great in art, it cannot even preserve what has been given to its keeping. I know no abuses of precious inheritance half so grievous, as the abuse of all that is best in art wherever the Romanist priesthood gets possession of it. It amounts to absolute infatuation."[66]

Yet Pugin was equally appalled by the specter of "modern Catholics with their own hands polluting and disfiguring, by pagan emblems and theatrical trumpery, the glorious structures raised by their ancestors in the faith,"[67] and in a long note to the conclusion of *Contrasts* he could have been describing someone like Ruskin:

> Many devout and well-intentioned persons, who are conscious of the insufficiency of the Protestant system, and are favourably disposed towards Catholic truth, go abroad full of expectation, and return utterly disheartened Could they but have seen one of these very churches, now so disfigured, as it appeared in all its venerable grandeur during the ages of faith, how different would have been the result produced on their mind; but while the present childish and tinsel ornaments are mixed up with the most sacred rites, . . . it is impossible for a mere observer to receive any but unfavourable impressions[68]

Pugin loved the Roman Church of the Middle Ages—and so did John Ruskin.

Nonetheless, it was the aesthetic appeal of medieval Catholicism that Ruskin most emphatically denied in his vicious attack on Pugin in *Stones of Venice I,* Appendix 12, when he argues that the "basest" motive for "sympathy with the Church of Rome" is "the being lured . . . by the glitter of it"—"blown into a change of religion by the whine of an organ-pipe; stitched into a new creed by gold threads on priests' petticoats": "I know nothing in the shape of error so dark as this, no imbecility so absolute, no treachery so contemptible. I had hardly believed that it was a thing possible, . . . until I came on this passage in Pugin's *Remarks on Articles in the Rambler*" Ruskin goes on to quote from Pugin's ecstatic evocation of the original beauties of medieval Catholic ceremony when the cathedrals were as yet unravaged, the stained glass windows shining gloriously, the niches filled, the screen glowing with sacred imagery.[69] Contrast this with Ruskin's own famous description in his autobiography,

66. *Stones of Venice I,* app. 12 (*Works,* 9: 439).

67. Pugin, *Contrasts,* p. 52.

68. Ibid., p. 52n. Cf. Ruskin: "No man was ever more inclined than I, both by natural disposition and by many ties of early association, to a sympathy with the principles and forms of the Romanist Church . . ." (*The Seven Lamps* [1849] note 1 [*Works,* 8: 267], the opening of an anti-Catholic note omitted in later editions).

69. *Works,* 9: 436, 437-38.

Praeterita, of the Evangelical Beresford chapel to which as a child he was taken by his parents each Sunday: "an oblong, flat ceiled barn," with brick-arched, iron-mullioned windows; "galleries propped on iron pipes"; and straw-matted aisles running between the plain deal pews; the only source of visual gratification being a gold-tasseled cushion of crimson velvet gracing the pulpit ("I liked watching the rich colour of the folds and creases that came in it when the clergyman thumped it"). Ruskin himself points out the obvious implication: "Imagine the change between one Sunday and the next, . . . fancy the change from this, to high mass in Rouen Cathedral, its nave filled by the white-capped peasantry of half Normandy!"[70] To a person so dependent for his existence on visual beauty as Ruskin was from earliest childhood, and who, like Pugin, possessed the imaginative capacity to disentangle the authentically medieval splendors from the modern embellishments of the great Gothic cathedrals and to reassemble them into a glorious vision of What Must Have Been, the possibility of being lured into the Romanist Church by the glitter of it was surely a genuine threat.

On his first Continental trip alone (1845), in fact, Ruskin had already experienced the connection between great art and its possible effect on the intensity of his religious belief; he writes at that time to his father from Pisa:

> . . . the Campo Santo is the thing. I never believed the patriarchal history before, but I do now, for I have seen it. . . . Abraham and Adam, Rachel and Rebekah, all are there, real, visible, created, substantial, such as they were, as they must have been; . . . one comes away like the women from the sepulchre, having seen a vision of angels which said that he was Alive.[71]

And his diary during the decade contains a number of sympathetic entries that contrast distinctly with the stentorian anti-Romanism marking his published works of this period.[72] Moreover, at the time he was completing *The Stones of Venice,* his wife was definitely fearful of his apostasy, as she writes to her mother: "Believe me I shall watch him most closely. Some of these stories of miracles he is not persuaded are false and he wishes very much to be assured that the Stone of St Januarius at Naples is really an imposture."[73]

70. Vol. 1, ch. 7, pars. 152-53 (*Works,* 35).

71. May 18, 1845 (*Works,* 4: xxxi).

72. Perhaps the most familiar and surely the one most clearly indicating his ambivalence is his gratified October 15, 1848, reaction to a particularly impressive mass at Rouen, where he concludes that "splendour of music and architecture in religious service," though "certainly not to be enforced upon those whose vulgarity they offend," are "still less to be refused to, or blamed in, those whom they edify." See *The Diaries of John Ruskin,* ed. Joan Evans and J. H. Whitehouse, 3 vols. (Oxford (1956-59), 2: 369-70; hereafter cited as *Diaries.*

73. From London, August 2, 1852, in Lutyens, *Millais and the Ruskins,* p. 17.

Typically, the strongest appeal of Catholicism for Ruskin lay in its most medieval form, the monastic. He was acquainted from his earliest travels with the Alpine hospices; on his solitary 1845 journey he joined with the friars at Fiesole in making hay. One of the relatively more peaceful periods of his deeply troubled later years was the summer of 1874 that he spent living in the Franciscan community at Assisi, drawing from Giotto and Cimabue, and using the sacristan's cell as a study; at that time he dreamed of having been made a tertiary of the Order.[74] As early as 1853 he wrote to his parents, "Perhaps for *my health*, it might be better that I should declare at once I wanted to be a Protestant monk: separate from my wife, and go and live in that hermitage above Sion which I have always rather envied."[75] The ambivalence and indirection here are revealing: even considering his obvious desire to extricate himself from a deteriorating marriage as well as his justifying his wish on the grounds that would most readily elicit a sympathetic response, his health (which had always been a grave concern both to himself and his parents), Ruskin's underlying monkish impulse was undoubtedly strong and genuine. The Guild of St. George was structured in an essentially monastic pattern and much of his last major projected work, *Our Fathers have Told Us,* would, as planned, have been an eloquent anthem in praise of medieval monasticism. Ruskin is thoroughly sincere when in *Praeterita* he asserts that he never "doubted the purity of the former Catholic Church."[76]

On the other hand, Ruskin could scarcely ignore the appeal of modern Catholicism either, which other (and to his mind, better) men than Pugin had unsuccessfully resisted. He had, after all, been a student at Christ Church (1837-42) at the full tide of the Oxford Movement, and by 1853 he could reflect that half the most amiable men he knew then were now Catholics, "the others altogether unsettled in purpose and principle."[77] Like so many of the great Victorians, Ruskin himself felt such fear and confusion—and the accompanying longing for stability—as his well-known 1851 letter to his dear friend Henry Acland poignantly reveals:

You speak of the Flimsiness of your own faith. Mine, which was never strong, is being beaten into mere gold leaf, and flutters in weak rags from the letter of its old forms; but the only letters it can hold by at all are the old Evangelical formulae. If only the Geologists would let me alone, I could

74. Joan Evans, *John Ruskin* (London, 1954), pp. 109, 350.

75. From Edinburgh, November 11, 1853, quoted in Derrick Leon, *Ruskin, the Great Victorian* (London, 1949), p. 191. Cf. Effie's comment to Mrs. LaTouche in 1870 that Ruskin once offered her eight hundred pounds a year to let him go into a monastery, with her keeping his name (quoted in Sir William James, *The Order of Release* [London, 1947], p. 256).

76. Vol. 2, ch. 1, par. 9 (*Works*, 35).

77. To the Reverend W. L. Brown, from Edinburgh, November 8, 1853 (*Works*, 36: 155).

do very well, but those dreadful Hammers! I hear the clink of them at the end of every cadence of the Bible verses—and on the other side, these unhappy, blinking Puseyisms; men trying to do right and losing their very Humanity.[78]

He later would enjoy a long friendship with Cardinal Manning, who liked to remind him how similar their ideas were (which exasperated Thomas Carlyle, who labeled Manning "Yon beggarly bag of wind" and warned Ruskin against his "meddling"[79]). At all events, a number of times in his life he was called upon to deny, privately and publicly, his imminent conversion—we have seen his disclaimer to Mrs. Gray, above—and in his later years he became increasingly sympathetic toward medieval Catholicism, turning his original contempt for its "superstitions" instead toward what he considered their perverted embodiments in modern Protestantism, as, for instance, when he accuses his readers of "counting your pretty Protestant beads (which are flat, and of gold, instead of round, and of ebony, as the monks' ones were)" or asserts that "the worship of the Immaculate Virginity of Money, mother of the Omnipotence of Money, is the Protestant form of Madonna worship."[80] The ultimate expression of this change in direction was his notorious comparison in his last set of Oxford lectures (*The Pleasures of England* [1884]) of Carpaccio's St. Ursula as the quintessential Catholic with Bewick's alert little pig as the earnest Protestant spirit and Mr. Stiggins as its hypocritical version, which signaled his increasingly serious mental instability and led to his breaking all ties with Oxford.

Thus in later years Ruskin deeply regretted the anti-Catholic tone of *The Seven Lamps* and *The Stones of Venice,* and in the editions of the late seventies and early eighties of these volumes he either excised the offending passages altogether or added apologetic footnotes. In *St. Mark's Rest* (1877-84)—aside from his oft-quoted remark there that, on rereading *Stones,* "I am struck, almost into silence, by wonder at my own pert little Protestant mind"—he offered an abject *mea culpa* for his Venetian "sins":

> With no less thankfulness for the lesson, than shame for what it showed, I have myself been forced to recognize the degree in which all my early work on Venetian history was paralyzed by . . . petulance of sectarian

78. From Cheltenham, May 24, 1851 (ibid., p. 115).

79. Quoted in Ruskin's diary entry for May 2, 1875 (*Diaries,* 3: 843). The passage continues: "I saying that I felt greatly minded sometimes to join the Catholics . . . C. said 'he would desire in such case to have me assassinated.'" The extreme disapproval both of his parents and Carlyle must surely have inhibited whatever impulses Ruskin might have had toward conversion.

80. *The Two Paths,* lec. 5, par. 195 (*Works,* 16), in 1859; *Val d'Arno,* lec. 10, par. 277 (*Works,* 23), in 1874.

egotism; and it is among the chief advantages I possess for the task now undertaken in my closing years, that there are few of the errors against which I have to warn my readers, into which I have not myself at some time fallen. Of which errors, the chief, and cause of all the rest, is the leaning on our own understanding; the thought that we can measure the hearts of our brethren, and judge of the ways of God.[81]

John Rosenberg is certainly right when he holds that Ruskin "remained too radically an individualist, too Protestantly insistent upon his own interpretation of God's word, ever to have become a Catholic."[82] Whether Ruskin himself always clearly perceived this, however, is another question; he protested too much and too long not to have felt the temptation to which Pugin succumbed. As late as *Praeterita* (1885-89) he still finds it necessary to stress that he could never "be led into acceptance of Catholic teaching by my reverence for the Catholic art of the great ages,—and the less, because the Catholic art of these small ages can say but little for itself." And earlier in the same work he quotes again from *Stones of Venice I*, Appendix 12, on the weakness of that species of religious sensibility that can be "piped into a new creed by the whine of an organ pipe."[83] Ruskin never quite forgave Pugin for his alarming example.

81. Ch. 8, par. 88; ch. 5, par. 67 (*Works*, 24).
82. John Rosenberg, *The Darkening Glass* (New York, 1961), p. 55.
83. Vol. 3, ch. 1, par. 7; vol. 2, ch. 1, par. 9 (*Works*, 35).

2

What Ruskin Emphasized in Architecture

In the preceding chapter we have seen ample evidence that at the time Ruskin began his major architectural writings, many of his ideas were not new, although he probably had little doubt of his own originality. But it is important to note the range of their currency. The Ecclesiologists' emphasis was narrow; their interest in Gothic and its revival was dependent on and subservient to their concern for liturgy; they were not crusading for universal appreciation or adoption of the Gothic mode. On the other hand, the man arguing most brilliantly and vigorously for just such ends was tainted because of his religion; further, he was primarily and indefatigably a practicing architect, not a propagandist. Ruskin, however, possessed leisure, a genuine love of Gothic, highly developed sensibilities and an exquisite style of writing through which to express them—plus an impeccably Protestant background. He was able, then, to attract a wider audience than any previous writer on architecture, and thus also became automatically identified as the originator of many ideas not truly his. "If Ruskin had never lived, Pugin would never have been forgotten," says Kenneth Clark[1] —nor, one might add, would a number of other less gifted Victorian architectural theorists.

1. Kenneth Clark, *The Gothic Revival* (New York, 1962), p. 144.

Because of his comfortably privileged situation as the precocious only child of a prosperous Victorian sherry merchant, Ruskin from an early age had the opportunity to study fine architecture, both at home and abroad. As a young boy he was taken about England by his father, John James Ruskin, when he called on his wealthy customers; he initially traveled to Paris in 1826 at the age of seven. His first extensive Continental tour came in 1833 when he was introduced to Switzerland and Northern Italy; 1835 marked his first visit to Venice. He was to retrace these routes several dozen times in his life; from 1840 to 1850 alone, by his own accounting, he went abroad nine times.[2] During the earliest tours, his avid interest in geology and his discovery of the glorious Alpine and Italian scenery tended to discourage any very serious interest in architecture; beginning around 1840 his diaries contain increasingly numerous references to the architectural sights in his travels, but they are generally casual rather than analytical, and the buildings seem important to him mainly as focal points in landscape compositions. A typical entry, especially in its terminology, is this notation at Avignon in October 1840:

> The huge mass of the "cathedral" (which is not a cathedral, but a gigantic barracks) interrupting the panorama to the south, just enough to make it a picture; the town running clear round the rock; Italian roofs of beautiful form and grouping; one light Gothic tower, contrasting beautifully with the heavy battlemented towers of the walls On the other side a noble fortress—I don't know what it is—but a mass which Turner would luxuriate in[3]

Thus many of the monuments he was later to memorialize so eloquently were then uninteresting to him. In Pisa, for example, he declares the Campo Santo "very narrow, not elegant, and totally wanting in melancholy or in peace"; Florence proves a grievous disappointment. The appeal of Venice—one that never faded for him—lies mainly in the beautiful silhouette of St. Mark's viewed against the echoing jagged outlines of the distant Alps.[4] Looking back on diary entries like these while writing *Praeterita,* Ruskin remarks, "Altogether I am impressed by their coldness and apathy . . . in great part of course caused by my then total ignorance of the real beauty of architecture"[5]

It was in 1845, at Lucca, on his first trip to the Continent by himself, that

2. From a manuscript sheet given in the Library Edition of *The Works of John Ruskin,* ed. E. T. Cook and Alexander Wedderburn, 39 vols. (London and New York, 1903-12), 35: 362; hereafter cited as *Works.*

3. *The Diaries of John Ruskin,* ed. Joan Evans and J. H. Whitehouse, 3 vols. (Oxford, 1956-59), 1: 91; hereafter cited as *Diaries.*

4. November 10, November 15, 1840, and May 6, May 8, 1841, ibid., pp. 109, 110, 183, 185.

5. A first draft passage of Volume 2, ch. 3, par. 53, given in *Works,* 35: 293n.

he learned to value architecture rightly, independent of picturesque settings and associations:

> Hitherto, all architecture, except fairy-finished Milan, had depended with me for its delight on being partly in decay. . . .
>
> Here in Lucca I found myself suddenly in the presence of twelfth century buildings, originally set in such balance of masonry that they could all stand without mortar; and in material so incorruptible, that after six hundred years of sunshine and rain, a lancet could not now be put between their joints.
>
> Absolutely for the first time I now saw what mediaeval builders were, and what they meant. I took the simplest of all facades for analysis, that of Santa Maria Foris-Portam, and thereon literally *began* the study of architecture.[6]

Such a revelation was the more crucial because it coincided with discoveries in sculpture and painting as well: he saw there the tomb of Ilaria di Caretto, which was to become his touchstone of sculptural beauty for the rest of his life, and in Fra Bartolomeo's rendering of the Magdalene in the church of San Romano, he found "a faultless example of the treatment of pure Catholic tradition by the perfect schools of painting."[7]

From Lucca he went on to Pisa, where he was stunned by the sculptures of the Campo Santo and wrote, as we have seen, to his father, completely overwhelmed: "one comes away like the women from the sepulchre, having seen a vision of angels which said that he was Alive." Finally, during this same journey he discovered Tintoretto at the Scuola di San Rocco in Venice; again he writes to John James in a state of abject amazement: "I have had a draught of pictures to-day enough to drown me. I never was so utterly crushed to the earth before any human intellect as I was to-day—before Tintoret. . . . As for painting, I think I didn't know what it meant till to-day"[8] The combination of these artistic epiphanies, each succeeding more powerfully the next, marked the real beginning of Ruskin's commitment to art and architecture:

> And I never needed lessoning more in the principles of the three great arts. After those summer days of 1845, I advanced only in knowledge of individual character, provincial feeling, and details of construction and execution. Of what was primarily right and ultimately best, there was never

6. *Praeterita,* vol. 2, ch. 6, par. 115 (*Works,* 35). Cf. the 1883 epilogue to *Modern Painters II* on his experience at Lucca (*Works,* 4: 347): "then and there on the instant, I began, in the nave of San Frediano, the course of architectural study which reduced under accurate law the vague enthusiasm of my childish taste."

7. *Praeterita,* vol. 2, ch. 6, pars. 114, 115 (*Works,* 35).

8. September 24, 1845 (*Works,* 4: xxxviii).

more doubt to me, and my art-teaching, necessarily, in its many local or
personal interests, partial, has been from that time throughout consistent,
and progressing every year to more evident completion.[9]

This prolonged and intense interest in architecture yielded an array of writings amounting to a substantial portion of Ruskin's voluminous *corpus*. Reference has already been made to *The Poetry of Architecture* (1837-38), a collection of papers composed when he was in his teens and contributed monthly under the pseudonym "Kataphusin" to J. C. Loudon's *Architectural Magazine*. His subject was domestic architecture; the ten sections treated cottages and villas. More were planned on fortresses and palaces, but the periodical failed in the meantime and the projected portions were never undertaken. (This was a rare instance when one of Ruskin's grandiose publishing schemes was left incomplete because of an external cause instead of his own overreaching imagination.) Although strongly characterized by a preoccupation with picturesque effects of the kind his 1845 experiences allegedly taught him to devalue, these articles are significant in that they contain germs of many of his later emphases, especially the combination of statements of very general, even metaphysical, principles with minutely prescriptive illustrations. In a *Praeterita* manuscript, Ruskin says of this initial effort: "I am a little proud to find on re-reading some detached passages of those first Architectural essays, that . . . there are already formed convictions of my own, from which in after life I never saw cause to swerve, on matters in nature and in art"[10] Another decade and two volumes of *Modern Painters* intervened, however, before Ruskin returned to architecture as a subject; it was the years 1848-53 that produced the great works, *The Seven Lamps of Architecture* and *The Stones of Venice*. Never thereafter did he examine architecture with the brilliant intensity of these books.

But he lectured on it for the remainder of his life, largely to reach a wider audience with his ideas. "[Y]ou don't like lecturing as a principle, nor do I," he wrote his father in 1859, "but it does much good. . . . [A] book influences the best people, though not the most."[11] His earliest addresses, those published as *Lectures on Architecture and Painting* (1854), deal fairly strictly with architecture, or at least as strictly as Ruskin ever dealt with a defined subject; but later in that decade and into the sixties, architecture became for him mainly a point of departure for his discussion of social concerns. Nonetheless, the lectures delivered during his first tenure as Slade Professor at Oxford (1870-79), though few specifically take architecture as a subject, contain important peripheral clarifications and refinements of his earlier ideas—for to a man so

9. *Praeterita*, vol. 2, ch. 6, par. 116 (*Works*, 35).
10. *Works*, 35: 615.
11. From Bolton Bridge, February 28, 1859 (*Works*, 16: xxi).

profoundly sensitive to analogies as Ruskin was, one subject inevitably merged with another, and he was always lapsing into comments on architecture, even in *Modern Painters.* Those series on sculpture, particularly *Aratra Pentelici* (1872) and *Val d'Arno* (1874), are of special interest since to Ruskin sculpture and architecture were almost synonymous.

Then there are the "sequel" books of the late seventies, the travelers' guides to Italy published as *Mornings in Florence* (1875-77), *Guide to the Venetian Academy* (1877), and *St. Mark's Rest* (1877-84, to which in a letter to Charles Eliot Norton he actually refers as "my new fourth vol. of *Stones of Venice*"[12]). Again, though primarily concerned with painting and sculpture, these works yield useful incidental comment on architecture. Only in the 1880s did he return very directly to architecture as a subject, when in *Our Fathers have Told Us,* of which just *The Bible of Amiens* (1880-85) was completed, he proposed to focus on particular buildings as symbols of Christian history.

As I pointed out in my preface, however, the chronology of these writings is less important than it is with most authors. Ruskin's ideas on architecture did not change substantially over time; rather, they grew by accretion. He himself frequently asserted that age had only confirmed his basic impressions; we have seen his claims for *The Poetry of Architecture,* while his 1880 notes to *The Seven Lamps* and those of 1879-81 to *The Stones of Venice* are filled with affecting instances of wry self-congratulation. A particularly telling one: "A great deal of this talk is flighty, and some of it fallacious . . . but the sentiment and essential truth of general principle in the chapter induce me to reprint . . . it in this edition."[13]

How much, though, did Ruskin *actually* write about architecture, and about Gothic in particular? No author has been more the victim, or probably more deservedly so, of purple-passage anthologizing; from the closing decades of the nineteenth century on, "gems" of Ruskin, whether in limp-covered, floridly embossed presentation volumes or standard Victorian prose collections for the college classroom, have been the educated public's main, if not only, contact with his work; such compendia usually include the resplendent St. Mark's description in *Stones of Venice II,* a "Lamp" from the seven available, and highlights from "The Nature of Gothic." The familiarity of the latter chapter of *Stones* has been further enhanced by William Morris's high praise and his printing a separate edition of it at the Kelmscott Press in 1892. Such wrenching from context, for whatever well-intentioned purpose, coupled with his popular identification as a leader of the Gothic Revival, has thus perhaps made it seem as if Ruskin wrote predominantly on architecture.

12. From Venice, October 5, 1876 (*Works,* 37: 210).
13. An 1879 note to *Stones of Venice II,* ch. 2, par. 3 (*Works,* 10: 20n).

Yet when taken in its entirety rather than in selected bits, even Ruskin's most straightforwardly art-historic work, *The Stones of Venice,* treats numerous other subjects beside architecture, just as much of *Modern Painters* is not about painting but, as he feyly titled his third volume, "Of Many Things." Long sections on matters of Venetian history or medieval dress are logically justifiable in a work like *Stones,* but such passages in Ruskin often assume independent lives. "[I]f I were to go thoroughly into each thing that interests me," he complains to his father from Venice in 1852, "—I might chase a single doge through all the shelves of St. Mark's library."[14] Sometimes he simply yielded to the temptation. How often, in studying *The Stones of Venice* (or almost any of the more ambitious works), does the reader all but forget what Ruskin set out to discuss and then feel surprise at being jarred eventually back on the track? The motley nature of the thick appendices to these three volumes further illustrates the inexorably catholic and digressive character of his interests, even when he is most strictly limiting himself to architectural analysis.

In *Stones,* moreover, much of the architecture discussed is not Gothic, although readers familiar only with "The Nature of Gothic" are apt to assume that the whole work is a celebration of it. Volume I, *The Foundations,* is marked by Gothic bias, but serves mainly as an elementary introduction to architectural forms and as a statement of Ruskin's general principles, largely independent of style. Almost one-third of Volume II is devoted to Byzantine and Romanesque structures and includes some of the finest passages of pure architectural appreciation in the whole work. Further, the central buildings of the study, St. Mark's and the Doge's Palace, are only partially Gothic. St. Mark's is discussed entirely in the Byzantine section, while part of Volume III treats the Ducal Palace's Renaissance additions, the remainder of that volume being wholly on Renaissance structures. The architectural listings in the long "Venetian Index" at the end of Volume III show how many Gothic or partly Gothic buildings he does not analyze in the text. *The Stones of Venice* is by no means, then, an exhaustive survey either of Venice's Gothic or of its architecture in general.

But in none of his works, and especially his architectural writings, does Ruskin employ a broad range of examples. In his 1849 preface to *The Seven Lamps,* he actually ventures to state that the reader may be surprised by the small number of buildings to which reference is made, and while asserting "I could as fully, though not with the accuracy and certainty derived from personal observation, have illustrated the principles subsequently advanced, from the architecture of Egypt, India, or Spain," he confesses that "my affections, as well as

14. February 6, 1852, in *Ruskin's Letters from Venice, 1851-1852,* ed. John L. Bradley (New Haven, 1955), p. 165.

my experience" have caused him to emphasize Italian and Norman buildings.[15] The "accuracy and certainty derived from personal observation," "my affections, as well as my experience"—despite his enthusiasm for making absolute generalizations, despite his constant search for broad underlying principles, Ruskin was an intensely empirical person. He was driven to see, draw, measure, feel, literally to *exhaust* particular examples of architecture, sculpture, and painting, not once but again and again. Thus the pattern of his frequent, luxurious travels was virtually the same all his life; he traced and retraced old routes, with relatively few variations: crossing to Calais, then through Normandy to Paris for a few days at the Louvre, across Champagne and Burgundy via Dijon to Geneva and Chamouni, down the Alps to Lombardy, Venetia, and Tuscany. It is hardly surprising, therefore, that throughout his work, and not just in *The Seven Lamps,* his examples of praiseworthy Gothic are most often drawn from Abbeville and Rouen, Venice and Verona.

From the first, nonetheless, Ruskin was never very deeply distressed by the unexpectedly narrow limits of his experience; in *Modern Painters I* (1843), though he claims familiar acquaintance with every important work of art from Antwerp to Naples, he draws his examples of "the ancients" largely from the Dulwich and National Galleries—but not merely because they were accessible to his readers, which he cites as his reason.[16] Rather, they were the galleries he *knew* extremely well. Yet both collections at the time consisted primarily of seventeenth- and eighteenth-century paintings; the National Gallery had been open to the public for just five years and had fewer than two hundred pictures.[17] Similarly, Turner had shown 555 paintings and watercolors by the end of 1843, but Ruskin mentions only 45 in *Modern Painters I.*[18] The resultant distortions may be excused as a matter of innocent, youthful self-confidence, and indeed before writing *Modern Painters II* Ruskin worked at expanding his background. His later writings, however, still tend to be equally limited; greater knowledge usually led simply to one small range of examples being superseded by another. Extensiveness of experience mattered little compared to intensiveness of experience.

Moreover, Ruskin never questioned the universal validity of his own preferences, of "my affections, as well as my experience." If Ruskin thought the Doge's Palace and Giotto's Tower were the most beautiful buildings in the world, then obviously they were, and everyone else should think so too. But

15. Preface to the 1849 edition, par. 5 (*Works,* 8).

16. Preface to the first edition, par. 4 (*Works,* 3).

17. R. H. Wilenski, *John Ruskin, an Introduction to Further Study of His Life and Work* (London, 1933), pp. 199-200. One of Ruskin's less friendly critics, Wilenski considers these questionable claims to broad expertise so characteristic that he calls them "Antwerp to Naples" passages.

18. Joan Evans, *John Ruskin* (London, 1954), p. 92.

everyone else would have to be persuaded on more objective grounds than the mere fact of Ruskin's delight, and it was the casuistic lengths to which he was forced in providing ex post facto "logical" justifications for his highly idiosyncratic prejudices that led to some of his most celebrated contradictions. Ruskin could never simply prefer anything: he was driven to exalt it, to establish its absolute superiority by denigrating the alternatives.

Hence, although Ruskin is renowned as an interpreter of Gothic, what he most frequently writes about is Gothic at its least typical, the Italian species, because that was the Gothic he knew and loved best. It is worth briefly reviewing the unique qualities of Italian Gothic, then, because they help to explain both the nature of Ruskin's emphases and the incompleteness of his view of the Gothic style.[19]

The most basic point to be made regarding Italian Gothic, the one which explains many of its singular characteristics, is that Italy, unlike the transalpine countries, had a strong, persistent classical heritage. The soaring verticality and complicated diagonal divisions and interpenetrations of space that mark the Gothic style were alien to the classical tradition of volumetric clarity and serene resolution of horizontal and vertical elements. Thus Italian Gothic is quite simple structurally—transparently logical and balanced rather than spectacularly intricate. Rib vaults, when they appear, are the simplest quadripartite form, spanning large, square bays; flying buttresses and the complex, lacy exteriors resulting from them are consequently rare, since the volumes of the building provide adequate support by themselves. Nor are interior walls articulated in the Northern manner; simple, horizontally emphatic two-part elevations—a large arcade and a small clerestory with modest, often round-arched or even circular windows—prevail, as opposed to the three-part elevations of arcade, triforium, and high clerestory with brilliantly glazed lancets of the mature Northern Gothic. Italian Gothic *affirms* the wall rather than dissolving it; the wall predominates in its most simple form—planar, solid, rectilinear.

On the exterior, therefore, the flat, blank wall may be filmed with marble or even mosaic patterns, while on the interior, fresco-painting assumes a dominant ornamental role. In Northern Gothic, where religious narrative is provided in the large stained glass windows and diffuse sculptural schemes, mural painting (or at least what has survived) is generally flat-patterned,

19. Except for specific quotations as cited, the following discussion is a synthesis of the commentary on Italian Gothic in these sources: Paul Frankl, *Gothic Architecture* (Harmondsworth, 1963), passim; Peter Kidson, *The Medieval World* (New York, 1967), passim; Andrew Martindale, *Gothic Art* (New York, 1967), ch. 3; and especially John White, *Art and Architecture in Italy, 1250-1400* (Harmondsworth, 1966), pp. 1-38, 159-232, 317-58, 366-70, 387-98. I have also made use of my personal class notes from Professor Frank Horlbeck's outstanding course "Gothic Architecture" (Art History 376) at the University of Wisconsin—Madison, 1966-67.

decorative, even random-looking, in the tradition of manuscript illumination. But in Italy, as Andrew Martindale explains, artists seem to have thought of their work as an extension of the mason's, and they incorporated into or surrounded their painting with *trompe-l'oeil* "fictive architecture."[20] Indeed, according to Peter Kidson, "The invention of linear perspective might almost be said to have arisen from the efforts of painters to do what in the north would have been left to the niche-workers. The creation of the illusion of space was first and foremost a question of creating an illusion of architecture."[21]

Perhaps the most important Italian Gothic quality of all, however, one that assumes a variety of significant manifestations, is its distinctness of parts. In Northern Gothic, buildings have a pervasive organic quality—spaces interpenetrate, constructive elements fuse into a total architectural fabric, so that interior and exterior echo and explain each other. The Southern monument, on the other hand, reflecting Italy's classical and Romanesque achievements, is built on a principle of addition rather than fusion. The disparate parts of the building coordinate, but each also preserves and declares its own identity. These qualities are especially clear on the exterior; the typical facade is a flat, massive screen, often taller and wider than the building back of it—a false front; in some instances, the windows punched out of it may even be dummy.

The disposition of sculpture on the Italian facade also preserves such distinctness. No one better describes the difference in effect between Northern and Southern Gothic on this score than Ruskin himself in his "Review of Lord Lindsay's *Sketches of the History of Christian Art*" (1847), the most nearly objective, comprehensive account he ever gave of Italian Gothic:

> A blank space of freestone wall is always uninteresting . . . [for] there is no suggestion of preciousness in its dull colour, and the stains and rents of time upon it are dark, coarse, and gloomy. But a marble surface receives in its age hues of continually increasing glow and grandeur; . . . its undecomposing surface preserves a soft, fruit-like polish for ever, slowly flushed by the maturing suns of centuries. Hence, while in the Northern Gothic the effort of the architect was always so to diffuse his ornament as to prevent the eye from permanently resting on the blank material, the Italian fearlessly left fallow large fields of uncarved surface, and concentrated the labour of the chisel on detached portions, in which the eye, being rather directed to them by their isolation than attracted by their salience, required perfect finish and pure design rather than force of shade or breadth of parts
>
> . . . [Such decorations] of Northern Gothic . . . however picturesquely adapted to their place and purpose, depend for most of their effect upon

20. Martindale, *Gothic Art*, pp. 178, 185; see also White, *Art and Architecture in Italy*, p. 173.

21. Kidson, *Medieval World*, p. 136.

bold undercutting, accomplish little beyond graceful embarrassment of the eye, and cannot for an instant be separately regarded as works of accomplished art. . . . [The] harmony of classical restraint with exhaustless fancy, and of architectural propriety with imitative finish, is found throughout all the fine periods of the Italian Gothic, opposed to the wildness without invention, and exuberance without completion, of the North.[22]

Northern Gothic sculpture, though a great deal better than Ruskin considers it, is nevertheless basically architectural in purpose; figures are placed *on* the jambs and voussoirs or rigidly enclosed in niches which in turn are ranged in patterns subordinated to the total design scheme of the facade. By contrast, as John White states, the refusal to use figures as substitutes for major architectural forms is "wholly Italian."[23] Italian Gothic sculpture can literally stand by itself, as if spotlighted on a bare stage.

Consequently, Italian Gothic is, on the one hand, in its characteristics of space and mass, more classical than Gothic, and, on the other hand, in the independent prominence allowed to highly finished sculpture and painting, even anti-Gothic. Gothic in Italy was an engrafted style (the Italian Renaissance architects actually labeled it *"maniera tedesca,"* the German style[24]) modified by previous long tradition into an original, often impressive, but fundamentally bastardized mode. Ironically, its most pronounced qualities, its serenely elegant volumes and simple rectilinear modules, anticipate the Renaissance forms by which Italian Gothic was so early and readily superseded.

It is apparent, therefore, that for a variety of unique reasons, Italian Gothic was a style quite different from the Gothic north of the Alps, a distinction Ruskin was perfectly able to recognize. But he was unable to view the two kinds dispassionately; despite his early affection for Norman Gothic, his interest in Italian Gothic implies a rejection of Northern forms. It was at Lucca, not at Winchester or Rouen or Cologne, that he felt he had truly discovered medieval architecture and committed himself to the serious study of it. Furthermore, as he was to admit rather offhandedly in *Stones of Venice I,* his new awareness of Italian architecture interfered with his continued appreciation of its Northern counterpart:

> I do not feel myself capable . . . of speaking with perfect justice of this niche ornament of the North, my late studies in Italy having somewhat destroyed my sympathies with it. But I once loved it intensely, and will not say anything to depreciate it now, save only this, that while I have studied long at Abbeville, without in the least finding that it made me

22. Pars. 28-29 (*Works,* 12: 197-98).
23. White, *Art and Architecture in Italy,* p. 66.
24. Frankl, *Gothic Architecture,* p. 218.

care less for Verona, I never remained long in Verona without feeling some doubt of the nobility of Abbeville.[25]

English Gothic he had rejected from the start anyway; he found it "small and mean, if not worse—thin, and wasted, and unsubstantial."[26] At various points in his writing he singles out for criticism most of the major monuments, including Lincoln, St. Albans, Durham, Westminster Abbey (particularly Henry VII's Chapel), Winchester, Gloucester, York, King's College Chapel, Worcester, Lichfield, and especially Salisbury, the one English cathedral he ever attempted to study closely. Only Wells is consistently mentioned favorably, but this is at least partly a case of damning with faint praise: in his Oxford lectures on *The Aesthetic and Mathematic Schools of Art in Florence* (1874) he maintains, "long ago [in *The Seven Lamps* (1849)] . . . I gave Giotto's Tower as the central type of beautiful edifice yet existing in the world. In my having done so, Fortune or Kind Fate had at least as much share as my own effort to discern what was right," and he goes on to explain how the tomb of Ilaria at Lucca "forced me to leave my picturesque mountain work for what was entirely true and human." But in the first draft he had interposed, "If chance of fate had kept me in England, the Cathedral of Wells would have been my highest conception of architecture."[27] We can almost hear the sigh of relief at the narrowness of his escape.

More curiously, although he refers here and there in his published writings to the uncontested superiority of French thirteenth-century Gothic, and in *Lectures on Architecture* acknowledges that "the French not only invented Gothic architecture, but carried it to a perfection which no other nation has approached, then or since,"[28] he uses French churches comparatively infrequently as examples, except for those of Normandy, while his diaries contain even as late as the midfifties many derogatory references to the greatest French Gothic structures. For Reims he harbored a lifelong aversion; in *Praeterita* he quotes from his 1835 "Don Juan journal" derogating that masterpiece of the High Gothic:

> The carving is not rich,—the Gothic heavy,
> The statues miserable; not a fold
> Of drapery well-disposed[29]

And he is still flaying it in his diary of 1882: "Here [at Reims], nothing but

25. Ch. 24, par. 10 (*Works*, 9).
26. *Seven Lamps*, ch. 3, par. 24 (*Works*, 8).
27. Lec. 6, par. 74 (*Works*, 23); the manuscript note is given on p. 240n.
28. Lec. 1, par. 21 (*Works*, 12).
29. Vol. 2, ch. 6, par. 114 (*Works*, 35).

disgusts and disappointments, even to 13th cent[ur]y windows of cathedral, which are entirely grotesque and frightful in design, though glorious in colour. And the shafts and vaultings are the worst I ever saw of the time; the arches of nave meagre and springless The towers more and more are like confectioners' Gothic to me"[30] As late as 1854 he finds the interior of Chartres "meagre and uninteresting"; it "has lost the power of Norman, without gaining the grace of Gothic."[31] Even Amiens, the beauties of which he immortalized at the end of his career, is mentioned critically in his 1849 diary, where he denigrates its facade for being disjointed; its sculpture for being, "without a single exception, coarse and unfinished"; its vaulting, for want of "infinity."[32]

Charles H. Moore, the friend of Charles Eliot Norton and Harvard fine arts professor who spent much time with Ruskin in Venice when he was at work on *St. Mark's Rest,* asserts that Ruskin was "virtually unacquainted with the pure style" of the High Gothic of the Ile-de-France.[33] This is, I think, an exaggeration; he had at least visited nearly all the great examples, many of them regularly. But he never studied them the way he did the buildings of Verona or Venice; generally he would spend a day, perhaps two, at Beauvais or Chartres, and be off for the Alps. Again, he did not *know* them; compared to the fascination exerted by Italian monuments, they did not engage "my affections, as well as my experience." Therefore, they scarcely existed for argumentative purposes.

When Ruskin makes his infrequent overt recommendations on the forms of medieval architecture the nineteenth century should revive, his Italian bias also comes through clearly. In *The Seven Lamps,* three of his four choices are Italian, the fourth a mélange of English and French. In the last volume of *Stones of Venice* he envisions a day when "we may do things like Giotto's campanile, instead of like our own rude cathedrals," while in *Lectures on Architecture* he assures his Edinburgh audience that their Scottish beds of green serpentine would permit them to emulate the exquisite examples of sculpture and inlay found in Florentine Gothic.[34]

His Italian preferences become the more apparent—and the more final— when we consider the extensive use he makes of North/South contrasts throughout his work. Fittingly, his earliest effort, *The Poetry of Architecture,* "rose immediately out of my sense of the contrast between the cottages of West-

30. August 15, 1882, *Diaries,* 3: 1015.

31. May 25, 1854, ibid., 2: 495. But Chartres was planned as the subject of the seventh book of *Our Fathers.*

32. September 14, 1849, *Diaries,* 2: 439-41.

33. Charles H. Moore, "Ruskin as Critic of Architecture," *Architectural Record* 56 (August 1924): 118.

34. *Seven Lamps,* ch. 7, par. 7 (*Works,* 8); *Stones of Venice III,* ch. 4, par. 36 (*Works,* 11); *Lectures on Architecture,* lec. 2, par. 53 (*Works,* 12).

moreland and those of Italy."[35] Even the basic first volume of *Stones* is permeated with these contrasts. Like Pugin, Ruskin found establishing polarities essential to his arguments; indeed, his use of contrasts was one of the bases for the accusations of plagiarism that he endured.[36] And, like Pugin's, his alternatives are couched in terms that by their very nature force a moral judgment. Ruskin's contrasts almost never consist of equal pairs; both quantities are frequently stated extremely, and one side is clearly meant to be unattractive or untenable. It is indicative that the contrast at the very heart of his social criticism is Life/Death. Therefore, even the North/South contrasts intended as neutral illustrations usually have a prejudicial edge.

The quintessential North/South contrast in Ruskin is, of course, the magnificent Salisbury/St. Mark's passage in *Stones of Venice II.*[37] The Northern building is a great bleak pile of "mouldering wall of rugged sculpture and confused arcades, shattered, and grey, and grisly with heads of dragons and mocking fiends, worn by the rain and swirling winds into yet unseemlier shape, and coloured on their stony scales by the deep russet-orange lichen, melancholy gold," surrounded by a lawn on which we must take care not to step, in turn bordered by "somewhat diminutive and excessively trim houses" with "little shaven grass-plots," the sole signs of well-regulated life being the tradesmen's delivery carts and the canons' children walking with their nursemaids; this static scene is punctuated only by the cacaphony of rooks circling like predators amid the towers, "a drift of eddying black points." Then we are presented with the glorious Venetian spectacle of bustling St. Mark's Place, the church itself an Arabian Nights phantasm come to pulsating life, glistening with rich color, even to the irridescence of the gentle doves placidly nestling among the marble foliage:

> . . . a multitude of pillars and white domes, clustered into a long low pyramid of coloured light; a treasure-heap, it seems, partly of gold, and partly of opal and mother-of-pearl, hollowed beneath into five great vaulted porches, ceiled with fair mosaic, and beset with sculpture of

35. *Praeterita*, vol. 1, ch. 12, par. 250 (*Works*, 35).

36. See his defensive 1855 letter on this point to Dr. Furnivall in *Works*, 5: 429n.

37. Ch. 4, pars. 10ff. (*Works*, 10). Cook and Wedderburn point out that the English cathedral in this renowned contrast is a generic one, that although it has been variously identified as Salisbury and Canterbury, it possesses features of many English Gothic cathedrals (*Works*, 10: 78n). However, in *Seven Lamps*, ch. 4, par. 43 (*Works*, 8), Ruskin explicitly compares Giotto's Campanile with Salisbury in much the same language and detail as he uses in the more famous *Stones of Venice* contrast, and Salisbury was his most frequent source of English Gothic examples. On the basis of these coincidences and for the sake of convenience, I refer to this passage as the "Salisbury/St. Mark's contrast." It should be noted that generally in these North/South contrasts, the Southern term includes a broader range of styles—for example, Byzantine, Pisan Romanesque, even very early Renaissance—while the Northern term is exclusively Gothic.

alabaster, clear as amber and delicate as ivory,—sculpture fantastic and in-
volved, of palm leaves and lilies, and grapes and pomegranates, and birds
clinging and fluttering among the branches And round the walls of
the porches there are set pillars of variegated stones, jasper and porphyry,
and deep-green serpentine spotted with flakes of snow, and marbles, that
half refuse and half yield to the sunshine, Cleopatra-like, "their bluest
veins to kiss" . . . and above them, in the broad archivolts, a continuous
chain of language and of life—angels, and the signs of heaven, and the
labours of men, each in its appointed season upon the earth; and above
these, another range of glittering pinnacles, mixed with white arches edged
with scarlet flowers,—a confusion of delight . . . until at last, as if in ecstasy,
the crests of the arches break into a marble foam, and toss themselves far
into the blue sky in flashes and wreaths of sculptured spray, as if the
breakers on the Lido shore had been frost-bound before they fell, and the
sea-nymphs had inlaid them with coral and amethyst.

"Between that grim cathedral of England and this," exclaims Ruskin, "what
an interval!" Indeed. Seen as Ruskin so memorably describes them, it is small
wonder that he should side with the medieval South and declare:

. . . those who study the Northern Gothic remain in a narrowed field—one
of small pinnacles, and dots, and crockets, and twitched faces—and cannot
comprehend the meaning of a broad surface or a grand line. . . . The Gothic
of the Ducal Palace of Venice is in harmony with all that is grand in all the
world: that of the North is in harmony with the grotesque Northern spirit
only.[38]

It is logical, then, that the characteristics of architecture that attracted Ruskin
and which thus came to constitute his emphases in his architectural writings
should be those of medieval Italy. (This is only the most obvious explanation—
although one generally overlooked by Ruskin critics; more complicated under-
lying causes will be discussed intensively in chapter 6.) The first of these
emphases is his preoccupation with architectural *surfaces;* Ruskin conceives of
a building as a series of *planes.* These planes may be undecorated, beautiful in
themselves because of the lovely patterns inherent in their materials, especially
the different kinds of marble—many available only in the South. Perhaps part-
ly as a reflection of his keen early interest in geology, Ruskin was always fasci-
nated by rich building materials; often in his writings, as in the St. Mark's pas-
sage above, he revels in exhausting their varieties by reciting them in splendid
Miltonic catalogues. "For again and again I must repeat it," he tells us in
Praeterita, "my nature is a worker's and a miser's; and I rejoiced, and rejoice

38. *Stones of Venice I,* ch. 13, par. 9 (*Works, 9*).

still, in the mere quantity of chiselling in marble, and stitches in embroidery; and was never tired of numbering sacks of gold and caskets of jewels in the Arabian Nights"[39]

Naturally, the most practicable means of exploiting the beauties of these elegant materials, as he is quick to point out both in *Seven Lamps* and *Stones*, is for them to be shaved thin and applied as precious skins to a building, masking its merely utilitarian construction; hence the glory of the Venetian "architecture of incrustation," in which the visible building is only a film. Indeed, such veneering may be viewed "as simply an art of mosaic on a large scale."[40] A building becomes a kind of geological painting. When rich materials are used as solid, three-dimensional architectural elements such as shafts, on the other hand, they are to be treated as "nothing else than large jewels, the block of precious serpentine or jasper being valued according to its size and brilliancy of colour, like a large emerald or ruby." "[I]ts end is to *be* beautiful," and this far outweighs its structural duties, the perception of which may even interfere with our experience of its loveliness.[41] Again, the beautiful surface is what matters, as in the gleaming facets of a well-cut gem.

Clearly Ruskin's love of opulent materials is related to his still greater love of color, and in architecture, especially of color worked into elegant incrusted patterns; the tinted plates of the first edition of *Stones*, for instance, are filled with samples of flat, multi-hued inlaid marble decorations from the facades of Venetian palaces and churches. "I cannot . . . consider architecture as in anywise perfect without colour," he asserts in *The Seven Lamps*, and "the colours of architecture should be those of natural stones."[42] The magnificence of St. Mark's resides almost wholly in its color; "it is on its value as a piece of perfect and unchangeable colouring, that the claims of this edifice to our respect are finally rested."[43]

Furthermore, throughout Ruskin's works, whether on nature or the arts, color is regarded as "of all God's gifts to the sight of man, . . . the holiest, the most divine, the most solemn." Color is always associated by Ruskin with moral and spiritual integrity ("the purest and most thoughtful minds are those which love colour the most"), even with intellectual and physical health.[44] Conversely, he labels the loss or lack of color as symptomatic of spiritual decline and artistic enervation; his most persistent argument for rejecting Renaissance architecture is the "numbness" of its "barren stone."[45] Yet at least in part

39. Vol. 3, ch. 1, par. 18 (*Works*, 35).
40. *Seven Lamps*, ch. 2, par. 18 (*Works*, 8); *Stones of Venice II*, ch. 4, pars. 25ff. (*Works*, 10).
41. *Stones of Venice II*, ch. 4, pars. 33-34 (*Works*, 10).
42. Ch. 4, par. 35 (*Works*, 8).
43. *Stones of Venice II*, ch. 4, par. 28 (*Works*, 10).
44. Ibid., ch. 5, par. 30; see also *Elements of Drawing*, ch. 3, par. 182 (*Works*, 15).
45. *Stones of Venice III*, ch. 1, par. 24 (*Works*, 11).

this same standard must be applied to Northern Gothic as well; the Salisbury/ St. Mark's passage is, at bottom, entirely a contrast of coloration. The Northern builders lacked the broad range of delicately shaded veneering materials available in the South; the dull greys and buffs of their freestone could only be masked by paint, Ruskin explains, the colors being applied quite literally rather than subtly: "Flames were painted red, trees green, . . . the result . . . being often far more entertaining than beautiful." Moreover, the depth of the carving—again a function of the difference in materials—compelled the Northern architect "to use violent colours in the recesses, . . . and thus injured his perception of more delicate colour harmonies"[46]

In any event artificial coloring, especially as buffeted by the harsher Northern climate, is necessarily impermanent:

> . . . a time will come when such aids must pass away, and when the building will be judged in its lifelessness, dying the death of the dolphin. Better the less bright, more enduring fabric. The transparent alabasters of San Miniato, and the mosaics of St. Mark's, are more warmly filled, and more brightly touched, by every return of morning and evening rays; while the hues of our cathedrals have died like the iris out of the cloud[47]

This early reference to the dying of the iris out of the cloud is, of course, an irresistible reminder of Ruskin's late obsession with the "Storm Cloud of the Nineteenth-Century"; it was his feeling that the industrial age was actually draining the color out of the universe that helped drive him mad. As early as his 1841 diary there is a poignantly ominous entry, "I am ashamed to find myself so much at the mercy of a dark sky,"[48] which helps to demonstrate how deep was his aversion to greyness, to the absence of color, throughout his life, and in turn indicates how much more appealing subtly tinted building materials glowing in the bright Southern sun would be to him than the dully monochromatic stone of the clouded North. At any rate, if the proper colors of architecture are those of natural stones, it follows that Northern Gothic must, by an unkind quirk of geological fate, be inferior to that of the medieval South. But color itself is finally an abstract quality, basically independent of

46. *Stones of Venice II*, ch. 4, par. 45 (*Works*, 10).
47. *Seven Lamps*, ch. 2, par. 18 (*Works*, 8).
48. Herne Hill, December 6, 1841, *Diaries*, 1: 220. One of the great values of Ruskin's diaries is the record they contain of his dislike, later fear, of greyness as associated with the appearance and intensity of the sun; at various points throughout his life he made notations of the hours at which candles were lit or extinguished, the number of days till the longest or shortest day of the year, the relative richness of the daily sunrise and sunset, etc. Cf. *Modern Painters IV*, pt. 5, ch. 3, par. 24 (*Works*, 6), where he asserts that color is "associated with *life* in the human body, with *light* in the sky, with *purity* and hardness in the earth,—death, night, and pollution of all kinds being colorless."

form, which Ruskin himself consistently notes, especially in *Modern Painters;* as an architectural characteristic, it is two-dimensional, a *surface stain.*

Yet when Ruskin goes beyond color and its patterns to talk about more complicated embellishments of the planes of a building, his emphasis is likewise two-dimensional. Again, this emphasis derives partly from his love of marble and his preoccupation with it as the supreme architectural material. We have already reviewed his explanation of how marble permits broad, undecorated areas in a building because of its inherent beauty. Even the decorated surfaces, however, will receive only shallow carving, particularly when they are veneers. This is especially the case in Venetian architecture because of its strong Byzantine heritage, as Ruskin repeatedly explains in *Stones of Venice.* Nonetheless, he emphasizes shallow relief throughout his writings on architecture, and in his later Oxford lectures on sculpture as well. In *Stones of Venice I* he argues: "It is to be remembered that, by a deep and narrow incision, an architect has the power, at least in sunshine, of drawing a black line on stone just as vigorously as it can be drawn with chalk on grey paper; and that he may thus, wherever and in the degree that he chooses, substitute *chalk sketching* for sculpture."[49] But in *Lectures on Art* (1870) he drops the distinction between sculpture and "sketching" altogether, maintaining that "sculpture is indeed only light and shade drawing in stone."[50] In *Aratra Pentelici* (1872) he states, "A great sculptor uses his tool exactly as a painter his pencil," and it is there also that he defines sculpture as "essentially the production of a pleasant bossiness or roundness of surface."[51] In a London lecture from the same period, "The Flamboyant Architecture of the Valley of the Somme" (1869), he declares: "there is not a greater distinction between vital sculpture for building, and dead sculpture, than that a true workman paints with his chisel,—does not carve the form of a thing, but cuts the effect of its form."[52]

These more direct later pronouncements on the superiority of low relief are quite consistent, however, with his implied earlier positions, especially that expressed in the "Review of Lord Lindsay" (1847), where he faults the author for not having sufficiently insisted "on what will be found to be a characteristic of all the truly Christian or spiritual, as opposed to classical, schools of sculpture—the scenic or painter-like management of effect. The marble is not cut into the actual form of the thing imaged, but oftener into a perspective suggestion of it"[53] It is significant that in *Stones of Venice* one of

49. Ch. 21, par. 23 (*Works*, 9).
50. Lec. 6, par. 165 (*Works*, 20).
51. Lec. 5, par. 178, and lec. 1, par. 21 (*Works*, 20).
52. Par. 13 (*Works*, 19). He does go on to warn that such a technique can eventually lead to "too much superficial effect,—too much trickery,—not enough knowledge of real form."
53. Par. 39 (*Works*, 12: 207).

the most damning points he believes he can make about the decadence of the
Renaissance is that tomb figures are no longer supine, but rise up, as if in death
trying to assert continued bodily existence. Despite his love of sculpture, Rus-
kin almost never examines the free-standing variety; rather he devotes himself
to sculpture intimately associated with architecture: "Sculpture, separated
from architecture, always degenerates into effeminacies and conceits; archi-
tecture, stripped of sculpture, is at best a convenient arrangement of dead
walls; associated, they not only adorn, but reciprocally exalt each other."[54]
They not only exalt, however, but *affirm* each other; for "all good wall orna-
ment . . . retains the expression of firm and massive substance, and of broad
surface," from "mere inlaid geometrical figures up to incrustations of elaborate
bas-relief."[55] Thus even in praising sculptured detail so lavishly as he does
throughout his works, Ruskin still conceives it more in two dimensions than
three, in keeping with the planar emphasis of Italian Gothic.

Naturally, Ruskin also considers frescoes a suitable embellishment of archi-
tectural planes—again, an area in which the Italians excel to the exclusion of
the North. He feels some reservations about frescoes on the basis of their im-
permanence, especially on surfaces exposed to the elements,[56] but he loved
painting too much, and particularly the work of Giotto and Cimabue on the
walls of Assisi, to reject this kind of decoration merely for its fragility. Once
more, however, the way the Italian Gothic painters handled frescoes rendered
"architecture" literally in two dimensions.

Last, Ruskin conceives of architectural surfaces as decorated by incidental
effects—by patterns of light and shade, for example. In *The Seven Lamps* he
emphatically argues that the architect should regard light and shade as raw
materials; "a wall surface is to an architect simply what a white canvas is to a
painter," to be touched with strokes of light and dark:

> . . . I do not believe that ever any building was truly great, unless it had
> mighty masses, vigorous and deep, of shadow mingled with its surface.
> And among the first habits that a young architect should learn, is that of
> thinking in shadow, not looking at a design in its miserable liny skeleton;
> but conceiving it as it will be when the dawn lights it, and the dusk leaves
> it; when its stones will be hot and its crannies cool His paper lines
> and proportions are of no value: all that he has to do must be done by
> spaces of light and darkness[57]

Indeed, it was the Byzantine heritage of masterful light and shade "drawing"

54. Second Letter in *The Oxford Museum,* par. 21 (*Works,* 16).
55. *Stones of Venice I,* ch. 26, par. 7 (*Works,* 9).
56. See, for example, *Stones of Venice III,* ch. 1, pars. 31ff. (*Works,* 11).
57. Ch. 3, pars. 12-13 (*Works,* 8).

that helped make Venetian architecture so appealing to him. Still, light and shade are not architectural elements in themselves; as beautiful and as integral to architectural effect as they may be, they are entirely superficial, a result of the absorption or reflection of light by a *surface,* according to the vagaries of the weather. And once again, using this criterion, the Northern Gothic must by virtue of climatological accident be inferior. For only in a very bright, sunny climate can effects of light and shade be fully exploited, especially in the low-relief decoration Ruskin loved so well.

But the incidental decorations of architectural surface most dear to Ruskin are those provided by nature herself over long periods of time, such as weathering or accretions of vegetation. These are the qualities he classes in *Stones of Venice III* as "the picturesque elements of architecture,"[58] which he continued to analyze in his work despite his assertion at the end of his career in *Praeterita* that they no longer mattered to him after his 1845 epiphany at Lucca. One of the main appeals of such elements for Ruskin is their enhancement of *surface color,* and by implication he asserts Southern superiority in this aspect too. We have noted his contention that marble weathers especially exquisitely; to return once more to the Salisbury/St. Mark's passage, one of the basic color contrasts is of the rich patinas of St. Mark's jasper and serpentine with the melancholy gold of the lichen-encrusted, mouldering Northern stone.

Another appeal of these elements is clearly their addition of *surface texture,* which always fascinated Ruskin. In an unpublished passage of *Praeterita* he refers to his

> . . . idiosyncrasy which extremely wise people do not share,—my love of all sorts of filigree and embroidery, from hoarfrost to the high clouds. The intricacies of virgin silver, of arborescent gold, the weaving of birds'-nests, the netting of lace, the basket capitals of Byzantium, and most of all the tabernacle work of the French flamboyant school, possessed from the first, and possess still, a charm for me[59]

An interesting example of the way Ruskin tended to identify "filigree" as an architectural element, even when it was most accidental, is this 1846 diary passage about an ironwork balcony at Verona:

> . . . I found an instance to-day, close in its reticulation, and taking strong light on its design owing to the grey, dusty, lustreless surface of it, which is partly owing to the work of an indefatigable spider here, whose work is almost ornamental, being trumpet shape, with a hole or tube in the middle

58. Ch. 3, par. 37 (*Works,* 11).
59. *Works,* 35: 157n.

for him to live in; these black holes and starry forms tell on the architec-
ture like elegant bits of decoration.[60]

Obviously, therefore, one of Ruskin's primary objections to architectural
restorations is that they destroy these adventitious accumulations of "pic-
turesque elements." In one of his more fervent pleas for preservation of
Europe's architectural heritage, the 1854 pamphlet on "The Opening of the
Crystal Palace," he even goes so far as to imply that these superficial qualities
are more integral to aesthetic pleasure than the architecture itself; speaking of
the entrance to Rouen's north transept he remembers it for being

> . . . beautiful, not only as an elaborate and faultless work of the finest
> time of Gothic art, but yet more beautiful in the partial, though not
> dangerous, decay which had touched its pinnacles with pensive colouring,
> and softened its severer lines with unexpected change and delicate fracture,
> like sweet breaks in a distant music. The upper part of it has been already
> restored to the white accuracies of novelty[61]

No wonder, therefore, that Ruskin persistently claims the greatness of a build-
ing lies ultimately in its age, as revealed in these romantic, *nonarchitectural* en-
hancements of surface:

> . . . so far as it can be rendered consistent with the inherent character, the
> picturesque or extraneous sublimity of architecture has just this of nobler
> function in it than that of any other object whatsoever, that it is an ex-
> ponent of age, of that in which . . . the greatest glory of a building con-
> sists; and, therefore, the external signs of this glory, having power and pur-
> pose greater than any belonging to their mere sensible beauty, may be
> considered as taking rank among pure and essential characters; so essential
> to my mind, that I think a building cannot be considered in its prime until
> four or five centuries have passed over it[62]

The second of Ruskin's major architectural emphases, and one that has under-
lain much of the preceding analysis, is his stress on ornamental elements, espe-
cially sculptural detail. Sculpture was by far the most important architectural
component for Ruskin; in *Aratra Pentelici* he asserts that some of the best
buildings he knows are simply "minute jewel cases for sweet sculpture."[63]
This emphasis is clearest in the addenda he provides to Lectures 1 and 2 of

60. May 10, 1846, *Diaries*, 1: 333.
61. Par. 12 (*Works*, 12).
62. *Seven Lamps*, ch. 6, par. 16 (*Works*, 8).
63. Lec. 5, par. 145 (*Works*, 20).

Lectures on Architecture and Painting (1854), in which he purports to distill for his readers the gist of the propositions he desires to maintain about architecture. Of the six basic propositions enunciated, five deal exclusively with ornamentation. For Ruskin, ornament is *"the principal part of architecture. That is to say, the highest nobility of a building does not consist in its being well built, but in its being nobly sculptured or painted"*; therefore, "no person who is not a great sculptor or painter *can* be an architect. If he is not a sculptor or painter, he can only be a *builder*."[64] In his 1855 preface to the second edition of *Seven Lamps* Ruskin even asserts that "there are only two fine arts possible to the human race, sculpture and painting. What we call architecture is only the association of these in noble masses, or the placing them in fit places," and it is their combination that becomes the entire basis for "artistical and rational admiration" of architecture. Outlining in the same preface how he arrived at such a position, he continues,

> I found . . . that this, the only admiration worth having, attached itself *wholly* to the meaning of the sculpture and colour on the building. That it was very regardless of general form and size; but intensely observant of the statuary, floral mouldings, mosaics, and other decorations. Upon which . . . it gradually became manifest to me that the sculpture and painting were, in fact, the all in all of the thing to be done; that these, which I had long been in the careless habit of thinking subordinate to the architecture, were in fact the entire masters of the architecture[65]

Thus it was obvious that he would constantly emphasize in his own writing the statuary, the floral mouldings, the mosaics. What is less obvious is the extent to which they constituted virtually his *entire* emphasis in architecture.

Ruskin's preoccupation with detail is especially evident in the illustrative plates he chose for his architectural works. Rarely are we given a view of anything larger than a window, door, or balcony; rarely are we permitted any perspective on how this window or door or balcony forms part of an architectural whole, although the opposite may obtain and additional plates be offered of still smaller details from those features.

Two *caveats* should be kept in mind, however, when judging the character of these illustrations. The range of plates Ruskin could include was certainly limited by their being time-consuming to engrave and expensive to reproduce; they could add substantially to the price of an already costly multivolume set like *Stones*. Writing to his father from Venice in 1852, for example, Ruskin laments, "The plates of this third volume may absorb all its profits—i.e. Smith and Elder [his publishers] will give me nothing for it—but undertake its plates—

64. Pars. 59, 61 (*Works*, 12).
65. Pars. 7, 6 (*Works*, 8).

I am prepared for this—"[66] For the earlier *Seven Lamps* he actually etched his own, learning the techniques as he went along; he finished the last in a washbasin at a Dijon hotel.[67]

Ruskin's desire for absolute accuracy is the second *caveat* regarding the emphasis on detail of his illustrations. Even his just-noted home-made plates he vigorously defends on grounds of their fidelity:

> They are black, they are overbitten, they are hastily drawn, they are coarse and disagreeable But their truth is carried to an extent never before attempted in architectural drawing. . . . [T]he sketches of which those plates in the *Seven Lamps* are facsimiles, were made from the architecture itself, and represent that architecture with its actual shadows at the time of day at which it was drawn, and with every fissure and line of it as they now exist[68]

At the same time, however, he despairs in *Stones of Venice II* of truly conveying the general effect of the buildings he discusses:

> Nothing is so rare in art . . . as a fair illustration of architecture; *perfect* illustration of it does not exist. For all good architecture depends upon the adaptation of its chiselling to the effect at a certain distance from the eye; and to render the peculiar confusion in the midst of order, and uncertainty in the midst of decision, and mystery in the midst of trenchant lines, which are the result of distance, . . . requires the skill of the most admirable artist, devoted to the work with the most severe conscientiousness[69]

He then offers a drawing (Plate 6) of a St. Mark's archivolt, not to depict the archivolt itself, but to demonstrate "the impossibility of illustration." This passion for exactness must have discouraged Ruskin, at least in part, from including perspective views of the buildings he discussed. Doubtless, too, his brilliant descriptive passages represent in considerable measure an attempt to render satisfactorily in words what Victorian publishing constraints prevented his depicting in illustrations.

Nonetheless, even a folio-size work like *Examples of Venetian Architecture* (1851),[70] the only partly completed supplement to *Stones of Venice* specifically intended to provide illustrations not easily reducible to the quarto confines of the main text, is entirely details. Of the fifteen plates that were published, just three convey even a partial sense of architectural context. The rest—draw-

66. February 13, 1852, in *Ruskin's Letters from Venice*, ed. Bradley, p. 177.
67. *Works*, 8: xxxv, xxxvn, xlv, xlix.
68. *Stones of Venice I*, app. 8 (*Works*, 9: 431).
69. Ch. 4, par. 48 (*Works*, 10).
70. Published in reduced form in *Works*, 11: 311-50.

ings of capitals, mouldings, door-heads, windows—are often *details of details* already depicted in *Stones*. To Ruskin, one great advantage of the twelve-by-eighteen-inch average dimensions of these plates is not that they permit overviews but rather that they make possible actual-size renderings of architectural detail. Of those details not given in their true measurements, Ruskin repeatedly avers that they are carefully drawn to scale; the prospectus for the edition states that "nearly all" the plates "are *portions* of buildings" and that their "chief value will be their most servile veracity."[71]

Of the fifty-three plates found in *The Stones of Venice* itself, only one, Plate 6 of Volume I, "Types of Towers," pictures a structure in its entirety, and Ruskin's purpose there is merely to show how puny are modern British towers compared to the huge campanile of St. Mark's. Plate 1 of Volume II offers ground plans of the churches of Torcello and Murano; certainly there is no difficulty in rendering these accurately, and they provide crucial reference points, yet none are furnished either for St. Mark's or the Doge's Palace, despite their centrality in the work. The broadest view of St. Mark's itself given anywhere in *Stones* is an archivolt; of the Doge's Palace, except for a simple aerial sketch, the sculpture of the "Vine Angle."[72] But there is plate after plate of bases, capitals, cornices, jambs, and windows, perfectly rendered and carefully distributed in numbered and lettered rows.

In the fourteen plates of *Seven Lamps*, by contrast, the details—the largest, a traceried opening from Giotto's Campanile—are simply spilled onto the page with no regard to comparative scale, so that any sense of their architectural identity is altogether lost.[73] The point may seem belabored, but it is extremely important both to assessments of his criticism and of his influence to realize how totally Ruskin's architectural analysis was in fact devoted to architectural detail, as well as how necessary it was for his readers to seek out other sources of illustrations (to the extent such were available) if they were to gain any grasp of the contexts of these fragments he so beautifully presented for their edification.

His preoccupation with detail was one of the main points on which he was attacked by contemporaries; as might be expected, Ruskin justified his emphasis on a variety of grounds, all having moral bearings. "It is often said, with some

71. Given at the end of the first edition of *Stones of Venice I*, and reprinted in *Works*, 11: 313-14n.

72. But see *Stones of Venice II*, ch. 4, par. 44 (*Works*, 10), where he claims that he has omitted illustrations of these two structures not only because it is impossible to do them justice but also because "a noble cast" of one of the Ducal Palace's angles will soon be placed in the Crystal Palace. A cast of a single angle will apparently be (to Ruskin) an acceptable basis for judging the entire monument.

73. See especially Plates 1, 4, 7, 10, 12, 13 (*Works*, 8, facing pp. 52, 96, 128, 165, 199, 212). It is perhaps significant that these were Ruskin's own work, done *sans* professional advice regarding format.

appearance of plausibility, that I dwell in all my writings on little things and
contemptible details; and not on essential and large things," he remarks in the
addenda to *Lectures on Architecture and Painting*, but he goes on to contend
that an understanding of minuteness precedes an understanding of size. Mod-
ern architects, he asserts, cannot master detail; they are merely builders,
copyists: "Let them first learn to invent as much as will fill a quatrefoil, or
point a pinnacle, and then it will be time to reason with them on the princi-
ples of the sublime." He also argues, however, that the same creative skills are
involved in each instance: whoever can design small things perfectly, can de-
sign whatever he chooses, because "to arrange (by invention) the folds of a
piece of drapery, or dispose the locks of hair on the head of a statue, requires
as much sense and knowledge of the laws of proportion, as to dispose the
masses of a cathedral."[74]

The analogy between great and small also forms the basis of another of his
justifications, that small and large are all part of a unifying continuum: the
pebble is a mountain in miniature, the humblest detail is full of meaning and
necessary to a just appreciation of the whole. For "greatness can only be right-
ly estimated when minuteness is justly reverenced. Greatness is the aggregation
of minuteness"[75] This argument pervades the volumes of *Modern Painters*
and forms the basis for the series of chapters "The Law of Help," "The Task
of the Least," and "The Rule of the Greatest" in the fifth volume.[76] In "The
Task of the Least," on one of the surprisingly rare occasions in his major books
when he analyzes the total composition of a work of art, Ruskin takes a plate
from Turner's *Rivers of France* series and impressively demonstrates how the
most seemingly insignificant bits are crucial to the effect of the whole, conclud-
ing, "It is the necessary connection of all the forms and colours, down to the
last touch, which constitutes great or inventive work, separated from all com-
mon work by an impassable gulf."[77] Ruskin regularly applies the same standard
to architecture, as in *Lectures on Architecture and Painting*, when, after minute-
ly analyzing a less-than-two-feet-square portion of Lyons facade and showing
how its tiniest rosebud cannot be obliterated without artistic injury, he ex-
claims, "Yet just observe how much design, how much wonderful composition,
there is in this building of the great times . . . and having examined this well,
consider what a treasure of thought there is in a cathedral front"[78] In
Stones of Venice I he states as a general principle: "a noble building never has

74. Pars. 64, 63 (*Works*, 12).

75. *Modern Painters V*, pt. 8, ch. 3, par. 2 (*Works*, 7).

76. Chs. 1-3 (*Works*, 7). Chapter 2 even opens with the words, "The reader has prob-
ably been surprised at my assertions made often before now, and reiterated here, that the
minutest portion of a great composition is helpful to the whole."

77. Ibid., ch. 2, par. 14.

78. Lec. 2, par. 37 (*Works*, 12).

any extraneous or superfluous ornament; . . . all its parts are necessary to its loveliness, and . . . no single atom of them could be removed without harm to its life."[79]

Moreover, the artist's treatment of detail is an index of his moral worth— always an important concern for Ruskin; truly noble men show respect for all forms of being, and therefore express themselves with as much care in tiny ways as in great: "Greatness of mind is not shown by admitting small things, but by making small things great under its influence. He who can take no interest in what is small, will take false interest in what is great" Thus, he explains, "in the little bits which I fix upon for animadversion, I am not pointing out solitary faults, but only the most characteristic examples of the falsehood which is everywhere"[80] And again, though in this instance Ruskin is specifically discussing painting, he habitually judged architecture in a similar manner, the more so because of his perennial insistence that no one who is not a great sculptor or painter *can* be an architect.

Finally, Ruskin impliedly offers a metaphysical vindication for his emphasis. Life is a series of divine fragments glimpsed through a glass darkly: "the work of the Great Spirit of nature is as deep and unapproachable in the lowest as in the noblest objects"; "the least thing is as the greatest and one day as a thousand years in the eyes of the Maker of great and small things."[81]

> Our whole happiness and power of energetic action depend upon our being able to breathe and live in a cloud; content to see it opening here and closing there; rejoicing to catch, through the thinnest films of it, glimpses of stable and substantial things; but yet perceiving a nobleness even in the concealment, and rejoicing that the kindly veil is spread where the untempered light might have scorched us, or the infinite clearness wearied.[82]

Yet despite his repeated declarations that details are to be seen as part of a magnificently unified whole, when Ruskin discusses them he tends to analyze them in isolation—just as his architectural plates so beautifully but incompletely depict them. The whole is simply not there as a constant reference point. This emphasis too is partly traceable to his overriding interest in Italian Gothic; we have noted how its sculpture is sparsely distributed compared to that of the Northern style, how its finish is more smoothly sophisticated and will, therefore, yield to more concentrated aesthetic analysis. Besides, the best examples of medieval Italian sculpture—those found in the pulpits, tombs, or low-relief plaques which Ruskin considers basically architectural—are scarcely

79. App. 17 (*Works*, 9: 452).
80. *Modern Painters I*, pt. 2, sec. 4, ch. 4, pars. 28, 14 (*Works*, 3).
81. Ibid., par. 30; *Modern Painters V*, pt. 8, ch. 3, par. 1 (*Works*, 7).
82. *Modern Painters IV*, pt. 5, ch. 5, par. 3 (*Works*, 6).

creations of the anonymous, imperfect workman described in "The Nature of Gothic," but are the masterpieces of identifiable proud personalities like Niccola and Giovanni Pisano and Jacopo della Quercia. In other words, they virtually ask to be viewed in isolation.

In still other ways, Venetian architecture specifically promotes this mode of examination. Many of the structures that interested Ruskin most had suffered grievously from neglect; they were literally the stones of Venice. Furthermore, because he found Venetian antiquaries hopelessly unreliable, "it became necessary for me to examine not only every one of the older palaces, stone by stone, but every fragment throughout the city which afforded any clue to the formation of its styles."[83] To complicate matters additionally, the Venetians often pirated fragments of building materials as well as of finished architecture from other lands to incorporate into their own structures. And of course Ruskin's beloved St. Mark's is the very archetype of eclecticism, the product of eight centuries of Byzantine, Romanesque, Arabic, Gothic, Renaissance, and modern accretions. Or as Ruskin sums up for himself in his 1849 diary, "There is no town in Italy of which parts and detached groups of building [sic] are so perfect as some in Venice"[84]

But Ruskin not only focuses on small bits at the expense of the larger view, he actually exalts their independent value: "beauty cannot be parasitical. There is nothing so small or so contemptible, but it may be beautiful in its own right. The cottage may be beautiful, and the smallest moss that grows on its roof, and the minutest fibre of that moss which the microscope can raise into visible form, and all of them in their own right, not less than the mountains and the sky"[85] Moreover, discussing the bas-reliefs at the base of Giotto's Tower in *Mornings in Florence,* he clearly suggests that seeing details in isolation is necessary to their full appreciation:

> At first you may be surprised at the smallness of their scale in proportion to their masonry; but this smallness of scale enabled the master workmen of the tower to execute them with their own hands It is in general not possible for a great workman to carve, himself, a greatly conspicuous series of ornament; nay, even his energy fails him in design, when the bas-relief extends itself into incrustation, or involves the treatment of great masses of stone. If his own does not, the spectator's will.[86]

Certainly this is the assumption underlying his contention in *Lectures on Architecture and Painting* that the principal part of a building is that "in which its

83. *Stones of Venice I,* preface to the first edition, par. 1 (*Works,* 9).
84. Venice, November 23, 1849, *Diaries,* 2: 455.
85. *Stones of Venice III,* ch. 3, par. 36 (*Works,* 11).
86. Sixth Morning, par. 122 (*Works,* 23).

mind is contained, . . . its sculpture and painting. I do with a building as I do with a man, watch the eye and the lips: when they are bright and eloquent, the form of the body is of little consequence."[87]

This viewpoint also helps explain Ruskin's frequent assertion that architectural ornament bears no necessary relation to a building's structure. We have already reviewed Pugin's second "True Principle" that all ornament should consist of enrichment of the essential construction of the building. By the time of Ruskin's major writing on architecture, the notion that ornament, not only of buildings but of carpets and teapots, must be secondary and appropriate to the form of the object being adorned, had achieved fairly wide currency among better design theorists.[88] Ruskin, however, steadfastly denied this position. He maintains first of all that ornament is beautiful for its own sake; its only "function . . . is to make you happy." "It is the expression of man's delight in God's work," and is thus separated from any considerations of mere utility: "I have said . . . repeatedly . . . that the most beautiful things are the most useless; I never said superfluous. I said useless in the well-understood and usual sense, as meaning, inapplicable to the service of the body."[89] It follows, therefore, that ornament cannot be subordinated to or dictated by structural considerations but should only be measured by its aesthetic contribution to the building.

This notion is presented most forcefully in his Oxford lectures of the seventies, where he provides numerous examples denying the principle of ornamented construction. The most direct attack on that position comes in Lecture 6 of *Val d'Arno* (1874) when he remarks, "A disciple of Mr. Pugin would delightedly observe that the porch of St. Zeno at Verona was nothing more than the decoration of . . . construction," but then proceeds to examine minutely the sculpture beautifying the door of the Pisa Baptistery, demonstrating that this embellishment, measured only by its constructional relations, is actually illogical.[90] This does not mean that structure and ornament must necessarily clash, but rather that a preoccupation with structure distracts from the more vital considerations of beauty per se, as he explains in *Aratra Pentelici:*

> . . . the false theory that ornamentation should be merely decorated structure is so pretty and plausible, that it is likely to take away your attention from the far more important abstract conditions of design. Structure should never be contradicted, and in the best buildings it is pleasantly ex-

87. Addenda, par. 65 (*Works*, 12).
88. See, for detailed commentary, Nikolaus Pevsner, *Pioneers of Modern Design*, Pelican ed. (Harmondsworth, 1960), pp. 46-49; John Steegman, *Consort of Taste* (London, 1950), pp. 282-84; Alf Bøe, *From Gothic Revival to Functional Form* (Oslo, 1957), pp. 45-84.
89. *Stones of Venice I*, ch. 20, pars. 16, 15, app. 17 (*Works*, 9: 451).
90. Pars. 143ff. (*Works*, 23).

hibited and enforced . . . yet so independent is the mechanical structure of the true design, that when I begin my Lectures on Architecture [never written], the first building I shall give you as a standard will be one in which the structure is wholly concealed. It will be the Baptistery of Florence[91]

Furthermore, the emotional and mental responses evoked by ornament and by structure are totally different, even inimical; this is one of the first points enunciated in *The Stones of Venice*: "And, above all, do not try . . . to connect the delight which you take in ornament with that which you take in construction or usefulness. They have no connection; and every effort that you make to reason from one to the other will blunt your sense of beauty, or confuse it with sensations altogether inferior to it."[92]

These arguments are equally consistent with his exaltation of the beauty of incrusted surfaces, discussed earlier, in which construction is intentionally obscured. Again, just as Ruskin asserts that sculptural ornament should probably not contradict structure, he is quick to point out regarding marble veneers that they do not "deceive," for the "confessed *rivet*" clearly announces that the precious materials are merely beautiful skins.[93] But he insists that the *patterns* of these veneers bear no logical relation whatever to structure. As usual, Ruskin's major proof consists of reference to nature's method: "the stripes of a zebra do not follow the lines of its body or limbs, still less the spots of a leopard" or the plumage of birds. Thus "I hold this . . . for the first great principle of architectural color. Let it be visibly independent of form."[94]

From the foregoing evidence it becomes clear why Ruskin ignores architectural contexts, focusing instead on isolated decorations: structure is an entirely different subject from ornamentation, requiring a distinct and lower species of emotional and intellectual response; indeed, a response that even diminishes one's ability to perceive beauty, and which is scarcely worth analysis or depiction, therefore, in books aimed at inculcating appreciation for the highest forms of architectural splendor.

One important point, however, remains to be made about Ruskin's criteria for fine ornamental detail: it should be visually, and preferably even physically,

91. Lec. 1, par. 24 (*Works*, 20). Cf. *Val d'Arno*, lec. 6, par. 144 (*Works*, 23): "Perhaps you may most clearly understand the real connection between structure and decoration by considering all architecture as a kind of book, which must be properly bound indeed, and in which the illumination of the pages has distinct reference in all its forms to the breadth of the margins and length of the sentences; but is itself free to follow its own quite separate and higher objects of design."

92. Vol. 1, ch. 2, par. 17 (*Works*, 9). The early theoretical foundations for this emphasis, as found in *Modern Painters II* (1846), will be examined in the following chapter.

93. *Stones of Venice II*, ch. 4, par. 25 (*Works*, 10).

94. *Seven Lamps*, ch. 4, par. 36 (*Works*, 8).

accessible. "Another character of my perceptions I find curiously steady," he tells us in *Praeterita*, "—that I was only interested by things near me, or at least clearly and visibly present. . . . [I]t remained—and remains—a part of my grown-up temper."[95] Ruskin repeatedly praises buildings that are comparatively small and delicate, ones of which he can *see* all the parts. This preference for the modestly proportioned structure derives logically out of his fascination with beautiful surfaces and delicate details that we have already examined, and leads in turn to his regular assertion of the superiority of the South:

> Neither delicacy of surface sculpture, nor subtle gradations of colour, can be appreciated by the eye at a distance; and since we have seen that our sculpture is generally to be only an inch or two in depth, and that our colouring is in great part to be produced with the soft tints and veins of natural stones, it will follow necessarily that none of the parts of the building can be removed far from the eye, and therefore that the whole mass of it cannot be large. . . . And therefore we must not be disappointed, but grateful, when we find all the best work of the building concentrated within a space comparatively small; and that, for the great cliff-like buttresses and mighty piers of the North, shooting up into indiscernible height, we have here low walls spread before us like the pages of a book, and shafts whose capitals we may touch with our hand.[96]

A famous 1852 letter to his father from Verona provides a crucial perspective on such a judgment:

> . . . there is the strong instinct in me which I cannot analyse to draw and describe the things I love—not for reputation, nor for the good of others, nor for my own advantage, but a sort of instinct like that for eating and drinking. I should like to draw all St. Mark's, and all this Verona stone by stone, to eat it all up into my mind, touch by touch. More and more lovely I find it every time, and am every year dissatisfied with what I did the last.[97]

It was noted previously that Ruskin was driven to exhaust particular works of art, that he returned to them again and again, looking at them more and more microscopically. In a fascinating passage on "Turnerian Mystery" in *Modern Painters IV* (1856), he provides the reader with one of the many do-it-yourself exercises so essential to his teaching, one that throws significant light on the process by which he must have approached his favorite buildings over the years:

95. Vol. 1, ch. 6, par. 120 (*Works*, 35).
96. *Stones of Venice II*, ch. 4, par. 47 (*Works*, 10).
97. June 2, 1852 (*Works*, 10: xxvi).

What we call seeing a thing clearly, is only seeing enough of it to *make out what it is;* this point of intelligibility varying in distance for different magnitudes and kinds of things, while the appointed quantity of mystery remains nearly the same for all. Thus: throwing an open book and an embroidered handkerchief on a lawn, at a distance of half a mile we cannot tell which is which; that is the point of mystery for the whole of those things. They are then merely white spots of indistinct shape. We approach them, and perceive that one is a book, the other a handkerchief, but cannot read the one, nor trace the embroidery of the other. The mystery has ceased to be in the whole things, and has gone into their details. We go nearer, and can now read the text and trace the embroidery, but cannot see the fibres of the paper, nor the threads of the stuff. We take both up and look closely at them; we see the watermark and the threads, but not the hills and dales in the paper's surface, nor the fine fibres which shoot off from every thread. The mystery has gone into a fourth place, where it must stay, till we take a microscope, which will send it into a fifth, sixth, hundredth, or thousandth place[98]

It was this constantly moving closer and closer to a beautiful object, pursuing its mystery into more and more restricted compass, that was the essence of his desire to take St. Mark's or Verona up into his mind, touch by touch. Moreover, as Ruskin himself inadvertently confesses in *The Two Paths* (1859), the high state of imaginative excitement reached in such a process causes a disproportionate emphasis on smallness:

Remember that when the imagination and feelings are strongly excited, they will not only bear with strange things, but they will *look* into *minute* things with a delight unknown in hours of tranquility. . . . Things trivial at other times assume a dignity or significance which we cannot explain; but which is only the more attractive because inexplicable: and the powers of attention, quickened by the feverish excitement, fasten and feed upon the minutest circumstances of detail, and remotest traces of intention.[99]

And this same disproportion carries over into the architectural writings that his almost erotic love of Venice and Verona inspired.

This desire to see, to feel every stone of a building is at the root of what might be called Ruskin's "visual functionalism," that is, his insistence that all ornament should be treated and placed with reference to the physical circumstances of the spectator. Significantly, a main criterion for judging good Gothic, he says, is whether "the sculpture is *always* so set, and on such a scale, that at

98. Pt. 5, ch. 4, par. 4 (*Works,* 6).
99. Lec. 4, titled, appropriately, "Influence of Imagination in Architecture," par. 128 (*Works,* 16).

the ordinary distance from which the edifice is seen, the sculpture shall be thoroughly intelligible and interesting."[100] Indicative, too, is his casual comment in *The Seven Lamps* that "it was a wise feeling which made the streets of Venice so rich in external ornament, for there is no couch of rest like the gondola."[101] The best architectural detail is that which can be comfortably contemplated at close range, like pictures in a gallery. Finally, this emphasis on visual accessibility has, of course, important implications for Ruskin's dislike of those architectural qualities deriving from magnitude, implications to be explored in the next chapter.

It is not surprising, therefore, that throughout his work, Ruskin uses details to carry the entire weight of his arguments. One five-inch-square drawing of a spandrel and archivolt from St. Mark's in *Stones of Venice* becomes the measure of Byzantine mastery.[102] The two sides of a small balustrade protecting the gallery of the apse at Romanesque Murano mark a barrier between two great schools of early architecture.[103] When musical instruments and armor creep into early Renaissance ornament, "its doom [is] sealed, and with it that of the architecture of the world." The most distinctive feature of "perfect" Gothic is the trefoil: "it is the very soul of it."[104] If the details chosen and the generalizations they support shift from time to time, the pattern of argument nonetheless remains constant. Yet, as the eminent scholar Paul Frankl points out in analyzing characteristics like cusping, blind arcades, and capitals in his major study, *Gothic Architecture,* the full significance of such details, both aesthetically and historically, can only be grasped in relation to their place in a larger architectural scheme:

> . . . although the development of architecture as a whole can be seen very clearly in these details, the separate stages are secondary and are merely the consequence of those principles in the field of architecture in its entirety which were the preoccupation of successive generations of architects. There are changes in the forms of arches, in the forms of their supports, in overall proportions, and in the relief and the decoration of capitals; but all these are matters of decoration—architecture on a small scale, whose function is the service and support of architecture on the larger scale.[105]

Once more, nevertheless, there is a distinct, if perverse, logic to Ruskin's

100. *Stones of Venice II,* ch. 6, par. 114 (*Works,* 10).
101. Ch. 4, par. 23 (*Works,* 8).
102. Vol. 2, ch. 4, par. 49, and Plate 6 (*Works,* 10, facing p. 115), the one previously cited as conveying "the impossibility of illustration."
103. Ibid., ch. 3, par. 32.
104. *Seven Lamps,* ch. 4, par. 34; note 10 to ch. 3, par. 21, omitted after 1880 (*Works,* 8).
105. Frankl, *Gothic Architecture,* p. 110.

system of argument. For Ruskin, details are not merely the basis for the entire appreciation of the building, but they finally constitute the very definition of architecture, and its claim to be a Fine Art. Indeed, the necessarily utilitarian character of architecture must condemn it to a lesser place in the ranking of the arts. In a note to *Modern Painters II,* Ruskin makes this point quite explicit:

> I do not assert that the accidental quality of a theoretic pursuit, as of botany for instance, in any way degrades it, though it cannot be considered as elevating it. But essential utility, a purpose to which the pursuit is in some measure referred, as in architecture, invariably degrades, because then the theoretic part of the art is comparatively lost sight of; and thus architecture takes a level below that of sculpture or painting, even when the powers of mind developed in it are of the same high order.

In an emendation to the 1883 "Re-arranged Edition" of this volume, he declares approvingly: "This old note already anticipates the subjection of the constructive to the decorative science of architecture which gave so much offence, to architects capable only of construction, in the *Seven Lamps,* written two years later, and *Stones of Venice.*"[106] According to Ruskin, it is the decorative science that constitutes architectural nobility, and decoration can only be rightly judged in isolation—whether as two-dimensional sheaths of richly patterned geological "painting" or as delicately carved low-relief sculpture—because ornament requires a totally different emotional response and intellectual analysis from that elicited by constructive science. Effects proceeding from the management of larger architectural elements—effects deriving from the dispositions of masses and volumes, spacious bays and soaring vaults and ranges of galleries and chapels—are, in the end, "mere building," a completely separate subject.

Thus Ruskin's critical emphases are both extremely specific and surprisingly limited, roo.ed in his love for a singular species of medieval architecture. Unwittingly but felicitously, the novelist Henry James, describing the beauties of St. Mark's in a fine 1882 appreciation of Venice, aptly explains why that monument held the lifelong enchantment for Ruskin that it did—because the very qualities that James notes are precisely those which we have discussed here; they constitute the *sum* of architecture for Ruskin:

> . . . it is almost a spiritual function,—or, at the worst, an amorous one,—to feed one's eyes on the mighty color that drops from the hollow vaults and thickens the air with its richness. . . . The strange figures in the mosaic pictures, bending with the curve of niche and vault, stare down through

106. Pt. 3, sec. 1, ch. 1, notes to par. 10 (*Works,* 4: 35n).

the glowing dimness; and the burnished gold that stands behind them catches the light on its little, uneven cubes. St. Mark's owes nothing of its character to the beauty of proportion or perspective; there is nothing grandly balanced or far-arching; there are no long lines nor triumphs of the perpendicular. . . . Beauty of surface, of tone, of detail, of things near enough to touch and kneel upon and lean against,—it is from this the effect proceeds. In this sort of beauty the place is incredibly rich, and you may go there every day and find afresh some lurking pictorial nook. It is a treasury of bits[107]

107. Henry James, "Venice," *Century Magazine* 25 (November 1882): 10.

3

What Ruskin Ignored in Architecture

The analysis in the preceding chapter may strike the reader as incomplete. In fact, it is not. For Ruskin discusses few specifically architectural qualities; the technical narrowness of his emphases will become much more apparent as we examine here the many important facets of architecture he chose either to denigrate or to ignore. Only then can Ruskin's total architectural thought be validly assessed, especially its social implications as first clearly enunciated in "The Nature of Gothic."

From the evidence presented in the last chapter it is obvious that in his architectural writings Ruskin slighted—by his own criteria, for perfectly logical reasons—the major constructive elements in buildings. Here, too, previous critics have generalized that Ruskin was uninterested in structure. But no one has closely investigated either the extent or the real nature of this omission, or Ruskin's motives for it, confessed and unconfessed.

First of all, Ruskin did not concern himself with the overall plan of a building. Partly, no doubt, because he was so preoccupied with architectural surfaces, he did not conceive of buildings as enclosing and molding spaces; apparently, he did not even see structures as *occupying* space, vertically or hori-

zontally. We have already noted the dearth of ground plans in *Stones of Venice;* they are absent from his other works as well. On the rare occasions when he reproduces one, it usually serves some peripheral purpose; for instance, in his lecture "Mending the Sieve; or, Cistercian Architecture" (1882) he offers a plan of the entire monastery of St. Gall, but mainly to illustrate the community's economic self-sufficiency. The most salient evidence of his lifelong disregard for the plan of a building comes in *The Bible of Amiens* (1880-85). Here he does briefly examine the relations between major parts of the cathedral's east end—choir, aisles, transepts, radiating chapels—though entirely in symbolic terms, explaining that the relation of altar to chapels parallels that of Christ to His Saints, which conception is "at the root of the entire disposition of the apse with its supporting and dividing buttresses and piers; and the architectural form can never be well delighted in, unless in some sympathy with the spiritual imagination out of which it rose." But most significant is that in the course of this discussion he asserts: "I shall endeavour in all my future writing of architecture, to observe the simple law of always calling the door of the north transept the north door; and that on the same side of the west front, the northern door, and so of their opposites. This will save . . . much printing and much confusion, for a Gothic cathedral has, almost always, these five great entrances"[1] That nearly forty-five years after his first architectural writings he should feel it necessary to provide such basic definitions to his readers is ample measure of his previous disregard for plan.[2]

We have also seen his derogation of masses and proportions as architectural qualities; he classes them as matters of "mere building," and the rules of their disposition as "mere principles of common sense."[3] In his addenda to *Lectures on Architecture and Painting* Ruskin even insists that too much concern for masses and proportions in architectural criticism betrays artistic ignorance: "*all* art, and all nature, depend on the 'disposition of masses.' . . . Proportion is a principle, not of architecture, but of existence. . . . So that the assertion that 'architecture is *par excellence* the art of proportion,' could never be made except by persons who know nothing of art in general"[4]

1. Ch. 4, pars. 4, 28, in the Library Edition of *The Works of John Ruskin*, ed. E. T. Cook and Alexander Wedderburn, 39 vols. (London and New York, 1903-12), 33; hereafter cited as *Works*.

2. It might be argued that he is being thus elementary because *Our Fathers* is supposedly intended for young people. The style of the volume, however, is not discernibly different from that of other works of this period; *The Bible of Amiens* was certainly read by his adult audience, and a separate "Traveller's Edition" of chapter 4 (from which this quotation is taken) came out in 1881. In any event, he nowhere provides this type of explanation earlier, despite its being needed and useful, and its appearance coincides with his "discovery" of structure late in life by way of Viollet-le-Duc, to be discussed below.

3. "Pre-Raphaelitism," par. 56 (*Works*, 12).

4. Par. 63 (*Works*, 12).

However, Ruskin avoided discussing the qualities of architectural space and mass not simply because he regarded them as secondary; evidently, he often found it difficult to grasp at all, either visually or conceptually, those qualities depending upon magnitude. For example, in an 1849 letter to his father from Courmayeur he remarks:

> I am quite unable to speak with justice, or think with clearness, of this marvellous view. One is so unused to see a mass like that of Mont Blanc without any snow, that all my ideas and modes of estimating size were at fault. I only felt overpowered by it, and that, as with the porch at Rouen Cathedral, look as I would, I could not *see it*. I had not mind enough to grasp it or meet it; I tried in vain to fix some of its main features in my memory [5]

In his diaries he repeatedly laments the difficulty of justly estimating large size, whether of the Matterhorn or St. Peter's. A note at Chamouni is typical: "more than ever astonished at the enormous scale of everything: cannot educate my eye to it." At Sallanches he finds himself unable to take in the entire splendid prospect, but salvages a revealing principle from his experience, noting that "when I confined myself to one thing, as to the grass or stones, . . . then I had mind enough to put into the thing," but that "when I looked at all together, I had not . . . mind enough to give to all, and none were therefore of any value." He concludes that at any point in time, depending on one's particular circumstances and state of mind, "each spirit can only embrace . . . so much of what has been appointed for its food, and may therefore rest contented with little" Otherwise, "the crushing of the mind by overweight" will result. [6]

Ruskin makes a similar point, specifically encompassing architectural effect, in some manuscript passages intended for *Modern Painters III:*

> No beauty of design in architecture, or of form in mountains, will entirely take the place of what may be called "brute largeness." . . .
> . . . Up to a certain point, the apprehension of size is indeed instructive, but this is only within very narrow limits; and as soon as those limits are past—that is to say, as soon as any object is more than a hundred feet wide or high—the understanding of its magnitude depends on careful observation and accurate comparison of part with part, more and more difficult as the size increases [7]

5. July 29, 1849 (*Works,* 5: xxvi).
6. June 12, 1844, June 10, 1849, *The Diaries of John Ruskin,* ed. Joan Evans and J. H. Whitehouse, 3 vols. (Oxford, 1956-59), 1: 283, 2: 384-85; hereafter cited as *Diaries.*
7. *Works,* 5: 434.

But, on the other hand, as he explains in the chapters on "Truth of Space" in *Modern Painters I,* "if . . . we look at any foreground object, so as to receive a distinct impression of it, the distance and middle distance become all disorder and mystery."[8] "Careful observation and accurate comparison of part with part" as means of grasping magnitude are therefore processes not so much of relating but of isolating—indeed, of taking up into one's mind and individually savoring each stone, touch by touch.

Ruskin finds grasping size difficult not only visually, however, but also emotionally: he actively *dislikes* largeness of scale. This clearly harks back, of course, to his demand for visual accessibility examined in chapter 2, his interest in "things near me, or at least clearly and visibly present." Again and again in his diaries we find entries expressing aversion to large size, whether in painting or sculpture or sometimes even mountains; of Mont Blanc he says at one point, "The whole mass is an admirable instance of the deadening effect of an excess, its breadth and roundness destroying its height, and its general quantity overpowering the size of its portions. One thing I have especially noted on this Swiss journey—that, after a certain point, the eye is not cognizant of proportion."[9] His dislike of large size in architecture, particularly as embodied in St. Peter's, is equally pronounced. He defends this antipathy by identifying the desire for "greatness" as a preoccupation of the Renaissance architects, and thus as the sign of prideful denial of humility before God, "as fruitless as it is vile; no way profitable—every way harmful: the widest and most corrupting expression of vulgarity."[10]

Ample data suggest that his visual and emotional aversion to size lies finally, perhaps, in an incapacity to explain largeness conceptually. Typically, the segments of his work treating qualities deriving from magnitude are brief. (Anyone reading very deeply in Ruskin will soon discover that he is rarely succinct by design; brevity of treatment nearly always signifies lack either of interest or knowledge or both.) Hence, "The Rule of the Greatest" is among the shortest chapters in *Modern Painters,* only eight paragraphs, seven of which justify the quality of minuteness in art (in the closing paragraph he actually admits, "I do not . . . purpose here to examine or illustrate the nature of great treatment . . ."); while in *The Seven Lamps* over half "The Lamp of Power" is devoted to how sublimity may be achieved through "details and lesser

8. Pt. 2, sec. 2, ch. 4, par. 3 (*Works,* 3).

9. St. Martin's, July 13, 1849, *Diaries,* 2: 409-10.

10. *Modern Painters V,* pt. 8, ch. 3, par. 3 (*Works,* 7). See also the section on "Proud Admiration" in his preface to the second edition of *The Seven Lamps* (par. 4 [*Works,* 8]). In part his specific aversion to St. Peter's is probably explained by an 1883 note to *Modern Painters II* (*Works,* 4: 103-5n), in which he argues that a small building cannot be expanded to a large one merely by proportionally expanding all its parts, and that architects too often assume "that the harmony will be equally agreeable on whatever scale it be rendered."

divisions," and includes supporting examples of capitals, traceries, door mould-ings, even a finial.[11] The basic Volume I of *Stones of Venice* preponderantly treats minor parts of buildings, like cornices and shafts; chapter 7, for instance, on "The Pier Base," runs for nineteen paragraphs, chapter 5 on "The Wall Veil," for seven. In Volume II he distills this emphasis into a principle, "LAW VII. *That the impression of . . . architecture is not to be dependent on size,"* ex-plaining that the architectural qualities he reveres "are independent of size, and partly even inconsistent with it."[12]

Yet in *Praeterita,* he repeatedly vaunts his capacity for accurately judging magnitude: "I had always a quite true perception of size, whether in moun-tains or buildings, and with the perception, joy in it"; of his first view of St. Peter's, he avers, "I have not vainly boasted my habit and faculty of measuring magnitudes, and there was no question to me how big it was."[13] These claims scarcely jibe, nonetheless, with the diary entries just reviewed. Rather, as we have seen in chapter 2, Ruskin argues that "greatness is the aggregation of minuteness" and thus can be examined little by little. But this position renders irrelevant to architecture the irreducible three-dimensional relationships of mass and space that cannot be measured at all in terms of minuteness the way accumulations of sculpture can. Further, this viewpoint undervalues the trans-forming power of the whole, which is greater than the sum of its parts; it is Ruskin's difficulty in considering a structure as a total entity, either visually or imaginatively, that causes him to attribute undue importance to immediate-ly accessible detail. And although in his discussions of paintings, Ruskin elo-quently displays sensitive awareness of the welding of parts into an organic

11. *Modern Painters V*, pt. 8, ch. 3, par. 8 (*Works*, 7); *Seven Lamps*, ch. 3, pars. 11ff. (*Works*, 8). "The Lamp of Power" assumedly represents Ruskin's most explicit attempt to describe and praise effects of magnitude in architecture. In those paragraphs dealing directly with size, however, he suggests that "power and majesty" are not a function of "mere size" but of the architect's manipulation of the spectator's vision. Thus in order to show its magnitude a building's "extreme points" must be seen all at once through "one visible bounding line from top to bottom, and from end to end" which must not be "violently broken"; this line can be best expressed if the building is "gathered up into a mighty square" (pars. 6, 8). Yet these standards contradict two of Ruskin's most em-phatic points about Gothic in "The Nature of Gothic" (to be discussed in detail below): first, that it is a wonderfully flexible style, free to "shrink into a turret" or "spring into a spire," uninhibited by conventions of geometry or symmetry; second, that the gable is one of its two essential defining features (*Stones of Venice II*, ch. 6, pars. 38, 86 [*Works*, 10]). The efficiency and power of Gothic are directly bound up with *interruptions* of a "bounding line." For a succinct analysis of the architectural difficulties inherent in the concept of a continuous bounding line, even as applied to relatively small Gothic Revival buildings, see Paul Thompson, *William Butterfield* (London, 1971), pp. 216-17. I regret that this very fine monograph was not available to me until after I had completed my study.

12. Ch. 4, par. 47 (*Works*, 10).

13. Vol. 1, ch. 6, par. 136; vol. 2, ch. 2, par. 32 (*Works*, 35).

unity, even there he dwells inordinately on detail, still using the artist's execution of details as an infallible test of mastery. Then, too, as we have already noted, though Ruskin maintains that the same knowledge of proportion is required to arrange folds of sculptured drapery as to dispose the masses of a cathedral, he concurrently argues that different mental processes are involved in contemplating "decorative" and "constructive science." Besides, he tends to view enjoyment of magnitude as potentially damaging to aesthetic sensibility: "there are, in verity, in the humblest scenery, powers in operation vast enough, and masses of material existence large enough, to excite the full sensation of sublimity; and it is necessary to be very careful how we deaden this faculty of finding sublimity in things comparatively small by over-indulgence in the excitement of greater magnificence."[14] Perhaps, however, the deepest motive underlying his denigration of effects of magnitude in architecture, beyond his basic problem of grasping them, comes out in *Aratra Pentelici,* and, as is so often the case with Ruskin, it suggests that his elaborate theoretical justifications are ultimately prompted by the need to give logical sanctity to personal preference: "The employment of large masses is sure . . . to draw away the attention from the sculpture."[15]

Ruskin's disregard for the major architectural qualities of plan, mass, and proportion is but a manifestation of the general neglect in his writings of what they express—structure, as opposed to ornament. In part this omission is owing simply to his lack of interest in the subject. Although in a *Praeterita* manuscript he refers to his "architectural love of structure" and also to his "intense delight in, with sound elementary knowledge of, physical science, based on a love of mathematical structure, which . . . led me continually away from painting into architecture,"[16] such fascination was apparently inadequate to offset that subjection of the constructive to the decorative science of architecture first asserted in *Modern Painters II* and ringingly reaffirmed as late as 1883.

His avoidance of the subject was probably caused in greater measure by lack of knowledge, a charge frequently leveled against him by contemporary architects—one which stung Ruskin deeply and undoubtedly limited his influence on them. (As Charles Eastlake explains, "Many an architect who had no time to read through the 'Seven Lamps' with attention cast the book impatiently aside as he lighted on some passage which betrayed the author's in-

14. Manuscript passages for *Modern Painters III,* given in *Works,* 5: 436. Cf. the similarity of the principle expressed here to his discoveries about "the crushing of the mind by overweight," above.

15. Lec. 5, par. 148 (*Works,* 20).

16. *Works,* 35: 619.

experience in technical details."[17]) Thus in *Praeterita* he claims early structural expertise, but on tenuous grounds:

> . . . I . . . mastered . . . by help of my well-cut bricks, very utterly the laws of practical stability in towers and arches, by the time I was seven or eight years old: and these studies of structure were farther animated by my invariable habit of watching, with the closest attention, the proceedings of any bricklayers, stone-sawyers, or paviours,—whose work my nurse would allow me to stop to contemplate in our walks; or, delight of delights, might be seen at ease from some fortunate window of inn or lodging on our journeys.[18]

Frank Lloyd Wright and his Froebel blocks notwithstanding, childhood play experiences are scarcely enough to insure a comprehensive grasp of architectural structure, especially the complexities of Gothic methods. Yet despite still other *Praeterita* references to his "native architectural instinct," as well as his "fastidious structural knowledge of later time,"[19] there is little evidence that he ever studied structure in any formal or even methodical way. It was one of his criticisms, in fact, of his Oxford training that "the University as a historical body, having a youth cast into their hands for educational treatment with his head full of mountains and cathedrals, never required of him a single exercise in map or section drawing, and never taught him either the tradition of a saint or the dynamics of a buttress."[20]

His self-education by random experiment and observation was spotty at best. His few practical attempts at construction were abortive: the hapless Hinksey road building project is the most famous, while his efforts at learning to lay brick were quickly abandoned. In *Val d'Arno* he ruefully confesses to his audience how he was recently interesting himself "in some of the quite elementary processes of true architecture" by building a pier and terraces at his new Coniston home. Whereas the farmer's son helping him made these walls rise "as if enchanted," "my own better acquaintance with the laws of gravity and of statics did not enable me, myself, to build six inches of dyke that would stand; and all the decoration possible under the circumstances consisted in turning the lichened sides of the stones outwards."[21] (How typical of Ruskin is the concern for "decoration" here, even of such simple, utilitarian work.) In *Praeterita* he admits that despite his "violent instinct for architecture

17. Charles Eastlake, *A History of the Gothic Revival* (London, 1872), p. 271.
18. Vol. 1, ch. 3, par. 65 (*Works*, 35).
19. Ibid., ch. 4, par. 85, and a manuscript version of a passage at the end of ch. 9, par. 181, p. 157n (*Works*, 35).
20. A *Praeterita*, vol. 1, manuscript passage following ch. 6, par. 137 (*Works*, 35: 611).
21. Lec. 6, par. 142 (*Works*, 23).

. . . I never could have built or carved anything, because I was without power of design; and have perhaps done as much in that direction as it was worth doing with so limited faculty."[22] Ruskin was doomed to build and carve in his kitchen, experimenting with cheeses and puddings.

Probably the best indicator of Ruskin's limited structural knowledge, however, is the variety of slightly underhanded ways in which he avoids discussing structure directly in his writings. A common device is his assuming the general reader already understands it. For example, in his letters published in *The Oxford Museum* (1859) he notes, prior to launching into a detailed explanation of the nature of Gothic ornament, that "the principles of Gothic decoration, in themselves as simple and beautiful as those of Gothic construction, are far less understood, as yet, by the English public"[23] By contrast, in *Stones of Venice I*, which is predicated on the opposite assumption—that his audience knows nothing at all of either—he excuses the comparative slightness of his treatment by sending the reader elsewhere, "the abstract science" and "mechanical detail" of construction being "altogether beside the purpose of this essay"[24] When he specifically addresses architects, as in "The Study of Architecture in Our Schools" (1865) or Lecture 4 of *The Two Paths* (1859), he papers over the gap between theory and practice with persistent, rather pretentious use of the phrase "we architects."

Ruskin also regularly overstates the simplicity of structural principles, suggesting that anyone can master them quickly and completely. He enthusiastically assures his Edinburgh audience in *Lectures on Architecture and Painting*, "Architecture . . . is so simple, that there is no excuse for not being acquainted with its primary rules Far less trouble . . . than a schoolboy takes to win the meanest prize of the passing year, would acquaint you with all the main principles of construction of a Gothic cathedral"[25] In *Stones of Venice I*, Ruskin lulls the reader into a false sense of newly acquired structural expertise, in a tone much like that of an advertisement for the abridged books and symphonies so much a part of today's popular culture:

> The reader has now some knowledge of every feature of all possible architecture. Whatever the nature of the building which may be submitted to his criticism, . . . it will be instantly and easily resolvable into some of the parts which we have been hitherto considering Respecting each of these several features I am certain that the reader feels himself prepared, by understanding their plain function, to form something like a reasonable and definite judgment, whether they be good or bad; and this right judg-

22. Vol. 1, ch. 7, par. 139 (*Works*, 35).
23. First Letter, par. 4 (*Works*, 16).
24. Ch. 19, par. 16 (*Works*, 9).
25. Lec. 1, par. 5 (*Works*, 12).

ment of parts will, in most cases, lead him to just reverence or condemnation of the whole.[26]

But again, much of this introductory volume deals not at all with constructive elements: of its thirty chapters, three are general introduction or conclusion and ten are an ornament, leaving seventeen, or apparently better than half the book, to examination of structure. In total pages in the main text, however, only 158 out of 347 (in the first edition), or less than half, are actually devoted to this subject; even these pages focus mainly on lesser structural elements, and are interlarded as well with observations on ornament, geology, climate, and scenery. As usual, though, Ruskin's omissions tend to be obscured by the sheer quantity and eloquence of everything else.

Ultimately, and to some extent justifiably, Ruskin's preoccupation with Italian Gothic enables him to avoid discussing structure, since, as we have seen in chapter 2, comparatively less structural knowledge is required to comprehend its construction than for the complex Northern mode. Still less background is necessary to understanding Venetian architecture as Ruskin treats it. The interiors of the Gothic palaces were so much altered that he could logically skip over them, thus avoiding any discussion of spatial elements, while the unique, densely developed island geography of Venice generally precluded such Gothic characteristics as irregularity of plan since building space was so tightly circumscribed. Hence, for example, the Doge's Palace as Ruskin sees it is finally not a building at all, but two beautiful exterior planes, hovering like stage scenery in mid-Piazzetta, with neither enclosed space nor supporting structure behind it. This is not to imply that Ruskin chose Italian and especially Venetian Gothic architecture as his subject because he could thereby avoid revealing his ignorance of construction, but the comparative simplicity and clarity of Italian structure suggest a great deal about Ruskin's preference for the South over the North. Northern Gothic structural mastery and the dramatic, beautiful spatial effects deriving from it were of minimal interest to Ruskin; he neither truly saw nor understood them because he was overwhelmingly concerned with the foreground of sculptural detail and colored incrustation at which the Italians excelled. And thus because he did fasten so exclusively on "minuteness" instead of "greatness," on "shafts whose capitals we may touch with our hand" instead of "cliff-like buttresses and mighty piers . . . shooting up into indiscernible height," the extent of his glorification of Southern Gothic is at the same time a measure of how much he could not perceive in Northern Gothic.

26. Ch. 19, par. 1 (*Works*, 9). Notice even here the emphasis on judging parts as the best means of valuing the whole.

But Ruskin did not merely understate or gloss over problems of structure; as with the qualities of mass and proportion, he actively derogated the importance of construction. Probably the single most questionable claim about Ruskin's architectural thinking made by some of his modern critics is their identifying him as a "functionalist"—according to John Rosenberg, "one of the earliest, . . . and one of the most articulate, advocates."[27]

If we define functionalism as the principle that a building's form should derive from its efficient, economical satisfaction of physical needs and be expressed through materials the inherent qualities of which are respected and revealed, many sensible functionalist pronouncements can indeed be found in Ruskin, particularly in *Seven Lamps* and *Stones.* For instance, at the top of his list of "Architectural Deceits" in *The Seven Lamps* is "the suggestion of a mode of structure or support, other than the true one"; architecture "will be noble exactly in the degree" to which such a false expedient is avoided.[28] On a broader scale: "The nobility of each building depends on its special fitness for its own purposes; and these purposes vary with every climate, every soil, and every national custom: nay, there were never, probably, two edifices erected in which some accidental difference of condition did not require some difference of plan or of structure"[29] Perhaps Ruskin's most famous functional declaration—certainly the one critics most frequently light on as proof—is his memorable argument in "The Nature of Gothic" regarding Gothic flexibility and practically dictated asymmetry:

> The variety of the Gothic schools is the more healthy and beautiful, because in many cases it is entirely unstudied, and results, not from mere love of change, but from practical necessities. For in one point of view Gothic is not only the best, but the *only rational* architecture, as being that which can fit itself most easily to all services, vulgar or noble. Undefined in its slope of roof, height of shaft, breadth of arch, or disposition of ground plan, it can shrink into a turret, expand into a hall, coil into a staircase, or spring into a spire, with undegraded grace and unexhausted energy; and whenever it finds occasion for change in its form or purpose, it submits to it without the slightest sense of loss either to its unity or majesty,—subtle and flexible like a fiery serpent, but ever attentive to the voice of the charmer. And it is one of the chief virtues of the Gothic builders, that they never suffered ideas of outside symmetries and consistencies to interfere with the real use and value of what they did. If they

27. John Rosenberg, *The Darkening Glass* (New York, 1961), p. 60. See also Francis G. Townsend, *Ruskin and the Landscape Feeling* (Urbana, 1951), p. 54n, and Jerome Hamilton Buckley, *The Victorian Temper* (Cambridge, Mass., 1951), p. 141, who suggests that Ruskin became a functionalist in spite of himself.

28. Ch. 2, par. 6 (*Works*, 8).

29. *Stones of Venice I*, ch. 19, par. 2 (*Works*, 9).

wanted a window, they opened one . . . utterly regardless of any estab-
lished conventionalities of external appearance, knowing . . . that such dar-
ing interruptions of the formal plan would rather give additional interest
to its symmetry than injure it.[30]

Nonetheless, however vividly Ruskin expressed them, these basic ideas had al-
ready won currency among both design reformers like Henry Cole and "Goths"
like the Ecclesiologists, while Pugin had condensed them as principles almost
a decade earlier. Ruskin's passages on "honest structure" were in fact among
those most frequently cited as evidence of his plagiarism.

On the subject of "honest materials" Ruskin writes both more originally
and extensively; the proper treatment of materials is a constant theme through-
out his architectural writings:

> Of all the various principles of art which, in modern days, we have de-
> fied or forgotten, none are more indisputable, and few of more practical
> importance than this, which I shall have occasion again and again to allege
> in support of many future deductions:
> "All art, working with given materials, must propose to itself the ob-
> jects which, with those materials, are most perfectly attainable; and be-
> comes illegitimate and debased if it propose to itself any other objects bet-
> ter attainable with other materials."[31]

Indeed, some of the finest passages in his entire canon are those dealing with
the innate properties of wood or marble or porphyry, and how these can be
most fully and faithfully exhibited, coming even as late as *The Art of England*
(1883). This sort of emphasis accorded well with Ruskin's instincts and prefer-
ences; it ties in both with his passion for natural beauty, especially natural color
and texture, and with his intense absorption in detail, in objects of small com-
pass. All of these aspects are touched on in a simple passage from *Aratra
Pentelici:*

> [Man's] truest respect for the law of the entire creation is shown by his
> making the most of what he can get most easily; and there is no virtue of
> art, nor application of common sense, more sacredly necessary than this
> respect to the beauty of natural substance, and the ease of local use; neith-
> er are there any other precepts of construction so vital as these—that you
> show all the strength of your material, tempt none of its weaknesses, and
> do with it only what can be simply and permanently done.
> . . . The highest imitative art should . . . provoke the observer to take
> pleasure in seeing how completely the workman is master of the particular

30. *Stones of Venice II*, ch. 6, par. 38 (*Works*, 10).
31. Ibid., app. 12 (*Works*, 10: 455).

material he has used, and how beautiful and desirable a substance it was, for work of that kind. . . . In a flint country, one should feel the delightfulness of having flints to pick up, and fasten together into rugged walls. In a marble country, one should be always more and more astonished at the exquisite colour and structure of marble[32]

How characteristic of Ruskin is the imaginative process described here: the beauty of honestly used materials lies in their natural purity that yields "more and more" to the observing eye and the empirical intelligence, so that one can mentally "pick up" and "feel" the sharpness of a piece of flint (the way Ruskin himself did in assembling his mineral collection) as it existed even *before* it became part of a building—one can exhaust it in its isolated uniqueness. Thus at bottom Ruskin's appreciations of architectural materials emphasize not so much their sensible, practical use but their innate loveliness as objects of divine creation.

Once more, it is also crucial to keep in mind that Ruskin views appreciation of functional qualities as a nonaesthetic response: "I wish the reader to note this especially; we take pleasure, or *should* take pleasure, in architectural construction altogether as the manifestation of an admirable human intelligence; . . . it is the intelligence and resolution of man in overcoming physical difficulty which are to be the source of our pleasure and subject of our praise."[33] We have already seen how he warned his audience that "the delight which you take in ornament" has no connection with "that which you take in construction or usefulness," and that it would be fatal to their sense of beauty to reason from one to the other. This distinction finds theoretical foundation in Ruskin's discussion of "apparent" and "constructive" proportion in *Modern Painters II*,[34] which antedates the *Stones of Venice* pronouncements above by five years. "Apparent proportion" is "the melodious connection of quantities," "a cause of unity, and therefore one of the sources of all beautiful form"; this is because "there is no sense of rightness, or wrongness connected with it, no sense of utility, propriety, or expediency." On the other hand, "constructive proportion," defined as "the adaptation of quantities to functions, is agreeable not to the eye, but to the mind, which is cognizant of the function to be performed":

The proportions of a wooden column are wrong in a stone one, and of a small building wrong in a large one, and this owing solely to mechanical considerations, which have no more to do with ideas of beauty, than the

32. Lec. 5, pars. 150-51 (*Works*, 20).
33. *Stones of Venice I*, ch. 2, par. 4 (*Works*, 9).
34. Pt. 3, sec. 1, ch. 6, pars. 10-17 (*Works*, 4), from which the following quotations are taken, passim.

relation between the arms of a lever, adapted to the raising of a given weight; and yet it is highly agreeable to perceive that such constructive proportion has been duly observed, as it is agreeable to see that anything is fit for its purpose or for ours, and also that it has been the result of intelligence in the workman of it

Most of his illustrations are, however, not (as above) drawn from architecture but from the plant and animal kingdoms; yet his reasoning about their structure does shed light on his limited understanding of architectural structure:

> . . . everything that God has made is equally well constructed with reference to its intended functions. But all things are not equally beautiful. The megatherium is absolutely as well proportioned, with the view of adaptation of parts to purposes, as the horse or the swan; but by no means so handsome as either. The fact is, that the perception of expediency of proportion can but rarely affect our estimates of beauty, for it implies a knowledge which we rarely and imperfectly possess, and the want of which we tacitly acknowledge.

He next explains that to assess justly the "expediency of proportion" in a plant, one must be aware of such facts as the toughness of the materials of the stem and the mode of their mechanical structure. But the observer seldom has the technical expertise to evaluate these data; therefore, they can only rarely affect one's "estimates of beauty"—just as, ironically, Ruskin's incomplete knowledge of architectural structure caused him to disregard the effect such information might have had on his own assessments of beauty. At all events, it seems clear that for Ruskin the fulfillment of functional requirements, no matter how ingenious or dramatic, is not in and of itself finally a cause of beauty; our pleasure in it is mental, deriving from a sense of physical difficulty having been conquered.

The distinction between apparent and constructive proportion, then, parallels Ruskin's separation of architecture from mere building and suggests the actual significance of his functional passages in his writings. Ruskin simply *assumes* that an edifice should conveniently and economically (in the broadest sense) fulfill its purpose; *then* it is ready to be transmuted from mere building into architecture:

> The first thing to be required of a building—not, observe, the *highest* thing, but the first thing—is that it shall answer its purposes completely, permanently, and at the smallest expense. . . .
> . . . [I]n doing all this, there is no High, or as it is commonly called, Fine Art, required at all. . . .
> But when the . . . building is thus far designed, . . . comes the divine part of the work—namely, to turn these dead walls into living ones. . . .

And that is to be done by painting and sculpture, that is to say, by ornamentation. Ornamentation is therefore the principal part of architecture, considered as a subject of fine art. . . .

. . . The essential thing in a building,—its *first* virtue,—is that it be strongly built, and fit for its uses. The noblest thing in a building, and its *highest* virtue, is that it be nobly sculptured or painted.[35]

Yet even the first virtue in this process is broadly interpreted. For example, in *Stones of Venice I* Ruskin claims that buildings must fulfill two requirements, "the doing their practical duty well" and then their being "graceful and pleasing in doing it; which last is another form of duty." But he goes on to define practical duty in two ways: "acting, as to defend us from weather and violence" (that is, the satisfaction of purely physical requirements); equally important, however, "talking, as the duty of monuments or tombs, to record facts and express feelings; or of churches, temples, public edifices, treated as books of history, to tell such history clearly and forcibly,"[36]—that is, the practical duty I earlier labeled "visual functionalism," Ruskin's insistence that architecture must be designed with constant reference to the spectator's sight, and not just to his ordinary physical movements and comforts. Thus a building does not simply shelter a person; it "talks" to him when he looks at it. Its symbolic value is an integral part of its function.

The same insistence on the primacy of the spectator yields yet another unique qualification of Ruskin's functionalist assertions. The faithful expression of structure must at times be compromised in deference to the *psychological* comfort of the spectator: "features necessary to express security to the imagination are often as essential parts of good architecture as those required for security itself." A pillar, for instance, can fulfill its supportive function quite adequately without having an elaborate base; yet—according to Ruskin—a base is necessary, replete with ornamental spurs, to "convince the eye" of the pillar's stability. It finds functional justification as "an *expression* of safety."[37] He could conveniently employ this same principle to denigrate the most obviously functional Victorian materials, iron and glass, on the basis that they appear incapable of supporting the loads they actually do and are hence visually painful. For "every idea respecting size, proportion, decoration, or construction, on which we are at present in the habit of acting or judging, depends on presupposition of [traditional] materials" like clay, wood, and stone.[38]

What, then, is Ruskin's real position as a functionalist? Clearly he speaks of functional requirements in a practical, sensible, even modern way, but to argue that such remarks occupy an important position in his architectural

35. Addenda to *Lectures on Architecture and Painting*, pars. 59-60, 65 (*Works*, 12).
36. Ch. 2, par. 1 (*Works*, 9).
37. *Stones of Venice I*, ch. 7, pars. 9 ff. (*Works*, 9).
38. *Seven Lamps*, ch. 2, par. 10 (*Works*, 8).

thought is inaccurate. In the first place, he insists that the fulfillment of functional requirements does not automatically yield beauty, and beauty was always Ruskin's foremost concern in architecture. Second, we must once again be careful to take Ruskin whole. Quantitatively, his functional passages constitute only a small proportion of his total canon—and even these are hedged about with qualifications; the Lamp of Truth is, after all, but one of seven. Moreover, the passages that do occur were probably dictated in considerable measure by tactical motives.

To begin with, they were undoubtedly written in reaction to existing Victorian abuses in design, which many critics, artists, and architects besides Ruskin were likewise deploring. The notion that form, especially of utilitarian objects, was somehow unseemly and should be heavily camouflaged with florid ornament, that decoration meant disguise, lay back of the "muchness" that characterized so many Victorian structures and their furnishings, and that makes Ruskin's love of ornament seem almost ascetic by comparison. Furthermore, insensitivity to the materials out of which both form and ornament were created was endemic to the period, particularly because of the Victorian fascination with machine-made objects, whether cast-iron Gothic traceries or muddy lithographs. Individual craftsmanship, on the other hand, was defined more as wondrous ingenuity than as refinement or creative integrity, a point of view convincingly verified in the show-piece creations that clogged the Great Exhibition of 1851, from garden seats made of coal to *papier-mâché* pianofortes. Seen against this background, Ruskin's functionalism is not so much a positive plea for honesty as a negative cry against abuses.[39]

Another reason for Ruskin's functional declarations certainly lay in his hatred of Renaissance architecture and his antipathy to its revival. In the famous "flexibility" passage quoted above from "The Nature of Gothic," the term of comparison implicit throughout is the Renaissance Revival mode of architects like Charles Barry. Examined from this angle, the virtue of Gothic lies mainly in its exact opposition to everything Palladian: it is unstudied; undefined; free of symmetries, consistencies, and established conventionalities of external appearance or formal plan. Borrowing the neoclassicists' own terminology to use against them, Ruskin even declares that Gothic is "the *only rational* architecture," implying that Renaissance order is actually unnatural disorder. In this aspect too, therefore, Ruskin's functional emphasis is determined at least as much by negative as by positive considerations.

39. Cf. his comment in *Seven Lamps* (ch. 5, par. 24 [*Works*, 8]) that in seeking to recover architectural beauty, "one thing we have in our power—the doing without machine ornament and cast-iron work. All the stamped metals, and artificial stones, and imitation woods and bronzes, over the invention of which we hear daily exultation—all the short, and cheap, and easy ways of doing that whose difficulty is its honour—are just so many obstacles in our already encumbered road."

Most important of all, these passages embody Ruskin's attempt to meet the Victorians on their own favorite grounds of utility and economy. The Puritan and Utilitarian emphasis, so strong in the early Victorian period, on usefulness as the measure of all value, combined with a suspicion of beauty (since, as Ruskin frequently pointed out, the most beautiful things are the most useless), represented a formidable barrier between him and a wider audience. If he could convince his readers that the architecture he loved simply because it was beautiful could also be justified because it was at the same time useful and economical, he could achieve his goal of a new Gothic millennium much more readily. Yet this tactic would have to be repellent to one who constantly protested the Victorian tendency to measure all worth in shillings and pence or in service to selfish bodily comfort. It must surely have been painful for him to argue in the best Benthamite tradition and to justify great architecture by the humble standards of "mere building."

Finally, we should recall that the qualities Ruskin revered most in architecture were basically unrelated to function: color is accidental, independent of form; sculptured details, as he treats them, are considered solely as ornament to be applied to a building relatively freely. His singular constructional terminology, too, has the effect of transmuting structural substance into personal poetry: Ruskin does not speak of prosaic walls and roofs but of "wall-veils" and "roof masks." Even the literally structural titles of *Stones of Venice I* and *II*, *The Foundations* and *The Sea-Stories*, are pointedly rich in non-architectural connotation. Ruskin's most incorrigible but probably his truest pronouncement on functionalism is this defense of the school of Pisa in his lecture "The Flamboyant Architecture of the Valley of the Somme," delivered at a time (1869) when he had shed his mantle of proselytizer for the Gothic Revival:

> . . . the builder's mind is far too busy in other and higher directions to care about construction. It is full of theology, of philosophy, of thoughts about fate, about love, about death,—about heaven and hell. It is not at all an interesting question with him how to make stones balance each other; but it is, how to reconcile doctrines;—the centre of gravity of vaults is of little moment with him,—but the centre of Fortitude in spirits is much;—not but that his arches and stones, however rudely balanced, did stick together somehow; there is no defiance of construction in them, only no attention is paid to it; if the thing stands, that is all that is wanted. But I think you must see at once what a vital difference it must make at last in schools of building, whether their designer has his head full of mathematical puzzles, or of eager passions;—whether he is only a dextrous joiner, manufacturing hollow stone boxes,—or a poet, writing his book on pages of marble, and not much caring about the binding of them.[40]

40. Par. 18 (*Works*, 19).

"[I]f the thing stands, that is all that is wanted."

Ruskin's lacking knowledge of and interest in structure is critical, of course, to any assessment of the validity of his definition of the Gothic style. Fittingly, he claims of the Pisan builder that "the centre of gravity of vaults is of little moment with him," for vaulting was of little moment with Ruskin as well, although today the rib vault is considered a central defining quality of Gothic, and a main source of its effects of space, movement, and light.[41] Yet Ruskin rarely talks about vaults, and when he does, it is ordinarily for a secondary reason, such as pointing out the frescoes adorning their surfaces; occasionally he calls attention to the *absence* of vaulting in a particular building. In his casual direct references, vault structure is most frequently dismissed through simplistic analogies with upturned vases or teacups; speaking in *Mornings in Florence* of a vault in S. Croce, for example, he assures his readers, "This is nothing else than a large, beautiful, coloured Etruscan vase you have got, inverted over your heads like a diving-bell."[42] At other points, generally as a means of introducing social commentary, he obscures their significance by reducing them to their simplest definition as shelter and placing them in a continuum with all types of roofs: "the best architecture [is] but a glorified roof"; "begin with thatching roofs, and you shall end by splendidly vaulting them."[43]

Ruskin's attempts to discuss vaulting explicitly, sparse as they may be, are thus worth analyzing at some length, for if it can be conclusively shown that he does not fully perceive the vital function of the rib vault, it will follow that neither does he clearly grasp the significance of those other aspects of the Gothic structural system which derive from vaulting and are so essential to any comprehensive definition of the Gothic style.

His most extended effort to explain vaulting comes in the sections on roofs in *Stones of Venice I*. In the introductory chapter 3, "The Six Divisions of Architecture," one of the briefly defined divisions is "*Roofs.*" He calls a roof "the covering of a space, narrow or wide." Yet curiously enough, he asks his audience initially to conceive of such covering simply as *a series of multiplied planes:*

. . . the reader . . . is first to consider roofs on the section only, thinking

41. See Paul Frankl's brilliant analysis of "The Stylistic Significance of the Rib Vault" in *Gothic Architecture* (Harmondsworth, 1962), pp. 10-14. He points out, however, that the import of the rib vault was beginning to be perceived as early as 1835 by the German scholar Johannes Wetter (pp. 1, 2-3), and Ruskin himself refers (see below) to recent "subtle and ingenious endeavours to base the definition of Gothic form entirely upon the roof-vaulting."

42. Third Morning, par. 46 (*Works*, 23).

43. Lec. 4, pars. 122, 124 of *Lectures on Art* (*Works*, 20).

how best to construct a narrow bar or slice of them, of whatever form
Having done this, let him imagine these several divisions, first moved along
(or set side by side) over a rectangle, . . . and then revolved around a point
(or crossed at it) over a polygon, . . . or circle, . . . and he will have every
form of simple roof; the arched section giving successively the vaulted roof
and dome, and the gabled section giving the gabled roof and spire.[44]

In order to explain a three-dimensional concept, Ruskin uses a two-dimensional
illustrative device which technically negates the very notion of a roof as "cover-
ing"—but is quite consistent with his habit of conceiving of architecture as sur-
face.

In the ten-paragraph chapter 13, which is specifically devoted to "The Roof,"
he scarcely advances, however, from this elementary definition; indeed, he ob-
viously scrambles to avoid doing so. First, he divides roofs into the "Roof
Proper," that is, the internally visible roof, which in Gothic is the rib vault, and
the "Roof Mask," the protective external covering. But he has decided not to
discuss with us the "Roof Proper," claiming that no person without long ex-
perience can tell whether a roof is well constructed or not; that such knowledge
is "useless to us in our Venetian studies" since Venetian roofs are either flat or
not contemporary with the structures they enclose, or else consist of vaults of
the simplest possible construction; and that, anyway, the reader can find else-
where all such information he might wish. Then follow two paragraphs on
"purely decorative" roofs such as various eastern domes and cupolas whose ap-
plicability on a large scale he "much doubt[s]." Next come five paragraphs
dealing mainly with how differences in climate affect roof pitch, but which also
include a lengthy dismissal of the "aspiration theory" of Gothic, assorted re-
marks on the contrasts between Northern and Southern scenery, and assertions
of the superiority of Southern Gothic.

The concluding paragraph of this short chapter therefore quite appropriate-
ly states, "We are, however, beginning to lose sight of our roof structure in its
spirit, and must return to our text." But the long sentence on vaulting that im-
mediately follows suggests that what Ruskin might have said would be of
limited value:

As the height of the walls increased, in sympathy with the rise of the roof,
while their thickness remained the same, it became more and more neces-
sary to support them by buttresses; but—and that is another point that the
reader must specially note—it is not the steep roof mask which requires
the buttress, but the vaulting beneath it; the roof mask being a mere wooden
frame tied together by cross timbers, and in small buildings often put to-
gether on the ground, raised afterwards, and set on the walls like a hat,

44. Par. 5 (*Works, 9*).

bearing vertically upon them; and farther, I believe in most cases the
northern vaulting requires its great array of external buttress, not so much
from any peculiar boldness in its own forms, as from the greater compara-
tive thinness and height of the walls, and more determined throwing of
the whole weight of the roof on particular points.

It is difficult but revealing to analyze this statement because of its strange in-
direction and hesitation. First Ruskin quite clearly states that walls (the only
possible referent for "them") are supported by buttresses; then he suddenly
shifts and states that it is not the walls, and definitely not the roof mask, but
the vaults that require buttressing. In all cases, however, he is apparently think-
ing of buttresses solely as supporting members; yet the flying buttresses that
Northern vaulting requires instead *transmit* the sidewise thrust of the main
vault over the intervening aisles to pier buttresses. The clause that follows is
muddier because of the vague meaning of the phrase "peculiar boldness in its
own forms." Assumedly "its own" refers back to "Northern vaulting," but
the expression "peculiar boldness" is more ambiguous. Supposing that Ruskin
means the *structural* boldness of northern vaulting forms, then it should fol-
low that vaults require external buttress *wholly* because of their boldness,
since the buttresses must accept and neutralize the thrust the vaulting exerts.
Perhaps, however, this is not what he means at all, because the concluding
phrase of the sentence, "more determined throwing of the whole weight of
the roof on particular points," is set up in contrast to "peculiar boldness" as
an alternative and more likely reason for buttressing.

On the other hand, the claim that in most cases the increasing thinness
and height of the walls somehow make buttressing necessary is quite mislead-
ing. In the Gothic system the walls do not affect the vaulting; the opposite
relationship obtains. The weight of the vaulting is exerted on the multi-shafted
piers and the crucial sidewise thrust is carried off on the exterior by the flying
buttresses, thereby eliminating the original supporting and bracing function of
the masonry walls and thus enabling them to be dissolved into curtains of
stained glass. The building's support is no longer the heavy, solid walls that
clearly divided interior from exterior in Romanesque churches; now, because
of the rib vault, the main support can be entirely externalized in a lacy-look-
ing masonry network placed at right angles to the main structure, thus on the
outside melting the boundaries between interior and exterior, just as the walls
of glass have the effect on the inside of dematerializing matter.

It is hard to judge, therefore, whether Ruskin has a genuine grasp of the
structural cause and effect relations among vaulting, buttressing, and walls; if
he does, it is obfuscated both by his imprecise diction and by his apparent un-
willingness to pursue the important structural and aesthetic implications of
vaulting for the total Gothic system. At all events, he promptly gives up the

task of enlightening us further in this insignificant matter of roofs, and moves on to his next chapter, which is (to him) obviously more germane: eighteen paragraphs on parapets and cornices, "of so great importance in the effect of the building."[45]

Ruskin manages to avoid any further analysis of roofs until chapter 29, when he turns to their proper ornamentation. One of the ten paragraphs deals with the decoration of vaults. It is best, he tells us, to leave the vault plain, and he uses this occasion to dismiss the English Late Gothic achievement as "all the fanning and pendanting and foliation that ever bewildered Tudor weight." Mosaics and frescoes are permissible adornment, however, "as far as we can afford to obtain them."[46] (Mosaics are utterly uncharacteristic of Northern Gothic, while the painting of Northern vaults—in part because of their great height—was simple and decorative, never approaching the pictorial sophistication of Italian frescoes.) The remaining paragraphs deal entirely with exterior decoration, including one on dormer windows and no less than three on crockets and finials. Of the 347 pages of main text in Volume I of the first edition of *Stones*, a meager fifteen pages supposedly treat the most important and distinctive part of the Gothic structural system; approximately two pages actually do.

45. A later chapter of this first volume does deal specifically with "The Buttress," and there (ch. 15, par. 6) he seems to understand well the flow of force through the flying buttress system, explaining that "the weight to be borne is designedly and decisively thrown upon certain points; the direction and degree of the forces which are then received are exactly calculated, and met by conducting buttresses of the smallest possible dimensions; themselves, in their turn, supported by vertical buttresses acting by weight, and these, perhaps, in their turn, by another set of conducting buttresses: so that . . . the weight to be borne may be considered as the shock of an electric fluid, which, by a hundred different rods and channels, is divided and carried away into the ground." But the typically Ruskinian natural analogy with "an electric fluid" is misleading, and again, he refuses to follow out the crucial interconnection of structural implications. Nor can he appreciate the unique aesthetic effect derived. Instead, he spends much of the remaining chapter *criticizing* the scheme of flying buttresses because "even in their best examples, their awkward angles are among the least manageable features of Northern Gothic" and because they impede decoration: "You gain much light for the interior, but you cut the exterior to pieces . . . [so that] you have a series of dark and damp cells, which no device that I have yet seen has succeeded in decorating in a perfectly satisfactory manner." This comment is part of yet another North/South contrast that concludes, "after the eye has been accustomed to the bold and simple rounding of the Italian apse, the skeleton character of the [Northern] disposition is painfully felt. After spending some months in Venice, I thought Bourges Cathedral looked exactly like a half-built ship . . ." (pars. 9, 11). Although Bourges is not, of course, in Normandy, this statement corresponds with his remark noted earlier that he could not study long in Verona without feeling some doubt of the nobility of Abbeville. Ironically, Ruskin's early-beloved Normandy was the pioneering region in the development of Gothic elevations and vaulting; but he did not know how to value this achievement.

46. Par. 4.

This slightness of treatment parallels that in Ruskin's one other ostensibly explicit discussion of roofs, an eight-paragraph section of Lecture 1 in *Lectures on Architecture and Painting*.[47] Three paragraphs deal with roofs in general, with no illustrative figures; in them he stresses only the exterior picturesque effect of steep gable roofs, whether of simple cottages, Continental streetscapes, or Gothic cathedrals. Four paragraphs follow, illustrated by five figures, on the beauties of Gothic towers. Here, however, he fastens not on structural or even ornamental aspects, but instead on the associative value of towers, discussing Biblical references to them, their picturesqueness in the backgrounds of Dürer's engravings, and their romantic connotations in Scott's novels. Vaulting is not mentioned at all.

There is, though, a brief reference to vaulting earlier in the same lecture,[48] and, like the passage in *Stones*, it is tellingly imprecise and confusing. He has produced for his audience two drawings of a spray of ash leaves, one a realistic perspective view, the other a stylized outline "plan of their arrangement" (see fig. 1),[49] to demonstrate the beauty and naturalness of the pointed arch

Figure 1. "Plan of arrangement" of a spray of ash leaves used by Ruskin as a vaulting illustration.
Figure 2. Pattern of Ruskin's "rib vault" abstracted from the spray of ash.
Figure 3. Pattern of the standard Gothic rib-vaulted bay.

shape. He comments: "You know how fond modern architects . . . are of their equalities, and similarities; how necessary they think it that each part of a building should be like every other part. Now nature abhors equality" He then analyzes the "inequalities" of the ash spray, showing in detail how its two

47. Pars. 17 ff. (*Works*, 12).
48. Par. 8.
49. Figs. 4 and 5 in *Works*, 12, facing p. 26 and on p. 25, respectively.

pairs of stalks have unequal numbers of leaves: "and observe, they spring from the stalk *precisely as a Gothic vaulted roof springs,* each stalk representing a rib of the roof, and the leaves its crossing stones; and the beauty of each of those leaves is altogether owing to its terminating in the Gothic form, the pointed arch." But his illustration is hardly effective: the underlying pattern of the spray with its "unequal" stalks, which I have abstracted here as Figure 2, bears no relation to the standard Gothic rib vault pattern (fig. 3). (Circles in each figure mark springing points of the ribs.) The four "ribs" are only partial; they have nowhere to go once they spring from their central "pier." They define no spatial unit, as the true Gothic rib vault does; there is no "covering of a space, narrow or wide." The only Gothic structure to which this description could possibly apply, save certain crypts and occasional monastic dormitories and refectories, would be the hall-church form in which nave and aisles are all of similar height, a rather unusual type found mainly in Poitou, Anjou, and Bavaria, and with which Ruskin does not seem to have been familiar. Even so, his ash spray outline would not define a complete vault in a hall church either, but rather *segments* of *four* vaults. (See fig. 4, in which I have superimposed this pattern over part of the ground plan of Poitiers Cathedral.)

Figure 4. Ruskin's "rib vault" pattern superimposed on a segment of the ground plan of Poitiers Cathedral, a hall church.

If Ruskin were using this illustration simply to suggest casually the seemingly free, elastic way in which the individual rib springs, it would serve admirably, but he insists on drawing a point-for-point analogy with the vault as a whole; hence the example fails because it does not describe a vault at all. Nor does it prove the virtue of inequalities. How is a vault possible in which each of its ribs and cells is a different size? Unfortunately for Ruskin's argument, in the Gothic vault "foolish equalities and similarities" are exceedingly important. The very fact, however, that he would choose such an illustration, employing a quintessentially structural example to prove an aesthetic point, namely that the pointed arch is a beautiful pattern, demonstrates his misunderstanding of the form and function of the Gothic vault.

Not unexpectedly, therefore, in "The Nature of Gothic" Ruskin goes to considerable pains to deny that vaulting is a major characteristic of the Gothic style:

> There have been made lately many subtle and ingenious endeavours to base the definition of Gothic form entirely upon the roof-vaulting; endeavours which are both forced and futile; for many of the best Gothic buildings in the world have roofs of timber, which have no more connexion with the main structure of the walls or the edifice than a hat has with that of the head it protects; and other Gothic buildings are merely enclosures of spaces, as ramparts and walls, or enclosures of gardens or cloisters, and have no roofs at all[50]

Referring back to his distinction in Volume I between "roof proper" and "roof mask," he explains that an edifice can be in the strictest sense of the word Gothic in all respects yet have a flat, coved, or domed roof proper. But "so far forth as the roofing alone is concerned," a building is "not Gothic unless the pointed arch be the principal form adopted either in the stone vaulting or the timbers of the roof proper." He further qualifies this statement, however, to stress that what is really important, at least to a definition of Northern Gothic, is the gabled roof mask, designed to throw off rain and snow: "the gable is a far more essential feature of Northern architecture than the pointed vault, for the one is a thorough necessity, the other often a graceful conventionality; the gable occurs in the timber roof of every dwelling-house and every cottage, but not the vault"[51] Ruskin is thus widening his definition, first, assumedly, to obscure the significance of the vaulting which characterizes virtually all the great Northern cathedrals; second, to include picturesque minor expressions of Gothic, interesting for the irregular silhouettes they add to the landscape; and hence, third, to reinforce his erroneous notion—though one so necessary to

50. *Stones of Venice II,* ch. 6, par. 80 (*Works,* 10).
51. Pars. 81, 82.

the disinfecting process—that Gothic had its roots in civil rather than ecclesiastical use.

But then he is alarmed to discover that his definition excludes such favorite buildings as the Florentine Duomo and the Pisa Baptistery, since it applies to large roofs only; therefore, "we must always admit that [this principle] *may* be forgotten, and that if the Gothic seal be indeed set firmly on the walls, we are not to cavil at the forms reserved for the tiles and the leads." Better yet, "we must either mend it, . . . or understand it in some broader sense."

> Let us then consider our definition as including the narrowest arch, or tracery bar, as well as the broadest roof, and it will be nearly a perfect one. For the fact is, that all good Gothic is nothing more than the development, in various ways, and on every conceivable scale, of the group formed by the *pointed arch for the bearing line* below, and *the gable for the protecting line* above [see fig. 5]; and from the huge, grey, shaly slope of the cathedral roof, with its elastic pointed vaults beneath, to the slight crown-like points that enrich the smallest niche of its doorway, one law and one expression will be found in all.[52]

Figure 5. Ruskin's definition of "all good Gothic": "the *pointed arch for the bearing line* below, and *the gable for the protecting line above* . . ." (*Stones of Venice II*, ch. 6, par. 86, and fig. 9 [*Works*, 10]).

He then presents supporting illustrations from minor ornamental details of a tomb at Verona, a lateral porch at Abbeville, and "one of the uppermost points of the great western facade" at Rouen. Further still, the pointed arch must be "foliated"—defined as adapting "the forms of leafage," "whether simple, as in the cusped arch, or complicated, as in tracery." This time he draws his example from an illuminated manuscript. "And our final definition of Gothic will, therefore, stand thus:—'*Foliated* Architecture, which uses the pointed arch for the roof proper, and the gable for the roof-mask.'"[53]

The important point here is that all these qualifications relate only to Gothic *profiles*. Ruskin is defining Gothic wholly in terms of the two-dimensional emphasis I pointed out in chapter 2. He conceives of Gothic not as the

52. Pars. 84, 86.
53. Pars. 94, 95, 98.

molding of space and the expression of a network of structural forces, but as
flat surfaces to be decorated with rich detail. A gable is by definition an end-
wall, not a covering of a space; it is a *plane.* A vault, taken as a three-dimen-
sional whole of ribs and cells defining a distinct spatial quantity, a bay, cannot
be "foliated" in Ruskin's terms. Ruskin is trying to identify an ornamental
motif as a structural principle;[54] he can do this quite confidently because of
his difficulty in perceiving the third dimension in architecture. To him an ex-
ample of leaf ornament in the margin of a medieval manuscript is perfectly
valid architectural proof, and he is content to define the principle underlying
the Gothic vault by drawing a faulty analogy with an ash spray.

But the ultimate evidence of Ruskin's view of Gothic architecture only as
surface is his apparent blindness to the beauty of the rib vault. The structure
of such vaulting is undeniably complicated and even now a matter of contro-
versy; one would think, however, that its aesthetic contribution would be
very clear to someone of Ruskin's sensitivity. For the vault gives final unity
to the Gothic edifice, joining its interior planes and turning the building into
a total skeleton of stone as well as an organic spatial unit. The vault becomes
the aesthetic apex at which the illusory upward flows of the opposed piers
and shafts merge. Yet Ruskin dismisses it simply as "a graceful conventionali-
ty."

Interestingly enough, Ruskin apparently grew to realize in his later years that
by neglecting structure he had not fully valued the Gothic achievement. This
discovery came through the French architect and Gothic theorist Viollet-le-
Duc, whose love of Gothic architecture was as intense as Ruskin's, but whose
rationalistic engineering approach could scarcely have been more different.
Viollet-le-Duc's *Dictionnaire raisonné de l'architecture française du XI^e au
XVI^e siècle* appeared in installments from 1854 to 1868, his *Entretiens sur
l'architecture* in 1863 and 1872. Ruskin's writings of the midseventies and
early eighties contain several dozen references to him, most of them unex-
pectedly favorable: in "Mending the Sieve" he calls Viollet-le-Duc "the most
sensible and impartial of French historians"[55] and praises him lavishly in *The
Pleasures of England* as "the best informed, most intelligent, and most thought-
ful of guides." Although he does fault him there for "his professional interest
in the mere science of architecture, and comparative insensibility to the power
of sculpture,"[56] Ruskin must nevertheless have learned from him, for in 1884

54. Charles H. Moore makes a similar point in his brief but excellent "Ruskin as
Critic of Architecture," *Architectural Record* 56 (August 1924): 118, explaining that the
diagram Ruskin gives of arch penetrating gable (fig. 5 in the text) cannot possibly describe
a Gothic vault; the arch of a vault does not rise into the gable at all, since the tie-beam of
the timber roof must pass over it.

55. Par. 15 (*Works,* 33).

56. Lec. 3, par. 70 (*Works,* 33).

he purchased copies of the *Dictionaries of Architecture* and of *Furniture* to be placed in his drawing school at Oxford.[57] Charles H. Moore, the American architectural scholar who came to know Ruskin at Venice in the midseventies, recalls Ruskin's telling him that Viollet-le-Duc "has shown the skeleton of a Gothic building to be as wonderful as that of an animal."[58] A possible indicator of the extent to which Ruskin realized all he had missed is a poignant 1882 diary entry: "Disturbed sleep, dreaming I tried to introduce myself to M. Viol[let]-le-Duc and that he wouldn't have anything to say to me"[59]

This awakening to the wonder of Gothic construction helps to explain why in *Praeterita,* and almost only there, Ruskin adamantly insists on his "fastidious structural knowledge." Heretofore, it had not seemed so necessary and desirable. Now, he became eager to stress, however dubiously, that he had always possessed it. Thus in chapter 4 of his last art-historic work, *The Bible of Amiens,* in which the cathedral itself is actually discussed (the other three chapters are historical), after agreeing in the opening paragraph that Viollet-le-Duc is right to call Amiens "The Parthenon of Gothic Architecture," he utters an offhanded, matter-of-fact endorsement of Gothic structure and the principle of ornamented construction worthy not only of his French rival but of that much-maligned old enemy, A. W. N. Pugin:

Of Gothic, mind you; Gothic clear of Roman tradition, and of Arabian taint; Gothic pure, authoritative, unsurpassable, and unaccusable;—its proper principles of structure being once understood and admitted.

No well-educated traveller is . . . unaware of the distinctive aims and character of Gothic. . . .

. . . [The builder's] object, as a designer, in common with all the sacred builders of his time in the North, was to admit as much light into the building as was consistent with the comfort of it; to make its structure intelligibly admirable, but not curious or confusing; and to enrich and enforce the understood structure with ornament sufficient for its beauty[60]

Ruskin's tone is that of a man who has been talking this way for years. Yet as

57. Noted in the 1884 *Master's Report* of the Guild of St. George, par. 11 (*Works,* 30), and listed in the catalogue of the Ruskin Collection at the Oxford Drawing School (*Works,* 21: 301).

58. Quoted in Moore, "Ruskin as Critic of Architecture," p. 120.

59. Lucca, October 18, 1882, *Diaries,* 3: 1034.

60. Pars. 1, 2 (*Works,* 33). Notice how he specifically rejects Arabian influence here—that particularly associated with Venetian architecture. Cf., too, this about-face comment from *Mornings in Florence* (1875-77): "There are two features, on which, more than on any others, the grace and delight of a fine Gothic building depends; one is the springing of its vaultings . . ." (First Morning, par. 10 [*Works,* 23]). Significantly, most of Ruskin's scattered casual references to Gothic vaulting cluster in his works of the seventies and eighties.

I pointed out at the beginning of this chapter, only now does he stop to define a term like "north door," or inform his readers that a Gothic cathedral typically has five entrances, or discuss the relations of the various parts of the apse. We can almost feel him physically lifting his eyes to take in the whole magnificent configuration of the Amiens interior as he guides his readers through the south portal:

> . . . all cathedrals of any mark have nearly the same effect when you enter at the west door; but I know no other which shows so much of its nobleness from the south interior transept; the opposite rose being of exquisite fineness in tracery, and lovely in lustre; and the shafts of the transept aisles forming wonderful groups with those of the choir and nave; also, the apse shows its height better, as it opens to you when you advance from the transept into the mid-nave[61]

Nowhere else in his writings does Ruskin give us such a sense of an entire Gothic interior, of its airy height and spatial directions. Once again, though, we must measure these remarks in their total context. Viollet-le-Duc may have offered Ruskin new perspectives on structure, but in giving him something else to admire about Gothic, he in no way caused Ruskin's love of "things near me, or at least clearly and visibly present" to diminish. Four-fifths of *The Bible of Amiens,* chapter 4, deals with the sculptural program of the quatrefoil medallions that decorate the base of the cathedral's facade (see fig. 6), and in the entire structure, he tells us, the one not-to-be-missed sight is the woodcarving of the choir stalls: "Aisles and porches, lancet windows and roses, you can see elsewhere"[62]

Both the brilliance and narrowness of Ruskin's architectural writing become especially clear when it is compared to a contemporaneous study, *Brick and Marble Architecture of the Middle Ages: Notes of a Tour in the North of Italy* (1855, revised and expanded second edition, 1874), by the Gothic Revival architect George Edmund Street (1824-81). Street is entitled to a quite respectable niche in English architectural history. He rivaled William Butterfield as the most accomplished and dedicated of the Revival architects; he built a great number of churches and designed the last major public building of the Revival, the New Law Courts in the Strand (1868-82). Moreover, his office produced two of England's leading architects in the last half of the century, Norman Shaw and Philip Webb. William Morris was also briefly associated with Street in 1856; Henry-Russell Hitchcock suggests that much of Morris's decorative work, as well as some of his ideas on architecture, "had

61. Par. 8.
62. Par. 5.

Figure 6. Facade, Amiens Cathedral: ". . . the series of sculpture in illustration of Apostolic and Prophetic teaching, which constitutes what I mean by the 'Bible' of Amiens" (*Bible of Amiens*, ch. 4, par. 44 [*Works*, 33]).

their origin in Street's office, . . . however much Morris also owed to the writings of Ruskin."[63] Street was a scholar as well; besides the editions of *Brick and Marble Architecture*, he published numerous papers on German Gothic in *The Ecclesiologist* during the fifties, and in 1865 the well-respected *Some Account of Gothic Architecture in Spain* (second edition, 1869).

Street and Ruskin held in common many preferences and beliefs. Both ob-

63. Henry-Russell Hitchcock, "G. E. Street in the 1850s," *Journal of the Society of Architectural Historians* 19 (December 1960): 145.

viously had a serious scholarly interest in Gothic and a conviction of its adaptability to modern needs. Street to a considerable extent shared Ruskin's belief in the sanctity of great monuments, and spoke out against "destructive" restorations. He, too, felt that greatness in architecture requires building for permanence with fine materials; this was one cause of his Ruskinian aversion toward the Renaissance architects, especially Palladio. Like Ruskin, he believed that traditional materials and principles of building were adequate to contemporary purposes, especially if applied with sensitivity to the glories of color. Finally, Street's seriousness of purpose is evident throughout his work. He was a devout Ecclesiologist with a high sense of mission as an architect, believing that Victorian builders should seek to recapture the "earnestness and thorough self-sacrifice in the pursuit of art, and in the exaltation of their religion"[64] that marked their medieval counterparts. And if he could neither sculpt nor paint (though he admired both Ruskin's favorite Scaliger tombs at Verona and Giotto frescoes at Padua), in his enthusiasm and solemn dedication he probably came as near as anyone in the Victorian era to approaching Ruskin's standards for the ideal architect.

The two men were acquainted, though not well. In the late fifties and early sixties they shared several lecture platforms together; in his diary, Ruskin twice notes meeting Street socially.[65] Ruskin apparently felt some admiration for the architect, since in an 1872 letter to the *Pall Mall Gazette* he ventures, "I am proud enough to hope . . . that I have had some direct influence on Mr. Street,"[66] and in "The Flamboyant Architecture of the Valley of the Somme" he mentions him as "one of our quite leading Gothic architects" to whom "we owe so much."[67] (Interestingly, it was a conversation between the two men in which Street derogated Pisan construction, Ruskin tells his audience, that directly prompted the "if the thing stands" passage in that lecture.)

The majority of Ruskin's references to Street, however, are criticisms of the architect's Italian Gothic scholarship. Ruskin had some grounds for complaint in that *Brick and Marble Architecture* was exactly what its subtitle proclaimed, *Notes of a Tour in the North of Italy*. It is not a volume having the scholarly foundation of *Stones of Venice* but is instead a collection of observations and drawings made during brief stops in assorted Italian cities on Street's first trip there in 1853. As such, Street's reactions carry the fresh enthusiasm of delighted first sight by a trained observer, but not the weight of prolonged, intensive examination. Ruskin could thus understandably resent Street's audacity in proposing, for example, that the Doge's Palace had been expanded horizon-

64. G. E. Street, *Brick and Marble Architecture* . . . (London, 1855), p. 286. All references will be to this edition unless specifically noted.
65. February 12, 1869, August 28, 1873, *Diaries*, 2: 664, 756.
66. March 16, 1872, reprinted in *Works*, 10: 459.
67. Par. 18 (*Works*, 19).

tally rather than vertically (a theory which Street nonetheless reiterated, with more detailed proofs, in his 1874 edition).

The volume was well received, however, especially among professionals, for its illustrations "were far more useful . . . as sources of direct 'inspiration' . . . than the very restricted range of visual models provided in Ruskin's so much more famous books of 1849-1853."[68] It was also an excellent travel guide for the architectural pilgrim with limited time and relatively modest funds—two conditions Ruskin never contended with. Hitchcock maintains that "as much as Ruskin, certainly," Street made Continental Gothic "both acceptable and available as a source of inspiration to his contemporaries."[69] It was ironically appropriate that when in 1874 Ruskin rejected the Gold Medal of the Royal Institute of British Architects, which was being offered that year for literary writings on architecture, George Edmund Street received it instead.

Street is by no means unworthy, therefore, of comparison with Ruskin, even though in *Brick and Marble Architecture* his weaknesses are at first glance more apparent than his strengths. He obviously lacks Ruskin's brilliant style, his passionate reactions, his exquisite sensitivity, and especially his sense of drama. At the same time, Street's concerted architectural interest precludes the digressions and declamations that can mar as often as they enrich Ruskin's books. One feels that he is constantly open to new impressions and that within the bounds of his Gothic predisposition he is willing to measure objectively and calmly his previous opinions against them. Above all, one senses in Street an eagerness to learn rather than to dictate, a desire to understand better his mission as an architect. For in *Brick and Marble Architecture* Street is looking at Italian buildings first and foremost *as* an architect—not as a historian, or a devout Christian, or a critic of his age. If *The Stones of Venice* is a great sermon, *Brick and Marble Architecture* is a workbook.

Yet it is this workbook quality that makes *Brick and Marble Architecture* such a useful contrast to Ruskin's writings. The volume is that of a man who is accustomed, unlike Ruskin, to thinking of a building not only in its separate parts but as an integrated whole, not only in two- but in three-dimensional terms; who has a keen awareness of the practical necessities and problems of construction; and who possesses the structural expertise Ruskin lacks. On the other hand, he is also a man of sensitivity and scholarship, capable of perceiving and appreciating, if not so eloquently, those architectural qualities Ruskin loved. Thus Street's work serves as a valuable indicator of Victorian knowledge of the Gothic style, especially its structure, as well as of what building characteristics held greatest immediate interest to the practicing architects of the

68. Hitchcock, "G. E. Street in the 1850s," p. 150.
69. Ibid., p. 148.

period—the group it was most important for Ruskin to reach if he were to see his principles adopted. Street helps us to see how Victorians other than Ruskin were *looking* at Gothic buildings. Finally, therefore, his inclusions tellingly illuminate Ruskin's omissions, and underscore the idiosyncratic nature of Ruskin's preference for Italian Gothic.

If *Brick and Marble Architecture* lacks the depth of analysis found in Ruskin, its breadth is a partially offsetting advantage. Whereas Ruskin elucidates his architectural principles by examining a very small number of structures intensively, Street surveys a large range of buildings scattered among many North Italian cities. For reaching a valid definition of the pervasive qualities of Italian Gothic, Street's is the better method; while the decorative details Ruskin fastens on may vary considerably in quality and quantity from one building to another, the constructional forms and spatial configurations are far more likely to remain constant. Not surprisingly, it is these latter qualities that Street dwells on most; in fact he defines Gothic as

> . . . essentially the work of scientific men; the most consummate skill being displayed in arranging thousands of small blocks of stones . . . into walls rising far in height above anything ever dreamt of by the Greek, bridging great openings, and providing by the exactest counterpoise of various parts for the perfect security of works whose airiness and life seem to have lifted them out of the region of constructive skill [70]

And he actually claims that Gothic requires *less* beauty of detail than classical architecture does because its "intricacy of outline and delicacy of structure" are sufficient to "satisfy the eye."

Hence in analyzing a building, he nearly always discusses the ground plan first, usually depicting it as well in a drawing, although he points out that the Southern ground plan is much less complex than the Northern:

> Just as in the elevation of Northern churches there is a great intricacy and interminableness . . . so in their planning the same thing is visible: the spaces between arches are small, and the piers and arches, infinitely reproduced and repeated, give an air of confusion and intricacy, . . . heightened . . . by the triple arrangement . . . of arcade, triforium, and clerestory, all differing in design and all excessively elaborated. In Italian churches . . . the arrangement of the ground-plan was much simpler, the spaces between the main shafts being very considerably spread out, so as to be nearly as wide as the nave, and the groining bays in the aisles expanding consequently into oblong compartments nearly twice as long from east to west as they are from north to south, instead of forming nearly exact squares, as they almost invariably do with us. The first consequence of this absence of subdivision is a certain

70. Street, *Brick and Marble Architecture*, p. 257.

air of openness and clearness . . . and this is much increased by the sim-
plicity of the bearing-shafts, the plainness of the arches, and the almost
complete absence of any openings at all in the space between the arches
and the groining[71]

I quote this passage at length partly to demonstrate how clearly Street con-
ceives of these buildings' interiors as spatial wholes, seeing their parts as logical-
ly interacting both two- and three-dimensionally, and partly to convey the very
different architectural vocabulary Street employs from that of Ruskin. Clere-
story, triforium, bay—these essential features are scarcely named by Ruskin,
much less investigated, but it is their arrangements that produce the unique
forms and spaces of the Gothic cathedral.

Street is likewise cognizant of the sternly structural significance of vault-
ing, and in this respect he wholly approves the simple Italian vaults:

. . . the real beauty of these interiors is owing, I believe, more to the
simplicity and purity of the quadripartite groining which arches them in,
and which . . . invariably recalls us to a proper recollection of the infinite
value of simplicity in this important feature. . . . [F]or I take it for granted
that we all feel that ornament for its own sake is valueless, and equally,
that doing in a troublesome, and therefore costly way, that which may be
done as well in a simpler manner, is unpleasant and distasteful[72]

Dominant here is the attitude of a genuine functionalist, who "takes it for
granted" that unadorned structure can be beautiful in itself and that ornament,
when employed, must have clear, subordinate reference to structural necessity
and economy. These premises find expression not only in Street's writings but
in his buildings, for as Eastlake admiringly explains, "Mr. Street was one of the
first architects of the Revival who showed how effective Gothic architecture
might be made where it simply depends for effect on artistic proportion."[73]
In other words, Street understood and could boldly work with precisely those
architectural elements Ruskin deprecated.

Nevertheless, Street does not exclude discussion of aesthetic matters in
preference to constructive and spatial effects, as Ruskin does in the opposite
manner. If he reveres the quadripartite vault for its structural logic and
economy, he is also cognizant of the aesthetic unity it provides: "[I] cannot
help marvelling how far this one pointed feature harmonises and (I had almost
said) sanctifies the whole interior"[74] He is especially interested in decora-

71. Ibid., pp. 265-66.
72. Ibid., p. 133.
73. Eastlake, *History of the Gothic Revival*, p. 323.
74. Street, *Brick and Marble Architecture*, p. 210.

tive color and pattern, incorporating into his work many drawings of windows, doorways, pavement designs, and other details. But these are balanced by perspective views and descriptions, both interior and exterior, so that the reader has a sure sense of ornamental context. It is typical, too, that although Street valued polychromy as much as any Revival architect, he plainly prefers the so-called structural coloration of Siena, in which the constructional materials themselves are colored, to the Venetian method of incrustation exalted by Ruskin—arguing, as he does repeatedly in *Brick and Marble Architecture,* that constructional features should be confessed and not concealed, again a standard functionalist point of view.

Street's synthesis of his impressions of Italian Gothic in his closing chapter is remarkably comprehensive and modern. Some of those qualities he regards as central to Italian Gothic are never so much as mentioned by Ruskin (who may possibly not even have been aware of them); others that Street notes point inadvertently to the basically nonarchitectural nature of Ruskin's emphases. He is especially critical of "faulty" Italian construction, which he ascribes in large measure to Italy's persistent classical heritage. According to Street, the Italians never fully grasped the structural logic of the pointed arch:

> They ignored, as much as possible, the clear exhibition of the pointed arch, and, even when they did use it, not unfrequently introduced it in such a way as to show their contempt for it as a feature of construction; employing it often only for ornament, and never hesitating to construct it in so faulty a manner, that it required to be held together with iron rods from the very first day of its erection.[75]

Ruskin never acknowledges the presence of the great tie rods which span the naves of so many Italian cathedrals, and which even on a small scale bind together the arches of the Scaliger tombs at Verona; he apparently just visually tuned out these unsightly structural intrusions. It is striking, moreover, that Street should note the Italians' predominantly ornamental rather than constructional use of the pointed arch, which perhaps helps explain Ruskin's confusing a decorative motif with a structural principle in defining Gothic.

Street also emphasizes the planar quality of Italian Gothic. He is especially bemused by the almost universal broad, flat facade that obscures the interior plan behind it, which he likewise regards as a denial of Gothic functional logic, in which the exterior should reflect interior arrangements. (He notes this type of facade so often that at Pavia he finally exclaims, "I begin really to wonder whether I shall see a west front before I leave Italy which is not a purely un-

75. Ibid., p. 258.

necessary and unprepossessing sham!"[76]) Ruskin, since he conceived of architecture in terms of planes, and as parts rather than wholes, was not troubled by this contradiction.

Street remarks as well the flatness of Italian Gothic decoration, attributing it to various causes, including climate, classical heritage, simplicity of construction, the wide use of marble, and especially the presence of accomplished painters. Ultimately he argues that this prevalent flatness derives from the Italians' preoccupation with "breadth of effect," a basically classical quality which could never be sought in the North; it was, in fact,

> . . . the very point in which Northern architects were most careless to succeed, and about which they apparently thought least, perhaps in part because the gloomy skies so usual here allowed . . . deep recessed windows
> But in Italy, where sunshine is brilliant and constant, men were perhaps better able to satisfy themselves with plain unbroken surfaces of wall, marked here and there with some delicate line of moulding or ornament, whose every outline and change of shape was marked unmistakably by the deep black line of shade cast upon it by the power of the sun. And this same feeling went much farther than to the treatment of walls: for window tracery, mouldings, and all details were regulated with the same view. . . . The difference is great,—the one kind giving that depth and mystery so characteristic of Northern Gothic; the other broad and flat in its effect[77]

How well Street's comments here elucidate Ruskin's conception of the best sculpture as "chalk sketching" or "light and shade drawing in stone."

Street's specific critique of Venetian Gothic is particularly noteworthy in that, like Henry James's description of St. Mark's, it accidentally but tellingly illuminates Ruskin's limited and antiarchitectural emphases. Above all, Street says, Venetian Gothic "was never essentially constructional in the sense in which it was in our own land." Further, it was fundamentally a static style, in which the same architectural idea was repeated "an infinite number of times." Street attributes this phenomenon to Venice's geographical isolation, so that while changes were occurring on the mainland, Venice "rested satisfied with a slight alteration only, and that one of detail always, for centuries"[78] But what an ideal architectural environment Venice thus provides for someone of Ruskin's proclivities! Uninterested in structure to begin with, but fascinated by minute variation in ornamental detail that yields "more and more" to the

76. Ibid., p. 209.

77. Ibid., pp. 263-65.

78. Ibid., pp. 165, 142. Ruskin makes a similar point in *Stones of Venice II,* ch. 8, pars. 1-2 (*Works,* 10), but explains that such "pause" in "the Gothic imagination" was owing to the overwhelming glory of the Doge's Palace.

close observer, he could painstakingly measure great quantities of mouldings and capitals, then in isolating fractional changes of curve and angle convince himself that he was seeing the entire progression of the Gothic style and was justified in making universal statements about its nature.

Another significant indicator of Ruskin's emphases is Street's ambivalence toward marble incrustation. Although he loves the color and pattern of marble so used, his objections to it are obviously those of the practicing architect. First, he sees such decoration as sadly in danger of sloughing off, to reveal construction which was allowed to be ugly and even inferior on the assumption that it would be forever masked. Hence, the Venetian method of coloration "was rather likely to be destructive of good architecture, because it was sure to end in an entire concealment of the real construction of the work." Street cannot help admiring the effect of incrustation, but its beauty is achieved, he realizes, at the expense of the architect: "The men who did this work were, perhaps, more of sculptors than of architects, . . . [for] never in buildings in which the construction is mainly thought of, so far as I know, is so much elaborate thought and skill exhibited in the decorative part of the work as in buildings such as these."[79] Again, however, the cause of Street's reservations about Venetian Gothic is the very reason for Ruskin's celebration of the style. In Venice, architecture *is* surface. The sculptor *is* more important than the "mere builder"; much more than in Pisa, "the builder's mind is far too busy in other and higher directions to care about construction. . . . [T]here is no defiance of construction, . . . only no attention is paid to it; if the thing stands, that is all that is wanted." No wonder Ruskin loved Venetian Gothic so well.

No wonder, too, that when Street focuses on the apex of Venetian architecture, St. Mark's, though he gamely tries to analyze it in the methodical way he does other Italian monuments, he is finally overwhelmed, and ends up isolating those same characteristics Henry James noted, which coalesce so strikingly with Ruskin's fundamental emphases; St. Mark's seems

> . . . more akin to some fairy-like vision, such as one in dreams might see, than to any real and substantial erection of stone and mortar; . . . yet, as it is looked at more and more carefully, it grows much and rapidly on one's love, and at last imprints itself on the mind as a very beautiful vision
> . . . It is quite in vain to describe this architecturally. The colour is so magnificent that one troubles oneself but little about the architecture, and thinks only of gazing upon the expanse of gold and deep rich colour all harmonised together . . . so that all architectural lines of moulding and the like are entirely lost, and nothing but a soft swelling and undulating sea of colour is perceived.[80]

79. Street, *Brick and Marble Architecture,* pp. 279, 281.
80. Ibid., pp. 123, 125.

In his 1874 version, he adds, "There is no long vista of arches, no complicated perspective, and no vast height to awe the beholder, yet the mystery of colour does for [St. Mark's] even more than the mystery of size does for Köln or Beauvais, Milan, Toledo, or Bourges." (Equally telling in this later edition is his comment on the Doge's Palace: "For a building which owes its general impressiveness entirely to the uniform character of its architecture, it is especially fortunate that there should be so much also in the detail to reward constant and minute examination."[81]) As much as Ruskin, then, Street recognizes the strength and nobility of Venice's Byzantine heritage, yet at the same time, he can see how it impeded as much as it enhanced the development of the Venetian Gothic style: "pointed architecture . . . though it retained its sway [in Venice] nearly as long as it did elsewhere, . . . never thoroughly understood or felt its own strength, and worked and toiled tied down and encumbered by Byzantine fetters and classic sympathies." But, he adds, "There is much, notwithstanding this, to admire"[82]

This tone of qualified admiration pervades Street's book because he is so strongly aware of the non-Gothic influences not just on Venetian but on all medieval Italian architecture. Much more than Ruskin, Street grasps the full extent of Italy's classical heritage as it modified Gothic expression in the South, not only ornamentally but especially constructionally. Because he understands Gothic structure and is cognizant of how much Gothic as a style is an expression of that structure, he can discern and objectively evaluate the anti-Gothic characteristics of medieval Italian work. Street's assessment of Italian Gothic is the more accurate one because he sees *whole buildings.* Finally, of course, he recognizes Italian Gothic as the hybrid expression it is because he is not concerned with providing ex post facto rational justifications for basically nonrational personal preferences. He is not driven to confound singularity with purity; he feels no need to deprecate Northern Gothic as being "in harmony with the grotesque Northern spirit only" in order to proclaim that Italian Gothic is "in harmony with all that is grand in all the world."

Reading Street, then, we emerge with a coherent total view of a building illumined by the unglamorous light of day; with Ruskin, the building stands deep in darkness, lit only by a brilliant spotlight which is successively beamed on unrelated parts, and extinguished each time. Street provides the prosaic guided tour; Ruskin, *son et lumière.* This distinction is illustrated in Figures 6, 7, and 8, where I have provided outline sketches of representative buildings Ruskin treats, and accented those parts on which he lavishes the bulk of his eloquent analysis. It can be seen what comparatively small segments of these structures Ruskin fastens on; they stand out, however, in these simple figures

81. G. E. Street, *Brick and Marble Architecture . . .* , 2d ed. (London, 1874), pp. 155, 207.

82. Street, *Brick and Marble Architecture*, pp. 168-69.

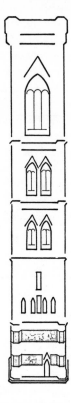

Figure 7. Giotto's Tower, Florence: "At first you may be surprised at the smallness of the [bas-reliefs'] scale in proportion to their masonry; but this smallness of scale enabled the master workmen of the tower to execute them with their own hands; and for the rest, in the very finest architecture, the decoration of most precious kind is usually thought of as a jewel, and set with space around it . . ." (*Mornings in Florence*, Sixth Morning, par. 122 [*Works*, 23]).

because I have suppressed all other detail. If the buildings are viewed either in actuality or in photographs, with all their forms and shadings perceptible, not just what I have highlighted, it is much harder to locate the parts Ruskin discusses, so small are they. One of the best tests, in fact, of the narrowness of Ruskin's architectural interest is to obtain a full-view photograph of virtually any monument with which he deals, but especially of its facade, and then attempt to find the exact elements he describes; it can be a surprisingly difficult task.

Because, in the end, architecture for Ruskin is anything but a building: thus the richness and range, for instance, of his metaphors for St. Mark's—it is "a sea-borne vase," "a purple manuscript," "a jewelled casket," "a vast illuminated missal, bound with alabaster instead of parchment, studded with porphyry pillars instead of jewels, and written within and without in letters of enamel and gold."[83] A building is a gilded, gem-incrusted, oversized reliquary,

83. *Deucalion*, vol. 1, ch. 7, par. 40 (*Works*, 26); "Circular Respecting Memorial Studies of St. Mark's" (1879-80), par. 3 (*Works*, 24); *Stones of Venice II*, ch. 4, par. 46 (*Works*, 10).

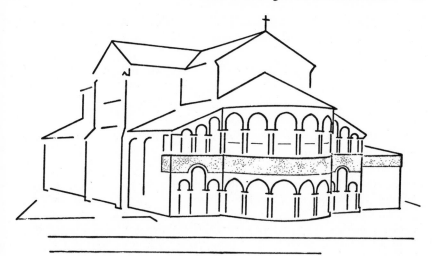

Figure 8. Apse, San Donato, Murano: "... the eye can rest upon this coloured chain with the same kind of delight that it has in a piece of the embroidery of Paul Veronese" (*Stones of Venice II*, ch. 3, par. 25 [*Works*, 10]).

"a jewel case for sweet sculpture." And hence the only great architects *must* be painters and sculptors. We are back yet again to the distinction between architecture and mere building. Ruskin can therefore argue quite consistently that Niccola Pisano's midthirteenth-century pulpit at Pisa marks the beginning of Christian architecture and call Taddeo Gaddi an architectural master on the basis of the buildings he "constructs" in his frescoes.[84] Undoubtedly, too, much of Ruskin's abject admiration for Giotto's Tower stemmed from its being designed by a great painter. When Ruskin says a building is the most beautiful Gothic in the world, what he actually means is that this structure built in the middle ages has the most beautiful and subtly colored surface decoration, whether mosaic or fresco or low-relief sculpture, in the world—and mostly at or near eye level.

Appropriately enough, when John Everett Millais was staying with the Ruskins at Glenfinlas during the summer of 1853, Ruskin worked with him in designing a church, as the young Pre-Raphaelite wrote excitedly to a friend:

> . . . Ruskin has discovered that I can design Architectural ornamentation more perfectly than any living or dead party. . . . He draws the arches and frames the mouldings for me to fill up. The Church which will be designed *entirely by me* (excepting the ground plan) will *for certain* be exe-

84. *Val d'Arno*, lec. 1, par. 24 (*Works*, 23); *Mornings in Florence*, Fourth Morning, par. 86 (*Works*, 23).

cuted shortly Ruskin believes now that I have almost mistaken my
vocation and that I was born to restore Architecture.[85]

Had Millais not been at the same time falling fatefully in love with his patron's
wife, perhaps it might have been built. At any rate, Ruskin's impulse to set a
talented painter to work designing traceries and doorheads was perfectly con-
gruent with his ideal of the true architect.

But there is a still deeper, more fundamental consistency in his claim at
the close of *Stones* that

> Exactly in the degree that the [Renaissance] architect withdrew from his
> buildings the sources of delight which in early days they had so richly pos-
> sessed, demanding, in accordance with the new principles of taste, the
> banishment of all happy colour and healthy invention, in that degree the
> minds of men began to turn to landscape as their only resource. The
> picturesque school of art rose up to address those capacities of enjoyment
> for which, in sculpture, architecture, or the higher walks of painting, there
> was employment no more; and the shadows of Rembrandt, and savageness
> of Salvator, arrested the admiration which was no longer permitted to be
> rendered to the gloom or the grotesqueness of the Gothic aisle. And thus
> the English school of landscape, culminating in Turner, is in reality nothing
> else than a healthy effort to fill the void which the destruction of Gothic
> architecture has left.[86]

Even though he goes on to stress that landscape art will never be a truly ade-
quate substitute, yet it is the painter who, by Ruskin's standards, most nearly
duplicates the emotional power and appeal of Gothic, and who is therefore,
in an indirect but definable way, an architect.

In view of the foregoing analysis, what, then, is the validity of Ruskin's sup-
posedly quintessential architectural statement, "The Nature of Gothic"? From
a strictly architectural standpoint (and it is this perspective that has determined
all my commentary up to now), the famous *Stones of Venice* chapter is a bril-
liant but limited explanation of the Gothic style. We have already seen the in-
consistencies surrounding Ruskin's definition there of Gothic form as "*Foliated*
architecture, which uses the pointed arch for the roof proper, and the gable for
the roof-mask." Similar limitations obtain in his well-known enumeration of the
six "characteristic or moral elements" of Gothic buildings: savageness (with its

85. John Everett Millais to Charles Collins, given without specific date in Mary
Lutyens, *Millais and the Ruskins* (London, 1967), pp. 81-82. Among the designs Millais
concocted was a dreadful traceried window in which all the bars are angel-forms—and all
the angels have Effie's profile (reproduced, ibid., facing p. 147).

86. Vol. 3, ch. 4, par. 33 (*Works*, 11).

counterpart in the builder's character, rudeness), changefulness (love of change), naturalism (love of nature), grotesqueness (disturbed imagination), rigidity (obstinacy), and redundance (generosity).[87] They are basically ornamental qualities—what Nikolaus Pevsner calls "craftsman's categories," or what Street goes so far as to label "accidents," that is, the characteristics "which individual minds may have given to their work, the savageness, or the grotesqueness as it has been called, . . . mainly to be discovered in the elaboration of particular features by some particular sculptor or architect"[88] Paul Frankl contemptuously dismisses them altogether as "characterized by utter vagueness and dilettantism, and in consequence [they] attracted a wide public."[89]

That students of Gothic structure like Street and Frankl particularly should label these elements inaccurate once again suggests how much Ruskin could not appreciate in Northern Gothic. For oddly enough, the characteristics Ruskin defines here as central to Gothic "Mental Power or Expression" he attributes primarily to its *Northern* form, and especially his first and most important quality, savageness, resulting when the Northern builder

> . . . smites an uncouth animation out of the rocks which he has torn from among the moss of the moorland, and heaves into the darkened air the pile of iron buttress and rugged wall, instinct with work of an imagination as wild and wayward as the northern sea
>
> There is . . . no degradation, no reproach in this, but all dignity and honourableness: and we should err grievously in refusing . . . to recognize as an essential character of the existing architecture of the North, . . . this wildness of thought, and roughness of work; this look of mountain brotherhood between the cathedral and the Alp[90]

Ruskin is able to isolate this "savage" element mainly because he is looking at Northern details, and at minor details, for that matter—not the elegant, stately jamb figures of saints and kings, prophets and church fathers, that line the great Northern Gothic portals, but the smaller-scale background decoration of shafts and canopies framing them; not the majestic carvings of complex iconographic programs but the elaboration of pinnacles and small ornamental panels. And he must almost entirely ignore the building as a whole, in which this kind of ornament assumes such a subordinate part; Reims or Wells or Cologne cannot be satisfactorily dismissed as a pile of iron buttress and rugged wall heaved

87. Vol. 2, ch. 6, par. 6 (*Works*, 10).

88. Nikolaus Pevsner, *Ruskin and Viollet-le-Duc, Englishness and Frenchness in the Appreciation of Gothic Architecture* (London, 1969), p. 22; Street, *Brick and Marble Architecture*, p. xii.

89. Paul Frankl, *The Gothic, Literary Sources and Interpretations through Eight Centuries* (Princeton, 1960), p. 560.

90. *Stones of Venice II*, ch. 6, par. 8 (*Works*, 10).

into the darkened air. The quality of savageness is there in Gothic, just as Ruskin's other elements are, and may perhaps be that which eventually moves us as the spirit of these buildings, but we must look closely for and at them, as well as embrace unquestioningly Ruskin's assumption that the typical Northern Gothic workman possessed an inferior mind and a wayward imagination that yielded wildness of thought and roughness of work.

Nonetheless, in this instance at least, Ruskin devalues Northern Gothic in order to glorify it. John Rosenberg rightly suggests that in "The Nature of Gothic" Ruskin's stress on rudeness and naïveté echoes Wordsworth's impulse to exalt the simple speech of the Cumberland peasant, and is part of the romantic tendency "to equate the real with the untutored, the natural with the imperfect."[91] For in this famous chapter Ruskin is operating on a completely different level than he is elsewhere in *Stones*. What Ruskin labels Gothic's characteristic elements are much more typical of the Northern than the Southern form, by his own admission. Yet they are listed in the middle of three volumes dedicated to asserting, both explicitly and implicitly, the preeminence of *Southern* Gothic—a superiority Ruskin proclaimed throughout his life. And, paradoxically, what in the rest of *Stones* Ruskin praises most highly in Southern Gothic are often its most classical qualities—the delicate, highly finished sculpture; the chastely plain flat marble surfaces, both interior and exterior—while what he derogates most frequently in Northern Gothic—vaulting, the system of flying buttresses, effects of soaring height and intricate perspective—are in fact its most truly Gothic features. Yet none of these qualities, Northern *or* Southern, finds abstract moral embodiment on Ruskin's list. In "The Nature of Gothic" Ruskin is momentarily shedding his Southern Gothic partisanship to exalt an idiosyncratic version of the kind of architecture he disdains or patronizes throughout much of the rest of *The Stones of Venice*. "The Nature of Gothic" does not fit. As is so often the case in Ruskin's work, what he professes to be discussing is not what he is actually talking about at all. Ruskin must establish the rude imperfection of Gothic, however dubiously, in order to prove something much more important to him.

The real value of "The Nature of Gothic" lies not in its moving, if eccentric, evocation of Gothic as a style of architecture, but in its interpretation of Gothic as a way of life.[92] It marks Ruskin's first eloquent formulation of the effect of labor on the individual's moral and spiritual health, and the real beginning of his venture into political economy. "I believe," he wrote to his

91. Rosenberg, *The Darkening Glass,* pp. 94-95.
92. To determine whether the Gothic workman actually led the existence Ruskin defines for him is completely outside the range of this study. But it should be noted that Ruskin probably underestimated the rigidity of iconographic conventions in Gothic architecture, and hence the extent to which the craftsman was merely the extension of the theologian.

father from Venice in 1852, "I shall some day—if I live—write a great essay on Man's Work, which will be the work of my life. I don't see anything beyond it."[93] In "The Nature of Gothic" he was already composing the preface to *Unto This Last*.

But even this social emphasis is at bottom non- or extra-architectural. In his 1865 lecture on "The Study of Architecture," he declares that the main thrust of his early work has been "to set forth the life of the individual human spirit as modifying the application of the formal laws of architecture"[94] This shift of focus from building to builder is already becoming apparent in *The Seven Lamps*: "I believe the right question to ask, respecting all ornament, is simply this: Was it done with enjoyment—was the carver happy while he was about it? It may be the hardest work possible, and the harder because so much pleasure was taken in it; but it must have been happy too, or it will not be living."[95] In stressing the individual's role in a building, he must of necessity focus only on smallness, on what the single human being can accomplish unaided—on *parts* of a building, especially carved detail and other ornamental effects; it is this point at which Ruskin's architectural and social interests touch. The mortar that joins these parts together becomes the shared humanity of the builders, not mere mechanical or even aesthetic means. For Ruskin, then, a great architectural masterpiece stands not only figuratively but also literally for the spiritually unified society, in which each member's creativity, however minor or imperfect, is respected and welcomed. This is how Ruskin "sees" a building in its entirety: not as a structural enclosure of space but as a symbolic shelter for mankind's noblest aspirations.

93. February 13, 1852, in *Ruskin's Letters from Venice, 1851-1852*, ed. John L. Bradley (New Haven, 1955), p. 177. Significantly, in the previous year John James had scotched Ruskin's first foray into political economy—three radical letters intended for the *Times* on taxation, representation, and education, which also contain germs of *Unto This Last*. (Ruskin had temporarily ceased working on *Stones* in order to write them.) The last letter Ruskin transmuted into the appendix "Modern Education" in *Stones of Venice III*. Perhaps in "The Nature of Gothic" he was consciously or unconsciously interpolating some of the substance of the other two suppressed letters.

94. Par. 2 (*Works*, 19).

95. Ch. 5, par. 24 (*Works*, 8).

4

Ruskin's Influence as an Exponent of the Gothic Revival

In the preceding pages I have stressed the crucial importance of "taking Ruskin whole." For it is only after investigating the emphases and omissions in his architectural criticism that we can begin to assess fairly his influence on Victorian and twentieth-century architecture, a process which will be the focus of the next two chapters. If taking Ruskin whole is a complex task now, however, it was still more difficult for the Victorians, who could not yet consult the thirty-nine volumes of the splendidly edited Library Edition of Ruskin's works, but were instead receiving his brilliant visions irregularly in apparently contradictory installments. Even given the most cultivated, respectful, open-minded audience, Ruskin's influence on Victorian architecture was therefore bound to be checkered.

According to Ruskin himself, his impact was both extensive (he believed that his "essays on architecture, . . . of all my writings have had the most direct practical influence"[1]) and disastrous. As early as 1851-52 in letters to

1. "Mending the Sieve," par.23, in the Library Edition of *The Works of John Ruskin*, ed. E. T. Cook and Alexander Wedderburn, 39 vols. (London and New York, 1903-12), vol. 33; hereafter cited as *Works*.

his father from Venice, he complains of having his ideas wrenched from context or misunderstood in ways entirely opposite to his intentions. Later in the decade he often incorporates into his works sardonic *caveats* about his supposed contradictions, explaining that they exist only in the minds of careless readers.[2] But in his preface to *Modern Painters IV* (1856) he laments, "every day convinces me more and more that no warnings can preserve from misunderstanding those who have no desire to understand."[3] In his later years, nonetheless, Ruskin to some extent promoted this unhappy result, both by issuing new works serially and by republishing parts of old works in separate editions (such as *Modern Painters II* in 1883) or in revised form (as in the 1880 edition of *Seven Lamps,* with marginal glosses added and its important "aphorisms" emphasized typographically).

At all events, by 1865 he could declare to an audience of architects, "I tell you honestly—I am weary of all writing and speaking about art, and most of my own."[4] He assured the *Pall Mall Gazette* in 1872 that he had exerted "indirect influence on nearly every cheap villa-builder between [Denmark Hill] and Bromley" and that "one of my principal reasons for leaving my present house is that it is surrounded everywhere by the accursed Frankenstein monsters of, *in*directly, my own making."[5] For, as he later explained in his preface to the third edition of *Stones of Venice* (1874), the effects of his writing on architecture had been wholly pernicious since only "partial use" of his books had been made, "which has mottled our manufactory chimneys with black and red brick, dignified our banks and drapers' shops with Venetian tracery, and pinched our parish churches into dark and slippery arrangements for the advertisement of cheap coloured glass and pantiles."[6] The caustic notes Ruskin added to the 1879-81 reissues of *Stones* and the 1880 edition of *Seven Lamps* constitute a tragic jeremiad on mangled opportunity and the perversities of human understanding. On the other hand, he was bound to be bitterly sensitive to every symptom of failure, considering the impracticable kind of power he apparently sought: "I don't say I wouldn't care for reputation if I had it, but until people are ready to receive all I say about art as 'unquestionable,' just as they receive what Faraday tells them about chemistry, I don't consider myself to have any reputation at all worth caring about."[7] Ruskin was unsuccessful in exercising the kind of absolute authority he coveted; those Victorians who made only "partial use" of his writings, whether incompetent speculative builders or talented designers like Alfred Waterhouse and E. W. Godwin, had, in his view, rejected his principles altogether.

2. For example, in *A Joy for Ever,* addenda, par. 140 (*Works,* 16).
3. Par. 4 (*Works,* 6).
4. "The Study of Architecture in Our Schools," par. 4 (*Works,* 19).
5. Letter to the Editor, March 16, 1872 (*Works,* 10: 459).
6. Par. 1 (*Works,* 9).
7. Letter to Dr. F. J. Furnivall from Vevay, June 9, 1854 (*Works,* 5: 5n).

Hence Ruskin's own assessment of his influence, both in its nature and extent, is not wholly reliable. It is obvious by this point that Victorian taste was in a state of flux and controversy and that Ruskin therefore had the ideal occasion for exerting influence. Just as obviously, many of the ideas he considered uniquely his were already in the air, as we have seen, and he was frequently charged with plagiarism. A particularly harsh attack came in an 1850 paper on *The Seven Lamps* read to the Architectural and Archaeological Society of Liverpool, criticizing "the general want of honesty in this author. To read his works, you would think no one had ever touched the subjects before. He unscrupulously adopts, without acknowledgment, whatever may suit his purpose from previous writers"[8] Charles Eastlake's is probably a fairer evaluation, though: "There are sentiments expressed in 'The Lamps' of Sacrifice, of Truth, and of Memory, which had been frequently expressed before; but they are founded on novel theories, identified with minutiae of facts which had hitherto escaped attention, or so clothed in metaphysical language as to assume a different aspect."[9] Ruskin invested these relatively familiar and thus already somewhat influential ideas with new vitality and urgency; he extended their currency, especially among nonprofessional readers. But it would be dangerous to underestimate the combined influence exerted by a group like the Ecclesiologists, or a church like William Butterfield's All Saints', Margaret Street—during the fifties, according to John Summerson, "the most discussed modern building in England"[10]—or a practical volume like Street's *Brick and Marble Architecture*. It is almost impossible, then, to disentangle the many cross threads of influence in the Gothic Revival.

Most twentieth-century critics attribute enormous authority to Ruskin. Kenneth Clark calls *The Seven Lamps* "a book which was, in the history of taste, perhaps the most influential ever published."[11] Henry-Russell Hitchcock cites Ruskin and Butterfield as pivotal figures in Victorian architecture at mid-century, while after 1855 "a more peculiarly Ruskinian and Italianizing current . . . [became] significant."[12] Other typical encomiums include Alf Bøe's claim that Ruskin's influence "was tremendous throughout the Victorian era . . . [since] he was felt to combine the knowledge of the scholar with the insight of the artist," or John Steegman's assertion that "the immense force of Ruskin's critical authority could have turned the whole of English mid-

8. By Frank Howard, quoted in Joan Evans, *John Ruskin* (London, 1954), p. 156. Ruskin refers in *Stones of Venice I*, app. 17, to Howard's efforts "to pluck all my borrowed feathers off me" (*Works*, 9: 450).

9. Charles Eastlake, *A History of Gothic Revival* (London, 1872), pp. 267-68.

10. John Summerson, "William Butterfield, or The Glory of Ugliness," in *Heavenly Mansions* (New York, 1950), p. 164.

11. Kenneth Clark, *The Gothic Revival* (New York, 1962), p. 192.

12. Henry-Russell Hitchcock, *Early Victorian Architecture*, 2 vols. (New Haven, 1954), 1: 587.

Victorian building in a Classical and Renaissance direction, had it been his wish to do so."[13]

At least one modern critic, however, R. H. Wilenski, is convinced that Ruskin had practically no effect on the Revival. With all the Messianic energy of the debunker, Wilenski maintains that in the fifties, when Ruskin was writing most of his architectural criticism and the Revival was approaching its zenith, the sales of his books were low, he was regarded by architects as a "pretentious and malevolent amateur," and his engagements as a lecturer were always owing to special circumstances or to proposals made by personal friends.[14] Doubtless Ruskin was not the fierce art dictator that some biographers and anthologists have made him, but Wilenski's arguments, though forceful and factual, are not conclusive. If the sales figures for an expensive multivolume set like *The Stones of Venice* were low, for example, the work was nonetheless reviewed in numerous journals—the first step in wrenching ideas from context. *The Seven Lamps, Stones,* and *Lectures on Architecture and Painting* were very widely noticed; for *The Seven Lamps* alone, Cook and Wedderburn list reviews in over two dozen periodicals, including the *Ecclesiologist,* the *Builder,* and the Catholic magazine, the *Rambler.*[15] Thus, regardless of actual sales figures of his books, a considerable number of Victorians, including architects, had been exposed to Ruskin's doctrines—at least as quoted and evaluated, fairly or unfairly, by reviewers. J. D. Jump, directly answering Wilenski's charges, points out that during the 1850s at least one hundred fifty references to Ruskin appeared in three major Victorian weeklies, the *Spectator,* the *Saturday Review,* and the *Athenaeum.* The contexts in which these citations appear suggest, according to Jump, that "the general cultured public evidently knew [Ruskin] well— better, probably, than any other living writer on art—and regarded him with some respect."[16] He was clearly identified by the popular press with the Gothic camp in the 1856-60 "Battle of the Styles" over the new Foreign Office.

Even Wilenski agrees, however, that by the late sixties and seventies, Ruskin's reputation was considerable, evidenced by his selection as first Slade Professor of Art at Oxford (1870, though Wilenski stresses that the appointment resulted mainly from the intervention of Ruskin's friends Henry Acland and H. G. Liddell) and certainly by the gratifying reception of his opening lectures there. Over these years he had accumulated many other distinctions as

13. Alf Bøe, *From Gothic Revival to Functional Form* (Oslo, 1957), p. 102; John Steegman, *Consort of Taste* (London, 1950), p. 101.

14. R. H. Wilenski, "Ruskin's Position in the 'Fifties," an appendix to *John Ruskin, an Introduction to Further Study of His Life and Work* (London, 1933), pp. 369-83 passim.

15. *Works,* 8: xxxvi-xl passim.

16. J. D. Jump, "Ruskin's Reputation in the Eighteen-Fifties: the Evidence of the Three Principal Weeklies," *PMLA* 63 (June 1948): 678, 685.

well, including honorary memberships in the Florentine, Venetian, and
Pennsylvania Academies of Fine Arts, and the Royal Society of Painters in
Water Colours; in 1871 he was elected Lord Rector of Saint Andrews Uni-
versity (but was disqualified by Scottish law because of his Oxford appoint-
ment). It was in this same decade that Ruskin societies began springing up.
The full recognition of his specifically architectural contributions came in
1874, when the Royal Institute of British Architects awarded him its Gold
Medal for distinction in literary writings on architecture. Ruskin refused it,
however, on the grounds that the R.I.B.A. was "assuredly answerable" for
the widespread desecration of precious monuments across Europe, and there-
fore had no business dispensing awards when it should be actively fighting in-
stead of fostering such destruction.[17] For Ruskin saw his defeat from two
perspectives: not only had he failed to cause beautiful architecture to come
into being, but he had been unable to protect the priceless structures that al-
ready existed.

Ruskin was, of course, in many ways uniquely suited to lead the general pub-
lic toward appreciation of and desire for fine architecture. He possessed un-
doubted sensitivity to beauty, but, more important, he was able to translate
his aesthetic judgments into concrete terms intelligible to the layman. Although
he despaired of being known only as a word-painter, his talent for creating in-
tensely visual pictures with words and thus heightening his readers' own per-
ceptions of beauty was a gift of great value. Such an ability was particularly
felicitous in the Victorian period, for as Jerome Hamilton Buckley explains,
this was an age of scrupulous regard for literal detail: "Unfamiliar with the
formal conventions that governed the various aesthetic media, the middle-class
critic would frequently resort to the sanction of verisimilitude. In judging orna-
ment he would attach less value to the pleasing line than to a 'truth to nature'
quite literally conceived."[18] This respect for minutely rendered actuality was
as characteristic of the Victorian artist as of his audience. Sharp physical detail
is found throughout the literature of the period, from the poems of Tennyson
to the novels of George Eliot; meticulous accuracy was a major goal of all the
Victorian painters (even if Ruskin spent a good portion of his life trying to
demonstrate how most of them had failed to achieve it). The Pre-Raphaelites,
especially, made practically a fetish of physical realism. But if Ruskin's own
writings were in the last analysis full of abstractions, his theories were always

17. An excellent account of the episode is John Harris's "The Ruskin Gold Medal
Controversy," *R.I.B.A. Journal* 70 (April 1963): 165-67. Ruskin's letters of refusal to
R.I.B.A. president Sir Gilbert Scott are found in *Works*, 34: 513-16. This incident is dis-
cussed further below.

18. Jerome Hamilton Buckley, *The Victorian Temper* (Cambridge, Mass., 1951), p.
133. Buckley labels this standard "the lamp of literalism."

tied to the concrete: a lily capital in St. Mark's might inspire a dissertation on fidelity to natural form as a criterion of moral excellence—but before Ruskin soared off into the theoretical empyrean, he had given the exact measurements of the pier base and shaft under that capital and perhaps illustrated it in a carefully executed engraving. His architectural criticism was shot through with reassuring actuality; his readers could certainly feel that he had looked almost microscopically at the world he judged.

Further, in an age of moral earnestness, Ruskin's frankly didactic emphasis would be appreciated. For every aesthetic judgment he rendered, he could cite in profusion scriptural passages to support or elucidate his argument. He was never simply speaking of art (which, after all, was perhaps a dangerously frivolous and unedifying subject to some Victorian minds) but of moral values and of God's will. Architecture was much more than assembling piles of stones; it was a means of venerating God and of joyfully accepting His gifts to mankind. Ruskin could eloquently justify good buildings with an authority far beyond the mere fact of their pleasing appearance. And once again we should note the importance of these judgments emanating from an impeccably Protestant source, who could be heeded without fear of Papist taint.

Yet despite these impressive advantages which might have aided him in reforming Victorian taste or at least modifying it for the better, Ruskin almost had to fail, both because of what he emphasized about architecture and, perhaps more important, the manner in which he did so, especially in those lectures of the fifties frankly intended to popularize his doctrines.

Probably the most dangerous of his tactics was his romantically sanctifying individual taste. It can be argued that as a good Evangelical, he was forced to encourage his readers' private judgment;[19] his eagerness to stimulate their powers of observation and to convince them of the importance of architecture may also have caused him to overestimate their capacities. In any event, the emphasis was unfortunate, since it undermined his whole purpose of educating his audience by denying that such training was even necessary. The elementary first volume of *Stones* is supposedly directed to persons of little architectural sophistication, yet Ruskin readily gives full credit to the light that is within them, thereby encouraging the characteristically Victorian tendency toward "doing as one likes," and, with his lofty, apocalyptic tone, legitimizing it: "Then, as regards decoration, I want you only to consult your own natural choice and liking. There is a right and wrong in it; but you will assuredly like the right if you suffer your natural instinct to lead you. Half the evil in this world comes from people not knowing what they do like;—not deliberately setting themselves to find out what they really enjoy."[20] This theme is re-

19. As Hitchcock maintains, in *Early Victorian Architecture*, 1: 600.
20. Ch. 2, par. 16 (*Works*, 9).

peated frequently in his other architectural writings. If readers will only free themselves from their sooty, constricting environment and follow their natural tastes, they will infallibly be led to beauty: "People have no need of teaching if they could only think and speak truth, and ask for what they like and want, and for nothing else"[21] But this is a perilous strategy, to say the least; rather than causing his readers to shed their old ways of thinking about architecture and adopt his, Ruskin could actually reinforce those they already harbored, or foster—with his apparent blessing—more bizarre preferences. Unwittingly, he was endorsing egotism and eccentricity in his audience rather than careful judgment.

The vigorous rhetoric Ruskin used in putting forth his dicta was equally dangerous. His preferences are so glowingly stated and his dislikes buried under so much opprobrium that it is easy to focus on his seemingly absolute judgments and completely overlook the subtle qualifications that usually surround them. (Ruskin rarely goes so far out on a limb as he appears to be doing.) Again, untutored readers, who would be especially prone to ignore such qualifications, could find many pronouncements to interpret quite literally and then remove wholly from context; why should they see the forest when there were so many well-shaped trees? How easy for his public to justify the gaudiest polychromy on reading—"The simple fact is, that the builders of those cathedrals laid upon them the brightest colours they could obtain, and that there is not, as far as I am aware, in Europe, any monument of a truly noble school which has not been either pain ed all over, or vigorously touched with paint, mosaic, and gilding in its prominent parts"—and to overlook entirely Ruskin's notation that he is merely describing the past: "it is not now the question whether our Northern cathedrals are better with colour or without." The same is true of his stress on variety, almost as a good in itself:

> Every successive [Gothic] architect, employed upon a great work, built the pieces he added in his own way, utterly regardless of the style adopted by his predecessors; and if two towers were raised in nominal correspondence at the sides of a cathedral front, one was nearly sure to be different from the other, and in each the style at the top to be different from the style at the bottom.[22]

Yet in this typical instance he goes on to explain, in much milder terms, that monotony or repetition is necessary to accent the more noble beauties of a building.

Furthermore, Ruskin's emphasis on decoration was at once so eloquent and exclusive and his distrust of the sensible principle of ornamented construc-

21. *Seven Lamps*, ch. 4, par. 23 (*Works*, 8).
22. *Stones of Venice II*, ch. 4, par. 43, ch. 6, par. 38 (*Works*, 10).

tion so deep, that his readers could easily envision ornament simply as serving the already standard Victorian purpose of camouflage, an unfortunate notion that in his most exuberant lectures he seemingly promoted; for example:

> Do not be afraid of incongruities—do not think of unities of effect. Introduce your Gothic line by line and stone by stone; never mind mixing it with your present architecture; your existing houses will be none the worse for having little bits of better work fitted to them; build a porch, or point a window, if you can do nothing else; and remember that it is the glory of Gothic architecture that it can do *anything*.[23]

Ruskin's hopes were ironically realized. By making ornament the major source of beauty in a structure and praising so copiously the Venetian "architecture of incrustation" he also encouraged superficial remodelings and the wholesale application of geegaws, while his emphasis on variety might suggest that the more of them one could paste on, the better. Many members of Ruskin's audience were not prepared to appreciate the subtle distinctions and assumptions which actually underlay his directives. The beauties of architecture that he stressed in his dazzling manner were precisely those which could be most easily distorted in the minds of literal or aesthetically untrained readers and abused in practice: his glorification of color could lead to the most garish "streaky bacon"; his love of change, to mere novelty; his emphasis on ornament, to miscellaneously applied Gothic turrets and porches on neoclassic buildings. In the most stunningly eloquent terms, he had first assured his readers that they were full of good taste if they would only follow their natural dictates; then he had given them the materials of beauty, which, injudiciously put to use by persons intent on uncovering their "real" aesthetic sensibilities, could only yield architectural monstrosities. And, unhappily, by heavily interlarding his directives with scripture, he had sanctified them.

That Ruskin offered his public so many appealing examples of beautiful ornament from which to pick and choose indiscriminately was in itself potentially dangerous, but perhaps he might still have succeeded in improving Victorian taste had he not been so enamored of Continental Gothic and so disdainful of every kind of English architecture. Unlike Pugin, who sought to return to England's ancient national style, Ruskin, as we have seen, persistently denied that there was an English style *worth* reviving:

> . . . we have built like frogs and mice since the thirteenth century (except only in our castles). What a contrast between the pitiful little pigeon-holes which stand for doors in the east [sic] front of Salisbury, looking like the entrances to a beehive or a wasp's nest, and the soaring arches and kingly

23. *Lectures on Architecture and Painting*, lec. 2, par. 55 (*Works*, 12).

crowning of the gates of Abbeville, Rouen, and Rheims, or the rock-hewn piers of Chartres, or the dark and vaulted porches and writhed pillars of Verona! Of domestic architecture what need is there to speak? How small, how cramped, how poor, how miserable in its petty neatness is our best! how beneath the mark of attack, and the level of contempt, that which is common with us! What a strange sense of formalised deformity, of shrivelled precision, of starved accuracy, of minute misanthropy have we . . . ![24]

Nor was Ruskin content merely to derogate English Gothic; he fostered active disrespect for it by exhorting his countrymen in essence to repudiate their own artistic heritage and save Continental Europe's instead:

. . . here we are all cawing and crowing, poor little half-fledged daws as we are, about the pretty sticks and wool in our own nests. There's hardly a day passes, when I am at home, but I get a letter from some well-meaning country clergyman, deeply anxious about the state of his parish church, and breaking his heart to get money together that he may hold up some wretched remnant of Tudor tracery . . . when all the while the mightiest piles of religious architecture and sculpture that ever the world saw are being blasted and withered away The country clergyman does not care for *them*—he has a sea-sick imagination that cannot cross channel. What is it to him, if the angels of Assisi fade from its vaults, or the queens and kings of Chartres fall from their pedestals? They are not in his parish.[25]

24. *Seven Lamps*, ch. 3, par. 24 (*Works*, 8). Significantly, his aversion was a cause of hostile criticism from contemporaries; see, for example, the architectural historian E. A. Freeman's letter to the *Morning Chronicle*, November 16, 1854, condemning Ruskin for retailing an apocryphal story about King Alfred's learning to read from a French missal: "Mr. Ruskin's motive is obvious, being of a piece with the anti-national character of his writings in general. . . . [He] evidently knows as little of mediaeval kings as of English architecture" (quoted, *Works*, 12: 492-93n).

25. *A Joy for Ever*, lec. 2, par. 86 (*Works*, 16). Similar passages are found in his 1854 pamphlet, "The Opening of the Crystal Palace" (*Works*, 12). He could be even more adamant in his general rejection of English art, and in the same lecture urges, "You should stand, nationally, at the edge of the Dover cliffs . . . and wave blank cheques in the eyes of the nations on the other side of the sea, freely offered, for such and such canvases of theirs" (par. 89). Cf. the virulent opening of his January 7, 1847, letter to the *Times* on the cleaning of pictures at the National Gallery (*Works*, 12: 398): "I returned to England in the one last trust that, though her National Gallery was an European jest, her art a shadow, and her connoisseurship an hypocrisy, though she neither knew how to cherish nor how to choose, and lay exposed to the cheats of every vendor of old canvass, yet that such good pictures as through chance or oversight might find their way beneath that preposterous portico, and into these melancholy and miserable rooms, were at least to be vindicated thenceforward from the mercy of republican, priest, or painter, safe alike from musketry, monkery, and manipulation."

Then, perversely, he would turn on his countrymen and blame them, as he did the R.I.B.A., for ruining Europe by encouraging restorations; in his 1877 "Letter to Count Zorzi," for instance, disapproving the projected restoration of St. Mark's, he claims, "I must be mute, for shame, knowing as I do that English influence and example are at the root of many of these mischiefs."[26]

Yet at the same time he was arguing that Englishmen could only look abroad for architectural inspiration, he stressed still more emphatically the profoundly deterministic effects of national character and geography on art and architecture. Therefore, according to Ruskin, the English nation is *incapable* of architectural greatness. As early as *The Poetry of Architecture* he asserts: "If the English have no imagination, they should not scorn to be commonplace; or rather they should remember that poverty cannot be disguised by beggarly borrowing, that it may be ennobled by calm independence. Our national architecture never will improve until our population are generally convinced that in this art, as in all others, they cannot seem what they cannot be."[27] He also notes there how the "Simple Blue Country" especially prevalent in England is the only kind of terrain in which the brick he detested is appropriate, being peculiarly English in its effect because of "its perfect air of English respectability": "It is utterly impossible for an edifice altogether of brick to look affected or absurd: it may look rude, it may look vulgar, it may look disgusting, in a wrong place; but it cannot look foolish We may suppose its master a brute, or an ignoramus, but we can never suppose him a coxcomb."[28]

This same kind of national and geographic determinism pervades the Salisbury/St. Mark's passage in *Stones*, and becomes a sardonic *leitmotif* running throughout Ruskin's writings. But it is found most fully—and fatally—developed in *Modern Painters IV* (1856). Though no one has ever written with more terrifying eloquence of the spiritually degrading effects of "Mountain Gloom" on the Alpine peoples than Ruskin does in this volume, yet it is a celebration of the far greater creative benefits of "Mountain Glory" which closes the book. In that memorable final chapter Ruskin explains, with casuistry worthy of Bishop Blougram, how England, being a lowland country, is forever excluded from intellectual, religious, or artistic greatness. Only among mountains, "these great cathedrals of the earth, with their gates of rock, pavements of cloud, choirs of stream and stone, altars of snow, and vaults of purple traversed by

26. Par. 9 (*Works*, 24).
27. Note to par. 225 (*Works*, 1: 168n).
28. Par. 188. Cf. also his claim in the same work that "the mind of the inhabitant of the continent, in general, is capable of deeper and finer sensations than that of the islander ... [and] consequently, in the higher walks of architecture, where the mind is to be impressed or elevated, we never have equalled, and we never shall equal, them" (par. 58).

the continual stars," can true sensitivity to "loveliness of colour, perfectness of form, endlessness of change, [and] wonderfulness of structure" develop: "the superiority of the mountains in all these things is, I repeat, as measurable as the richness of a painted window matched with a white one, or the wealth of a museum compared with that of a simply furnished chamber."[29] The geography, the geology, the climate of England, and, above all, the effect of these on the British as a people, prohibit artistic glory: England cannot be true to herself without being third-rate.

Thus Ruskin argues Victorian aesthetic reform at the same time that his basic premises preclude its achievement. As so often happened, he was trapped by his own contradictions—contradictions which, in this case, cannot even be resolved by taking Ruskin whole. And his audience was likewise trapped. He had created in English readers some sort of appreciation for a variety of architecture expressing a culture foreign to theirs, one that arose from singular geographical and political circumstances that could not be duplicated in England. By contrast, the architecture that had most appropriately expressed England's circumstances he dismissed as atrocious. On the one hand, then, Victorian readers were confronted with what they had been told were the grey, uninspired buildings of their own country; on the other, with a semi-mirage of exquisitely ornamented Venetian palaces and Veronese churches glowing in the bright Southern sun. Ruskin might have told a child that spinach tastes awful and then expected him to eat it. No wonder that by the 1860s, "nearly every cheap villa-builder" between Denmark Hill and Bromley was busy satisfying the demand for Italian Gothic.

Assessing Ruskin's uneven effect on Victorian taste, Eastlake perhaps quite justly observes: "It is probable that Mr. Ruskin's plea for Italian Gothic would have had a more lasting and more favourable influence on our architecture but for the hasty response with which it met and the manner in which it was misinterpreted. Real artists shrank from the adaptation of structural features and the ornamental detail which had been copied *ad nauseum* and had been vulgarised in the copying."[30] For Ruskin's discomfiture was compounded by his failure to respect and encourage those Victorians who were in the best position to apply his doctrines, the professional architects as opposed to the cheap villa-builders. Although he claimed to be their friend, asserting

29. Pt. 5, ch. 20, par. 9 (*Works*, 6). Although little of the chapter is explicitly architectural in content (even if architectural images abound, as above), Ruskin does directly claim that the fonts of all great medieval art were Normandy and Tuscany, but that French art "paused strangely at a certain point, as the Norman hills are truncated at the summits, while the Italian rose steadily to a vertex, as the Carrara hills to their crests" (par. 20, and expanded upon in pars. 21-22).

30. Eastlake, *History of the Gothic Revival*, p. 358.

in *Stones of Venice I* that if only he could gain the public ear and thereby edu-
cate their clients, "porphyry and serpentine would be given to them instead
of limestone and brick; instead of tavern and shop-fronts they would have to
build goodly churches and noble dwelling-houses,"[31] he was vehemently attack-
ing the profession even in his teens in *The Poetry of Architecture:*

> ... though much of the degradation of our present school of architecture
> is owing to the want or the unfitness of patrons, surely it is yet more at-
> tributable to a lamentable deficiency of taste and talent among our archi-
> tects themselves. . . . [Their] energy . . . is expended in raising "neat"
> poor-houses, and "pretty" charity schools; and, if they ever enter upon a
> work of a higher rank, economy is the order of the day: plaster and stucco
> are substituted for granite and marble; rods of splashed iron for columns
> of verd-antique; and in the wild struggle after novelty, the fantastic is
> mistaken for the graceful, the complicated for the imposing, superfluity
> of ornament for beauty, and its total absence for simplicity.[32]

He stepped up these criticisms in *The Seven Lamps* and throughout the fifties
was practically merciless, by his own admission; in 1854 he writes to C. T.
Newton, "you may easily imagine me going on in my old wild way . . . and
writing all I can in defence of Gothic against Greek, and now producing im-
pression enough to provoke the architects, as a body, into very virulent abuse
of me, which is a considerable point gained; at all events it shows I am hurting
them."[33]

The deficiencies of architects that Ruskin first enumerated in his *Poetry
of Architecture* salvo were those he continued to deplore throughout his writ-
ing. The modern architect is a mere frame-maker, an assembler of "miserable
liny skeletons," mired in utilitarian considerations. And, since "the proper
definition of architecture . . . is merely 'the art of designing sculpture for a
particular place, and placing it there on the best principles of building,'" it
therefore "clearly follows, that in modern days we have no *architects.*"[34]
(You cannot sculpt, therefore you do not exist.) But even though totally un-
equipped to design in *any* style, these men are nonetheless ever in pursuit of
a new one, a ridiculously unattainable "Eldorado of imagination" conceived
only as soulless, faddish caricatures of a past they do not respect but neither
will they leave alone—instead they insist on "restoring" ancient buildings.

31. App. 17 (*Works*, 9: 454-55).
32. Par. 7 (*Works*, 1).
33. From Herne Hill, January 20, 1854 (*Works*, 36: 161). Cf. Effie's letter to Rawdon
Brown after Ruskin's 1853 Edinburgh lectures: "His opinions have made a great stir there—
and the Architects have met and entered into a protest against them—which amuses him"
(November 30, 1853, in Mary Lutyens, *Millais and the Ruskins* [London, 1967], p. 114).
34. Addenda to *Lectures on Architecture and Painting*, par. 61 (*Works*, 12).

Then they bicker over such spoils in undignified competitions, thinking mainly of the magnitude of publicity and the size of the commission they can obtain. They are ignobly guilty, moreover, of "lazy compliance with low conditions," "preferring always what is good of a lower order of work or material, to what is bad of a higher."[35] Yet modern architects cannot fulfill even their modestly defined utilitarian aims; Ruskin repeatedly dwells on the flimsiness of Victorian construction: "There is hardly a week passes without some catastrophe brought about by the base principles of modern building: some vaultless floor that drops the staggering crowd through the jagged rents of its rotten timbers; . . . some fungous wall of nascent rottenness that a thunder-shower soaks down with its workmen into a heap of slime and death."[36] Finally, by understating the complexities of architectural structure because he did not understand it well himself, calling its principles so simple that there is no excuse for not being acquainted with them, and thereby promoting the idea of Every Man His Own Architect, Ruskin struck at the very core of the Victorian architects' hard-won professionalism.

Not surprisingly, then, he frequently alludes to the vilification he must endure from them:

> You must not, . . . if you feel doubtful of the truth of what I have said, refer yourselves to some architect of established reputation, and ask him whether I am right or not. . . . I deny his jurisdiction; I refuse his decision. . . . Remember that, however candid a man may be, it is too much to expect of him, when his career in life has been successful, to turn suddenly on the highway, and to declare that all he has learned has been false, and all he has done, worthless; yet nothing less than such a declaration as this must be made by nearly every existing architect, before he admitted the truth of one word that I have said You must be prepared, therefore, to hear my opinions attacked with all the virulence of established interest, and all the pertinacity of confirmed prejudice; you will hear them made the subjects of every species of satire and invective[37]

Even allowing for obvious overstatement, Ruskin's essential point is accurate. Though established designers like Street and Gilbert Scott allude respectfully to Ruskin in their writings and must have culled insights from him, as did certainly a number of younger men, yet it would take an extraordinarily self-effacing architect to embrace unquestioningly all the precepts of one who so vigorously reviled the profession. When Ruskin addressed the R.I.B.A. in 1865 on "The Study of Architecture in Our Schools" and asked pardon "sincerely and in shame" for his "boyish expressions of partial thought, . . . ungraceful

35. *Seven Lamps*, ch. 1, par. 10 (*Works*, 8).
36. *Stones of Venice II*, ch. 7, par. 47 (*Works*, 10).
37. *Lectures on Architecture and Painting*, lec. 2, par. 54 (*Works*, 12).

advocacy of principles which needed no support from [me], and discourteous blame of work of which [I] had never felt the difficulty,"[38] this was merely a fleeting moment of truce. In the ensuing decades, if he wrote less directly on architecture than before, his rejection of its modern practitioners became still more bitter, and by 1877 he could declare to himself in his diary that he was "wholly disgusted by the fools of architects in England."[39]

Ruskin's virulent general condemnation of the Victorian architectural profession was just that, however—virulent and general. He offers almost no creative critical analysis of any designer's abilities or individual buildings; he simply heaps on abuse. For instance, he uses the Renaissance Revival club-house architecture of Pall Mall, including Charles Barry's elegant Reform Club (1837), as a constant source of examples by architects whose rustication looks like "worm casts; nor these with any precision."[40] Barry's Houses of Parliament, on the other hand, despite Pugin's medieval ornamental detail, he did not regard as an impetus to the Gothic Revival but only as "the absurdest and emptiest piece of filigree, . . . eternal foolscap in freestone."[41] Yet its effective massing and functional plan remain an important architectural legacy.

Ruskin was equally uncharitable, however, toward nearly all Gothic Revival buildings. In his preface to *The Two Paths* (1859) he maintains, "so-called Gothic or Romanesque buildings are now rising every day around us, which might be supposed by the public more or less to embody the principles of those styles, but which embody not one of them, nor any shadow or fragment of them; but merely serve to caricature the noble buildings of past ages, and to bring their form into dishonour by leaving out their soul."[42] His references even to the most devout Gothic Revivalists are sparse in number and at best bland in content; he offers few specific reactions, praising in passing if at all. To the Ecclesiologists' favorite, William Butterfield, he makes in the whole of his career just one concretely favorable reference. He endorses the landmark All Saints' Church for being "free from all signs of timidity or incapacity"; in one four-line sentence he singles out its proportions, mouldings, and floral ornament for approval, though he adds in a note, "I do not altogether like the

38. Pars. 1, 2 (*Works*, 19).

39. Venice, March 20, 1877, *The Diaries of John Ruskin*, ed. Joan Evans and J. H. Whitehouse, 3 vols. (Oxford, 1956-59), 3: 943; hereafter cited as *Diaries*. Cf. the distinguished English architectural historian John Summerson's recent claim (*Victorian Architecture: Four Studies in Evaluation* [New York and London, 1970], pp. 17-18): "*never* in English architecture was there present more brilliant talent than between 1840 and 1870; never was there more powerful draftsmanship, more dedicated research, more painstaking inquiry; never was there such industry and application, never such seriousness, such energy."

40. *Stones of Venice I*, ch. 26, par. 5 (*Works*, 9).

41. *Eagle's Nest*, lec. 9, par. 201 (*Works*, 22).

42. *Works*, 16: 252.

arrangements of colour in the brickwork" and opines that much will depend
on the as yet incomplete scheme of frescoes, which he feels the Pre-Raphaelites
should be allowed to undertake.[43] By contrast, he makes an acidic later refer-
ence to the Butterfield-designed St. Augustine's College at Canterbury (1844-
48) for its "multiplication of the stupidest traceries that can be cut cheapest."[44]
I have been unable to locate any mention of another major Butterfield project,
the buildings for Keble College (1867-83), which were going up just opposite
the Oxford Museum during the entire span of Ruskin's first Slade Professor-
ship. It seems impossible, but may actually be typical, that Ruskin could have
ignored this imposing new complex.

Ruskin's allusions to Street are more numerous—about two dozen—but
these are explained largely by the two men having shared an occasional lec-
ture platform, so that most of Ruskin's recorded comments merely constitute
civilized bows to the-distinguished-colleague-beside-me-tonight; others, as we
have already seen, are mainly criticisms not of Street's buildings but his Italian
Gothic scholarship. About Pugin, of course, the most Ruskin could say was,
"no one at present can design a better finial." His remarks on the prolific
Gilbert Scott were likewise few, and generally contained in diaries and letters.
Scott's wholesale involvement in Gothic restorations undoubtedly rendered
him villainous in Ruskin's eyes,[45] while the architect's vicissitudes in defend-
ing the Gothic cause in the Battle of the Styles Ruskin found ludicrous. "Nice
sensible discussions you're having in England there about Gothic and Italian,"
he writes from Thun in 1859 to the critic E. S. Dallas: "And the best of the
jest is that besides nobody knowing which is which, there is not a man living
who can build either. What a goose poor Scott (who will get his liver fit for
pâté de Strasburg with vexation) must be, not to say at once he'll build any-
thing."[46]

"And the best of the jest is that . . . there is not a man living who can build
either." Ruskin simply did not respect the architects of the Gothic Revival; he
scarcely, in fact, noticed them. Significantly, his only truly gracious specific
endorsement of the Revival's leaders comes in his short, apologetic 1865 lec-
ture delivered to the R.I.B.A., and was thus probably dictated as much by
politeness as by conviction; even so, it is hedged with pessimistic qualifications:

43. *Stones of Venice III*, ch. 4, par. 36 (*Works*, 11), and an accompanying note
(196n).

44. An 1880 note to *Seven Lamps*, ch. 3, par. 19 (*Works*, 8: 128n).

45. Ruskin's contempt for Scott's restorations is summed up in an 1876 diary refer-
ence: "Y[esterday] through Selby here to Knaresborough. Selby all be-Scottified" (April
30, 1876, *Diaries*, 3: 896).

46. August 18, 1859 (*Works*, 36: 316-17). Cf. Scott's own assertion in *Personal and
Professional Recollections* (London, 1879) that after he was forced to revise his design,
"My shame and sorrow were for a time extreme, but, to my surprise, the public seemed to
understand my position . . . and even Mr. Ruskin told me that I had done quite right" (p. 201).

Do not let it be thought that I am insensible to the high merits of much of our modern work. It cannot be for a moment supposed that in speaking of the inefficient expression of the doctrines which writers on art have tried to enforce, I was thinking of such Gothic as has been designed and built by Mr. Scott, Mr. Butterfield, Mr. Street, Mr. Waterhouse, Mr. Godwin, or my dead friend, Mr. Woodward. Their work has been original and independent. So far as it is good, it has been founded on principles learned not from books, but by study of the monuments of the great schools But I am entirely assured that those who have done best among us are the least satisfied with what they have done, and will admit a sorrowful concurrence in my belief that the spirit, or rather, I should say, the dispirit, of the age, is heavily against them[47]

For despite his denial, Ruskin *was* "insensible to the high merits of much of our modern work," of which the best Victorian architecture, however garish or eclectic, was not devoid. He was insensible to modern work altogether. Quantitatively, his commentary on major contemporary architects, both in praise and derogation, would constitute but a short chapter in *Stones of Venice I.*

Nine years later, when he rejected the R.I.B.A.'s Gold Medal, he was repudiating the very men he had supposedly encouraged, and an organization that represented the best of the British architectural profession. A stung Gilbert Scott, president of the R.I.B.A. at the time, remarked, on presenting the renounced medal to Street instead, that Ruskin was "a man, whom we might have guessed, had we sufficiently thought of it, would be likely to bring some theory to militate against our intentions, and who has really not done so much to merit this honour as Mr Street; for, after all, an anathematiser of what is bad claims lesser honours than he who practically carries out what is good."[48] It was an appropriate summation of Ruskin's relations with the architects of Victorian England.

It is easy to picture John Ruskin as the beleaguered genius jousting with a society of unregenerate philistines who were maliciously conspiring to frustrate him at every turn, especially once what Eastlake calls "the utterly impracticable nature of his philanthropic intentions" became clear.[49] Undeniably, as Ruskin assured the R.I.B.A., "the spirit, or rather . . . the dispirit, of the age" was heavily against those who sought to create cities of beauty and dignity. Yet

47. "The Study of Architecture in Our Schools," par. 4 (*Works,* 19).
48. November 2, 1874, quoted in Harris, "Ruskin Gold Medal Controversy," p. 167. His refusal was a considerable embarrassment to the R.I.B.A., moreover, which had received its "Royal" designation only eight years earlier, for the Queen herself had already approved their choice before Ruskin (who was abroad) could reply.
49. Eastlake, *History of the Gothic Revival,* p. 272.

much of both the praise and criticism his contemporaries directed at Ruskin's architectural thought was surprisingly just. Few of the points I have developed in these chapters are not randomly made, at least in embryonic form, by Ruskin's Victorian critics, good or bad. Nor were his contemporaries wholly incapable of perceiving that consistent larger views underlay his distracting contradictions and digressions. One of the most balanced appraisals in this sense is that of Eastlake, whose *History* was written when Ruskin was still actively lecturing and the Revival beginning a gradual decline. His evaluation is especially interesting in that, on the one hand, many of Ruskin's assumptions are implicit in Eastlake's own criticism, and, on the other, not only were Eastlake's uncle and aunt Sir Charles and Lady Eastlake among Ruskin's most influential enemies, but the author himself served as secretary of the R.I.B.A. from 1866 to 1877. He is critical of Ruskin's occasional illogic, his lack of formal architectural training, and some of his social views, but he could nonetheless pronounce Ruskin "one of the most accomplished art critics, and perhaps the most eloquent writer on art that England has seen, in this or any other age," concluding:

> Previous apologists for the Revival had relied more or less on ecclesiastical sentiment, on historical interest, or on a vague sense of the picturesque for their plea in its favour. It was reserved for the author of "The Stones of Venice" to strike a chord of human sympathy that vibrated through all hearts, and to advocate, independently of considerations which had hitherto only enlisted the sympathy of a few, those principles of Mediaeval Art whose application should be universal.[50]

A *Pall Mall Gazette* reviewer of Eastlake's volume (surmised by Cook and Wedderburn to be Coventry Patmore) was further prompted to note, "Mr. Ruskin's direct and immediate influences [have] almost always been in the wrong; and his more indirect influences as often in the right." Ruskin quickly pounced on the reviewer (this was the occasion of his claiming to have "*indirectly*" influenced every cheap villa-builder from Denmark Hill to Bromley), who then clarified his meaning in a remarkably shrewd assessment:

> The direct influences, then, which I had principally in my mind were those which had resulted in a preference for Venetian over English Gothic, in the underrating of expressional character in architecture, and the overrating of sculptured ornament, especially of a naturalistic and imitative character, and more generally in an exclusiveness which limited the due influence of some, as I think, noble styles of architecture. By the indirect influences I meant the habit of looking at questions of architectural art in the light of

50. Ibid., pp. 272, 278.

imaginative ideas; the recognition of the vital importance of such questions even in their least important details; and generally an enthusiasm and activity which could have resulted from no less a force than Mr. Ruskin's wondrously suggestive genius.[51]

Not all his critics, of course, were either so sensitive or so gracious; their arguments were often marred by pettiness and vested interest. Even so, they could grasp glimpses of Ruskin's fundamental virtues and faults; this somewhat hysterical but certainly all-inclusive 1874 summation is archetypal:

Acutely learned, subtilely dexterous of diction, magnificently rhetorical, intensely hostile to cants and deceptions of every species, penetrating the very marrow of aesthetic right and wrong by his moral chemistry; as fiercely prophetic of tongue as a maddened seer, implacable as a savage in his hates, yet tender-hearted and sympathetic as a maiden in his loves; illogical, . . . having no faculty of generalisation, always seeing things apart in minutest detail and from closest vision, the natural sight running to one extreme of material observation, and his imaginative sight to its opposite; as bitterly ingenious in fault-finding as eloquently extravagant in laudation and conclusion; the most sincerely impressible of theorists and fervid demolisher of false gods, with the loftiest ideas on man's duty and his own pet idealisms; vehemently publishing his intuitions and observations as immutable principles of life; rejoicing, like Job's war-horse in the battle, but easily made despondent; with an unbalanced brain, running to fine points and bent on Ruskinising the world—the while most inconsistently sad and angry because of failure—despite himself, John Ruskin has done much good work for us all in his adopted cause. He has stirred anew the languid currents of aesthetic thought both in England and America; incited a deeper interest and investigation into the motives as well as the methods of Art-education; suggested beautiful and noble ideas; disclosed fresh sources of enjoyment and inspiration; helped to reconcile Art with Nature, and put us in better fellowship with both; and, best of all, relentlessly exposed and denounced evils, driving to bay the mean parasites that habitually infest all good work and sound aims. In short, notwithstanding his many entanglements of thought, eccentricities of presentment, incapacity of putting objects and ideas relatively right, or of accurately measuring the differences between the little and the great, of seeing the world as it actually exists, of curbing his own egoism, unphilosophical turmoil of soul, foregone prejudices, constitutional irritability, restraining his passion for Utopias, and of making intellectual allowance for his own defective physical fibre—notwithstanding all these drawbacks, Ruskin has been a profitable as well as fascinating writer for the general reader.[52]

51. March 20, 1872, quoted in *Works*, 10: 458n.

52. J. J. Jarves, "John Ruskin, the Art-Seer," *The Art Journal* 13: 5, quoted in John Gloag, *Victorian Taste* (London, 1962), p. 84.

But the sneering condescension and sly *ad hominem* thrusts frequently accompanying such insights were, unfortunately, part of the costly price Ruskin had to pay for his greatness, for exposing himself and his passionate preferences so thoroughly in his writings. Henry James's famous remark after an evening at Denmark Hill that Ruskin "has the beauties of his defects" was essentially true, and accounts in great measure for his failures as an architectural reformer. The very characteristics that were Ruskin's strength were inextricably entangled with his weaknesses, and were sometimes even synonymous with them. Whether he could have revolutionized Victorian taste is debatable, but he might perhaps have channeled it into more appropriate directions. His own hatred of Victorian industrialism was so great that he most likely was incapable of guiding his countrymen toward the sensible but aesthetic use of new materials. He might, however, have moderated the trend toward increasingly riotous eclecticism, and also have provided guidelines and correctives for the confused tastes of the growing middle and upper middle classes. But he made it too easy for people to attend to the letter rather than the spirit of his writing, and he erred in holding up as exemplary a form of architecture inappropriate to British climate, character, and needs. Sadly enough, he rather deserved the "streaky bacon" that he got.

This coalescence of personal misemphasis and cultural conflict that accounted for Ruskin's defeat is emblematized almost to the point of parody in that Compleat Gothic Revival Project with which he will forever be identified, the Oxford Museum. Indeed, his involvement with the building has come over the years to assume an aspect of myth or legend; a number of scholars suppose that his direct influence was immense and that the project's collapse was "his personal tragedy,"[53] while in the popular mind, he all but raised the edifice single-handedly. The current Oxford booklet in the ubiquitous Pitkin "Pride of Britain" souvenir series asserts, for instance, "the University Museum must be regarded as the embodiment of all that John Ruskin most admired, for it was the Gothic flower of his genius."[54] Kenneth Clark recalls that when he was an Oxford student in 1927, Ruskin was "universally believed" to have been responsible as well for Butterfield's Keble College across the way

> . . . and that it was the ugliest building in the world. . . . Ruskin . . . was believed also to have designed Balliol Chapel and Meadow Buildings at Christ Church; and this belief was held not only by the young, but by men whose fathers must have been in Oxford when those buildings were constructed. One eminent historian . . . went so far as to call me a liar

53. Paul Frankl, *The Gothic, Literary Sources and Interpretations through Eight Centuries* (Princeton, 1960), p. 562.
 54. 1968 edition, p. 7.

at a public meeting because I denied Ruskin's part in these buildings.[55]

Thus the documentation of Ruskin's role in this undertaking is worth examining in some detail. For just as a close analysis of his remarks on Gothic vaulting has demonstrated how unexpectedly limited was his conception of the Gothic style, so a careful evaluation of the objective evidence for his leadership of the museum project suggests that his involvement was actually surprisingly narrow and ambivalent—which in turn provides a crucial perspective on his identification with the entire Gothic Revival.

The ill-fated project was from the start encumbered by confusion and controversy. Its very purpose was suspect: the overdue recognition of scientific study as an honorable part of the Oxford curriculum, after years of dedicated lobbying by Ruskin's dear friend and Christ Church classmate, Dr. Henry Acland. Although in his account of the museum's beginnings, Acland is quick to declare that the controversy over the building was not, as "often supposed . . . chiefly owing to a dominant theological party,"[56] it is obvious that the official acknowledgment of scientific study in an age when science was rapidly destroying traditional grounds for religious belief constituted a threat to the long-established classical and theological disciplines of the university.

But eventually a fund was started and land purchased; in April 1854 a design competition opened. We have noted the controversy that invariably plagued Victorian architectural competitions; the Oxford Museum contest ran true to form. Part of the furor grew from the basically untenable requirements of the project in the first place: the structure was to be two stories in the form of three sides of a quadrangle (to allow later expansion), glassed over, but costing no more than thirty thousand pounds. Acland himself recollects, "It was quite understood that no building could be satisfactorily completed for the proposed amount, and provide what the several Professors even at that time required."[57] The remaining contention was a product of Victorian architectural eclecticism, which in the midfifties was approaching the unruly stage. The *Builder*'s ironic classifications for the thirty-odd design entries amusingly indicate the chaotic state of contemporary taste: "Gothic of all kind"; "Greek, more or less German in treatment"; "Roman, more or less after Wren with pedimented porticos, columns, etc."; "Italian, more or less Barryan or Palatial"; "Elizabethan"; "The Order of Confusion"; "Original,

55. Clark, *Gothic Revival*, pp. 2-3.

56. Henry Acland's preface to the enlarged 1893 edition of *The Oxford Museum* (London) is reprinted in *Works*, 16: 235. All references to this preface will be to *Works*.

57. *Works*, 16: 236. An understatement! According to H. M. and K. D. Vernon's *History of the Oxford Museum* (Oxford, 1909), the original contract with the builder, accepted in May 1855, excluded such items as ventilation, lighting, heating, water supply, enclosing and laying out of the grounds, paving of the central court, oak doors and floors for the main rooms, painting, varnishing, and glazing (pp. 59, 68).

Crystal Palace work tacked on to various regular book details"; and "Abomina-
tions."[58] The final heat of the competition was actually a precursor of the
sensational 1857 Foreign Office contest, as Palladian and Gothic designs were
the alternatives. After much last-minute electioneering, the Goths barely pre-
vailed by a Convocation vote of 68-64.[59] But neither design could have been
built for thirty thousand pounds.

From the time the cornerstone was laid in June 1855, therefore, the project
was plagued by skimpy funds and the academic bureaucracy that dispensed
them: "Every grant was carried in Convocation by a narrow majority," ex-
plains Acland. "That for the gas-pipes for lighting the Court, for instance, was
carried. That for the burners was lost by two." Indeed, "economy, not com-
pleteness, was practically the first object with even the majority," while the
scientists themselves were concerned "that the building should be rapidly com-
pleted, and fitted for scientific work in the most practical manner."[60] The
contract had been let in 1855 for 29,041 pounds; by 1860 over sixty thousand
pounds had been spent, yet the building was still unfinished.[61] In the mean-
time, the free-spirited Irish sculptor James O'Shea, whose work was to give
the museum its authenticity, had scandalized Oxford when, after being suc-
cessively criticized for carving monkeys, then cats around the museum's win-
dows, impatiently announced that he was now chiseling "Parrhots and Owwls!
Parrhots and Owwls! Members of Convocation," and was promptly shipped
back to Ireland.[62] Finally funds were cut off altogether.

The nature of Ruskin's participation in the unfortunate project, however,
is by no means clear. Although he is popularly thought to have advised Ben-
jamin Woodward on the design, then campaigned earnestly for its adoption,
then supervised as well as taken part in the construction, a mere glance at his
varied activities during the years 1854-60 belies intensive participation. He
made trips abroad, lasting from four to six months each, in 1854, 1856, 1858,
1859, and 1860, and toured Scotland from mid-July to October 1857. During
these same years, he published *Giotto and his Works in Padua, Harbours of
England, Academy Notes, Elements of Drawing, Elements of Perspective,* and
the last three volumes of *Modern Painters;* he collected some of the numerous
lectures given over this period in *The Political Economy of Art* and *The Two
Paths.* He also taught regularly at the Workingmen's College in London from

58. Quoted in Peter Ferriday, "The Oxford Museum," *Architectural Review* 132
(December 1962): 411.

59. From the Cook and Wedderburn account in *Works,* 16: xli-liii. The history of the
project will be drawn from this version, unless otherwise noted.

60. Acland's 1893 preface to *Oxford Museum* (*Works,* 16: 235-36).

61. Ferriday, "Oxford Museum," p. 412.

62. Acland's original amusing account will be found in Appendix 2 to the 1893 edi-
tion of *The Oxford Museum.* Ruskin himself refers briefly to the incident in *Aratra
Pentelici,* lec. 4, par. 134 (*Works,* 20).

1854 to 1858, and again in spring 1860. In 1857-58 he was at work in the National Gallery, laboriously sorting out the almost twenty thousand items in the Turner Bequest, the wearing details and staggering statistics of which he recounts in his preface to *Modern Painters V,* concluding: "I have never in my life felt so much exhausted as when I locked the last box, and gave the keys to Mr. Wornum, in May, 1858."[63] Nor did he meet the museum's chief designer, Woodward, until after the architect's basic plan was submitted; moreover, the competition opened in April 1854, the design was chosen in early December, and Ruskin was abroad from May to October. It is apparent, then, that even for a man of Ruskin's prodigious energy and dedication, prolonged direct involvement with the museum would have been impossible.[64]

The project was nevertheless a focal point for a cluster of Ruskinian dicta. An affecting earnestness of purpose is seen in Acland's support for a Gothic design and in his idealistic belief that the studies to be conducted in such a building would illuminate "Nature in its Unity, and . . . in its relation to her Maker and to Man"—promote, in other words, that sense of human wholeness so vital to Ruskin.[65] The assumption that Gothic, especially in its Italian forms, was perfectly adaptable to modern needs, and that the museum would be an effective demonstration of this flexibility, underlay the enthusiasms of Acland and of the architects themselves. The project was also viewed as the first step in the revival of architectural craftsmanship, both through the creative latitude allowed to James O'Shea and his compatriots, and in the promised participation of Pre-Raphaelite painters.[66] Ruskin himself reported to an 1857 Manchester audience that giving the workmen a variety of stimulating inventive assignments had even produced economic benefits: "Sir Thomas Deane, the architect of the new Museum at Oxford, told me, as I passed through Oxford on my way here, that he found that, owing to this cause alone, capitals of various design could be executed cheaper than capitals of similar design . . . by about 30 per cent."[67] Finally, Acland's insistence on the sincerity and probity of the workmen recalls "The Nature of Gothic," and echoes the assumption that good men build good buildings: "But with the laying the foundation-stone we also erected a humble mess-room by its side, where the workmen . . . have begun each day with simple prayers from willing hearts,

63. Par. 3 (*Works,* 7).

64. These remarks are based on Ruskin's own accounts of his activities during this period in *Praeterita,* vol. 3, ch. 1, pars. 10-13 (*Works,* 35) and the preface to *Modern Painters V* (*Works,* 7), and on Cook and Wedderburn's year-by-year tabulation in the index volume of *Works* (39: 470-71).

65. Acland's 1893 preface to *Oxford Museum* (*Works,* 16: 236-37).

66. There seems to be no evidence that the Pre-Raphaelite Brotherhood did any designing for the museum; they are famous, though, for their ephemeral decoration of Woodward's Oxford Union.

67. *A Joy for Ever,* lec. 1, par. 32 (*Works,* 16).

have had various volumes placed for their use, and have received frequent in-
struction"[68]

Yet Ruskin's enthusiasm for the scheme seems in general to have been
curiously tepid, especially at first. The earliest reaction Cook and Wedderburn
record is hardly an unqualified endorsement of the plan, which he describes as
"though by no means a first-rate design, yet quite as good as is likely to be got
in these days, and on the whole good."[69] He supposedly warmed to the project,
however, as plans progressed, and after the positive Convocation vote, he ideal-
istically wrote Acland, "The Museum . . . will be the root of as much good to
others as I suppose it is rational for any single living soul to hope to do in its
earth-time."[70] And he was soon enthusiastically promising him, "I hope to be
able to get Millais and Rossetti to design flower and beast borders—crocodiles
and various vermin—such as you are particularly fond of . . . and we will carve
them and inlay them with Cornish serpentine all about your windows. I will
pay for a good deal myself, and I doubt not to find funds. *Such* capitals as we
will have!"[71] Even here, however, allowance must be made for friendship; un-
doubtedly each man felt deeply obligated to encourage the other in a potential-
ly troubled project meaning much to their respective goals of the advancement
of science and of architecture, and to buoy up their mutual convictions with
sanguine assurances. An 1855 letter to Dr. Furnivall, with its rather clear make-
do implication, is perhaps a more accurate gauge of Ruskin's real hopes and
fears for the undertaking: "You will hear at Cambridge, very probably, that
my father don't sell sherry, but only Mr. Domecq, who has the vineyards.
However, if you want sherry you must go to my father. If I want Gothic, I
must for the present go to Mr. Woodward, or Mr. Scott."[72]

As for Ruskin's direct involvement in the actual building of the museum,
even Cook and Wedderburn, though they claim he "was in constant communi-
cation with Woodward, and interested himself in every detail,"[73] offer scant
factual corroboration. Records exist that he gave three hundred pounds toward
the decoration of the windows, and that his father donated a statue of Hip-
pocrates for the interior; on April 18, 1856, Ruskin addressed the workmen
employed on the museum with a kind of shorthand version of "The Nature of

68. Acland and Ruskin, *Oxford Museum* (1893), p. 42.
69. *Works,* 16: xliii. No date or other documentation is given, but the context sug-
gests that it is a letter to Acland sometime in midfall of 1854; the same material is in J. B.
Atlay's *Sir Henry Wentworth Acland, Bart., a Memoir* (London, 1903), p. 214. Cook and
Wedderburn depend heavily on Atlay's version.
70. December 12, 1854; quoted from Atlay's *Memoir* in *Works,* 16: xliii.
71. Quoted without date from Atlay's *Memoir* in *Works,* 16: xlv.
72. Quoted, with only the 1855 postmark noted, in *Works,* 16: xlvin.
73. Ibid., p. xlv. Cf. Acland, who recalled in 1893, "As I look back over the thirty-
nine years, I feel that Ruskin, Woodward, and Deane were the centre of all" (*Works,* 16:
237), but he too is discouragingly unspecific about Ruskin's contribution.

Gothic."[74] We also know that he made a number of decorative designs for the building;[75] one for a window was actually executed, according to Ruskin himself in *Sesame and Lilies* and corroborated by Acland in an appendix to the *Oxford Museum* 1893 edition. But no one can tell which window it was.[76] The claim that he also designed six iron brackets for the roof rests, as Cook and Wedderburn themselves point out, on a single note in a secondary source.[77] In any case, we should recall Ruskin's own late confession that "I never could have built or carved anything, because I was without power of design"

He nonetheless apparently did communicate ideas on decoration to Woodward for execution and also judged among some of the architect's own designs. In the previously quoted 1855 letter to Furnivall he declares: "Sir Charles [*sic*] Deane and Mr. Woodward are, I believe, partners. Mr. Woodward is, as far as I am concerned, the acting man. Who designs the things I neither know nor care. I see Woodward, and tell him what I want—and if Sir Charles Deane does it, I am much obliged to Sir Charles Deane."[78] To Jane Carlyle he writes in the same year, "I have also designed and drawn a window for the Museum at Oxford; and have every now and then had to look over a parcel of five or six new designs for fronts or backs to the said Museum."[79] (It is entirely typical that the few concrete references we have to his actual participation should bear on the planes and details I have noted as his emphases, and that he should be offering advice *after* the basic plan and structure of the museum were determined.)

One of the most persistent tales of his direct involvement regards his bricklaying activity. Supposedly, he built with his own hands one of the brick columns, which later had to be torn down and reconstructed by less distinguished masons. It makes a good story and is quite consistent with Ruskin's lifelong "stern habit of doing the thing with my own hands till I know its dif-

74. Reprinted from *Jackson's Oxford Journal* in *Works*, 16: 431-36. Ruskin's and his father's contributions are listed in the 1859 and 1893 editions of *The Oxford Museum*.

75. Two of these drawings are reproduced in *Works*, 16—Plate 11, facing p. 230, of a rather plain Italianate window detail with a very lifelike reptile working its way up one side, and Plate 12, facing p. 234, of a small Venetian-type balcony, boxy and planar with a protective double-gabled overhang.

76. Cook and Wedderburn surmise that "in all probability it is the one on the first floor next, on the spectator's left, to the centre of the building," but they offer no grounds for this conjecture (*Works*, 16: xlvin). In *Sesame and Lilies*, Ruskin only refers to it as "the first window of the facade of the building" (lec. 3, par. 103 [*Works*, 18]).

77. Thomas J. Wise's and James P. Smart's *Bibliography of Ruskin*, 2 vols. (London, 1893), 1: 94, cited in *Works*, 16: xlvin.

78. *Works*, 16: xlv-xlvin. Cf. too his reference in the Manchester lecture cited above to Sir "Thomas" Deane ("Charles" here is a mistake) as "the architect of the new Museum at Oxford." For having supposedly been so deeply involved in the project, Ruskin seems awfully confused as to who the chief designer of the building really was.

79. Quoted without further date in *Works*, 5: xlix-l.

ficulty."[80] But it is also very possibly apocryphal. The Cook and Wedderburn account, perpetuated by Clark and Joan Evans, comes at second hand from J. B. Atlay in his *Sir Henry Wentworth Acland, Bart.: a Memoir* (1903), who asserts of the column in question, "Acland used to show it with great pride to visitors at the Museum."[81] But in neither the 1859 nor the 1893 versions of *The Oxford Museum* does Acland mention any such effort, though he notes Ruskin's window. Nor does Ruskin himself anywhere directly refer to it—and he could be embarrassingly frank about his failures. On July 3, 1857, however, he writes from Oxford to Mrs. John Simon: "then [I] . . . dine with my friend Dr. Acland, and after dinner take a lesson in bricklaying. He is building a study; and I built a great bit yesterday, which the bricklayer my tutor in a most provoking manner pulled all down again. But this bit I have done to-day is to stand."[82] Perhaps this is the brickwork of which Acland was so proud, and time, place, and opportunity coincided so felicitously that the mists of legend ultimately enveloped mere fact.

Yet another source of confusion is Ruskin's reaction to the museum's glass and iron roof. Robert Furneaux Jordan claims that the roof "was anathema to Ruskin and caused his resignation as consultant" to the project.[83] Again, there seems to be little evidence one way or the other (and none for an official status of consultant which Ruskin could renounce). In his letters published as part of *The Oxford Museum* (to be discussed below) Ruskin refers briefly to the difficulty of designing a complex structure "at a time when the practice of architecture has been somewhat confused by the inventions of modern science, and is hardly yet organized completely with respect to the new means at its disposal";[84] he later singles out one of Thomas Skidmore's spandrels as "not . . . an absolutely good design." But his criticism of the spandrel pattern bears on its insufficient expression of the vital forms in the leaves and nuts depicted, not on the defects of iron as a material.[85] Years later, in his *Lectures on Art* (1870), he perhaps alludes to the museum when he tells his audience, "you cannot but have noticed here in Oxford . . . that our modern architects never seem to know what to do with their roofs. Be assured, until the roofs are right, nothing else will be Never build them of iron, but only of wood or stone"[86] At the time of the project, nevertheless, Ruskin apparently was uncharacteristically reticent.

80. *Praeterita*, vol. 2, ch. 10, par. 197 (*Works*, 35).
81. P. 223, and quoted in *Works*, 16: xlvi. Atlay offers no documentation or additional details.
82. *Works*, 36: 263.
83. Robert Furneaux Jordan, *Victorian Architecture* (Harmondsworth, 1966), p. 106.
84. First Letter, par. 3 (*Works*, 16). The two letters published as part of *The Oxford Museum* (1859, 1893) are reprinted in *Works*, from which all references will be drawn.
85. Second Letter, par. 27 (*Works*, 16).
86. Lec. 4, par. 122 (*Works*, 20).

Next we come to the issue of Ruskin's direct superintendence of the building. Nikolaus Pevsner, for instance, reports that the museum progressed "under the immediate supervision of Ruskin and with his full blessing";[87] Jordan calls him a consultant. According to Cook and Wedderburn, when Woodward fell terminally ill with consumption in 1859-60, "Ruskin assumed much of the responsibility for the decorations." This claim is based on Ruskin's letter to Miss Ellen Heaton of January 27, 1860: "Cheque received with best thanks. You will be glad to know that it will enable another window to be carved in the front of the building, under my immediate direction, for the architect, Mr. Woodward, is ill and had to go to Madeira for the winter, and I was obliged to take the conduct of the decoration while he was away."[88] But at this late date there was little to supervise; the project was practically moribund, having already cost double the budgeted amount.

The most lasting evidence of his involvement is the two letters he wrote to Henry Acland on May 25, 1858, and January 20, 1859, about the project, which were then published as part of *The Oxford Museum* (1859; enlarged second edition, 1893), a volume designed to inspire public support for the proper completion of the structure. In them, however, Ruskin assumes an oddly detached tone, and in a passage from the second letter almost appears to deny any previous very active participation, for he assures Acland: "Yet I must write, if only to ask that I may be in some way associated with you in what you are now doing to bring the Museum more definitely before the public mind—that I may be associated at least in the expression of my deep sense of the noble purpose of the building—of the noble sincerity of effort in its architect"[89] Although he obviously refers here to the immediate effort of publishing *The Oxford Museum*, he nonetheless seems to imply that he has not been sufficiently involved or at least identified with the building heretofore. On the other hand, perhaps he would want to convey this idea as a means of obscuring his previous tracks because of the prospect of imminent failure; but this kind of ruse would not be quite fair to Acland, whose Gothic propagandizing was surely intended as a tribute and encouragement to his friend John Ruskin.[90]

At any rate, both letters, though they represent Ruskin's clearest assumption of the role of Gothic Revival propagandist, are marked by a tone of sup-

87. Nikolaus Pevsner, *Pioneers of Modern Design*, Pelican ed. (Harmondsworth, 1960), p. 135.

88. *Works*, 16: xlvi, xlvin.

89. Par. 12 (*Works*, 16).

90. But see Ruskin's opening comment to him in the First Letter (par. 2 [*Works*, 16]), "I am quite sure that when you first used your influence to advocate the claims of a Gothic design, you did so under the conviction," etc., as if the choice of Gothic were entirely Acland's.

pressed disenchantment and expressed qualification. The first letter (written, typically, from abroad) opens on a somber note: *"Entirely* satisfactory very few issues are, or can be; and when the enterprise . . . involves the development of many new and progressive principles, we must always be prepared for a due measure of disappointment"[91] Even so, this letter also contains one of Ruskin's most positive paeans to Gothic's appropriateness for modern needs, because of "that perfect and unlimited flexibility which enable[s] the architect to provide all that [is] required, in the simplest and most convenient way; and to give you the best . . . which [can] be provided with the sum of money at his disposal":

> So far as the architect has failed in doing this; so far as you find yourself, with the other professors, in anywise inconvenienced by forms of architecture; so far as pillars or piers come in your way, when you have to point, or vaults in the way of your voice, when you have to speak, or mullions in the way of your light, when you want to see;—just so far the architect has failed in expressing his own principles, or those of pure Gothic art.[92]

But for his most cogent proof of Gothic flexibility he manages to fasten on the silliest adaptation in the whole structure—the chemistry laboratory, a tacked-on parody of the polygonal, lofty-vaulted Abbot's Kitchen at Glastonbury—and then obscures any functional justification in a miasma of purple prose:

> No other architecture . . . could have otherwise than absurdly and fantastically yielded its bed to the crucible, and its blast to the furnace; but these old vaultings and strong buttresses—ready always to do service to man, whatever his bidding—to shake the waves of war back from his seats of rock, or prolong, through faint twilights of sanctuary, the sighs of his superstition—he had but to ask it of them, and they entered at once into . . . the sternest and clearest offices in the service of science.[93]

Moreover, as demonstrated especially in chapter 3, for Ruskin the satisfaction of mere functional requirements bears little relation to architectural nobleness: "For it may, perhaps, be alleged by the advocates of retrenchment, that so long as the building is fit for its uses . . . economy in treatment of external feature is perfectly allowable, and will in nowise diminish the serviceableness of the building Yet there are other points to be considered." "Pieces of princely

91. Par. 1.
92. Pars. 2-3.
93. Second Letter, par. 14. Nonetheless, so impractical did the laboratory's dim light, drafty vault, and dust-catching surfaces prove that in 1902 the "Kitchen" was cut in half by a dividing floor (Vernon and Vernon, *History of the Oxford Museum*, pp. 92-93).

costliness" should be allowed to "mingle among the simplicities or severities of the student's life" so as to inculcate respect for learning and to encourage the development of "that sense of the value of delicacy and accuracy which is the first condition of advance" in knowledge.[94] In great architecture, the Lamp of Sacrifice must shine forth.

Hence, Ruskin's two letters deal preponderantly not with Gothic flexibility but with the nature of Gothic ornament. The first enunciates three basic principles of Gothic decoration (expressed mostly in social terms, with particular emphasis on the creative freedom of the workman), while the second treats their proper application to the finishing of the museum. Even here, however, Ruskin hedges; probably the most convincing symptom of his misgivings about the undertaking is his desire to keep the museum's coloring simple, an ascetic renunciation of one of the qualities of architecture he treasured most: "I would not . . . endeavour to carry out such decoration at present, in any elaborate degree, in the interior of the Museum. Leave it for future thought; above all, try no experiments."[95] And although he expresses greater optimism regarding the sculptural program, he still carefully limits his praise:

> Your Museum at Oxford is literally the first building raised in England since the close of the fifteenth century, which has fearlessly put to new trial this old faith in nature, and in the genius of the unassisted workman, who gathered out of nature the materials he needed. I am entirely glad, therefore, that you have decided on engraving for publication one of O'Shea's capitals; it will be a complete type of the whole work, in its inner meaning, and far better to show one of them in its completeness, than to give any reduced sketch of the building. Nevertheless, beautiful as that capital is, . . . it is not yet perfect Gothic sculpture; and it might give rise to dangerous error, if the admiration given to these carvings were unqualified.[96]

There is a certain halfheartedness to these letters; commenting on them to his father shortly after finishing the second, he remarks, "The real fact was, I couldn't make my mind up what was the fault in the Museum."[97] But that

94. Second Letter, par. 19.
95. Ibid., par. 18. This was undoubtedly written in reaction to the "experiments" that had been completed; writing to his father from Oxford two weeks earlier he reports, "I've been over the Museum carefully. All the practical part, excellent. All the decorative in colour, vile" (January 6, 1859, *Works*, 16: liin).
96. Second Letter, par. 24. It is thoroughly characteristic that Ruskin should consider a single engraving of an O'Shea capital "a complete type of the whole work," much preferable as illustration to "any reduced sketch of the building" (see chapter 2). But the sculptor in whom Ruskin was placing this hope was, of course, dismissed from the project.
97. From Northampton, February 18, 1859 (*Works*, 16: lxii).

something *was* the matter Ruskin must never have doubted. The theme that runs through both letters, then, is that at best the museum is only the first halting step in a great journey toward an architectural millennium; its historic possibilities rather than any inherent beauty are finally the basis for Ruskin's endorsement:

> . . . although I doubt not that lovelier and juster expressions of the Gothic principle will be ultimately aimed at by us, than any which are possible in the Oxford Museum, its builders will never lose their claim to our chief gratitude, as the first guides in a right direction; and the building itself— the first exponent of the recovered truth—will only be the more venerated the more it is excelled.[98]

Unfortunately, the Oxford Museum was deprived even of this humble but dignified fate. Further funds were not forthcoming; *The Oxford Museum* as a propaganda piece, coming at the end of a decade of lobbying, bickering, and exceeded budgets, failed. As if in sad confirmation of the lost potential of the project, Woodward, the building's architect, died in 1861 at the premature age of forty-six. On the exterior only six and one-half of the twenty-four windows were carved; on the interior, three-fourths of the four hundred capitals remained unadorned. Nor was the "bold entrance-porch" added, which Ruskin envisioned—leaving himself a big out—as "becom[ing] the crowning beauty of the building, . . . mak[ing] all the difference between its being only a satisfactory and meritorious work, or a most lovely and impressive one."[99] His 1859 verdict on the museum still holds: "As the building stands at present, there is a discouraging aspect of parsimony about it. One sees that the architect has done the utmost he could with the means at his disposal, and that just at the point of reaching what was right, he has been stopped for want of funds. This is visible in almost every stone of the edifice."[100]

Interestingly, Ruskin's connection with the building in later years was unquestionably direct; many of his Slade lectures were delivered there, and in one of these, sixth of the series *Readings in "Modern Painters"* (1877), he directly discusses "a very shabby bit of work of mine—this museum, namely— for the existence of which in such form, or at least in such manner, I am virtually answerable and will answer, so far as either my old friend and scholar, Mr. Woodward, or I myself, had our way with it, or were permitted by fate to follow our way through. I little thought at this hour to see it still unfinished"[101] He goes on to explain that the restrictions under which the project

98. Second Letter, par. 28.

99. First Letter, pars. 9, 10. He explains that "the blankness of the facade [has] been, to my mind, from the first, a serious fault in the design."

100. Second Letter, par. 19.

101. Ruskin's notes for this lecture are given in an appendix to *Works,* 22: 523-25, from which this and the following quotations are taken, passim.

was launched were as inevitable as they were fatal, so that the museum neces-
sarily "failed, and failed signally, of being what I hoped." He next assures his
audience that when in his architectural writings he taught that methods and
materials "should be true and truly confessed," he "never meant that a hand-
some building could be built of common brickbats," nor that when he argued
for the creative freedom of the workman he implied "that you could secure a
great national monument of art by letting loose the first lively Irishman you
could get hold of to do what he liked in it." (He grants that O'Shea was a
genius, but "I could not teach him") Then, to show his students "what I
did mean, and do mean" he produces drawings of the gorgeously unattainable
St. Mark's and other medieval Venetian structures, with their materials of
"exquisitest marble and precious porphyry and gold." Yet despite his willing-
ness to accept responsibility for the building's defects, he is remarkably vague
about his direct involvement, concentrating instead on the indirect influence
he exerted through his books. Such plaints are of a piece, however, with the
breast-beating blame he assumed during this stage in his life for all the excesses
of the Gothic Revival, and can probably be judged best from that perspective.

The Slade lectures, particularly his later ones, abound too with virulent
asides on the pernicious narrowness of modern science: "You are to study
men; not lice nor entozoa. And you are to study the souls of men in their
bodies, not their bodies only."[102] When, on the verge of total mental break-
down, he resigned his second Slade Professorship in March 1885, his publicly
expressed reason was his deep aversion to vivisection as a method of scientific
experiment; ironically, the university's approval of a five-hundred-pound grant
for such research had ignited a bitter controversy of the same kind caused by
the original recognition of scientific study through the funding of the museum,
and this time Ruskin stood with the antiscience forces. The building envisioned
as a monument to the study of human wholeness and the unity of nature had
become to him instead a symbol for the ruthless violation of life. After De-
cember 1884, he never again returned to his university.[103]

102. *Val d'Arno*, lec. 1, par. 16 (*Works*, 23). Such admonitions had been heard with-
in the museum in its earliest days, however; the structure was also the site in 1860 of a
famous Victorian encounter, the Huxley-Wilberforce debate, in which T. H. Huxley was
supposed to have said that he would rather be descended from an ape than a bishop
(Ferriday, "Oxford Museum," p. 416).

103. Acland's preface to the 1893 edition of *The Oxford Museum* contains a full ac-
count of the circumstances of Ruskin's resignation; see also the Cook and Wedderburn
version in *Works*, 33: liv-lv. Although Ruskin's increasing mental instability made his
retirement essential, his averred motive was perfectly consistent with views expressed as
early as 1846 in *Modern Painters II* (pt. 3, sec. 1, ch. 12, pars. 6-7 [*Works*, 4]). Ruskin's
editor and biographer, E. T. Cook, giving his personal recollections of the *Readings in
"Modern Painters"* lectures, paraphrases Ruskin as stating in them, "The mere sight of
this museum . . . with its specimens of death and disease, instead of life and health,
paralyzes me in all artistic work" (*Studies in Ruskin* [London, 1890], p. 206).

The museum's status today is fraught with ironic Ruskinian symbolism. When I first visited it in June 1968, the exterior was in the process of being cleaned; the "picturesque or extraneous sublimity" of its age, "in which the greatest glory of a building consists," was half scrubbed off. But considering that these particular accretions consisted primarily of the corrosive coal soot Ruskin regarded as utterly incompatible with sculpture, perhaps even he would temporarily suspend his ultimate definition of architectural nobility and applaud their erasure. Both the remaining grimy planes and those "restored to the white accuracies of novelty" did indeed have a skimped, meager quality, though the building cannot be ranked, as Peter Collins classes it, among the most "gruesome" expressions of revivalism[104]—unfortunately, it hasn't enough character. When I returned three years later, the cleaning of all but the "Abbot's Kitchen" had been completed, and the fresh new warmth of the yellow Bath stone (Ruskin's "common brickbats") on a clear summer afternoon made the museum seem a friendly sort of anachronism, especially as contrasted to the boxy, glass-sheathed Geology and Mineralogy annex newly erected to the north, or Butterfield's irredeemably ugly Keble College across the street, which even lush lawn and bright sun will not soften.[105] It strikes one as the sort of structure city dwellers today mount frantic last-minute campaigns to save from the wrecking ball, not for any fundamental beauty it may possess but because of the relief it provides from the "endless perspective of black skeleton and blinding square" that have, as Ruskin prophesied, "encompassed us all"[106] in so much of our twentieth-century urbanscape. In fact, the building *was* thus threatened during the early sixties when a group of Oxford scientists proposed its demolition in the indefinite future should more laboratory facilities be required. Happily, according to the museum's curator, Dr. F. Brian Atkins, this action instead stimulated efforts to preserve and renovate the structure; a northern extension to the Radcliffe Science Library that adjoins it on the south is even purposely being constructed underground so as not to interfere with the museum's setting.[107]

104. Peter Collins, *Changing Ideals in Modern Architecture, 1750-1950* (London, 1965), p. 144.

105. I was amused to discover that on both visits I had providentially encountered exactly the right conditions for doing the building maximum justice, according to Eastlake, who desperately asserts, "The chromatic effect of the whole seen on a bright sunny day surrounded by natural verdure and with a blue sky overhead, is charming" (*History of the Gothic Revival*, p. 284). Or, as Clark adds, so "are most things when surrounded by lawns and trees" (*Gothic Revival*, p. 208).

106. *The Two Paths*, lec. 4, par. 101 (*Works*, 16).

107. According to Dr. Atkins, an editor's note in the December 1962 *Architectural Review* (132: 409-10) reporting that the university had officially decided on the museum's eventual destruction was inaccurate; no such resolution was actually brought before any of the appropriate governing bodies. I am most grateful to Dr. Atkins and his colleague, Mr. J. M. Edwards, for providing this information on the museum's status.

The spatial surprise of the interior provides an additional piquant irony. One penetrates the solidity of the exterior shell to find one's self standing in a court with warm sunlight diffusing through the glass and iron roof overhead— except for the supporting "Gothic" wrought-iron spandrels, it is the archetypal vault of the nineteenth-century engineer, not the thirteenth-century mason. Ironically, too, the transparent, functional framework of the roof, a harbinger of the ultimate triumph of the Modern Movement, at the same time echoes the skeletons of prehistoric beasts ranged in the court below,[108] animals that, be- cause of their inability to adapt to changed conditions, became extinct—like the Gothic Revival, and Ruskin's dreams of it. A faint odor of formaldehyde hangs over all.

The story of the Oxford Museum is that of the Gothic Revival in miniature and of Ruskin's ambivalent part in it. Undoubtedly, the failure of the project brought home to Ruskin the modern conditions of building which he could neither accept nor adjust to: the insistence on economy (in its most simplistic definition) of materials and methods, the need for speedy construction, the political machinations and mediocre results of building-by-committee; hence the advantage of standardized machine-age materials and techniques; hence the sacrifice of beauty to simple utility and the corruption of the noble art of architecture into mere building. Above all, the undertaking probably made poignantly clear to Ruskin how completely the medieval tradition of crafts- manship was dead, and demonstrated beyond what he had guessed the ex- treme difficulty of reviving it in the modern world:

> Perhaps I have been myself faultfully answerable for this too eager hope in your mind (as well as in that of others) by what I have urged so often respecting the duty of bringing out the power of subordinate workmen in decorative design. But do you think I meant workmen trained (or un- trained) in the way that ours have been until lately, and then cast loose on a sudden, into unassisted contentions with unknown elements of style? . . . I meant workmen as we have yet to create them: men inherit- ing the instincts of their craft through many generations, rigidly trained in every mechanical art that bears on their materials, and familiarized from infancy with every condition of their beautiful and perfect treat- ment; informed and refined in manhood, by constant observation of all natural fact and form; then classed, according to their proved capacities, in ordered companies, in which every man shall know his part, and take it calmly without effort or doubt—indisputably well,—unaccusably ac-

108. This part of the analogy was certainly not lost on Ruskin, who remarks in the *Readings in "Modern Painters"* lecture discussed above that Dr. Acland "is now trium- phantly able to arch his museum aisles with vaults of vertebrae, and glorify its Gothic shrines with craniological mosaic" (*Works*, 22: 524).

complished—mailed and weaponed *cap-à-pie* for his place and function. Can you lay hand on such men? . . .[109]

From a realization like this, it is only a short step to the abandonment of the limited mission of architectural propagandizing for preaching of a more broadly revolutionary kind. Significantly, the demise of the museum project and the first appearance of *Unto This Last* coincide.

But again, just as Ruskin's support of the museum was unexpectedly vague and curiously equivocal, so was his attitude toward the Gothic Revival as a whole. For Ruskin, the medieval past was so beautiful, so preferable to the sooty corruption of modern England, that every effort at reviving its architecture had to be doomed. None could possibly meet Ruskin's standard of perfection, but only caricature it, making ever clearer its utter impracticability in an age of iron. Clark's assessment of Ruskin's influence on Victorian architecture is overstated but basically true: "Seen at our present distance Ruskin is not the man who made the Gothic Revival; he is the man who destroyed it."[110] And in the end, he rejected not just an architectural movement but the society that had produced it.

109. Second Letter on the Oxford Museum, par. 17 (*Works*, 16).
110. Clark, *Gothic Revival*, p. 212.

5

The Relevance of Ruskin's Architectural Thought

You may perhaps think that no man ought to speak of disappointment, to whom, even in one branch of labour, so much success was granted. Had Mr. Woodward now been beside me, I had not so spoken; but his gentle and passionate spirit was cut off from the fulfilment of its purposes, and the work we did together is now become vain. It may not be so in future; but the architecture we endeavoured to introduce is inconsistent alike with the reckless luxury, the deforming mechanism, and the squalid misery of modern cities; among the formative fashions of the day, aided, especially in England, by ecclesiastical sentiment, it indeed obtained notoriety; and sometimes behind an engine furnace, or a railroad bank, you may detect the pathetic discord of its momentary grace, and, with toil, decipher its floral carvings choked with soot. I felt answerable to the schools I loved, only for their injury. I perceived that this new portion of my strength had also been spent in vain[1]

1. *Sesame and Lilies*, lec. 3, par. 104, in the Library Edition of *The Works of John Ruskin*, ed. E. T. Cook and Alexander Wedderburn, 39 vols. (London and New York, 1903–12), 18; hereafter cited as *Works*.

So Ruskin described his association with the Oxford Museum, and the effect of his architectural writings in general. Yet, although he contended that they were his most directly influential works, he seems to have regarded them all along as secondary. At the time he was actually working on *The Stones of Venice*, he told his father that compared to his studies for *Modern Painters*, "The architectural works have been merely bye play"—even though he was finding *Stones* a more serious study than he had anticipated.[2] In later years, certainly, he wrote architectural criticism less and less; his travel guides of the seventies are largely on painting, while in the fragments of *Our Fathers have Told Us* (1881–85) the buildings which were to be his focus seem almost incidental. Apart from his Oxford lectures, so rich in scattered architectural observations, his occasional addresses like "The Flamboyant Architecture of the Valley of the Somme" (1869) treat architecture the most directly, but even in these the declared subject often tends to become submerged in discussions of the larger social issues that now preoccupied him.

In *Praeterita*, comment on his Venetian sojourn of the early fifties, his most intensive period of architectural study, is noticeably lacking; the omission cannot be wholly explained by his associating this period with Effie. Possibly in subsequent chapters he would have treated this experience, before madness prevented their being written ever; nonetheless, in Ruskin's manuscript scheme for the remaining sections of *Praeterita* and the accompanying *Dilecta* the one projected portion on Venice seems to exclude discussion of the fifties.[3] In the paragraphs of the third volume of *Praeterita* that summarize the events of 1850–60 year by year, Ruskin's terse 1852 account reads: "Final work in Venice for *Stones of Venice*. Book finished that winter. Six hundred quarto pages of notes for it, fairly and closely written, now useless. Drawings as many —of a sort; useless too." And he sums up the decade as having been "for the most part wasted in useless work."[4]

Ruskin's mental state in the late 1850s and early 1860s was one of increasing disillusion and isolation. Not only had he seen the Oxford Museum project founder, but he was disgusted by the spectacle of architects and politicians bickering absurdly in the Battle of the Styles. Concurrently, he saw his favorite medieval buildings being sacrificed: "I have got people to look a little at

2. From Venice, February 15, 1852, in *Ruskin's Letters from Venice, 1851–1852*, ed. John L. Bradley (New Haven, 1955), p. 181. This attitude corresponds, interestingly, with his assertion that "the best architecture is merely the child's play and bye-work of sculptors and painters . . ." (first draft of the 1859 preface to *The Two Paths* [*Works*, 16: 252n]).

3. The only notation in the manuscript scheme dealing directly with Venice reads simply, "Venice from beginning; the first wonder of the Bridge of Sighs, first drawing in St. Mark's Place. The last time at Venice, 1876. Prince Leopold's wish" (*Works*, 35: 635). Cook and Wedderburn class it as part of a section treating the years 1860–70.

4. Ch. 1, par. 10 (*Works*, 35).

thirteenth-century Gothic, just in time to see it wholly destroyed (*every* cathedral of importance is already destroyed by restoration)"[5] The Pre-Raphaelite Brotherhood, in which he had placed such hope for a renaissance of painting, was falling apart: "Hunt spends too much time on one picture, without adequate result," he told the Brownings; "Rossetti is half lost in mediaevalism and Dante, . . and nearly all the smaller fry have been led astray in Rossetti's wake."[6] Any further relationship with Millais was of course precluded by that artist's marriage in 1855 to Effie, though Ruskin continued to review his work impartially in *Academy Notes*. A trip to Germany in the summer of 1859 further deflated his hopes for art; diary entries and numerous letters of that date are filled with expressions of intense revulsion at contemporary German painting.

Ruskin was deeply unsettled by political events of the period as well. He had supported the Crimean War (1854–56) and was a staunch admirer of Napoleon III when in 1859 the emperor joined Sardinia to help drive the Austrians from Italy. But then France made a separate peace at Villafranca in July of that year, leaving Venetia in Austrian hands. England, meantime, was preoccupied with domestic political crisis brought on by the fall of Derby and the return of Palmerston. For Ruskin, the reluctance of his own country to join in freeing his adopted Italy was a great disappointment—just one more example, to him, of England's stultifying insularity. As a result of these events and despite the imminence of Italian unification, Ruskin's prognosis was gloomy; writing from Denmark Hill in late 1860 to thank Mrs. Browning for her "happy account of your hopes for Italy" he argues,

> . . . indeed it will be strange to me if the just cause of the Italians is allowed by Heaven to prosper I tremble every paper I open, but am prepared for the worst; perhaps my present despondency is because I have thoroughly anticipated all the probable worsts. I think of Venice as utterly destroyed, with Verona; and with all the pictures in them, which, to me, means nearly half the pictures in the world.[7]

In his emotional life he had also survived a difficult decade. Although he was plainly relieved and his parents delighted by Effie's leaving, the scandal attached to the annulment of his marriage persisted for years, especially with the

5. To Elizabeth Barrett Browning, from Denmark Hill, November 25, 1860 (*Works*, 36:350).

6. From Denmark Hill, December 11, 1859, ibid., p. 331.

7. November 25, 1860, ibid., pp. 349–50. Writing to Charles Eliot Norton soon after the Peace of Villafranca, Ruskin asserts: "The dastardly conduct of England in this Italian war has affected me quite unspeakably—even to entire despair—so that I do not care to write any more or do anything more than does not bear directly on poor people's bellies—to fill starved people's bellies is the only thing a man can do in this generation, I begin to perceive" (from Schaffhausen, July 31, 1859, ibid., p. 311).

help of Effie's influential confidante, the formidable bluestocking Lady East-lake, wife of the National Gallery's director. In 1858 he met Mrs. LaTouche and consented to give drawing lessons to her daughters, marking the onset of his long, ultimately tortured passion for Rose LaTouche. In that same year, moreover, he experienced his famous "unconversion" at Turin, when the contrast suddenly perceived between the grey narrowness of mind and spirit in the Waldensian chapel and the splendidly colored affirmation of man in the Paolo Veronese paintings at the Royal Gallery there, caused him to "put away" forever his Evangelical beliefs, "to be debated of no more."[8] An 1859 letter to Charles Eliot Norton amply sums up the frustration, loneliness, disappointment, and hopeless sense of flux Ruskin felt by the end of a decade of architectural study:

> . . . you are almost the only friend I have left. I mean the only friend who understands or feels with me. I've a good many Radical half friends, but I'm not a Radical and they quarrel with me . . . about my governing schemes. Then all my Tory friends think me worse than Robespierre. Rossetti and the P.R.B. are all gone crazy about the Morte d'Arthur. I don't believe in Evangelicalism—and my Evangelical (once) friends now look upon me with as much horror as on one of the possessed Gennesaret pigs. Nor do I believe in the Pope—and some Roman Catholic friends, who had great hopes of me, think I ought to be burned. Domestically, I am supposed worse than Blue Beard; artistically, I am considered a mere packet of squibs and crackers. . . . I'm as alone as a stone on a high glacier, dropped the wrong way, instead of among the moraine. Some day, when I've quite made up my mind what to fight for, or whom to fight, I shall do well enough, if I live, but I haven't made up my mind what to fight for[9]

Very likely, however, the confusion in Ruskin's mind over what to fight for was more apparent than real at this point, explicable in terms of recent demoralizing events in his life rather than by any sudden interior metamorphosis. These developments of the middle to late fifties merely became the necessary catalyst to trigger the final stage of a process that had actually begun years earlier. Much of Ruskin's work of the previous decade had revealed an incipient interest in social criticism; "The Nature of Gothic" is only the most conspicuous, profound example. We have already seen that in *The Seven Lamps*

8. For a full and sympathetic account of Ruskin's relationship with Rose, see Derrick Leon, *Ruskin, the Great Victorian* (London, 1949). Ruskin's rejection of his Evangelical beliefs is recounted in *Praeterita*, vol. 3, ch. 1, par. 23 (*Works*, 35); frequent expressions of disgust at Protestant services are found in his diaries, however, at an early date.
9. From Thun, August 15, 1859 (*Works*, 36: 313).

Ruskin was beginning to shift his sights from building to builder by asking of architectural ornament, "was the carver happy while he was about it?" Minor works of this period also contain such evidence of change. For example, his pamphlet "Pre-Raphaelitism" (1851) opens with a disquisition on the necessity of happiness in human labor: "It may be proved, with much certainty, that God intends no man to live in this world without working: but it seems to me no less evident that He intends every man to be happy in his work. It is written, 'in the sweat of thy brow,' but it was never written, 'in the breaking of thine heart,' thou shalt eat bread"[10] An evocation of poverty in his 1854 pamphlet marking the reopening of the Crystal Palace at Sydenham matches in power those in any of his later more direct attacks on Victorian moral myopia:

> But it is one of the strange characters of the human mind, necessary indeed to its peace, but infinitely destructive of its power, that we never thoroughly feel the evils which are not actually set before our eyes. If, suddenly, in the midst of the enjoyments of the palate and lightnesses of heart of a London dinner-party, the walls of the chamber were parted, and through their gap, the nearest human beings who were famishing, and in misery, were borne into the midst of the company—feasting and fancy-free—if, pale with sickness, horrible in destitution, broken by despair, body by body, they were laid upon the soft carpet, one beside the chair of every guest, would only the crumbs of the dainties be cast to them—would only a passing glance, a passing thought be vouchsafed to them? Yet the actual facts . . . are not altered by the intervention of the house wall between the table and the sick-bed—by the few feet of ground (how few!) which are indeed all that separate the merriment from the misery.[11]

Here, however, this horrifying vignette is used for a quite different purpose. In its proper context, it is simply a vivid metaphor by which Ruskin illustrates the ruin of great art through ignorance, restoration, and war; he is pleading with his readers to save not human beings but rain-soaked paintings and crumbling cathedrals. Yet the rhetoric is the same; only the focus must be altered.

Ruskin's social conscience finds further oblique expression during this time in his emphasis on the two-edged moral obligation of art patronage. On the one hand, the patron must remember that his choice of works affects all persons who will look upon them. Ruskin stresses this responsibility as far back as *The Poetry of Architecture*; although he deals there with the most private form of architecture, the country villa, he repeatedly underscores its owner's duty to make his home a pleasing, harmonious part of the larger environment, to remember that his land is "the means of a peculiar education" to artists

10. Par. 1 (*Works*, 12).
11. "The Opening of the Crystal Palace," par. 18 (*Works*, 12).

and literary men and therefore as much "a national possession" as it is his own.[12]
But in the fifties, again reflecting his accelerating shift of emphasis from build-
ing to builder, Ruskin becomes increasingly insistent on a complementary aspect
of patronage: the obligation of the buyer to encourage the struggling artist to do
only good work and to reward him justly for it, always mindful that

> By the purchase of every print which hangs on your walls, of every cup out
> of which you drink, and every table off which you eat your bread, you are
> educating a mass of men in one way or another. You are either employing
> them healthily or unwholesomely; you are making them lead happy or un-
> happy lives; you are leading them to look at Nature, and to love her—to
> think, to feel, to enjoy,—or you are blinding them to Nature, and keeping
> them bound, like beasts of burden, in mechanical and monotonous employ-
> ments. We shall all be asked one day, why we did not think more of this.[13]

Once more, the rhetoric is already fully developed—the focus need merely be
broadened to include not just artists and craftsmen, but workers of all kinds.

A momentary equipoise between Ruskin's social and aesthetic criticism,
again centering on the moral aspects of art patronage, is struck in his two lec-
tures "The Discovery and Application of Art" and "The Accumulation and
Distribution of Art," published in 1857 as *The Political Economy of Art.* (Even
the titles are hybrid.) Here he argues that "artistical gold" is not only limited
in quantity but in use and must therefore be set to its proper work:

> So far as we induce painters to work in fading colours, or architects to
> build with imperfect structure, or in any other way consult only imme-
> diate ease and cheapness in the production of what we want, to the exclu-
> sion of provident thought as to its permanence and serviceableness in after
> ages; so far we are forcing our Michael Angelos to carve in snow. The first
> duty of the economist in art is, to see that no intellect shall thus glitter
> merely in the manner of hoar-frost[14]

And it also follows that artistic resources limited in quantity should be expend-
ed in ways such that the greatest number of people can be favorably influenced,
an implication Ruskin made emphatically clear when in 1880 he retitled these
lectures *A Joy for Ever,* on the grounds that the beauty which is a joy for ever
must be a joy for all. In the later volumes of *Modern Painters* as well, Ruskin
is operating on two levels—his ostensible purpose is artistic analysis, yet the
principles enunciated simultaneously bear symbolic interpretation. The "laws"
he is applying to composition in art, for example, are likewise the standards

12. Par. 174 (*Works,* 1).
13. *Lectures on Architecture and Painting,* lec. 2, par. 46 (*Works,* 12).
14. Lec. 1, pars. 21, 37 (*Works,* 16).

which permit a healthy composition of society; this is especially apparent in
such chapter titles as "The Law of Help" and "The Task of the Least," which
might as appropriately be attached to his social documents as to his art criti-
cism. Ruskin was always talking about the just distribution of resources,
first in and among works of art; ultimately, in society.[15]

He himself was fond of pointing out these roots of his social theory. Even
as early as 1854 in *Lectures on Architecture and Painting* he expresses his
disappointment that "among all the writers who have attempted to examine
the principles stated in the *Stones of Venice,* not one has as yet made a single
comment on what was precisely and accurately the most important chapter in
the whole book; namely, the description of the nature of Gothic architecture,
as involving the liberty of the workman"[16] In *Modern Painters V* (1860)
he confesses that these political ideas have long been germinating in his art-
historic works, struggling to burst free:

> And in these books of mine, their distinctive character, as essays on
> art, is their bringing everything to a root in human passion or human hope.
> . . . [T]hey have been coloured throughout,—nay, continually altered in
> shape, and even warped and broken, by digressions respecting social ques-
> tions, which had for me an interest tenfold greater than the work I had
> been forced into undertaking. Every principle of painting which I have
> stated is traced to some vital or spiritual fact; and in my works on archi-
> tecture the preference accorded finally to one school over another, is
> founded on a comparison of their influences on the life of the workman—
> a question by all other writers on the subject of architecture wholly for-
> gotten or despised.[17]

Thus for Ruskin his architectural writing was as much the occasion as the
cause of his social concern; it provided a kind of metaphoric clothing for more
fundamental ideas that time would eventually make manifest. Before great art
could exist, a healthy society had to exist: first, he had talked about beauty—
now he would have to talk about why it must necessarily be a joy for all, and
not just for a privileged coterie. Ruskin's supposed goal, aesthetic reform,

15. These published appeals to social conscience are in fact delayed expressions of a
slowly dawning commitment dating well back to the forties. Repeatedly during those
years he reproaches himself in his diary for his idleness and self-indulgence; he also demon-
strates increasing awareness that many of the picturesque elements he loves in art and
scenery are actually evidence of squalor and misery.

16. Addenda, par. 76 (*Works,* 12). Representative later examples are found in *Unto
This Last* (essay 3, par. 54 [*Works,* 17]), referring to *Modern Painters V;* a fragment of
ch. 28 of *St. Mark's Rest* (*Works,* 24: 448), referring to *Stones;* and his 1883 preface to
Modern Painters II (par. 3 [*Works,* 4]).

17. Pt. 9, ch. 1, par. 7 (*Works,* 7).

could only be achieved through the broader goal of social reform. It was a matter of working back to first causes, as Ruskin himself clearly grasped: "[I have] come to see the great fact that great Art is of no real use to anybody but the next great Artist; that it is wholly invisible to people in general—for the present—and that to get anybody to see it, one must begin at the other end, with moral education of the people, and physical, and so I've to turn myself quite upside down"[18] And he saw too that such a course was inevitable, that he would find himself driven to it, just as he felt driven to take in Verona touch by touch. "I am forced by precisely the same instinct to the consideration of political questions that urges me to examine the laws of architectural or mountain forms," he told Acland as early as 1856. "I cannot help doing so; the questions suggest themselves to me, and I am *compelled* to work them out. I cannot rest till I have got them clear." At the same time, however, he recognized with terrible clarity that no matter how necessitous or long-fermenting this interest was, such an effort ran counter to his whole being: "I am by nature and instinct Conservative, loving old things because they are old, and hating new ones merely because they are new. If, therefore, I bring forward any doctrine of Innovation, assuredly it must be against the grain of me; and this in political matters is of infinite importance." [19] In committing himself to social reform, in yielding to the compulsion to work out great political questions and turning away from the quiet contemplation of the art and mountains he loved, he knew that he was risking self-destruction. It was a frighteningly courageous—and fatal—decision that Ruskin eventually made.

Again, however, if Ruskin's works on architecture provided the occasion for his first tentative forays into social criticism, it was his failure through these writings to attain his limited goal of architectural reform that directly precipitated this commitment to social regeneration. As a critic of Gothic architecture he was brilliantly incomplete, both in geographical and structural terms; his idiosyncratic limitations made it easy for the Victorians to fasten on and misinterpret the letter of his specific architectural prescriptions, while overlooking his effort to penetrate to the spirit of Gothic, however personalized or romanticized the resulting definition. Therefore, his propagandizing for the Gothic Revival was bound to be ambiguous at best. The few genuinely enthusiastic endorsements of its aims to be found in his writings can probably be explained fairly simply: he saw the Gothic Revival in relation to Gothic in the same way he saw the Pre-Raphaelite Brotherhood in relation to Turner. In both he glimpsed the tantalizing possibility of recovering the irrecoverable aesthetic past; he was merely grasping at the

18. To Elizabeth Barrett Browning, from Denmark Hill, November 25, 1860 (*Works*, 36: 348).
19. April 27, 1856, ibid., pp. 238–39.

best available straws and was doomed to disappointment with both move-
ments. It was inevitable from the outset that the Gothic Revival would
have to be deficient in the characteristics of Gothic Ruskin loved best and
stressed most, while the Revival's positive legacy of boldly irregular massing
and proportion was outside Ruskin's sphere of appreciation.

If his influence on Victorian architecture was in many ways limited and even
deleterious, is it possible, on the other hand, to see Ruskin as in any way a
precursor of the Modern Movement in architecture, or as an influence upon
twentieth-century building in general? Basically, the answer is no—if we
measure his contribution by the most immediately applicable standards. In
chapter 3 I showed that his status as an early functionalist is dubious, his
so-called functional pronouncements forming but a minor part of his archi-
tectural *corpus* and being dictated largely by tactical considerations. Through-
out his writing, moreover, he is consistently reluctant to admit new possibili-
ties of materials and structure. A passage from "The Lamp of Truth" is of-
ten cited to suggest that Ruskin was prophetically aware of their imminence
because he declares that "the time is probably near when a new system of
architectural laws will be developed, adapted entirely to metallic construc-
tion." But rarely quoted are the qualifications that follow: since architec-
ture, being the earliest of arts, antedates "the possession of the science neces-
sary either for the obtaining or the management of iron," we should there-
fore in the interest of historical consistency, as well as of our preconditioned
notions of right proportion and ornament, limit ourselves to traditional materi-
als and methods.[20] At the end of *The Seven Lamps* he emphatically avers,
"The forms of architecture already known are good enough for us, and for
far better than any of us: and it will be time enough to think of changing
them for better when we can use them as they are."[21] In the basic chapters
of *Stones of Venice I* Ruskin continually stresses that he has covered all archi-
tectural forms, that no new ones are possible; a typically inclusive claim:
"This is the form of all good doors, without exception, over the whole world
and in all ages, and no other can ever be invented."[22] Further, we noted back
in chapter 1 that he found merely ludicrous the mania for discovering a new
style "worthy of our engines and telegraphs."
 Many of his general principles, moreover, though he sanguinely maintained

 20. *Seven Lamps*, ch. 2, pars. 9, 10 (*Works*, 8). Besides, as Nikolaus Pevsner shows in
Pioneers of Modern Design, Pelican ed. (Harmondsworth, 1960), such vague forecasts that
new materials would lead to a new architecture were common in the mid-Victorian peri-
od. See pp. 133–35 for assorted examples, including the frequently quoted passage from
Ruskin.
 21. Ch. 7, par. 5 (*Works*, 8).
 22. Ch. 17, par. 2 (*Works*, 9).

that they were universally applicable, in fact were not because he strait-jacketed them with myriad restrictions. First, on materials. Both implicitly and explicitly he argues that only "natural" materials—the traditional building components of clay, stone, and wood—are permissible. Metals may be used just "as a *cement* [and] not as a *support.*" Thus iron work, metal work, and rivets are acceptable "so only that the use of them be always and distinctly one which might be superseded by mere strength of cement."

> But the moment that the iron in the least degree takes the place of the stone, and acts by its resistance to crushing, and bears superincumbent weight, or if it acts by its own weight as a counterpoise, . . . or if, in the form of a rod or girder, it is used to do what wooden beams would have done as well, that instant the building ceases, so far as such applications of metal extend, to be true architecture.[23]

Yet though he regularly disparaged iron in all his writings, only once did he ever purport to analyze it intensively. This was in an address delivered at Tunbridge Wells in February 1858, "The Work of Iron, in Nature, Art, and Policy," published the following year in *The Two Paths.* In it, he takes his audience on a kind of cosmic voyage of Ruskinian free association, beginning with a dissertation on the "saffron stain" in the town's water and ending with a metaphorical discussion of iron in national policy, symbolized in the plough, the fetter, and the sword. Comment on iron as an architectural material is disappointingly sparse, mainly because he recognizes only its ductility and hence talks about it strictly as an ingredient of fences and balconies. Even here, nevertheless, he discusses such a use almost entirely symbolically, contrasting the sharp-spiked palings of Victorian London ("Your iron railing always means thieves outside, or Bedlam inside"[24]) with the delicately wrought foliage and trellis work of seventeenth-century Italian balconies. As serious consideration of the potential roles for iron in nineteenth-century buildings, the lecture is useless. Ruskin is similarly unhelpful regarding glass as a building material, dismissing it peremptorily in *Stones of Venice I* on the grounds that "all

23. *Seven Lamps,* ch. 2, par. 10 (*Works,* 8). A statement like this obviously precludes skyscraper construction; on the other hand, Ruskin's principles would seem to admit—in limited use—modern reinforced concrete as a material, though doubtless he would find its humble color and texture distasteful.

24. Lec. 5, par. 165 (*Works,* 16). In the same lecture, he explains that the propensity of iron to rust enables it to fulfill "its most important functions in the universe, and most kindly duties to mankind. Nay, in a certain sense, and almost a literal one, we may say that iron rusted is Living; but when pure or polished, Dead" (par. 143). Because of its rich natural color and patina, I suspect that of all modern construction materials, Ruskin would find Cor-Ten steel the most acceptable.

noble architecture depends for its majesty on its form: therefore you can never have any noble architecture in transparent or lustrous glass or enamel."[25]

He avoids dealing with the architectural potential of iron and glass combined, as in the Crystal Palace, first by roundly derogating that structure as "a greenhouse larger than ever greenhouse was built before,"[26] and then by placing it at the *end* of three centuries of corrupt Renaissance tradition, instead of at the beginning of a new movement:

> It is to this, then, that our Doric and Palladian pride is at last reduced! We have vaunted the divinity of the Greek ideal—we have plumed ourselves on the purity of our Italian taste—we have cast our whole souls into the proportions of pillars and the relations of orders—and behold the end! Our taste, thus exalted and disciplined, is dazzled by the lustre of a few rows of panes of glass; and the first principles of architectural sublimity, so far sought, are found all the while to have consisted merely in sparkling and in space.[27]

But it was the sparkling and space of the Crystal Palace which were its most revolutionary qualities, as other, if lesser, men than Ruskin were recognizing. Ruskin himself quotes from the Crystal Palace Company chairman's dedicatory address proclaiming the structure *"an entirely novel order of architecture"* and acknowledges that "the speaker is not merely giving utterance to his own feelings. He is expressing the popular view of the facts, . . . one which has been encouraged by nearly all the professors of art of our time."[28] Desperately countering this view on another occasion, Ruskin is driven to an especially silly exercise in scriptural justification:

> Assuming . . . that the Bible is neither superannuated now, nor ever likely to be so, it will follow that the illustrations which the Bible employs are likely to be *clear and intelligible illustrations* to the end of time. . . . Now, I find that iron architecture is indeed spoken of in the Bible. . . . But I do not find that iron building is ever alluded to as likely to become *familiar* to the minds of men[29]

This is plainly a case of what Kenneth Clark labels Ruskin's tendency to "rely on holy writ to save him further thought."[30] Ruskin simply did not like to contemplate the all-too-imminent possibility of metallic construction.

25. App. 17 (*Works*, 9: 455).
26. Ibid., p. 456.
27. "The Opening of the Crystal Palace," par. 4 (*Works*, 12).
28. Ibid.
29. *Lectures on Architecture and Painting*, lec. 1, par. 28 (*Works*, 12).
30. Kenneth Clark, *Ruskin Today* (London, 1964), p. xv.

Later, however, in his 1865 lecture to the R.I.B.A., he claims that "it is not an edifice's being of iron, or of glass, or thrown into new forms, demanded by new purposes, which need hinder its being beautiful. But it is the absence of all desire of beauty, of all joy in fancy, and of all freedom in thought."[31] Here is the more realistic—and more just—perspective. But it also came after he had all but shed his role of architectural critic to assume that of social prophet, and in any event, it is no resounding endorsement of modern materials. Such substances were too much the product and symbol of what Ruskin believed to be a sterile age for him to approve them, just as were the building uses to which they were being applied—warehouses, railway stations, exhibition halls, office buildings, department stores—a response to industrialization, to mass production and mass distribution.

Ruskin's abiding concern for the happiness of the workman caused him to place severe restrictions as well on the respective roles of men and machines in architecture. Great buildings are those which declare in every line the freedom and devotion of the individual worker who labored on them. (This principle, of course, provided him with his most fundamental argument against new materials: "the utmost power of art can only be given in a material capable of receiving and retaining the influence of the subtlest touch of the human hand."[32]) The worker, to be happy and productive, must thus be allowed maximum creative latitude as well as variety in his labor; machine work cannot be substituted for the inspired expression of the whole man. Worse still, the acceptance of machine work, besides deadening the spirit of the individual workman, also desensitizes the visual perception of everyone who looks on it, which in turn breeds tolerance of all manner of architectural evil:

> . . . [when] machine-work is substituted for hand-work, as if the value of ornament consisted in the mere multiplication of agreeable forms, instead of in the evidence of human care and thought and love about the separate stones; [then]—machine-work once tolerated—the eye itself soon loses its sense of this very evidence, and no more perceives the difference between the blind accuracy of the engine, and the bright, strange play of the living stroke And on this blindness follow all errors and abuses—hollowness and slightness of frame-work, speciousness of surface ornament, concealed structure, imitated materials, and types of form borrowed from things noble for things base[33]

In the lecture entitled "Structure" in *Aratra Pentelici* he actually argues that "the use of machinery other than the common rope and pulley, for the lifting

31. "The Study of Architecture in Our Schools," par. 5 (*Works*, 19).
32. *The Two Paths*, lec. 5, par. 160 (*Works*, 16).
33. "Review of Lord Lindsay," par. 5 (*Works*, 12: 172–73).

of weights, is degrading to architecture," and in the same address he sums up
the drift of all the restrictions discussed here by enunciating "two very severe-
ly fixed laws of construction": "namely, first, that our structure, to be
beautiful, must be produced with tools of men; and, secondly, that it must be
composed of natural substances."[34]

It is clear, therefore, that most of the conditions deterministically affecting
modern architecture Ruskin either could not predict or else could not accept.
He would scarcely be surprised at the extreme utilitarian quality of most mod-
ern buildings; he was, after all, a citizen of an age that made usefulness an over-
riding measure of value. But he would probably be dismayed by the extent to
which utility has become part of the twentieth-century architectural aesthetic—
its very definition, in fact: beauty seemingly arises spontaneously out of the
fulfillment of functional requirements, and if separated from such fulfillment
becomes somehow affected or dishonest, even suspiciously decadent. The
Lamp of Sacrifice has been all but extinguished.

Nor would he be able to fathom the modern demand for rapid construction;
the age of the Gothic builders, when men labored for generations on a single
grand edifice that was expected to last for centuries, is irrecoverable in a time
when burgeoning populations and rapid technological growth must be accom-
modated quickly and cheaply. Prefabrication of any kind he also would have
disapproved, for it reeks of impermanence and the degradation of the work-
man; he hated it in the Crystal Palace. Moreover, the modern necessity for
speedy construction demands economy of materials as well. Ruskin's gilded
capitals and rich films of glowing serpentine are infrequently to be had in an
era of glass, steel, aluminum, ferroconcrete, and fiberglass—Mies van der Rohe's
austerely elegant bronze and travertine surfaces notwithstanding.[35] Precious
natural materials are too scarce, too expensive (partly because they require
more highly skilled workmen to install them, labor costs being another obsta-
cle to twentieth-century architectural grandeur); they have generally been
superseded by low-cost, low-maintenance, mass-produced artificial components

34. Lec. 5, pars. 148, 147 (*Works*, 20).
35. It can be argued that today's curtain-wall construction actually *is* an "architec-
ture of incrustation." Peter Collins suggests that after the appearance of structural steel-
work in the 1880s, because a fireproof veneer was then needed, "even the most fervent
Rationalists now adopted Ruskin's ideals," while Louis Sullivan's ornamental terra cotta
panels "showed the real applicability of Ruskin's notions." Collins goes so far as to
claim that Sullivan's main significance lies in his being "the culminator of Ruskinism,"
since he was essentially an ornamentalist, that is, "a man who can put an attractive
sheath around someone else's structural frame" (*Changing Ideals in Modern Architecture,
1750–1950* [London, 1965], pp. 115–16). Nonetheless, the structural frame to be in-
crusted depends almost entirely on materials and principles emphatically proscribed by
Ruskin.

which do not take on Ruskin's beloved patina of age. The metals he would allow to be used only for cement, not support, dominate today's architecture.

Ruskin would also abhor the "committee" aspects of modern architecture, in which both client and builder tend to be large, impersonal organizations—a far cry from his notions of the unity and mutual dedication of medieval mason and patron. Nor would he endorse the division of labor major architectural projects now require even in their earliest design stages, when, for example, a whole corps of engineers may be working solely on specifications for elaborate elevator systems.

But most important, because of his two-dimensional orientation Ruskin would have trouble conceiving how modern building needs have led to new configurations of *space,* both horizontally and especially vertically. Indeed, it is the concern with space that Sigfried Giedion regards as the hallmark of modern architecture. Ruskin would have particular difficulty grasping the necessity for flexible interiors, in which large volumes of "universal space" are left for undefined uses, often to be divided by walls which are merely partitions, rearranged as needs change. But he would probably be equally insensitive to permanent spatial definitions achieved by manipulation of ceiling levels and angles of vision.

Therefore, even though Ruskin believed he was isolating "those large principles of right which are applicable to every stage and style" of architecture,[36] he pinioned them down so tightly with his own preferences and prejudices that they had to become mainly principles of the past rather than the future. His ornamental, two-dimensional, antistructural orientation precluded his understanding how it might eventually be possible for buildings to *become* sculpture (for instance, Eero Saarinen's TWA Terminal, New York; Le Corbusier's Notre-Dame-du-Haut, Ronchamps; the Brasilia of Oscar Niemeyer and Lucio Costa) or for technological requirements themselves to be exploited *as* sculpture (the way Louis Kahn has done by placing mechanical equipment such as air ducts in externalized networks of turrets and embrasures). Nor would he have grasped how technology could revise the relationship between structure and surrounding environment, so that buildings can now in a variety of ways frame, incorporate, or merge with nature rather than simply imitating its forms, from Saarinen's beautiful John Deere headquarters nestling in an Illinois ravine to Frank Lloyd Wright's spectacularly cantilevered Fallingwater.

On the other hand, he might applaud the ways in which major artists increasingly provide ornament for modern buildings, especially churches; Marc Chagall, for example, has done splendid stained glass windows, while incorporated into Basil Spence's Coventry Cathedral are impressive works by John Piper, Jacob Epstein, and Graham Sutherland. (In fact, Ruskin might even be

36. *Seven Lamps,* introductory, par. 2 (*Works,* 8).

gratified to note that some of the most vitally creative architecture designed in the twentieth century has been for religious uses.[37]) But I doubt that he would approve the widespread use of free-standing sculpture to complement a building, as demonstrated by the sensational "Chicago Picasso" or the currently *de rigueur* Noguchi cubes and Calder stabiles dotting plazas and courtyards of prestige structures. "Sculpture, separated from architecture," Ruskin repeatedly argued, "always degenerates into effeminacies and conceits; architecture, stripped of sculpture, is at best a convenient arrangement of dead walls" A single starkly abstract sculpture placed like a piece of jewelry at the base of—and dwarfed by—a soaring, starkly abstract skyscraper would hardly satisfy Ruskin's criteria for noble architecture on which the eye can feast endlessly.

"I have never applied myself to discover anything," Ruskin declared in the last published fragment of *St. Mark's Rest*, "being content to praise what had already been discovered"[38] He was, as we have seen, by his own admission profoundly conservative, "loving old things because they are old, and hating new ones merely because they are new." He was courageously willing to violate his nature in order to proclaim an innovative social philosophy, but he could not make a similar sacrifice to preach architectural change. It is symbolic that on the day the revolutionary Crystal Palace first opened, Ruskin should be serenely ensconced in his study at Denmark Hill, dedicating himself to the central architectural writing of his career: "All London is astir, and some part of all the world. I am sitting in my quiet room, hearing the birds sing, and about to enter on the true beginning of the second part of my Venetian Work. May God help me to finish it to His glory, and man's good."[39]

In a practical, *direct* way, therefore, Ruskin's place in the development of modern architecture and design seems fairly negligible. Indeed, even the two pioneering figures who overtly acknowledged a debt to him largely controverted his influence in their practice, albeit their motives were quite Ruskinian. William Morris, though he and Ruskin had scant personal contact, eloquently confessed throughout his life an obligation, making an early production at the Kelmscott Press "The Nature of Gothic," which he called "one of the very few necessary and inevitable utterances of the century." But at that time—1892—

37. I believe he would probably come closest to applauding Spence's Coventry Cathedral, not only for its subtle Gothic feeling and its rich artistic contents but because the adjoining ruins of the bombed-out medieval cathedral have been allowed to remain, keeping alight the Lamp of Memory. He would be infuriated, however, by the popular notion that skyscrapers are the cathedrals of the twentieth century.

38. Ch. 11, par. 209 (*Works*, 24).

39. May 1, 1851, in *The Diaries of John Ruskin*, ed. Joan Evans and J. H. Whitehouse, 3 vols. (Oxford, 1956–59), 2: 468.

Morris also declared, "delightful as is that portion of Ruskin's work which describes, analyses, and criticises art, old and new, yet this is not after all the most characteristic side of his writings."[40] The dignified, far-reaching aim of Morris and Company in the 1860s, to make furnishings, fabrics, and other accoutrements of the domestic environment beautifully understated examples of high craftsmanship, finds little direct justification in Ruskin's work, we will see. And, as Morris soon discovered, the exquisite handcraft his firm created was necessarily available only to an affluent few. Like Ruskin, he was finally driven to abandon aesthetic reform for social action.

Frank Lloyd Wright also admitted a debt to "good John Ruskin," and in *The Darkening Glass* John Rosenberg devotes a major portion of his section on Ruskin's architectural writing to an analysis of Ruskinian evidences in Wright's work, arguing that Wright's conception of "Organic Form" coincides with Ruskin's. Yet the references to Ruskin in Wright's *An Autobiography* (1932; revised and enlarged, 1943) are surprisingly minor. Wright does indeed mention there that he read *The Seven Lamps* as a boy, the book having been given to him by his favorite schoolteacher-aunts, Nell and Jane—but in context the reference is part of a random list including *Hans Brinker,* the *Arabian Nights,* and works of Jules Verne. A few pages beyond, Wright remembers reading during his college years *Fors Clavigera, Modern Painters,* and *Stones of Venice* (the latter again a gift from his aunts). But here too the titles are simply listed, along with works of Carlyle, Morris, Shelley, Goethe, Blake, and, significantly, Viollet-le-Duc. Only on Viollet-le-Duc does he comment later, recalling that as a young Chicago architect (prior to joining Adler and Sullivan) he read further in him: "I believed the 'Raisonné' was the only really sensible book on architecture in the world. I got copies of it for my sons, later. That book was enough to keep, in spite of architects, one's faith alive in architecture."[41] In the autobiographical sections of his 1957 *A Testament,* Ruskin's name is missing from the segment headed "Influences and Inferences," though early in this volume, Wright remarks that when he first arrived in Chicago "Good William Morris and John Ruskin were much in evidence" in intellectual circles there.[42] Other allusions to Ruskin are scattered among Wright's books and essays, but they are glancing and undeveloped; references to William Morris are perhaps as numerous.

It can be argued, on the other hand, that whereas the writings or examples

40. Morris's preface to the Kelmscott edition, reprinted in *Works,* 10: 460–62.

41. Frank Lloyd Wright, *An Autobiography* (New York, 1943), pp. 33–34, 53, 75.

42. Frank Lloyd Wright, *A Testament* (New York, 1957), p. 17. In context Ruskin is again part of a list of contemporary influences to which Wright found himself exposed, including such major European architectural pioneers as Mackintosh, Berlage, Loos, and Wagner, and "more important than all," the Americans Dankmar Adler and Louis Sullivan.

of working architects like Viollet-le-Duc and Louis Sullivan furnished an immediate practical stimulus, Ruskin's books provided Wright with broader philosophic inspiration, causing him to sense more keenly the noble mission of the architect. Even here, however, *if* we can depend on Wright's own accounts, the laurel must probably be given first to Victor Hugo. Repeatedly in both *An Autobiography* and *A Testament* he refers to the profound effect on him of the chapter "Ceci Tuera Cela" in *Notre Dame de Paris* (1831), praising it as "the most illuminating essay on architecture yet written": "I was fourteen years old when this usually expurgated chapter in *Notre Dame* profoundly affected my sense of the art I was born to live with—life-long; architecture. His story of the tragic decline of the great mother-art never left my mind."[43]

Frank Lloyd Wright was, of course, notably reluctant to admit genuine influences of any kind on his work save that of "Lieber Meister," Louis Sullivan (and some critics believe Wright influenced Sullivan at least as much); he could also strew occasional red herrings about in his books. But Wright's differences from Ruskin are significant. Ruskin loved the past; Wright was the product of a region and a nation without one. Ruskin desired to revive a tradition; Wright was determined to found a radically new one. Ruskin hated industrialism; Wright, though no less sensitive to its soul-killing potential, accepted the machine (including machine-made ornament) and modern materials. It should not be forgotten that Wright's seminal address at Hull House in 1901 was titled "The Art and Craft of the Machine," which Ruskin would consider an impossible contradiction. And although in his most typical buildings Wright magnificently exploited the traditional materials of wood and stone, he nonetheless required glass and steel to permit the skeletal configurations on which so many of his effects depend. Then, too, at the risk of seeming excessively literal, I venture that Ruskin could not have appreciated the attenuated, ground-hugging lines and dramatic interior spaces of Wright's work, any more than Wright could tolerate the "General Grant Gothic" he chided the Mesdames "Gablemore" and "Plasterbilt" for demanding. John Ruskin and Frank Lloyd Wright did have the same feeling for nature as a form-giving inner energy, and in the unabashedly moral foundations of their philosophies of architecture they are remarkably at one, as Rosenberg admirably demonstrates. But objective evidence that Ruskin's influence on Wright was direct and profound is disappointingly scant.[44]

43. Ibid., p. 17. In *An Autobiography* he calls it "one of the truly great things ever written on architecture" (p. 78).

44. In the hope of turning up more conclusive data, I have attempted to contact persons associated with Wright regarding possible references to Ruskin in his conversation. The two most helpful respondents, whose kindness I gratefully acknowledge, have been Professor John F. Kienitz of the departments of Art History and Landscape Architecture at the University of Wisconsin—Madison, who was acquainted with Wright for

Furthermore, like William Morris's, Frank Lloyd Wright's monumental achievement lay primarily in domestic design—and in luxury domestic architecture at that, despite Wright's unquestionably sincere desire to build for democracy. (Having owned two Frank Lloyd Wright homes, I will personally testify that even a Usonian-type house can be very costly to maintain.[45]) But beauty

thirty years, and Minneapolis architect John H. Howe, who was associated with the Taliesin Fellowship from 1932–64, serving as supervisor of the drafting room from about 1934 on, in which capacity he worked intimately with Wright in all his designing. Professor Kienitz, whose interest in Ruskin is longstanding, believes Ruskin's influence on Wright was considerable, coming partly perhaps through Wright's mother, who, Mr. Kienitz believes, also studied Ruskin. He recalls hearing Wright read aloud from Ruskin once to a group at Taliesin and asserts that in his conversations with the architect he is certain Wright understood well his allusions to Ruskin. Mr. Howe, by contrast, declares, "Though Mr. Wright occasionally mentioned reading Ruskin when he was a boy, he almost never referred to him; and never as an influence or inspiration. He seemed really to disregard him." He also grants, however, that "Mr. Wright seemed quite selective in writing or talking about his early influences and inspirations," and thus "*perhaps* Ruskin had a greater influence on Mr. Wright than he was conscious of or cared to admit."

Henry-Russell Hitchcock, author of a pioneering study on Wright, briefly discusses Ruskin and Wright in his essay "Ruskin and American Architecture" (in *Concerning Architecture*, ed. John Summerson [London, 1968], p. 206), stating, "How much, and what, Wright learned from reading Ruskin is not readily determinable." But then he argues, "Wright found generic inspiration in Ruskin's works and, if not a style of architecture, the basis of his own prophetic style of writing." He also avers, but without documentation, that Wright urged his sons to read Ruskin if they intended to become architects. Yet in the *Autobiography* it is Viollet-le-Duc that Wright says he commended to them. In *My Father Who Is on Earth* (New York, 1946) John Lloyd Wright devotes an entire chapter to comment on and excerpts from Viollet-le-Duc's *Discourses on Architecture* because "Dad . . . gave me those volumes to speak for him. . . . [M]y father said: 'In [them] you will find all the architectural schooling you will ever need'" (p. 136). Ruskin is nowhere named in the book. I was unsuccessful in my attempts to contact John Lloyd Wright before his death in December 1972, nor have I been able to reach Frank Lloyd Wright's surviving architect-son Lloyd, now in his eighties. Professor David Gebhard, Director of The Art Galleries at the University of California, Santa Barbara, organizer of a 1971 Lloyd Wright exhibition there and co-author of its excellent catalogue, kindly advises that Lloyd Wright has told him in conversation that a number of Ruskin's volumes were on hand in The Studio, and that his father gave him Ruskin to read at an early date. It seems apparent, however, that the precise extent or nature of Ruskin's influence on Frank Lloyd Wright will probably remain a source of speculation; my own feeling is that the two men's similarities can best be viewed as evidence of spiritual kinship rather than of a clearcut cause-and-effect relation.

45. My husband and I have owned in Madison, Wisconsin, the home Wright built in 1904 for his boyhood friend Robert Lamp and one of Wright's last efforts to design for the common man, the 1956 Erdman First Prefab, in which we now reside. Our general maintenance costs exceed the usual standards by up to one hundred per cent because of unusual construction features.

"The Frank Lloyd Wright Custom Built Prefabricated-house-building-system" for

in a private setting was of little concern to Ruskin. Miscellaneous lectures such as "Modern Manufacture and Design" in *The Two Paths* (1859) and "The Relation of Art to Use" in *Lectures on Art* (1870) contain references to the desirability of making one's immediate surroundings beautiful and utilitarian objects pleasing, but these are very minor viewed within the total context of his work. Moreover, for a person so open to visual impressions, Ruskin was amazingly uncaring about the attractiveness of his own environment. In *Praeterita* he recalls the bourgeois standard of decoration that prevailed in his parents' first suburban London home ("a numberless commonplace of a house, with a gate like everybody's gate on Herne Hill—and a garden like everybody's garden . . ."[46]):

> . . . we had not set ourselves up to have a taste in anything. There was never any question about matching colours in furniture, or having the correct pattern in china. Everything for service in the house was bought plain, and of the best; our toys were what we happened to take a fancy to in pleasant places—a cow in stalactite from Matlock, a fisher-wife doll from Calais, a Swiss farm from Berne, Bacchus and Ariadne from Carrara.[47]

Yet when in 1871 he acquired his own home in the Lake District, Brantwood, he continued to live in the same unaesthetic way. The house itself was entirely undistinguished; indeed, he bought it sight unseen, and mainly because he knew that a beautiful prospect of Coniston Water and "Old Man" would be visible from its windows. The extensive improvements made over the years did not enhance its attractiveness; the only evidence, in fact, that the house belonged to a renowned architectural critic was a jarringly inappropriate band of seven vaguely Venetian Gothic windows set into the stucco wall of the dining room about 1878–79, allegedly to represent the Seven Lamps of Architecture. The treasures Brantwood contained, moreover—manuscripts, Turners, Mantegna and Botticelli drawings, a della Robbia relief, paintings attributed to Tintoretto and Titian—were ill-displayed; the furniture was a mélange of wicker and his parents' heavy mahogany; the curtains and wallpapers, crudely patterned and floridly colored.[48]

which our present home was the prototype was available as a package to clients in 1957 for the not exactly bargain price of $35,000, exclusive of lot (stipulated to be at least an acre in size), carpeting, floor tile, built-in appliances or furniture, and landscaping; the experiment was a commercial failure. Wright was famous for his cavalier attitude toward money, and his autobiography is filled with often amusing, sometimes appalling accounts of his perennial financial scrapes.

46. From a letter to George Richmond about 1852 (*Works,* 36: 142).

47. Vol. 2, ch. 6, par. 113 (*Works,* 35).

48. Pictures of Brantwood and some description of its contents are found in the introduction to *Works,* 23. My observations above are based on a personal visit to Brantwood in 1971 and on published materials obtainable there, including *A Short History of*

But throughout his life Ruskin had a contempt for "taste" as "the irreverent habit of judgment instead of admiration": "everything is . . . beneath it, so as to be tasted or tested; not above it, to be thankfully received."[49] When in 1883 he issued a separate edition of *Modern Painters II* as a ringing reassertion of the moral basis of all great art, against which men like Whistler were rebelling, he specifically singled out for rebuttal "the aesthetic cliques of London" who wonder "why, in the pictures they have seen of my home, there is no attempt whatever to secure harmonies of colour, or form, in furniture." And, as usual, Ruskin takes the larger view, at the same time penetrating to the heart of the modern suburban mentality that desperately contracts itself into a small, "tasteful" private shell in which to forget the ugly, chaotic world outside:

> My answer is, that I am entirely independent for daily happiness upon the sensual qualities of form or colour; that, when I want them, I take them either from the sky or the fields, not from my walls, which might be either whitewashed, or painted like a harlequin's jacket, for aught I care
> It is to be noted, also, that the peculiar form of monastic life, which makes itself eminently comfortable in its cell instead of eminently miserable, is commonly provoked into farther extravagance by pride in its own good taste: while even the more amiable and domestic characters of mind which, for our true comfort and content, dispose us to make the most of what we can gather for the decoration of our homes, as chaffinches decorate their nests with lichen, have in these days taken an aspect of peculiar selfishness, in their carelessness of all mischief and suffering in the external world, as long as it is out of sight of the parlour window. . . . I cannot be consoled by a bit of Venetian glass for the destruction of Venice, nor for the destitution of a London suburb by the softness of my own armchair.[50]

Once again, the beauty that is a joy for ever must be a joy for all.

It is this larger view that constitutes one of Ruskin's great legacies to modern architecture—his bringing, as he himself asserted, "everything to a root in human passion or human hope." Architecture must minister to man's mind and soul, not simply to his body. This is the idea I have referred to previously as

Brantwood (Association for Liberal Education, n.d.). The Education Trust Ltd. owns and maintains the house and its grounds as a museum and education center; contributions are badly needed and gratefully welcomed.

49. *Modern Painters V*, pt. 9, ch. 5, pars. 3, 5 (*Works*, 7). Here Ruskin is specifically referring to the "school of taste" personified by Claude and Poussin, but the notion expressed of taste's being opposed to humility and joyful, sincere appreciation aptly sums up his general attitude.

50. Preface to the re-arranged edition, pars. 8–9 (*Works*, 4).

Ruskin's "visual functionalism," but perhaps "spiritual functionalism" would be a better phrase. It is an attitude that can take humble form, as in his measuring the value of carved ornament by its accessibility and intelligibility to the unaided human eye—and his insisting that such ornament *shall* be accessible and intelligible. It can be tinged with Victorian literalism, as when he objects to the "painful" effect of glass ground-stories or the "deceptive" use of iron because such materials do not assure the eye of their stability. In a broader sense, it is a part of Ruskin's theory of art patronage, when he stresses that the individual's aesthetic choices affect the visual sensitivities of many men, while his fascination with "low walls spread before us like the pages of a book, and shafts whose capitals we may touch with our hand" is finally an assertion that architecture must be concerned above all with human scale: "No towers of Babel envious of the skies; no pyramids in mimicry of the mountains of the earth; no streets that are a weariness to traverse, nor temples that make pigmies of the worshippers."[51] This perspective is still more inclusively conveyed in the very first paragraph of *The Seven Lamps:* "Architecture is the art which so disposes and adorns the edifices raised by man for whatsoever uses, that the sight of them may contribute to his mental health, power, and pleasure."[52] Therefore, a nation's buildings must reflect and, more important, should project its citizens' highest aspirations: buildings embody the "sculptures and mouldings of the national soul."[53] This is the meaning consistently underlying the qualities of Gothic defined in *Stones of Venice* and the "lamps" in *The Seven Lamps of Architecture:* architecture should be overwhelmingly important to all men. Even his most brilliant twentieth-century detractor, the Renaissance apologist Geoffrey Scott, admits that Ruskin "undoubtedly raised the dignity of his subject" in arguing that "the arts must be justified by the way they make men feel": "Mere legalism, mere mechanism, mere convention, and everything which, outside the spirit of man, might exercise lordship over the arts he combated."[54]

Unfortunately, however—judging from too many modern buildings—this legacy seems almost as irrelevant as Ruskin's obsolete notions on the nature of architectural sculpture and the iniquity of machines. For good or for ill, technology is rapidly erasing national architectural character. Man-made materials are internationally available, while modern developments in heating, lighting, and air conditioning have greatly negated climatic influences on design. And as the world becomes increasingly industrialized, building needs

51. *Aratra Pentelici*, lec. 5, par. 145 (*Works*, 20). A manuscript addition discusses in detail why tall buildings are oppressive and impracticable (*Works*, 20: 303n).

52. Ch. 1, par. 1 (*Works*, 8).

53. *Val d'Arno*, lec. 5, par. 129 (*Works*, 23).

54. Geoffrey Scott, *The Architecture of Humanism*, 2d ed. (New York, 1924), pp. 133–34.

everywhere become more and more similar. The result: a skyscraper in Milan cannot be differentiated from one in Hong Kong. It is fitting that the Modern Movement came to fruition as "the International Style," encouraged especially by the affirmation of technology and mass production in the Bauhaus curriculum, and that the great Miesian motto "less is more" has become almost as much a cant phrase as "form follows function." But simple, rational, rectilinear modules, whatever their size or configuration, can only "talk" to human beings so much, especially after their ultimate refinement in the Seagram Building.

In recent years, however, there have been reassertions of the importance of the larger symbolic values in architecture that Ruskin stressed, typified in the pronouncements of the Gropius-trained American architect Paul Rudolph, from 1958 to 1965 head of the Department of Architecture at Yale. "The early theory of modern architecture focused on a very limited area," he argues; "Many architectural problems were largely ignored, . . . as if they didn't even exist If we are concerned with new problems of scale and human response, we should also heed some older ones. Monumentality, symbolism, decoration, and so on—age-old human needs—are among the architectural challenges that modern theory has brushed aside." And, he claims, "Many of our difficulties stem from the concept of functionalism as the prime or only determinant of form." Instead, functional requirements are but one determinant; others, as immediate as the regional and climatic influences that industrialization has minimized or as abstract as the spirit of the times, must also be considered.[55] Above all, Rudolph has consistently and unapologetically maintained, "visual delight" is "the architect's prime responsibility, for other specialists can do everything else that he does, and, quite often, much better."[56]

But how much visual delight can a city—or the individual human being—absorb? If the prospect of endless alleys of glass, steel, and concrete slabs is depressing, the idea of a streetscape in which Wright's Guggenheim stands next to Marcel Breuer's Whitney Museum, flanked on either side by Oscar Niemeyer's Presidential Palace at Brasilia and Moshe Safdie's Montreal Habitat, with Eero Saarinen's St. Louis Gateway Arch hovering over all, is downright nauseating. Again, Rudolph has a suggestion; there should be "foreground" and "background" structures. Buildings which are functional in the narrowest sense, such as those for housing, commerce, and administration, should merely provide a neutral backdrop for more elaborate structures like churches, gateways, and concert halls.[57] This idea is surprisingly close to the basic meaning

55. Paul Rudolph, "The Six Determinants of Architectural Form," *Architectural Record* 120 (October 1956): 183, 184, 186.

56. Paul Rudolph, "The Architectural Education in U.S.A.," *Zodiac*, no. 8 (1961), p. 165.

57. Rudolph, "Six Determinants," p. 184.

of the Lamp of Sacrifice, that the best efforts and finest materials should be expended in the service of the most important communal values. The danger is, however, that renewed emphasis on non- and antifunctional qualities can result in pseudo-romantic, gimmicky exhibitionism, what Giedion calls play-boy architecture or Nikolaus Pevsner maligns as structural acrobatics—and in what Ruskin over a century ago mocked as a futile search for an Eldorado of imagination. Functional architecture often starves the eye, but at any rate it usually doesn't offend it.

On the other hand, many "aspiring" twentieth-century buildings, noble and beautiful in effect, are at least partial failures functionally—and even Ruskin maintained that a building must satisfy practical needs first. Frank Lloyd Wright, of all modern architects, persistently asserted the importance of human scale; his works provide glorious psychological sustenance. But his leaking roofs are legendary. Paul Rudolph's own *tour de force,* the Art and Architecture Building at Yale (1963), was full of exciting visual experiences, yet proved so dysfunctional that after it was gutted by fire in 1969, he was not enlisted to plan its reconstruction.[58] The siting of skyscrapers back from their lot lines in order to make plazas with benches, trees, and fountains an integral part of the total architectural program, heralded at first as a way of restoring human warmth to depersonalized environments, is also backfiring unexpectedly. Because wind velocities are greater on the top of a tall building than at the bottom, even light breezes at the top create pressures that move down the face of the structure, causing winds at the bottom that are often twice the normal ground-level velocity. Pedestrians are blown over; doors refuse to open; water ends up everywhere but in the fountains. Offending structures include I. M. Pei's handsome Earth Science building at M.I.T. and Skidmore, Owings and Merrill's audacious John Hancock Center, Chicago.[59] "Modern architecture," says Paul Rudolph, "is still a gangling, awkward, ungracious, often inarticulate, precocious, adolescent thing, which has not yet even begun to reach full flower."[60] So much for Le Corbusier, Mies van der Rohe, and Frank Lloyd Wright. The arrogance of this dismissal is astonishing, but there is some truth in it as well. The criticisms Ruskin fired at the Victorian age have yet to be fully dealt with; they constitute a challenging legacy to our own century.

Ruskin's final great architectural bequest is his insistence on preserving and revering the buildings of the past as an inspiration to the present. If the architecture of the present reflects a nation's values, so also does a nation's attitude

58. "Too Much Form, Too Little Function?," *Time,* March 16, 1970, p. 58.
59. James MacGregor, "Why the Winds Howl Around Those Plazas Close to Skyscrapers," *Wall Street Journal,* February 18, 1971, pp. 1, 16.
60. Rudolph, "Architectural Education in U.S.A.," p. 164.

toward its architectural heritage. Everywhere Ruskin looked in his own day, he saw beautiful monuments being razed, or worse yet, by his standard, "restored to the white accuracies of novelty." The copious measurements, delicate sketches, and glowing word-paintings in his own architectural notes and writings provide valuable factual records of buildings now destroyed or altered. Time and again in his letters and diaries we find anguished accounts of his trying to draw some beautiful medieval detail as it is simultaneously being demolished; when he declined the R.I.B.A. Gold Medal he bitterly accused the group of abetting "the injurious neglect" of Europe's most precious monuments, "the destruction, under the name of restoration, of the most celebrated works for the sake of emolument," and "the sacrifice of any and all to temporary convenience."[61] His eloquent pleas for preservation, as opposed to restoration, inspired William Morris to found in 1877 the Society for the Protection of Ancient Buildings, which Pevsner regards as the "line from Ruskin to our century,"[62] for indeed this British organization is still very active. The society is now fighting to preserve England's Victorian architectural tradition, including buildings by G. E. Street and Gilbert Scott.

Even so, the twentieth century is more often than not insensitive to this legacy as well. Many important buildings, ancient and modern, have been wantonly destroyed in armed conflict; the effects of two world wars have been disastrous. "Do you think that in this nineteenth century it is still necessary for the European nations to turn all the places where their principal art-treasures are into battle-fields?" Ruskin demands in *A Joy for Ever.*[63] Things haven't changed much. But in times of peace numberless buildings are sacrificed as well. The most casual reader of any volume on architectural history must be struck by the "Now destroyed" and "Demolished" captions affixed to so many illustrations.

At the present time, economic factors pose the most immediate threat to architectural preservation. As cities densify, demand for space in particular locations grows; buildings which do not allow sufficiently intensive use of existing land—a Georgian terrace, say, or a Gothic Revival church—therefore become uneconomical and are torn down, to be replaced by something bigger and better, until finally, as Ruskin predicted, "you shall draw out your plates of glass and beat out your bars of iron till you have encompassed us all,—if your style is of the practical kind,—with endless perspective of black skeleton and blinding square"[64]

Nowhere in the world is this pattern more pervasive than on the island of

61. To Sir Gilbert Scott from Rome, May 20, 1874 (*Works,* 34: 514).

62. Nikolaus Pevsner, *Ruskin and Viollet-le-Duc, Englishness and Frenchness in the Appreciation of Gothic Architecture* (London, 1969), pp. 41–42.

63. Lec. 2, par. 75 (*Works,* 16).

64. *The Two Paths,* lec. 4, par. 101 (*Works,* 16).

Manhattan, where older low- to medium-rise buildings are regularly razed to make way for higher structures, which, one supposes, will eventually meet a similar fate. Ironically, our national income tax laws actually encourage such ephemeral construction patterns by allowing real estate investors to generate tax losses at the same time their buildings are producing cash income. In practice, this means that cheap materials are used because the shorter their economic life, the larger the amounts of depreciation that can be taken in the early years of investor ownership. The consequences of such practices—either higher maintenance costs or more rapid physical deterioration—are then often avoided by the original investor, who sells the property as soon as he has exhausted his tax benefits. Thus in essence we destroy an architectural heritage without creating a new one. But even regulation designed to promote sensible development does not, however, always succeed; too strict or too lax zoning regulations and all-or-nothing urban renewal schemes can destroy the past without insuring the aesthetic future.

European countries have, by contrast, generally done a better job of preventing this kind of disaster, partly, no doubt, because they have a greater heritage to protect. Beyond more enlightened zoning and generally stronger metropolitan planning, both England and France now possess legislation that enables historic areas, as opposed to just single buildings, to be preserved through cooperation between local and national governments. But such measures can have untoward effects, too. For example, in the City, London's traditional business district, an embargo on further office buildings went into effect in 1964. Competition for existing low-rise building space has grown so fierce that exorbitant rents force many firms to move out of the immediate area, thereby threatening the identities of less well-protected districts, or into suburban locations, thus encouraging urban sprawl and its concomitant problems.[65] On the other hand, French authorities recently approved a new office complex in Paris that will block the view through the Arc de Triomphe, a vista already threatened by the projected skyline of La Défense, a satellite city three miles west.[66] Bureaucratic indifference and parsimony are so serious in Italy that in 1967 a group of Italian conservation and cultural organizations mounted a searing photographic and statistical exhibit, "Art and Landscape of Italy, Too Late to Be Saved?," which has since been touring the world to arouse public outcry for more concerted preservation efforts. Priceless Italian artifacts are uncatalogued and unguarded, important monuments ill-maintained because, for instance, the nation's Fine Arts Commission, operating as part of the Ministry of Education, receives less than 3 percent of that ministry's funds and maintains a staff of experts numbering 352—about half the figure serving New York's Metropolitan

65. "High office rents in a low-profile city," *Business Week*, May 30, 1970, p. 67.
66. "Building a New Paris," *Time*, July 10, 1972, pp. 60, 63.

Museum alone.[67] Italian tax policies hinder private preservation efforts as well: new construction is exempt from taxation for twenty-five years, while improvement of existing structures is taxed at the full rate; nor are individuals permitted to take charitable income tax deductions.[68]

More gradual and therefore more insidious destruction is wrought by indirect economic manifestations, especially the now ubiquitous automobile with its attendant air pollution and the insatiable demand it creates for roads and parking space. Traffic vibrations loosen ancient foundations; auto exhausts corrode already weathered masonry; Renaissance and Baroque plazas are transmuted into parking lots. The vibrations and pollution from jet aircraft are similarly destructive, while the possible effects of SST sonic booms, especially on medieval glass, are horrifying to consider. Economic development also means that more people can afford to travel to areas rich in historic architecture, and drive more cars and fly in more planes to get there. In 1968 alone, 28.6 million tourists invaded Italy, almost double the figure a decade earlier; some of them left names and slogans behind—scratched, for example, in frescoes of the Florentine Duomo.[69]

But the city whose architectural treasures have been ravaged most by the effects of modern life is Ruskin's own beloved Venice, whose future over the next half-century is tenuous indeed.[70] No one has ever described more memorably than John Ruskin the fragile balance of tidal patterns that permitted her greatness; Venice's sea-girt setting, originally her protection against invasion and depredation, has been a liability as well. Historically she has been sinking four to five inches per century, and over the years her pilings have been weakened by salt-water corrosion. This natural long-term destruction by water has been greatly hastened in recent years, however, by the pressures of modern industry and technology. The rate of sinking has been in part accelerated because the

67. These figures are drawn from the exhibit catalog, available from the Italian Art and Landscape Foundation, 660 Madison Avenue, New York, New York 10021. A depressing recent verification of such conditions: on December 10, 1972, thieves broke into the Cathedral of Castelfranco Veneto near Venice and stole Ruskin's revered "Madonna with Child and Saints" (the "Castelfranco Madonna") by Giorgione (*Wisconsin State Journal*, Madison, December 11, 1972, p. 3).

68. Indro Montanelli, "For Venice," in *Venice in Peril* (New York, 1970), p. 18.

69. Roger Ricklefs, "Many Historic Wonders In Europe Threatened By Modern Hazards," *Wall Street Journal*, December 22, 1969, pp. 1, 16.

70. The following discussion is a synthesis of facts drawn from these sources: "The Fight to Save the Sinking Jewel of the Adriatic," *Time*, July 25, 1969, pp. 30–35; "Is Venice Doomed?," *Life*, July 18, 1969, pp. 34–43; Ricklefs, "Many Historic Wonders," pp. 1, 16; promotional materials available from the Venice Committee of the International Fund for Monuments, Inc., 15 Gramercy Park, New York, New York 10003, including the volume *Venice in Peril*; and "Venice: Problems and Possibilities," a special issue of *Architectural Review* 149 (May 1971).

underground water that cushions Venice is being pumped away for mainland industrial and agricultural uses. Dredging operations for tanker canals in the lagoon between Venice and the coastal factory city of Marghera have altered tidal patterns, increasing their speed and force, while two large areas of the lagoon have been filled in for industrial development, reducing the marshlands that ordinarily help to absorb excess water. (A projected third area is being fought by a Venetian noblewoman, which Ruskin would applaud.) Consequently, flooding in the city has become both more frequent and more violent; after the second "industrial zone" was finished, unusually high tides eclipsed in only twelve years the numbers of such tides in the previous ninety.

Within the city itself, a further technological cause of water damage is the wakes thrown by *vaporetti*, the noisy, motor-powered water-buses which have supplanted the gondola as the primary form of Venetian transportation. Meanwhile, the melting polar ice cap is causing the sea level at Venice to rise .055 inches a year. But the appalling injury done Venetian architecture by these combined causes rises literally higher than tide and flood levels: the moisture seeps into foundations and upward through walls, sometimes as much as twelve feet, causing marble to crack and split, frescoes to flake, plaster to crack, and floors to heave.

An even more treacherous technological destroyer is air pollution. Smoke spewed by industrial complexes on the mainland and *vaporetti* exhausts are serious corroders, but the worst damage is traceable to the crude oil and high-sulphur-content soft coal Venetians have customarily used for heating purposes. The sulphur wastes from incompletely burned fuel are incredibly destructive of the marble Ruskin loved so well, because they combine with the calcium carbonate in moistened marble to form calcium sulphate. Since the new compound displaces twice the volume of calcium carbonate, the resultant expansion causes the marble to crumble or "explode." About 250 of St. Mark's pillars are affected. (Such deterioration has been exacerbated by *ciceroni* who finger the powdering surfaces to demonstrate their fragility to the over three million tourists descending on Venice annually.) Leprous madonnas with missing fingers and lips, and cancerous angels, their wings maimed, dot the churches of the dying city—grotesque repudiations of Ruskin's sanguine assumption that "a marble surface receives in its age hues of continually increasing glow and grandeur; its stains are never foul nor dim; its undecomposing surface preserves a soft fruit-like polish for ever, slowly flushed by the maturing suns of centuries." The Storm Cloud of the Twentieth-Century has done damage to Venice far worse than any wreaked by Ruskin's hated restorers in the nineteenth.[71]

71. It can be argued, of course, that all is not yet lost. Among remedial measures proposed or being taken: antipollution filters on smokestacks; phasing out of tanker shipping

But in later years Ruskin seems to have intuited that this would be the case. He complains in his 1881 "Castel-Franco Epilogue" to *Stones* that "when I was last in Venice [1876–77] . . . I was finally driven out of my tiny lodgings on the Giudecca by the rattling and screaming, night and day, of the cranes and whistles of the steamers which came to unload coals on the quay." [72] And in *St. Mark's Rest* he declares with chilling accuracy, "the development of civilization now only brings black steam-tugs, to bear the people of Venice to the bathing-machines of Lido, covering their Ducal Palace with soot, and consuming its sculptures with sulphurous acid." [73] The fate of modern Venice, the city Ruskin wanted most desperately to conserve, provides verification of his own tragic fate, which he glimpsed so early: "I seem born to conceive what I cannot execute, recommend what I cannot obtain, and mourn over what I cannot save." [74]

in the lagoon; applying water-resistant silicone treatments to statues; a system of dikes and locks to stem high tides. But given their costliness at a time when art treasures elsewhere are likewise threatened, the inertia of bureaucracies, and the unending modern struggle between economic growth and cultural conservation, not to mention man's inability to predict the long-range effects of even the most well-meant corrective measures (for example, Venice experimented with checking erosion by lining some canals with concrete, but this destroyed the microbes that fed on sewage), there seems limited room for optimism. Technology appears more likely to destroy Venice than to rescue her.

72. Par. 3 (*Works*, 11).
73. Ch. 1, par. 5 (*Works*, 24).
74. To his father, from Abbeville, August 9, 1848 (*Works*, 7: xxix).

6

The Ultimate Significance
of Ruskin's Architectural Writings:
An Index to His Mind

In the preceding chapters we have reviewed the emphases and omissions in Ruskin's architectural criticism—how he saw buildings as collections of planes to be enhanced with rich colors and delicate sculptured details, how he disregarded the bolder elements of architecture like mass, volume, and structure. We have also examined some of the immediate reasons for these biases, the most obvious being his use of Italian Gothic as a standard of perfection. These discussions have in turn permitted us to gauge the general nature and extent of his influence on both nineteenth- and twentieth-century architecture. But Ruskin's architectural writings possess a more basic and striking significance than any we have yet investigated. The broader, deeper, underlying causes of his emphases will be explored in this closing chapter, enabling us to judge how his architectural works fit into his *corpus* as a whole and to understand their ultimate importance as a revelation of his mind.

Unique as Ruskin's mentality was, we have seen ample evidence that many of his views on architecture were undeniably conditioned by the aesthetic temper of the Victorian period. This was especially true of his emphasis on ornament, which was characteristically Victorian. Nikolaus Pevsner claims

that the primacy of ornament as an architectural component was the basic doc-
trine of nineteenth-century architectural theory[1] —and of design theory in gen-
eral; when read closely, even avant-garde critics like Henry Cole and Owen
Jones, though they challenge the propriety of various kinds of ornament, never
seriously question its essential desirability. This emphasis on ornament marked
all the architectural revivals of the day, not just the Gothic; it was, in fact,
mainly through ornament that a building assumed its costume, its historical
identity. The Goths particularly concentrated on decorative detail, however,
in part because of the pronounced strain of archaeological purism that had per-
meated the Revival almost from its outset, and in part because of their ecclesi-
ological bias. Rich ornament was a way of praising God, a position Ruskin
himself sanctified as the Lamp of Sacrifice. Furthermore, this decoration was
invariably thought of as *applied;* hence it could easily be considered independ-
ent of mere structure, Pugin's notions of ornamented construction notwith-
standing. For ornament was universally viewed as a source of aesthetic gratifi-
cation, a mark of cultivation, and most of all as a status symbol, a way of broad-
casting institutional or individual dignity and prosperity to the world. Inevit-
ably, therefore, ornament came to be treated as an overwhelming good in itself.
This primacy of ornament can be traced also to the Victorian incapacity to
understand the formal logic of new materials: their structural possibilities
were difficult to envision, the decorative were not. And concurrently the no-
tion of the architect as a scholar, a man of culture, encouraged the definition
of architecture as ornament rather than structure, the latter being the province
of the uncultivated, inartistic engineer.

 But despite its overriding love of ornament, and therefore its tendency to
define Gothic, especially, by decorative motifs, the nineteenth century had
seen many attempts to assemble Gothic structural knowledge. Both in Charles
Eastlake's 1872 *History* and in Paul Frankl's authoritative 1960 survey of
Gothic sources, an impressive number of technical works are cited. Indeed,
although much important research was done later in the century by French
and German scholars, the English were the earliest serious students of Gothic
construction, thanks partly to the burst of comprehensive topographical vol-
umes during the opening decades, exemplified by John Britton's series. Spe-
cifically, a distinct literature on Gothic vaulting existed. The earliest published
vaulting theory cited by Frankl—in which the pointed arch is shown to result
from the problem of spanning different widths—dates from 1814, a printing
in *Archaeologia* of George Saunders's 1811 lecture, "Observations on the Origin
of Gothic Architecture."[2] Successive studies in which Gothic structure and

 1. Nikolaus Pevsner, *Pioneers of Modern Design,* Pelican ed. (Harmondsworth, 1960), p. 19.
 2. Paul Frankl, *The Gothic, Literary Sources and Interpretations through Eight Cen-
turies* (Princeton, 1960), p. 500.

particularly vaulting were directly discussed include Thomas Rickman's *Attempt to discriminate the Styles of Architecture in England from the Conquest to the Reformation* (1817), which represented the first systematic analysis of individual constructive features in British medieval architecture, Thomas Hope's widely read *Historical Essay on Architecture* (1835),[3] and architect Alfred Bartholomew's *Specifications for Practical Architecture* (1840).

Perhaps the most astute scholar of Gothic construction in Ruskin's early days was Robert Willis, whose *Remarks on the Architecture of the Middle Ages, especially of Italy* appeared in 1835. In this volume Willis distinguishes between "mechanical" and "decorative" construction as well as between French and Italian Gothic; he offers considerable discussion of vaulting, which became the subject of his 1842 study, *On the Construction of the Vaults of the Middle Ages,* described by Frankl as unusually informative and not outdated even as late as 1910, when it was reprinted.[4] Ruskin knew some of Willis's works, and he also knew Willis, whom he met in 1851 at Cambridge through Dr. William Whewell of Trinity College, himself a student of Gothic structure.[5] He refers directly to Willis in *The Seven Lamps,* and in an 1880 note to that passage remarks:

> Professor Willis was, I believe, the first modern who observed and ascertained the lost structural principles of Gothic architecture. His book [*Architecture of the Middle Ages . . .*] taught me all my grammar of central Gothic, but [the] grammar of the flamboyant I worked out for myself, and wrote it here, supposing the statements new; all had, however, been done previously by Professor Willis, as he afterwards pointed out to me[6]

These briefly cited authors are taken merely as representative of a general movement in the first half of the nineteenth century, labeled by Frankl "The Scientific Trend," which was well developed by the time of Ruskin's major architectural study; indeed, by the 1840s, vault structure specifically "came to occupy a chapter in every book that was intended to present a history of mediaeval architecture," whether by French, German, or English scholars.[7] Despite

3. Ruskin refers to Hope several times in his own writings, including a laudatory note in *Stones of Venice II* on the justice he does to the style of the early Christian churches (note to ch. 2, par. 5, in the Library Edition of *The Works of John Ruskin,* ed. E. T. Cook and Alexander Wedderburn, 39 vols. [London and New York, 1903–12] , 10: 22n; hereafter cited as *Works*).

4. Frankl, *The Gothic,* pp. 529–30.

5. See Ruskin's accounts of their meetings in letters to his father, April 6 and 7, 1851 (*Works,* 8: xl).

6. The reference is to ch. 2, par. 21 (*Works,* 8); the 1880 note is given in *Works,* 8: 95n.

7. Frankl, *The Gothic,* p. 538.

Ruskin's habitual innocence of others' ideas, therefore, it is evident he was aware that Gothic structure could, even should, be directly discussed in art-historic works of the kind he was writing, and that many informative volumes were available for his reference. He had to make a conscious decision to *ignore* such questions; his slighting of constructional matters in preference to ornament can be explained only partly as characteristic of the age.

To a far greater extent, Ruskin's emphases were by-products or rationalizations of his own special interests and experiences. Throughout this study I have stressed the highly personal character of Ruskin's work, and how his need not simply to declare his preferences but to exalt them as universally superior led to absurdly casuistic exercises in self-justification. Curiously, in *Modern Painters II* (1846), Ruskin warns his readers against considering one's own favorite associations as infallible indicators of beauty:

> For every one of us has peculiar sources of enjoyment necessarily opened to him in certain scenes and things, sources which are sealed to others; and we must be wary, on the one hand, of confounding these in ourselves with ultimate conclusions of taste, and so forcing them upon all as authoritative, and on the other, of supposing that the enjoyments of others which we cannot share are shallow or unwarrantable, because incommunicable.[8]

Then he explains that in this volume he "may have attributed too much community and authority to certain affections of my own . . . and too little to those which I perceive in others" But by and large he found such a sensible admonition difficult to heed, so that his statement in the paragraph preceding this confession is more accurately self-descriptive: "it is quite impossible for any individual to distinguish in himself the unconscious underworking of indefinite association peculiar to him individually, from those great laws of choice under which he is comprehended with all his race."[9]

Among Ruskin's earliest "peculiar sources of enjoyment" were, of course, his numerous trips to the Continent, with its spectacular Alpine scenery and—especially in Italy—its picturesque ruins, that made England seem to him drab indeed. This bias is the more understandable because of Ruskin's cloistered, toyless childhood; as relief from the quiet, strictly regulated confines of Herne Hill, his early luxurious travels must have seemed like excursions through an enchanted wonderland, which Ruskin himself admits in *Praeterita*: "[a] great part of my acute perception and deep feeling of the beauty of architecture and scenery abroad, was owing to the well-formed habit of narrowing myself to

8. Pt. 3, sec. 1, ch. 4, par. 12 (*Works*, 4).
9. Ibid., pars. 12, 11.

happiness within the four brick walls of our fifty by one hundred yards of garden; and accepting with resignation the aesthetic surroundings of a London suburb, and, yet more, of a London chapel."[10] Such contrast was the more piquant in romantic Venice, that "Paradise of cities," for "my Venice, like Turner's, had been chiefly created for us by Byron," and this early magical aura never wholly faded; in 1877 he could still declare: "She has taught me all that I have rightly learned of the arts which are my joy; and of all the happy and ardent days which, in my earlier life, it was granted me to spend in this Holy land of Italy, none were so precious as those which I used to pass in the bright recess of [the] Piazzetta"[11] The beauty of Venice became a constant touchstone for Ruskin; as late as *The Bible of Amiens* he praises the medieval city of Amiens as "the Venice of Picardy" and elaborates lengthily on the parallels between them, wondering in astonishment "Why should this fountain of rainbows leap up suddenly here by Somme; and a little Frankish maid write herself the sister of Venice . . . ? And if she, why not others also of our northern villages?"[12] Hence, when he turned his interest to architecture, it was almost inevitable that he should choose to set as a splendid standard those buildings so closely associated with his early rapturous journeys.

But it cannot be too much emphasized how necessary the continual deprecation of everything *English* was to his enjoyment of the Continent in general and Italy in particular. Judging from his diaries and letters, it is plain that for Ruskin England provides merely a temporary resting place, within whose dull, smoky boundaries he can recharge his sensitivities for a new excursion to the Continent. A typical diary entry is this 1841 observation in Rome: "very full of feeling, but I cannot feel now as I could five months ago. Must go home to get up the steam again." Five months later, at Leamington: "I am very glad to find that if I was pretty well satiated with the nine months abroad, I am recovering my fresh feeling very fast. I am nearly ready for another start already."[13] Whenever he returns home, moreover, he feels not even a twinge of affectionate recognition; the cliffs of Dover "look like mere banks of rubbish, . . . not so high as the first rocks of an Alpine foreground. . . . Cliffs indeed! . . . [But] I have had some pleasure even in my dull rambles here; they heighten the beauty of what I have seen lately by vigorous contrast and cast a charm of enchantment over all I remember."[14] In an 1859 message to the Brownings he frankly confesses: "There was another thing in

10. Vol. 1, ch. 7, par. 152 (*Works,* 35).

11. Ibid., vol. 2, ch. 3, pars. 57, 55; "A Letter to Count Zorzi," par. 2 (*Works,* 24).

12. Ch. 1, pars. 2, 3 (*Works,* 33).

13. April 10 and September 10, 1841, *The Diaries of John Ruskin,* ed. Joan Evans and J. H. Whitehouse, 3 vols. (Oxford, 1956–59), 1: 171, 212; hereafter cited as *Diaries.*

14. Dover, August 23, 1844, ibid., p. 318.

your letters comforting to me—your delightful want of patriotism—loving Italy so much; for I sometimes think I am going quite wrong when I don't feel happy in coming home."[15]

So deep-seated is this emotional pattern that Ruskin must attribute it to Turner also; otherwise, why did Turner paint unromantic Margate so often, "for the sake of this simple vision, again and again [quitting] all higher thoughts"? "There is only this one point to be remembered, as tending to lessen our regret, that it is possible Turner might have felt the necessity of compelling himself sometimes to dwell on the most familiar and prosaic scenery, in order to prevent his becoming so much accustomed to that of a higher class as to diminish his enthusiasm in its presence."[16] Likewise, it is painfully puzzling to Ruskin that once Turner had been to the Alps he should continue to depict so many British scenes:

> . . . it is remarkable that after his acquaintance with this scenery, so congenial in almost all respects with the energy of his mind, . . . the proportion of English to foreign subjects should in the rest of the [*Liber Studiorum*] be more than two to one; and that those English subjects should be, many of them, of a kind peculiarly simple, and of every-day occurrence; . . . and that the architectural subjects, instead of being taken . . . from some of the enormous continental masses, are almost exclusively British . . . and, farther, not only is the preponderance of subject British, but of affection also; for it is strange with what fulness and completion the home subjects are treated in comparison with the greater part of the foreign ones.[17]

Significantly, Ruskin's aversion to English topography is at least partly explained by his fascination with picturesque decay, especially in architecture (to be examined later in this chapter). Trying to define "the intense pleasure" he always feels on first seeing Calais church "after some prolonged stay in England" he comments:

> We, in England, have our new street, our new inn, our green shaven lawn, and our piece of ruin emergent from it,—a mere *specimen* of the Middle Ages put on a bit of velvet carpet to be shown But, on the Continent, the links are unbroken between the past and present, and, in such use as they can serve for, the grey-headed wrecks are suffered to stay with men And thus in its largeness, in its permitted evidence of slow decline, in its poverty, in its absence of all pretence, of all show and care

15. January 15, 1859 (*Works*, 36: 303).
16. Ruskin's note to Plate 6 of *The Harbours of England* (1856) in *Works*, 13: 61.
17. *Modern Painters I*, pt. 2, sec. 1, ch. 7, par. 40 (*Works*, 3).

for outside aspect, that Calais tower has an infinite of symbolism in it[18]

The English are ignobly guilty of "trimness" and "serenity of perfection," symptomatized by "the spirit of well-principled housemaids everywhere," by "border and order, and spikiness and spruceness." Continental "largeness and age" are exactly opposed to "that marvellous smallness both of houses and scenery" characterizing England.[19]

For our purposes, the most relevant aspect of this bias has been his abhorrence of English Gothic. In his preface to *The Seven Lamps* he excuses the lack of Early English examples, telling us, "I have always found it impossible to work in the cold interiors of our cathedrals; while the daily services, lamps, and fumigation of those upon the Continent, render them perfectly safe."[20] Had he taken the measurements of Salisbury as carefully as those of St. Mark's, he might not have so vehemently exclaimed, "all that we do is small and mean, if not worse—thin, and wasted, and unsubstantial." But it was not just one of those queer twists of mundane circumstance, the absence of heat, that prevented his developing respect for his native architecture, because he was throughout his life constantly declaring England's deficiencies in all areas of human activity: England produces ugly belfries,[21] inferior suspension bridges,[22] undignified duchesses,[23] and bad ballerinas;[24] "we have no taste, even in chimneys."[25] The English language itself, which Ruskin wielded so magnificently, is "ridiculous" in its "mincing of the vowels"; his longtime

18. *Modern Painters IV*, pt. 5, ch. 1, pars. 2, 3 (*Works*, 6).

19. Ibid., pars. 5, 6 passim.

20. Par. 6 (*Works*, 8). He goes on to explain that a few days' work at Salisbury left him in "a state of weakened health." Cf. a February 18, 1859, letter to his father from Northampton (*Works*, 16: lxii) complaining about the "nasty east wind" he endured during a ninety-minute visit to "gloomy" St. Albans, and his comment on his vexations at visiting Worcester in 1883 (an unidentified letter in *Works*, 33: 511n) that concludes, "I sometimes wish [the English cathedrals] were all in ruins rather than in their chill of uselessness." One wonders if Ruskin ever truly recognized, as Pugin did, how much the full daily use of these monuments would depend on the revival of the High Church or Catholic rituals and doctrines for which he expressed such antipathy as an Evangelical.

21. The horizontal blinds in the lights are bad (*Seven Lamps*, ch. 3, par. 23 [*Works*, 8]).

22. Fribourg's is "finer" and "more wonderful" than Thomas Telford's pioneering Menai Strait span (September 4, 1835, *Diaries*, 1: 59).

23. The English duchess is "generally a fat old woman, worse dressed than anybody else and highly painted—and with a whole jewellers [*sic*] shop of diamonds shaken over her till she looks like a chandelier . . ." (to his father from Venice, February 19, 1852, in *Ruskin's Letters from Venice, 1851–1852*, ed. John L. Bradley [New Haven, 1955], p. 186).

24. Italian dancers have "less discipline" but "more knowledge and spirit" (February 19, 1841, *Diaries*, 1: 155).

25. *Poetry of Architecture*, par. 79 (*Works*, 1).

editor W. H. Harrison, disputing with him over a preposition in *Elements of Drawing,* told him, "you have an unfilial hatred of your mother tongue." [26] At times he seems perversely bent on undermining the most inoffensively English characteristics, as when in his diary he notes that French ivy is "lighter and lovelier in leaf than ours" or says of a Florentine meadow that no English one "ever was . . . more simple and Isaac-Waltonish, more perfectly Pastoral." [27]

Even England's greatest author is not sacrosanct, for Ruskin argues in *Modern Painters IV* that Shakespeare, seeming "to have been sent essentially to take universal and equal grasp of the *human* nature," could thus "be allowed no mountains; nay, not even any supreme natural beauty. He had to be left with his kingcups and clover;—pansies—the passing clouds—the Avon's flow—and the undulating hills and woods of Warwick" Otherwise, "You would have made another Dante of him." But in view of Ruskin's oft-declared reverence for Dante above all other poets, he might have considered this transmigration preferable:

> . . . whatever difference, involving inferiority, there exists between [Shakespeare] and Dante, in his conceptions of the relation between this world and the next, we may partly trace . . . to the less noble character of the scenes around him in his youth; and admit that, though it was necessary for his special work that he should be put, as it were, on a level with his race, on those plains of Stratford, we should see in this a proof, instead of a negation, of the mountain power over human intellect. For breadth and perfectness of condescending sight, the Shakesperian mind stands alone; but in *ascending* sight it is limited. [28]

As with his treatment of Turner, one can't help perceiving Ruskin's genuine sorrow that these two great English geniuses had not his own inestimable advantage of going abroad at a formative age. It is appropriate that Ruskin's last set of Oxford lectures, *The Pleasures of England,* should have been in fact devoted largely to England's "tutor nations," and dealt mainly with what England might have been.

Paradoxically, this constant denigration of his own country exists side by side with pronouncements on the necessity to great artistic achievement of love and respect for one's nationality; we find him insisting at the beginning of his career in *Modern Painters I* that "of this I am certain, . . . whatever is to be truly great or affecting must have on it the strong stamp of the native

26. *Stones of Venice II,* ch. 8, par. 121 (*Works,* 10); Harrison, quoted in *Works,* 15: xixn.

27. Champagnole, April 19, 1846, Florence, April 29, 1841, *Diaries,* 1: 324, 179.

28. Pt. 5, ch. 20, pars. 28, 29, 38 (*Works,* 6).

land. Not a law this, but a necessity"[29] He is still proclaiming it in *The Bible of Amiens:* "nothing is permanently helpful to any race or condition of men but the spirit that is in their own hearts, kindled by the love of their native land."[30] And the great theme running through his major architectural writings is that a nation's buildings must indelibly reflect its character, for good or for ill. Yet Ruskin persistently denies his own national heritage. His description in "Pre-Raphaelitism" of the painters Samuel Prout and J. F. Lewis applies equally to himself: "[They] seem to have been intended to appreciate the characters of foreign countries more than of their own, nay, to have been born in England chiefly that the excitement of strangeness might enhance to them the interest of the scenes they had to represent."[31]

Ruskin was blind to the value of almost all things English; further, this prejudice against his homeland was clearly rooted before he fully grasped the defects of Victorian industrialism, his hatred of which might otherwise largely explain such an attitude. Instead, his views on political economy intensified or reinforced a pre-existing contempt. Perhaps, as G. M. Young has suggested, "Ruskin was a Grand Tourist, and below the level of the Grand Tour or the Journey in Pursuit of the Picturesque, in Dovedale or the Lakes, he could not see at all."[32] But certainly for Ruskin one of the great virtues of Italian Gothic was simply that it was not English.

In another very important way, Ruskin's early travels profoundly influenced

29. Pt. 2, sec. 1, ch. 7, par. 37 (*Works,* 3).

30. Ch. 3, par. 15 (*Works,* 33).

31. Par. 27 (*Works,* 12).

32. G. M. Young, "Eyes and No Eyes," *Last Essays* (London, 1950), p. 134. Any attempt to isolate recurring evidences of national character in art is perilous, but this is what the distinguished architectural historian Nikolaus Pevsner undertakes in *The Englishness of English Art* (London, 1956). Among the qualities of artistic character that he considers peculiarly English are a "preference for the observed fact and the personal experience," especially as a basis for "preaching"; a preoccupation with "things on a small scale" such as bosses, capitals, miniatures, and watercolors; and, specifically in architecture, a fondness for "beautiful surface quality" and "a refusal to mould space, to knead it together"—what he labels the English "anti-corporeal attitude," arguing finally that "disembodiment" is "the most significant formal quality in English art" (pp. 46, 36, 80, 105, 97, 166, 199). It is ironic, therefore, that by Pevsner's standards at any rate, Ruskin's way of seeing and valuing architecture does in spite of everything "have on it the strong stamp of the native land" and is as English as his anglicized references to "Paul" Veronese, "John" Bellini, and "Nicolas the Pisan."

Ironically, too, some of the Venetian Gothic qualities he reveres are found in England as well; for example, the ogee arch universal in Venetian architecture appears in English sculpture as early as 1291 (Paul Frankl, *Gothic Architecture* [Harmondsworth, 1962], p. 151); the dogtooth and billet mouldings G. E. Street notes as "so peculiarly characteristic of Venetian works of all dates" (*Brick and Marble Architecture* . . . [London, 1855], p. 166) are common in the Norman phase of medieval English building. Ruskin regards such elements as beautiful in Venice and barbarous in England.

his preference for Gothic architecture per se. Undoubtedly one of the qualities of Gothic that attracted him most was its rugged, irregular outlines, which he associated with the Alpine horizons he loved so well and had studied so zealously as a boy. Throughout his work, but especially in *Modern Painters,* Ruskin regularly draws comparisons between mountain and Gothic cathedral, often using one as a metaphor for the other. In *Modern Painters IV,* where he discusses mountains as creations of "the great Architect," he actually presents comparative figures of Alpine profiles and those of gable roofs and castle buttresses,[33] while in "The Nature of Gothic" the "look of mountain brotherhood between the cathedral and the Alp" is integral to Ruskin's definition of the Gothic spirit.

Yet even this attraction has a significant Italian bearing. For one of Ruskin's greatest visual pleasures was the *juxtaposition* of mountain and Gothic contours, and in no country were such echoes so widely possible as Italy, "where there is not one city from whose towers we may not descry the blue outline of Alp or Apennine."[34] As early as *The Poetry of Architecture,* furthermore, Ruskin was arguing that the glory of Italian mountains is greatest perceived at a distance: "their height is better told, their outlines softer and more melodious, their majesty more mysterious."[35] From his youngest years, so strongly was "the idea of distant hills . . . connected in my mind with approach to the extreme felicities of life," that when the painter James Northcote

> . . . asked me (little thinking, I fancy, to get any answer so explicit) what I would like to have in the distance of my [portrait, that] I should have said "blue hills" instead of "gooseberry bushes," appears to me—and I think without any morbid tendency to think over-much of myself—a fact sufficiently curious, and not without promise, in a child of [three and a half years].[36]

Thus at his first sight of Milan Cathedral in 1833 it is not surprising that "the mere richness and fineness of lace-like tracery against the sky was a consummate rapture to me—how much more getting up to it and climbing among it, with the Monte Rosa seen between its pinnacles across the plain!"[37]

However, the city in which Ruskin found these perspectives most splendid

33. Pt. 5, ch. 16, pars. 11, 13–14, figs. 30, 35; ch. 15, par. 9, figs. 50–52 (*Works,* 6: 223, 228, 249).

34. *Stones of Venice II,* ch. 7, par. 38 (*Works,* 10).

35. From a long note to par. 103 on Italian mountain scenery (*Works,* 1: 80n).

36. *Praeterita,* vol. 1, ch. 1, par. 15 (*Works,* 35). He refers here, however, to his early love of the hills of Highland Scotland, before he had visited the Continent.

37. Ibid., ch. 6, par. 136.

was, naturally, Venice. His Venetian diaries and letters are filled with references to the distant backdrop of "dark mountain chain, countless in its serrations and gathering together of pointed peaks, . . . sharp and shattered against the amber air," and to the Alpine summits "glowing like a golden chain in irregular links all round the horizon."[38] Immediately after the laborious researches for *Stones* were done, in fact, the only aspect of Venice that could still move him was this merging of her Gothic outlines with those of the surrounding mountains:

> There was only one place in Venice which I never lost the feeling of joy in— . . . and that was just half way between the end of the Giudecca and St. George of the seaweed, at sunset. If you tie your boat to one of the posts there you can see the Euganeans, where the sun goes down, and all the Alps and Venice behind you by the rosy sunlight: there is no other spot so beautiful.[39]

Fittingly, the grand central volume of *Stones of Venice* closes with an image of "the great chain of the Alps, crested with silver clouds, . . . rising above the front of the Ducal Palace," and Ruskin musing over which is the greater of God's expressions.[40]

Certainly Ruskin's attraction to Gothic had additional causes: as magnificently permanent evidence of a great age of faith, Gothic appealed to his own profoundly religious temperament, just as his idealized vision of generations of men working in unity, freely sacrificing themselves for an inspired common goal, was a pattern for his later social theory. He also considered Gothic the product of an era of clarity, a time without darkness and shadow, wholly unlike the "age of chiaroscuro" which is the post-medieval world:

> . . . all knowledge and sight are given, no more as in the Gothic times, through a window of glass, brightly, but as through a telescope-glass, darkly. Your cathedral window shut you from the true sky, and illumined you with a vision; your telescope leads you to the sky, but darkens its light, and reveals nebula beyond nebula, far and farther, and to no conceivable farthest—unresolvable.[41]

What is most striking, however, about Ruskin's lifelong identification of mountain with cathedral is that he *looked* at them both in the same way:

38. November 20, 1849, *Diaries*, 2: 450; to his father, December 18, 1851, in *Ruskin's Letters from Venice*, ed. Bradley, p. 96.

39. A May 1859 letter to Charles Eliot Norton (*Works*, 9: xxviii).

40. Vol. 2, ch. 8, par. 140 (*Works*, 10).

41. *Lectures on Art*, lec. 7, par. 179 (*Works*, 20).

... Alpine precipices ... have not been properly drawn, because people do
not usually attribute the magnificence of their effect to the trifling details
which really are its elements For [the reader] may rest assured that,
as the Matterhorn is built out of mica flakes, so every great pictorial impres-
sion in scenery of this kind is to be reached by little and little; the cliff must
be built in the picture as it was probably in reality—inch by inch [A]
literal facsimile is impossible, just as a literal facsimile of the carving of an
entire cathedral front is impossible. But it is as vain to endeavour to give
any conception of an Alpine cliff without minuteness of detail, and by
mere breadth of effect, as it would be to give a conception of the façades
of Rouen or Rheims, without indicating any statues or foliation.[42]

The deepest and most consistent impulses behind Ruskin's architectural prefer-
ences and emphases are rooted in the way he apprehended external reality.

I have repeatedly shown in this study that Ruskin perceived architecture main-
ly in two dimensions. But many of his other aesthetic preferences were "flat"
as well. Although in later years he was never as interested in medieval stained
glass as one might expect (probably because in Italian Gothic churches it is
used comparatively sparsely), one of his earliest discussions of the nature of
architectural materials comes in an 1844 series of letters on stained glass to a
friend, Edmund Oldfield,[43] who, with Ruskin, had agreed to design a large east
window for Gilbert Scott's church of St. Giles, Camberwell. Oldfield did most
of the work, but Ruskin typically provided copious advice from abroad, basing
his directions on the windows he was observing in French monuments. He
stresses that their beauty lies in their flat, irregular, richly colored pattern,
through which form is exclusively conveyed; years later, he is still insisting that
"a painted window should be a simple, transparent harmony of lovely bits of
coloured glass— ... pretending to no art but that of lovely colour arrangement,
and clear outline grouping."[44]

Another "flat" art which fascinated Ruskin was medieval manuscripts; he
first purchased one, by his own recollection, about 1850–51, but was studying
them in the British Museum as early as 1846. "John and his Father go on buy-
ing Missals at a most extravagant rate," Effie reported to her mother in 1853,[45]
and he continued to purchase them well into the 1880s. He gave many away,
but altogether at one time or another owned at least eighty-seven.[46] He loved
to study them, "counting their letters and unravelling their arabesques as if they

42. *Modern Painters IV*, pt. 5, ch. 16, par. 42 (*Works*, 6).
43. Given in *Works*, 12: 435–47.
44. Letter to E. S. Dallas "(circa 1860)" (*Works*, 36: 335).
45. Mary Lutyens, *Millais and the Ruskins* (London, 1967), p. 30.
46. James Dearden, "John Ruskin, the Collector," *The Library*, 5th ser., 21: 125,
126.

had all been of beaten gold,—as many of them indeed were,"[47] and they became a favorite source of metaphors in his architectural descriptions, especially of Venetian palaces. Conversely, as we have seen, he considered "a well-illuminated missal" to be "a fairy cathedral full of painted windows, bound together to carry in one's pocket." But the beauty of these manuscripts is scarcely architectural in feeling; rather, it is wholly two-dimensional, the fundamental principles of the art, as Ruskin himself defined them, being "clearness of outline and simplicity of colour, without the introduction of light and shade."[48] Moreover, he evidently had scant sense of the missal as a whole volume, or even of the relationship between illumination and text on a single page. He regularly annotated his manuscripts in ink and frequently tore them apart to share pages with his students or present them to friends. Joan Evans maintains that to Ruskin "the illuminations were merely bright pictures buried in a sea of uninteresting text,"[49] which meshes with his contention in the account of "Addresses on Illumination" that "for his own part, he would infinitely rather have a finely illuminated book than a picture. He would like to have a book of which every page was a picture."[50]

Ruskin also had an impressive collection of Greek coins, which likewise became a consuming interest in later years. In typical fashion, he made the tiny low-relief figures graven on them the focus for many Oxford lectures on the art and history of Greece, including the fine 1870 series, *Aratra Pentelici,* devoted to defining the laws of sculpture. In painting as well, notwithstanding his love of Tintoretto's magnificent panoramas or the voluptuous modelings of Titian and Veronese, he always reverenced the austere works of Fra Angelico and Giotto, with their stage-setting-like backgrounds. Finally, he was attracted to the engravings of Albrecht Dürer, particularly "Knight, Death and Devil," in which incredible fullness of finely modeled detail is achieved entirely by a network of delicate lines. Ruskin declares in *Praeterita* that as early as 1834 he developed a "real love of engraving, and of such characters of surface and shade as it could give," venturing that since he was himself "so entirely industrious in delicate line, . . . there was really the making of a fine landscape, or figure outline, engraver in me."[51]

Thus Ruskin's drawings provide interesting evidence, beyond that of his tastes in the art created by other men, of his tendency to perceive the world about him as two-dimensional. His touch is exquisitely sensitive, the details of his subjects expressively rendered. But specifically in his architectural

47. *Praeterita*, vol. 3, ch. 1, par. 18 (*Works*, 35).
48. Lec. 1 of "Addresses on Colour and Illumination" (1854), as collated from contemporary accounts (*Works*, 12: 481).
49. Joan Evans, *John Ruskin* (London, 1954), pp. 196–97.
50. From the account of Lec. 1 (*Works*, 12: 484).
51. Vol. 1, ch. 7, par. 139 (*Works*, 35).

drawings, there is comparatively little feeling of roundness or solidity. Balcony, vault, spire are depicted not as structural quantities occupying and defining space; rather, they are transmuted into complex passages of diaphanous filigree, conveying the effect of low relief. Ruskin is preoccupied with textured surfaces, as if he were recording the work of the goldsmith instead of the stonemason.[52] Indeed, many of Ruskin's drawings are concrete testimony to the strength of that earlier-noted "idiosyncrasy which extremely wise people do not share,—my love of all sorts of filigree and embroidery, from hoarfrost to the high clouds."

The media he employed are also consistent with this self-admitted idiosyncrasy of preferring delicate, semitransparent surfaces to boldly three-dimensional volumes. Despite his intense love of color and his great sensitivity to it, he believed himself to lack any talent for "colour arrangement," and felt his true gift lay in "drawing delicately with the pen point."[53] His color, therefore, is confined primarily to soft, flat washes, with the main effects in the drawings the result of intricate pen or pencil work. He avoided oil painting almost completely. In later years he told his secretary W. G. Collingwood that there was a practical explanation for this: "he had to draw, and to keep his drawings, among books and papers, and oils were messy and did not smell nice."[54] But a doggerel verse to his father in 1835 probably states a more important reason:

> I cannot bear to paint in oil,
> C. Fielding's tints alone for me!
> The other costs me double toil,
> And wants some fifty coats to be
> Splashed on each spot successively.[55]

Oils were too viscous, too opaque; to render the effects he sought—and the reality he saw—Ruskin needed the transparent medium of watercolor and the sharp point of the pen.

It is very important to keep in mind how completely Ruskin's love of art, and his own practice of it, permeated his existence. He came to the serious study of architecture only after having finished two volumes of *Modern Painters,* and he was always studying paintings, even when concentrating on architecture. (To Ruskin the buildings he was ostensibly examining for themselves

52. An especially good early example from his "Proutesque" phase is the sketch of Roslin Chapel (Plate 10 in *Works,* 35, facing p. 233), but later, less derivative cases abound. See, for instance, the 1845 "Ducal Palace, Venice" (Plate 9 in *Works,* 4, facing p. 306), the 1859 "Street in Münster" (Plate 5 in *Works,* 12, facing p. 36), and the 1872 "Arches of the Apse of the Pisa Duomo" (Plate 3 in *Works,* 23, facing p. 16).

53. *Praeterita,* vol. 1, ch. 12, par. 241, ch. 4, par. 84 (*Works,* 35).

54. Quoted in *Works,* 38: 219.

55. March 11, 1835 (*Works,* 1: xxxiin).

were often more interesting to him for the art they contained.) Throughout his life he constantly drew; Collingwood recalls, "At once on arriving anywhere he was ready to sketch, and up to the minute of departure he went on with his drawing unperturbed."[56] In his lifetime he made approximately five thousand drawings and sketches, not to mention the myriad notations in diaries and notebooks. Drawing was for him a prime method of recording facts and impressions, whether of nature or of art, as well as a way of "learning the difficulty of the thing"—a method of study he frequently commended to his readers. Despite his profound pleasure in mountain scenery or splendid sunsets, therefore, and his minute observation of minerals or leaves, Ruskin in fact spent a great deal of his time looking at the world as a *surface* rendered in drawings and paintings—or else he was in the process of reducing three-dimensional reality to a surface himself.

Not unexpectedly, Venice of all cities accords with this mental habit of transmuting three dimensions into two. We touched earlier on the geographically determined planar quality of its architecture: the flat regularity of its facades, with their seemingly veneered windows, the only relief being provided by balconies; the arcades that are less definitions of space than the decorative articulations of a plane. Even the huge supporting tracery of buildings like the Ca' d'Oro or the Doge's Palace is, by Ruskin's own declaration, treated like a length cut from a bolt of precious fabric, "planned as if it were to extend indefinitely into miles of arcade; and out of this colossal piece of marble lace, a piece in the shape of a window is cut, mercilessly and fearlessly: whatever fragments and odd shapes of interstice, remnants of this or that figure of the divided foliation, may occur at the edge of the window, it matters not"[57]

But Venetian flatness is more than just architectural: it is optical. The city's watery setting produces shimmering reflections that mimic and therefore deny the solidity of its buildings, tricking the eye into erroneous judgments of size and depth, as James Morris aptly explains:

> The atmosphere . . . is remarkable for a capricious clarity, confusing one's sense of distance and proportion, and sometimes etching skylines and façades with uncanny precision. The city is alive with *trompe-l'oeil,* natural and artificial—deceits of perspective, odd foreshortenings, distortions and hallucinations. . . . If you take a boat into the Basin of St. Mark, and sail towards the Grand Canal, it is almost eerie to watch the various layers of the Piazza pass each other in slow movement: all sense of depth is lost, and all the great structures, the pillars and the towers, seem flat and

56. Quoted in *Works,* 33: xxxiv.
57. *Stones of Venice III,* final app. (*Works,* 11: 284).

wafer-thin, like the cardboard stage properties that are inserted, one behind the other, through the roofs of toy theatres.[58]

Mary McCarthy, noting the same phenomenon in her appreciation *Venice Observed,* considers it part of a more fundamental Venetian characteristic she calls "twinning": "Venice is a kind of pun on itself, which is another way of saying that it is a mirror held up to its own shimmering image—the central conceit on which it has evolved." And she assures us, "Venice is not made to be seen in the round."[59] Ruskin himself frequently alludes to "the fantastic and unreal character" of the Piazza, whose buildings seem to express "a natural buoyancy, as if they floated in the air or on the surface of the sea," and to "the long ranges of columned palaces, . . . each with its image cast down, beneath its feet, upon that green pavement which every breeze [breaks] into new fantasies of rich tessellation."[60] Not merely is the barrier between three-dimensional solidity and the two-dimensional echoing image, between reality and reflection, dissolved, therefore; this very ambiguity becomes a necessary component in the aesthetic delight Venice inspires.

In another, equally singular way, though one relatively independent of her unique topography, two- and three-dimensional images merge in Venice; Henry James admirably describes this characteristic as "the interfusion of art and life":

> . . . for the whole Venetian art-world is so near, so familiar, so much an extension and adjunct of the actual world, that it seems almost invidious to say one owes more to one of them than to another. Nowhere . . . do art and life seem so interfused and, as it were, so consanguineous. All the splendor of light and color, all the Venetian air and the Venetian history, are on the walls and ceilings of the palaces; and all the genius of the masters, all the images and visions they have left upon canvas, seem to tremble in the sunbeams and dance upon the waves. That is the perpetual interest of the place,—that you live in a certain sort of knowledge, as in a rosy cloud. You don't go into the churches and galleries by way of a change from the streets; you go into them because they offer you an exquisite reproduction of the things that surround you. All Venice was both model and painter, and life was so pictorial that art could not help becoming so. With all diminutions, life is pictorial still, and this fact gives an extraordinary freshness to one's perception of the great Venetian works.[61]

58. James Morris, *The World of Venice* (New York, 1960), pp. 324–25.

59. Mary McCarthy, *Venice Observed* (New York, 1956), pp. 20, 113.

60. *Stones of Venice I,* ch. 13, par. 3 (*Works, 9*); *Stones of Venice II,* ch. 1, par. 1 (*Works,* 10).

61. Henry James, "Venice," *Century Magazine* 25 (November 1882): 16.

No one was more perpetually aware of this correspondence than Ruskin; he was constantly measuring the fidelity with which modern artists portrayed her. His virulent dislike of Venice's much-admired eighteenth-century chronicler Canaletto, for example, was prompted by what he considered the painter's disregard for architectural accuracy and his inability to catch faithfully the city's shimmering waters.[62] Venice was a favorite Turner subject, in his later phase assuming the obsessive importance that Carthage held for him in earlier years. Appropriately enough, Ruskin's abortive 1836 letter to *Blackwood's* that marked the genesis of *Modern Painters* specifically defended Turner's rendition of St. Mark's Place. Ruskin always saw Venice as much through Turner's eyes as through his own, often finding Turner's painted vision preferable to the reality desecrated by man:

> One only consolation I have—the finding, among the wrecks of Venice, authority for all that Turner has done of her. I am not indeed surprised to find with what care he has noted, and with what dexterity he has used, every atom of material—to find his baskets in the water, his heads of boats out of it, his oranges and vines hanging over their loaded sides; but I was a little taken aback when yesterday at six in the morning—with the early sunlight just flushing its folds—out came a fishing-boat with its painted sail full to the wind . . . the very counterpart of the "Sol di Venezia": it is impossible that any model could be more rigidly exact than the painting, even to the height of the sail above the deck. All his skies are here too, or would be, if man would let them alone; but yesterday, as I was trying to note some morning clouds, a volume of smoke from a manufactory on the Rialto blotted everything as black as the Thames.[63]

For Ruskin, the "interfusion of art and life" in Venice was painfully incomplete.

But if modern Venice as Turner painted her, unsullied by manufacturing smoke, struck Ruskin as more beautiful than the reality he observed from his gondola, how much lovelier still was Venice as depicted by her "ancient" artists—by Gentile Bellini, Carpaccio, Veronese—than the city Ruskin studied in the midnineteenth century, its Piazza dotted with cigar-smoking Austrian soldiers and screaming urchins pitching coins off San Marco's marble-filmed walls. He might enter a palace or a church to view "an exquisite reproduction of the

62. For a criticism of Canaletto as a painter of architecture, see *Modern Painters I*, pt. 2, sec. 1, ch. 7, par. 30 (*Works,* 3); of water, ibid., sec. 5, ch. 1, pars. 18–19.

63. To his father from Venice, September 14, 1845 (*Works,* 3: 251n). Cf. a letter written from Faido the previous month, expressing the same pattern (*Works,* 5: xvi): "I have found [Turner's] subject The stones, road, and bridge are all true, but the mountains, compared with Turner's colossal conception, look pigmy and poor."

things that surround you," but upon stepping out onto the palace balcony, or reemerging through the church portal, he saw such magnificent art validated only by a three-dimensional actuality that he regarded as faded and corrupt. Thus, to Ruskin, the true Venice, the Venice he loved and idealized, was the two-dimensional world presented by her great artists—not the actual Piazza overrun with blaspheming troops and beggar boys, but the painted one Gentile Bellini filled in 1496 with a pageant of solemn Corpus Christi celebrants.

A city of marble, did I say? nay, rather a golden city, paved with emerald. For truly, every pinnacle and turret glanced or glowed, overlaid with gold, or bossed with jasper. Beneath, the unsullied sea drew in deep breathing, to and fro, its eddies of green wave. Deep-hearted, majestic, terrible as the sea,—the men of Venice moved in sway of power and war; pure as her pillars of alabaster, stood her mothers and maidens; from foot to brow, all noble, walked her knights; the low bronzed gleaming of sea-rusted armour shot angrily under their blood-red mantle-folds. . . . A world from which all ignoble care and petty thoughts were banished, with all the common and poor elements of life. No foulness, nor tumult, in those tremulous streets, that filled, or fell, beneath the moon; but rippled music of majestic change, or thrilling silence. No weak walls could rise above them; no low-roofed cottage, nor straw-built shed. Only the strength as of rock, and the finished setting of stones most precious. . . . Ethereal strength of Alps, dreamlike, vanishing in high procession beyond the Torcellan shore; blue islands of Paduan hills, poised in the golden west
Such was Giorgione's school—such Titian's home.[64]

Ruskin was, of course, an intensely visual person (John Rosenberg justifiably calls him photoerotic[65]); he valued above all his ability to see, and had by his own admission "a sensual faculty of pleasure in sight, as far as I know

64. *Modern Painters V*, pt. 9, ch. 9, par. 1 (*Works*, 7). This is the famed description of Giorgione's sixteenth-century Venice Ruskin gives in "The Two Boyhoods" and that he repeats as an epilogue to the 1881 "Traveller's Edition" of *Stones*. But many of its images might be read directly off a painting like Gentile Bellini's "Procession in St. Mark's Place," to which he often referred. In *Guide to the Venetian Academy* (*Works*, 24: 163) Ruskin specifically describes that painting as being "the perfectly true representation of what the Architecture of Venice was like in her glorious time; trim, dainty,—red and white like the blossom of a carnation,—touched with gold like a peacock's plumes, and frescoed, even to its chimney-pots, with fairest arabesque,—its inhabitants, and it together, one harmony of work and life" In *Modern Painters I* he tells us "we are indebted" to Gentile Bellini and Carpaccio "for the only existing faithful statements of the Architecture of Old Venice"; they are "the only authorities to whom we can trust in conjecturing the former beauty of those few desecrated fragments . . ." (pt. 2, sec. 1, ch. 7, par. 28 [*Works*, 3]).
65. John Rosenberg, *The Darkening Glass* (New York, 1961), p. 4.

unparalleled."[66] The eye, he reasoned, is "a nobler organ than the ear," because "through the eye we must, in reality, obtain, or put into form, nearly all the useful information we are to have about this world."[67] Indeed, he considered himself a missionary sent into the nineteenth century to restore to men the too-long scorned delight in seeing freshly and accurately the world about them. The perpetual injunction to his readers to "Observe . . ." is more than just a rhetorical device.

But he also claimed that the useful information the well-developed sense of sight provides about external reality must be taken in by the eye unassisted by mechanical contrivances. He disliked the microscope, explaining that *"all great art is delicate* . . . [and] all delicacy which is rightly pleasing to the human mind is addressed to the *unaided human sight,* not to microscopic help or mediation," while he argued against T. H. Huxley that the difference between the eye and the telescope is that human sight "is an absolutely spiritual phenomenon; accurately, and only, to be so defined; and the 'Let there be light,' is as much, when you understand it, the ordering of intelligence, as the ordering of vision."[68] He was reluctant to begin using spectacles in the mid-1870s, and in a number of his later diary entries he notes his gratification at being able to perceive without them the pale blue lines on the diary pages. This aversion to wearing glasses resulted, however, not simply from the perfectly natural unwillingness of a person to acknowledge that he is growing old and that his faculties are necessarily diminishing in power and acuteness; instead, it signifies Ruskin's poignant realization that the prime source of *all* his intellectual and spiritual strength was diminished, for only "the human eye in the perfect power of youth," that "for ever indescribable instrument, aidless, is the proper means of sight, and test of all laws of work which bear upon aspects of things, for human beings."[69] The physical loss of this childlike accuracy of vision meant to Ruskin that the bond between himself and the external world was irrevocably weakened; his intense thirst for visible fact could no longer be slaked, and his mission to help the Victorians recover their sense of sight would finally remain unfulfilled.

Yet the world Ruskin urged his readers to discover was, ironically, often one without depth. When he was not teaching them to study carefully the surface of a great painting, he was calling their attention mainly, as I have shown, to the outlines and superficial textures of the actual world, and

66. From a *Praeterita* manuscript (*Works,* 35: 619). Cf. his assertion in the second volume of *Praeterita* that "the main good of my face, as of my life, is in the eyes,—and only in those, seen near . . ." (ch. 3, par. 43 [*Works,* 35]).

67. *A Joy for Ever,* lec. 2, par. 106 (*Works,* 16).

68. *The Art of England,* lec. 4, par. 118 (*Works,* 33); *Eagle's Nest,* lec. 6, par. 99 (*Works,* 22).

69. *Laws of Fésole,* ch. 4, par. 14 (*Works,* 15).

insisting, furthermore, that the real world looked exactly the way his favorite
artists painted it. Limited but tantalizing evidence suggests that Ruskin may
actually have *seen* the world as a picture. I have been able to locate few allu-
sions, either in his own writing or in secondary sources, to any visual prob-
lems beyond occasional mention of "motes" floating before his eyes, mostly
in the early 1840s; his concern about having to don spectacles in the 1870s;
and diary references to "dim" and "swimming" vision in the 1880s. But two
interesting letters, one to his father in 1852, the other to Dr. John Brown in
1881, demonstrate that one of his eyes was weaker than the other:

> It is noticeable also that the whisker on my right cheek grows strongly.
> I have always to cut it—that on the left hardly at all—when the head was
> oppressed—the veins on the left temple were those which swelled. Vice
> versa—I see far better with the left eye than the right—it has nearly all the
> work in drawing.[70]

> My drawing does not tire me, but the focus of my best, farthest-seeing eye
> has altered more than that of the nearer-sighted, weaker one; and now, in
> small work, they begin to dispute about where the line is to go, which I
> am sorry for, but shall take to larger work.[71]

Given Ruskin's extreme sensitivity to his vision, it may well be that the weak-
ness to which he alludes here was much less pronounced than he describes;
ophthalmological explanations are usually suspect and always very difficult to
validate. Mr. James S. Dearden, curator of the Ruskin Galleries, Bembridge,
Isle of Wight, has most kindly confirmed for me that Ruskin's spectacles are
not in the collections either at Bembridge or Brantwood, nor are they in the
Ruskin Museum, Coniston; he does believe their prescription may be some-
where among the 3,500 letters in the Ruskin-Severn correspondence at Bem-
bridge. The possibility remains open, therefore, that Ruskin's capacity to
judge depth was in some way impaired. Perhaps this might be the most basic
reason for his emphasis on architectural planes rather than volumes and his
obvious preference for low-relief sculpture, not to mention his affection for
Venice, a city veritably made to be appreciated by someone with limited
depth perception. It would be ironic indeed if for Ruskin the interfusion of
art and life was complete.[72]

Ruskin's other major architectural emphasis, his preoccupation with small
detached details, is likewise deeply revelatory of his whole way of apprehending

70. From Venice, February 11, 1852, in *Ruskin's Letters from Venice*, ed. Bradley, p.175
71. August 15, 1881 (*Works*, 37: 373).
72. Ruskin himself was furious when in 1872 a lecturer at the Royal Institution argued

reality. Again, his drawings provide fascinating evidence. He continually worked at depicting tiny, isolated subjects—feather, leaf, shell, blade of grass—often fastening on one for a whole series of studies. But even in his larger, more comprehensive sketches of architecture and landscape, minutely detailed passages stand out from the delicate, atmospheric blur of washes; as Kenneth Clark phrases it, "His eye focuses on one or two points with such intensity that it seems to be exhausted before it can comprehend the whole, and often a frenzy of emotion ends abruptly, like a piece of oriental music." [73] (During his "Proutesque" phase of the late 1830s, on the other hand, entire sheets are covered with details of equal sharpness and importance; little shading defines comparative depth or contour.) In copying his favorite paintings, he also concentrated on reproducing isolated details—a sprig of flowers in a Botticelli gown, the pet dog in the corner of Veronese's "Queen of Sheba." The same device I recommended in chapter 3 for gauging the narrowness of Ruskin's architectural emphases—trying to locate in a perspective photograph the diminutive parts on which he fastens his attention—is equally useful in reference to his copying from paintings; for instance, the exact rose sprig Ruskin duplicates from the figure of Spring in the "Primavera" is an incredibly tiny element in the whole composition. [74] These drawings are small in

that the characteristics of Turner's later works were owing to a change in vision. (See his indignant letter to the *Pall Mall Gazette,* reprinted in *Works,* 10: 458.) An interesting recent book in this area is British ophthalmologist Patrick Trevor-Roper's *The World through Blunted Sight* (Indianapolis and New York, 1970).

 In any event, whether physiologically or psychologically caused, cases of life and art interfusing abound in Ruskin's career. A well-known instance of this is his obsessive identification of Carpaccio's sleeping St. Ursula with the dead Rose LaTouche; he was allowed to keep the painting in his room at Venice in 1876–77, and when a friend sent him a pot of vervain and dianthus like that depicted in St. Ursula's bedroom window, art and reality became hopelessly tangled in his distraught mind. But less tortured and hence more revealing cases likewise occur; I give only random examples. In *Praeterita* he recalls "how consistently" his tutors at Christ Church "took to me the aspect of pictures, and how I from the first declined giving any attention to those which were not well painted enough. My ideal of a tutor was founded on what Holbein or Dürer had represented in Erasmus or Melanchthon, or even more solemnly, on Titian's Magnificoes or Bonifazio's Bishops" (vol. 1, ch. 11, par. 229 [*Works,* 35]). Ill at Padua in 1845 and confined to a small back room commanding a view "only of a few deep furrowed tiles and a little sky," he sent his valet out to buy a picture for him to look at instead, which "much comforted me" (ibid., vol. 2, ch. 7, par. 145). He tells his students in *Elements of Drawing* "It is good, in early practice, to accustom yourself to enclose your subject, before sketching it, with a light frame of wood held upright before you" (preface, par. 13 [*Works,* 15]).

 73. Kenneth Clark, "A Note on Ruskin's Drawings," *Ruskin Today* (London, 1964), p. 352.

 74. The 1872 rose sprig drawing is reproduced as Plate 2b in *Ruskin 1819–1900,* a catalog of an exhibition at Kendal and Sheffield, England, July–October 1969, published by Titus Wilson, Kendal, and was used in stylized form on the covers of his later books.

dimension as well as subject—often approximately six by eight inches, seldom more than about twelve by eighteen. Frequently, too, they were truncated exercises in several media: "he jumped restlessly from one medium to another, first working in pencil, then, becoming dissatisfied in this, putting in some touches with the pen, then perhaps a bit of wash or even colour in a few places—the drawing being left unfinished finally." [75]

Relatively uncomplicated reasons account in part, naturally, for these characteristics. The sketchy, unfinished quality derived in considerable measure from his drawing for the practical purpose of recording fact or understanding form. Another cause was sheer frustration; in *Praeterita* he remembers "my evermore childish delight in beginning a drawing; and usually acute misery in trying to finish one." [76] And sometimes he was simply the victim of vexatious working conditions, as when he describes his almost comic tribulations in attempting to copy Veronese's figure of King Solomon:

> The worst of him is that he is all in the dark; when I sit near the window I can't see him, and when I sit near *him*, I can't see my own work, so that I am obliged to work at him very little each day, and to go on afterwards with other things—the negro's mistress, namely, and the negro's mistress's petticoat and sleeve. I got her head first, tolerably to my satisfaction; it is size of life, in light and shade only, not colour; but her head off did not look nearly so well as her head on; so I felt obliged to do her waist and petticoat, and as the white and gold brocade was sadly lost in the light and shade drawing, I've done the piece of dress in colour; so that it don't fit her head, and I must do a rough light and shade from it at home to put her head on. When she is put together she will be a kneeling figure the size of life, about 4-½ feet high by two feet wide. [77]

At the same time, though, such sharp focusing on smallness was John Ruskin's idiosyncratic way of seeing the world. Of David Roberts's undetailed sketches, he told his father, "I am rather an unfair judge for I am morbidly accurate," and it was wholly consistent that, when Millais was painting the famous portrait of him standing by the falls of Glenfinlas in 1853, Ruskin should render a minutely detailed painting of the rock beside which he posed, fearing that Millais might not understand its geological character. [78] Ruskin was almost *forced* to "draw and describe," to take in "touch by touch," the small, immediately accessible detail, because only within limited compass was it possible

75. From Arthur Pope's introduction to the catalog of the 1909–10 Ruskin exhibition at Harvard's Fogg Museum, quoted in *Works*, 38: 218.

76. Vol. 2, ch. 7, par. 136 (*Works*, 35).

77. To his father from Turin, August 25, 1858 (*Works*, 16: xl).

78. To his father from Venice, October 23, 1851, in *Ruskin's Letters from Venice*, ed. Bradley, p. 44; Joan Evans, "John Ruskin as Artist," *Apollo* 66 (December 1957): 144.

fully to apprehend and convey the essence of a thing. In *Praeterita* he recalls how at Fontainebleau in 1842 he experienced an artistic epiphany that revealed to him the overwhelming importance of such penetration:

> . . . [I] found myself lying on the bank of a cart-road in the sand, with no prospect whatever but [a] small aspen tree against the blue sky.
>
> Languidly, but not idly, I began to draw it; and as I drew, the languor passed away: the beautiful lines insisted on being traced,—without weariness. More and more beautiful they became, as each rose out of the rest, and took its place in the air. With wonder increasing every instant, I saw that they "composed" themselves, by finer laws than any known of men. At last, the tree was there, and everything that I had thought before about trees, nowhere.[79]

Van Akin Burd has shown that this account bears no apparent connection with events recorded in Ruskin's diary for that period (which Ruskin did not have before him while writing his autobiography, having forgotten that he gave it to Charles Eliot Norton as a gift in 1872): "Experiences that become almost mystic in *Praeterita* were in fact," according to Burd, "all part of a summer in which Ruskin was demonstrating the most objective kind of observation."[80] Whatever the cause, nonetheless, Ruskin did about this time abandon his previous imitative drawing efforts and begin to evolve his own exquisite, highly personal style. Several years later, bemused by this new direction, Ruskin's father wrote to a friend,

> He is cultivating art at present, searching for real knowledge, but . . . it will neither take the shape of picture nor poetry. It is gathered in scraps hardly wrought, for he is drawing perpetually, but no drawings such as in former days you or I might compliment in the usual way by saying it deserved a frame; but fragments of everything from a cupola to a cartwheel, but in such bits that it is to the common eye a mass of Hieroglyphics—all true—truth itself, but Truth in a mosaic.[81]

John James had a shrewder grasp of his son's mind than is commonly supposed.

This same "Truth in a mosaic" pattern characterizes Ruskin's method and style of writing. In *Praeterita* he insists that writing gave him no serious trouble, that it was

79. Vol. 2, ch. 4, par. 77 (*Works,* 35).
80. Van Akin Burd, "Another Light on the Writing of *Modern Painters,*" *PMLA* 68 (September 1953): 755–63. The 1842 diary unavailable to Ruskin and his editors is now included in *Diaries,* 1: 221–37.
81. Quoted in Joan Evans, "John Ruskin as Artist," p. 144.

... always done as quietly and methodically as a piece of tapestry. I knew exactly what I had got to say, put the words firmly in their places like so many stitches, hemmed the edges of the chapters round with what seemed to me graceful flourishes, touched them finally with my cunningest points of colour, and read the work to papa and mamma at breakfast next morning, as a girl shows her sampler.[82]

Actually, Ruskin wrote in a patchwork manner, developing his ideas by accumulation and digression, darting about among superficially disparate passages and subjects whose relations were supposed to become clear in the end. He assumed that it was better to say much, then prune later. The compression did not, however, always occur. His teeming imagination and diverse interests continually drove him to expand his treatment of any subject, which in turn led him into a half-dozen other directions; finally, the resultant web would be so complexly woven that excision—at least in Ruskin's view—would unravel rather than strengthen it. (He had the same habit in his lectures. Though he prepared them carefully in advance, he frequently extemporized at length; his addresses as printed, therefore, possess a coherence that may not have been altogether apparent in oral delivery.) Further, since his books were until 1864 subsidized by a wealthy, indulgent father, he was not conditioned to bow to the strict publishing demands against which less favored writers struggled. What he wrote would get printed virtually as he wrote it.

It is profoundly typical, also, that, particularly in his earlier works, he was in the habit of going back after the initial draft to "ornament" passages, so that the compositional process was divided into two quite distinct stages. In his private writing, of course, the second stage did not usually take place. Thus his diaries are, overall, rather disappointingly pedestrian in style, as are many of his letters; rich color passages, especially, are comparatively few. Moreover, his habitual punctuation was revealingly eccentric. He depended heavily on the dash; his faithful editor W. H. Harrison gave Ruskin's sentences grammatical coherence, thereby obscuring the often breathless, disjointed quality of the original statements, in which each idea, or fragment of one, stands suspended in a tiny, self-sufficient universe, like beads on a string. (Many later editors of Ruskin's works and letters have likewise for the sake of intelligibility standardized his punctuation, but at the cost of concealing an essential aspect of Ruskin's mentality.) The following passages in their original punctuation—one from a manuscript version of *Modern Painters II*, the other from an 1852 letter written at Venice to his father—illustrate this quality convincingly:

It was then only that I understood that to become nothing might be to become more than Man;—how without desire—without memory—without

82. Vol. 2, ch. 7, par. 135 (*Works*, 35).

sense even of existence—the very sense of its own lost in the perception of a mightier—the immortal soul might be held for ever—impotent as a leaf—yet greater than tongue can tell—wrapt in one contemplation of the Infinite God.[83]

Take all the time that I have had here—about 12 months in all—in which I have had to examine piece by piece—buildings covering five square miles of ground—to read—or glance at—some forty volumes of history and chronicles—to make elaborate drawings—as many as most artists would have made in the time—and to compose my own book—what of it is done—(for I do not count the first volume anything) and you will not I think wonder that I grudge the losing of a single day—[84]

To some extent, this fragmented method of developing and ornamenting his ideas was the unavoidable result of problems inherent in researching artistic subject matter: bad weather, building repairs, crowds of tourists, the opening and closing hours of monuments—any might force him to drop one thread and pick up another. In addition, Ruskin had always to avoid overstimulation; sometimes it was essential to his physical and psychological health that certain studies be at least temporarily abandoned. But the primary explanation lies in the quality of Ruskin's mind, as these representative passages from his 1851-52 Venetian letters to his father, to whom he was regularly dispatching small sections of *Stones,* demonstrate:

I find that as to printing any of the volume till it is finished, it will be impossible for almost everything I read gives me some little notes to add. . . . So I must just send you a detached bit to read here and there as it comes into form.

.

[But] as soon as I begin to dwell on any bit carefully, thoughts come into my head about other parts—unfinished—which I am afraid of losing and then I go away and touch upon them.

.

. . . I hope that now the long days are coming, I shall get some pieces of colour—description which will give you pleasure. But I cannot promise. If I was to say, I will write this or that—in such and such a way—I should be instantly cramped and incapable of writing. I have indeed some bits of the kind done—but I don't like to send you them till they are in their places, and properly finished

.

83. Given in app. 1 of *Works,* 4: 364-65.
84. January 18, 1852, in *Ruskin's Letters from Venice,* ed. Bradley, p. 140. Cf. the edited Cook and Wedderburn version in *Works,* 10: xxxvii.

The chapter on the Ducal palace . . . is still devoid of all adornment . . . and in fact the whole book, even where it is quite put up—is a good deal like a house just built—full of dust and damp plaster—you could hardly see it at a worse time, but I must let it dry before I paint or paper it.[85]

The piecemeal publication of Ruskin's later works has always been attributed to the mental strain of those years, and much has rightly been made of the intimate, miscellaneous texture of the *Fors Clavigera* letters as the perfect stylistic solution Ruskin evolved for coping with this terrible instability. Nevertheless, these patterns were always typical of Ruskin's mentality. Ruskin invariably examined his subjects in series of nonconsecutive fragments, just as even in *Stones* one sometimes finds odd, *Fors*-like alternations of high eloquence and childlike personal confession.

This total absorption into single objects or ideas that distinguishes his drawing and writing was deeply rooted in his well-known childhood experiences. Confined within the small undisturbed world of Brunswick Square, then Herne Hill, he was restricted to the pleasure he could extract from methodical, exhaustive observation of humble, limited, visible facts—anthills, chair cushions, his mother's vinaigrette:

> . . . I soon attained serene and secure methods of life and motion; and could pass my days contentedly in tracing the squares and comparing the colours of my carpet;—examining the knots in the wood of the floor, or counting the bricks in the opposite houses
>
>
>
> This inconceivable passive—or rather impassive—contentment in doing, or reading, the same thing over and over again, I perceive to have been a great condition in my future power of getting thoroughly to the bottom of matters.[86]

It was thus natural for him throughout his life to look at things not in their relations with other things but in themselves and by themselves. He was convinced, furthermore, that in studying art this mode of examination was as characteristic of mature judgment as it was of naive enthusiasm:

> Infants in judgment, we look for specific character, and complete finish; we delight in the faithful plumage of the well-known bird, in the finely drawn leafage of the discriminated flower. As we advance in judgment, we scorn such detail altogether; we look for impetuosity of execution,

85. November 28, 1851, January 18, February 21, February 25, 1852, in *Ruskin's Letters from Venice*, ed. Bradley, pp. 72, 141, 188, 197.

86. *Praeterita*, vol. 1, ch. 1, par. 14, chap. 3, par. 64 (*Works*, 35).

and breadth of effect. But, perfected in judgment, we return in a great measure to our early feelings, and thank Raffaelle . . . for the delicate stamens of the herbage beside his inspired St. Catherine.[87]

Cogent evidence of this delight in exhausting single objects is Ruskin's dream of an ideal gallery of Turners: "Each picture with its light properly disposed for it alone—in its little recess or chamber. Each drawing with its own golden case and closing doors, with guardians in every room to see that they were always closed when no one was looking at *that* picture."[88] Still more telling is his advice on how best to "disentangle" Turner's 1823 oil "The Bay of Baiae":

> Take a stiff piece of pasteboard, about eight inches square, and cut out in the centre of it an oblong opening, two and a half inches by three. Bring this with you to the picture, and standing three or four feet from it, . . . look through the opening in the card at the middle distance, holding the card a foot or two from the eye, so as to turn the picture, piece by piece, into a series of small subjects. Examine these subjects quietly, one by one; . . . and you will find, I believe, in a very little while, that each of these small subjects becomes more interesting to you, and seems to have more in it, than the whole picture did before.[89]

Ruskin's love of discrete fragments of external reality is symbolic of his personal solipsism: whether as a child tracing figures in a carpet or as a mature thinker seeking to define the nature of meaningful human activity, Ruskin forever stood in isolation, weaving significance out of his own psyche and his immediate surroundings. Intellectually, he was notoriously oblivious of other people's ideas; his remark noted earlier that he worked out the grammar of flamboyant architecture "for myself, and wrote it here, supposing the statements new" until Professor Willis pointed out he had himself done it all previously, records not one of those unfortunate coincidences that occasionally

87. Preface to the 2d ed. (1844) of *Modern Painters I*, par. 24 (*Works*, 3).

88. To his father from Venice, January 1, 1852, in *Ruskin's Letters from Venice*, ed. Bradley, p. 121.

89. *Notes on the Turner Gallery at Marlborough House* (1856) (*Works*, 13: 134). Cf. the reminiscence of Ruskin's relative, artist Arthur Severn (*The Professor*, ed. James S. Dearden [London, 1967], p. 108): "In a picture gallery he had many curious ways. He never seemed able, or didn't care, to look at a picture first as a whole. He got no enjoyment out of it that way. No, he must go near and see what it was all about. Quite a badly painted picture would interest him if there was a letter being pushed under a door or a pretty girl looking rather sorry or anything unusual." Severn also recalls that although Ruskin loved watching a musician's hands moving over an instrument, "Orchestral playing had no interest for him. He could not *look* at it all at once . . ." (pp. 98–99).

happen in scholarly research, but the general pattern of much of Ruskin's thought. In his appendix "Plagiarism" in *Modern Painters III,* he freely acknowledges this problem:

> . . . as my work is so much out of doors, and among pictures, that I have time to read few modern books, and am therefore in more danger than most people of repeating, as if it were new, what others have said, it may be well to note, once for all, that any such apparent plagiarism results in fact . . . from my having worked out my whole subject in unavoidable, but to myself hurtful, ignorance of the labours of others.[90]

Yet he was basically unperturbed by this lack, and indeed, on first venturing into political economy, he seems to boast of it, claiming that he has never read any author on the subject "except Adam Smith, twenty years ago."[91]

Not only intellectually but emotionally as well, Ruskin existed in isolation. He counted himself "a man who has no attachments to living things" but only to "certain rocks in the valley of Chamouni" and to the works of Turner and Tintoretto: "Men are more evanescent than pictures yet one sorrows for lost friends—and pictures *are* my friends. I have none others. I am never long enough with men to attach myself to them—and whatever feelings of attachment I have are to material things. If the great Tintoret here [in Venice] were to be destroyed, it would be precisely to me what the death of Hallam was to Tennyson"[92] It is remarkable that human figures are virtually missing from his drawings. Ruskin's streets are nearly always deserted, although he frequently drew amid crowds and rather enjoyed their attention. (He recalls in *Praeterita* that for a while he even hoped that as he drew he was simultaneously educating his onlookers to see, in the same way he was teaching the readers of his books.[93]) On the rare occasions when human figures do appear—mostly in his early sketches imitating Samuel Prout—they are tiny and undetailed, placed merely to accent or measure certain architectural features, while the human faces he copies from paintings and sculptures often have the amateurish character of marginal doodles in a schoolgirl's notebook.[94] This, despite his assertion that but for his discovery of Tintoretto in 1845, and hence his subsequent Venetian projects, he might "have brought out in full

90. App. 3 (*Works,* 5: 427).

91. Preface to *A Joy for Ever* (*Works,* 16: 10).

92. To his father from Venice, December 28, 1851, January 28, 1852, in *Ruskin's Letters from Venice,* ed. Bradley, pp. 109, 156.

93. Vol. 2, ch. 6, par. 123 (*Works,* 35).

94. Examples include his depiction of the sons of Noah on the Vine Angle of the Doge's Palace (Plate 19 in *Stones of Venice II* [*Works,* 10, facing p. 360]) and an angel from a quatrefoil at Lyons Cathedral (Plate 7, *Works,* 12, facing p. 62). His portraits of

distinctness and use what faculty I had of drawing the human face and form with true expression of their higher beauty."[95] One of his students remembers Ruskin saying that he drew shells and other inanimate subjects because "not only could he not draw anything that was moving, but likewise nothing that had the power of moving—as it fussed and worried him too much to feel that at any moment it might begin to move."[96] An angel on the facade of Lyons Cathedral, however, does not move. Noah's sons on the Ducal Palace Vine Angle and Ilaria di Caretto lying on her tomb are forever frozen. Yet he could not render them with his usual exquisite precision. John Ruskin seems to evade, even shrink from, human beings in his art, just as in *Modern Painters I* when he discusses the landscapes of "the ancients" he is actually focusing on almost incidental parts of these paintings, looking *past* the human activity of saints or holy family in their foregrounds. It is at Raphael's delicate stamens of herbage that Ruskin gazes, not at St. Catherine.

This same emotional solipsism characterized his relationships with other people. Joan Evans observes of Ruskin's personal letters, "It is noticeable how rarely . . . he asks with any intimacy after the friends to whom he is writing, or comments—unless it be adversely—on the news they have sent him. He rarely even gossips about common acquaintances; he is simply and sincerely egocentric."[97] He was almost totally alienated emotionally, and certainly physically, from his vivacious, society-loving wife. After nearly four years of unconsummated marriage he writes to his father of Effie: "as she is very good and prudent in her general conduct—the only way is to let her do as she likes— so long as she does not interfere with *me:* and that, she has long ago learned— won't do."[98] (Significantly, this assessment comes in the same letter where he declares himself a man who has no attachments to living things.) Effie's own

Effie (reproduced in Clark, *Ruskin Today*, facing p. 26) and Rose LaTouche (in Rosenberg, *The Darkening Glass*, facing p. 206) also show naive, undetailed prettiness and absence of contour. By contrast, a head of Ilaria de Caretto (Plate 19, *Works*, 23, facing p. 230) is ghastly and rough, despite his love of the sculpture, while his later self-portraits are terrifyingly expressive; see especially the "Self-Portrait with Blue Neck Cloth" (c. 1873) reproduced as the frontispiece in Rosenberg, or the 1861 and 1874 portraits appearing as frontispieces to volumes 1 and 2 of the *Diaries*, respectively.

Interestingly, Turner also had great difficulty rendering human beings, prompting Ruskin to confess that the "infirmity in his figure conception . . . has always been to me, out of the whole multitude of questions and mysteries that have come across me concerning art, the most inexplicable. With the most exquisite sense of grace and proportion in other forms, he continually admits awkwardnesses and errors in his figures which a child of ten years old would have avoided" (*Notes on the Turner Gallery* . . . [*Works*, 13: 155]).

95. *Praeterita*, vol. 2, ch. 7, par. 140 (*Works*, 35).

96. Quoted in *Works*, 15: xxii.

97. Evans, *John Ruskin*, p. 421.

98. December 28, 1851, from Venice in *Ruskin's Letters from Venice*, ed. Bradley, p. 110.

letters to her family from Venice contain many vignettes of her husband's in-
sulating himself from human contact: John refusing to go to band concerts in
the Piazza because of the spittle and cigar smoke, John refusing to attend
Mass at St. Mark's because he finds the people there "so filthy that he cannot
bear to touch them or be amongst them," John reluctantly attending the opera
but "writing a Chapter on Chamfered edges" all during the performance. "He
says he has no friends and that he never will have any and that the world and
every body in it are all going wrong but that he is right, and then he sits and
writes such accounts to Mr R— of the state of society both here in Venice and
in London and thinks himself an excellent judge, although he knows no one
and never stirs out."[99] *Praeterita,* of course, is filled with wry, often poignant
references to his utter lack of social ease, and his desire throughout his life to
be by himself working quietly with "things."

Curiously, however, not only does Ruskin quarantine himself from the in-
tellectual, emotional, and social currents of the external world, but internally
as well he seems isolated from *himself* from one day to the next—a phenome-
non which is more than just the simple fluctuation of mood and idea typical
of any sensitive, intelligent person. In his published writings, the result was
his celebrated proclivity for contradicting himself, from one book to another,
sometimes from one chapter or even paragraph to another. This tendency is
still more pronounced in some of his diary entries: for example, on March 11,
1841, at Naples he reflects, "I never can enjoy any place till I come to it the
second time." Less than a week later at Mola di Gaeta: "Sketching all day at
Itri. Disappointed with it—always am with second sights."[100] Millais report-
ed to Holman Hunt from Glenfinlas in 1853, "I never heard a man contradict
himself like he does. I have given up reminding him of his own remarks for he
always forgets."[101] It was ironically appropriate that in his later years Ruskin
should select for an heraldic motto "ToDay." Reading his work, one often has
the feeling that his mind operated utterly independently of yesterday or to-
morrow, that his days, like his eccentrically punctuated sentences, were strung
out in a succession of tiny segments sufficient unto themselves.

In any event, this feeling of isolation was both emblematic of and vital to
Ruskin's sense of mission as an aesthetic and later a social reformer. He came
to believe that the extent to which he stood alone was actually an index of the

99. December 3 and 10, 1849, January 18, 1850, February 8, 1852, in Mary Lutyens,
Young Mrs. Ruskin in Venice (New York, 1965), pp. 83, 84, 117, 266. Effie's remarks
jibe well with many of Ruskin's diary entries throughout his life. Especially in his early
travels, he often notes being repelled by natives and is generally remarkably unsympathetic
toward them.

100. *Diaries,* 1: 165, 166.

101. Millais to Hunt, August 29, 1853, in Lutyens, *Millais and the Ruskins,* p. 89.

worth of his ideas; his 1852 comments to his father from Venice typify a deep-seated, lifelong mental and emotional construct:

> . . . it is one somewhat unpleasant result of my work, that I have got to feel totally differently from the public . . . and that the effect of what I believe to be my superior wisdom, is that nobody will attend to me. . . . It has cost me 7 years' labour to be able to enjoy Millais thoroughly. I am just those seven years' labour farther in advance of the mob than I was, and my voice cannot be heard back to them. And so in all things now—I see a hand they cannot see; and they cannot be expected to believe or follow me: And the more justly I judge, the less I shall be attended to.
>
>
>
> I could not write as I do unless I felt myself a reformer, a man who knew what others did not know—and felt what they did not feel.[102]

Ruskin *needed* to think "that the world and every body in it are all going wrong but that he is right"—however tragic the price such alienation eventually exacted of him.[103]

It is striking that many of these mental patterns I have pointed out cohere in, and are thus clarified by, Ruskin's profound reverence for Turner. Ruskin's first great books were, after all, celebrations of Turner, and he lived most of his life in rooms hung with the artist's works. His travels were always in part a search for Turner's subjects; his solitary 1845 trip that proved so crucial to his commitment to art had this as its main purpose. The Ruskin scholar who reads a Turner biography or walks through the splendid rooms filled with his works at London's Tate Gallery is haunted by a *déjà vu* feeling, so close is the correspondence between Turner's settings and many of his defender's favorite locales. Ruskin's 1858 assurance to his parents from Brunnen is typical evidence of a lifelong mental habit of viewing landscapes as a succession of Turners: "If I had known I was going to stay here so long I could have told you, by the help of the Turners, pretty nearly where I was all the day long;

102. February 15 and 28, 1852, in *Ruskin's Letters from Venice,* ed. Bradley, pp. 181, 203.

103. George P. Landow's *The Aesthetic and Critical Theories of John Ruskin* (Princeton, 1971) appeared after my study was completed, and I am thus able to offer only passing comment on an impressive work. Although he deals but briefly with Ruskin's architectural thinking, the intellectual history presented as background for Ruskin's developing art criticism is most interesting; particularly useful here is Landow's analysis of Ruskin's religious inheritance. He points out, for example, that the Evangelicals "reacted to all criticism of their own group as the clear sign of Satan's work; in fact, they all but cherished such criticism as a martyrdom which the children of God had to bear in an evil, unconverted world" (p. 262).

which, next thing to knowing I am in my study, ought to have been satisfactory to mama, for this is only a larger study a little farther off."[104]

We have already noted how deeply his view of Venice was conditioned by Turner. But even his first sight of Italy in 1835 was a verification of Turner's vignettes in Samuel Rogers's *Italy;* the villas and gardens banking Lake Como "to me ... were almost native through Turner,—familiar at once, and revered."[105] Ruskin was making Turner's vision a standard as late as 1887, when near Folkestone he "saw, to my amazement, that the skies of Turner were still bright above the foulness of smoke-cloud"[106] He began copying Turners himself at the age of fourteen on the assumption that "it is nearly impossible to observe the refinement of Turner unless one is in the habit of copying him"—first reproducing the Rogers engravings ("I took them for my only masters, and set myself to imitate them as far as I possibly could by fine pen shading"),[107] later attempting expressionistic watercolor experiments. It is hardly remarkable, therefore, that so many of the landscapes described in his early diaries are conceived in compositional terms, as we saw in chapter 2, or that the declared purpose of the five volumes of *Modern Painters* was to demonstrate how such scenes truly looked the way Turner depicted them. When in 1851 Ruskin wrote to his father from Venice that it made no difference where in London he would settle on coming home "because I shall be living altogether in Turner,"[108] he was inadvertently describing the interfusion of art and life central to his whole career. For much of his life, Ruskin "lived in Turner," not just in London, but everywhere.

The nature of Ruskin's taste for Turner, as expressed in his own extensive collection, is revealing. His first acquaintance with Turner's work was not through drawings or paintings at all, but engravings. In a *Praeterita* manuscript he remembers, "All my delighted early study and imitation of him had been of the engravings only, and it is wholly amazing to me to find that there is not, nor has been for years, trace in my mind of the day when first I saw a drawing."[109] Although he frequently cites Turner's oils in *Modern Painters* and was famed for owning the great 1840 oil "Slavers throwing overboard the dead

104. June 5, 1858 (*Works,* 7: xxxiii).

105. *Praeterita,* vol. 1, ch. 6, par. 136 (*Works,* 35).

106. Ibid., vol. 2, ch. 12, par. 235.

107. To H. G. Liddell, October 12, 1844 (*Works,* 3: 669); *Praeterita,* vol. 1, ch. 4, par. 87 (*Works,* 35).

108. December 27, 1851, in *Ruskin's Letters from Venice,* ed. Bradley, p. 106.

109. *Works,* 35: 253n. It is interesting that Martin Hardie notes of these engravings, "they tend to be overcrowded and to display too much insistence upon isolated particularities and secondary motives, which only [Turner's] immense skill and knowledge have woven into a semblance of harmony" (*Water-colour Painting in Britain,* ed. Dudley Snelgrove, with Jonathan Mayne and Basil Taylor, 3 vols. [London, 1966–68], 2: 33).

and dying," the Library Edition catalogue of his collection lists but three oils in all, none of them actually purchased by Ruskin. Two, "The Slaver" and "Venice: the Grand Canal" (1837), were gifts from his father and were sold within eight years of John James's death. The third, a small self-portrait of the artist at the age of seventeen, was bequeathed him by Turner's housekeeper Hannah Danby, and was assumedly of interest to him more for associative than purely aesthetic reasons.[110] Whether Ruskin's reluctance to purchase oils derived partly from his concern over their possible deterioration because of Turner's sometimes inferior materials and inadequate preparation of his canvases is not clear. At any rate, in the series of buying instructions Ruskin sent his father from Venice after Turner's death, he divided the artist's work into four classes of preferences; ranged sixth in the fourth class ("Those which I would not buy at all at any price they are ever likely to go for") is "Oils—of any description whatsoever—except only Bicknell's Ivy Bridge—which if it ever went cheap—is very beautiful"[111]

Turner's engravings, sketches, and drawings were what Ruskin loved and collected. He especially favored rough sketches, partial studies—and for a significant reason, as his buying directions to his father illustrate:

> . . . I can get *more* of Turner at a cheaper rate thus, than any other way—I understand the meaning of these sketches—and I can work them up into pictures in my head—and reason out a great deal of the man from them which I cannot from the drawings. Besides—no one else will value them— and I should like to show what they are. . . .
>
> So now I must leave you to do the best you can for me—remembering that I would always rather have *two* slight or worn drawings than one highly finished one. The thought is the thing.[112]

"I can work them up into pictures in my head." Again, we see Ruskin's habitual desire to build a glorious imagined whole out of closely studied fragments of reality, in this case Turner's quick, tentative brush strokes and pencillings.

Another mental pattern is illustrated as well. In *Modern Painters III* he ar-

110. *Works*, 13: 473, 603, 605, 606.

111. January 23, 1852, in *Ruskin's Letters from Venice*, ed. Bradley, pp. 145, 148. Also see his strangely subdued diary entry of January 1, 1844 (*Diaries*, 1: 257): "I write with the Slaver on my bed opposite me. My father brought it in this morning for a New Year's present. I feel very grateful; I hope I shall continue so. I certainly shall never want another oil of his." For Ruskin's own analysis of the kinds of deterioration to which Turner's later oils were subject, see *Notes on the Turner Gallery . . .* (*Works*, 13: 140–41).

112. December 28, 1851, in *Ruskin's Letters from Venice*, ed. Bradley, pp. 112–13, 114.

gues that because of the "fatiguableness" of the imagination

> . . . it is a great advantage to [a] picture that it need not present too much at once, and that what it does present may be so chosen and ordered as not only to be more easily seized, but to give the imagination rest
>
> And thus it is, that, for the most part, imperfect sketches, engravings, outlines, rude sculptures, and other forms of abstraction, possess a charm which the most finished picture frequently wants. For not only does the finished picture excite the imagination less, but, like nature itself, it *taxes* it more. . . . [The] details of the completed picture are so numerous, that it needs greater strength and willingness in the beholder to follow them all out[113]

Indeed, when he recommends viewing "The Bay of Baiae" through a tiny frame, it is because "the very goodness of the composition is harmful, for everything so leads into everything else, that without the help of the limiting cardboard it is impossible to stop—we are dragged through arch after arch, and round tower after tower, never getting leave to breathe until we are jaded"[114] Once more here is Ruskin's need to exhaust small bits of visible fact, penetrating to their essence. Too much fact in a painting or drawing leads to that same "crushing of the mind by overweight" that made it difficult for Ruskin to *see* Mont Blanc, St. Peter's, and the facade of Rouen Cathedral.

It is sometimes overlooked that Ruskin's dazzling attack on Claude Lorrain in *Modern Painters* was—infelicitously—directed at the very artist Turner revered most and whose historical and epic landscapes he consciously sought to rival in imposing canvases like his 1815 "Dido building Carthage" (the painting he considered his greatest, asking that it be hung in the National Gallery next to Claude's "Seaport") and the 1817 "Decline of the Carthaginian Empire." Yet Ruskin dismissed both works as "mere rationalizations of Claude" and categorized them with most of Turner's other classically inspired oils as "nonsense pictures."[115] The highly finished oil paintings deprived Ruskin of the chance "to show what they are."[116] Typically, when he anxiously volunteered in 1856 to arrange the Turner Bequest, he specifically limited himself to dealing with the sketches and drawings, leaving the oils to the National Gallery's

113. Pt. 4, ch. 10, par. 18 (*Works,* 5).

114. *Notes on the Turner Gallery* . . . (*Works,* 13: 134).

115. *Modern Painters I,* pt. 2, sec. 1, ch. 7, par. 42 (*Works,* 3).

116. Many critics have pointed out that Ruskin's gorgeous descriptions often compete with the very works of art they are intended to glorify; in the above case, at least, Ruskin could complete in a brilliant word-picture what the average observer would be wholly incapable of perceiving in a fragmentary sketch. In a way, he was upstaging his favorite artist.

Keeper, Ralph Wornum, on the grounds that "most of them [belong] to periods of Turner's work with which I [am] little acquainted."[117] Ruskin's passion for Turner was actually rather exclusive.

Yet the sketches and drawings Ruskin loved are undeniably important, for they represent Turner at his most original and delineate the territory he was exploring in his brilliant, prescient later oils. The characteristics of such works overlap both with those of Ruskin's own drawings, and, more important, with his architectural emphases: a combination of a few minute foreground details standing out sharply in a misty, indistinct atmosphere of sunset, sunrise, rain, fog, or snowstorm, often as reflected in river or sea—conditions which trick the eye, dissolving solidity into vapor the way Venice does. As Turner's fellow artist John Constable memorably exclaimed, "he seems to paint with tinted steam, so evanescent and so airy."[118] These effects were the product of Turner's obsession with light, symbolized in his legendary wish near death to be turned toward the sun, the same unflinching point of view in so many of his works. Above all, perhaps, he loved color, which eventually became almost entirely an abstract element for him, independent of observable natural forms, as seen in his extraordinary "Colour Beginnings," boards and canvases stained with broad bands of pure color.

Turner's dissolution of solid substance into mirages of color and light becomes especially apparent in comparison to the vision of his only serious contemporary rival Constable, whose painting Ruskin much disliked and persistently criticized. As he waspishly explains in *Modern Painters III,*

> The reader might . . . suspect me of ill-will towards Constable, owing to my continually introducing him for depreciatory comparison. So far from this being the case, I had, as will be seen in various passages of the first volume, considerable respect for the feeling with which he worked; but I was compelled to do harsh justice upon him now, because Mr. Leslie . . . [has] suffered his personal regard for Constable so far to prevail over his judgment as to bring him forward as a great artist, comparable in some kind with Turner. As Constable's reputation was, even before this, most mischievous, in giving countenance to the blotting

117. A July 7, 1857, letter of correction to the *Times,* clarifying the nature of his offer (*Works,* 13: 87).

118. From a letter reproduced in C. R. Leslie, *Memoirs of the Life of John Constable,* ed. Jonathan Mayne (London, 1951), p. 254. The remark was prompted by the pictures Turner showed at the Academy in 1836, including the Venetian scene "Juliet and her nurse" that inspired Ruskin's first defense. Turner's interior studies at Petworth during this period, however, show the same transmutation of solid form into disembodied patches of reflected light.

and blundering of Modernism, I saw myself obliged, though unwillingly, to carry the suggested comparison thoroughly out.[119]

Yet Constable loved and studied nature in the microscopic manner of Ruskin himself. Unlike Turner, who carried his quick, telegraphic sketches back to his studio, where nature was then imaginatively recollected in tranquillity, finally to appear on the canvas altered into sublimity, Constable filled diaries and sketchbooks with minute observations of individual phenomena, especially as they changed over seasons, days, sometimes even hours. Nonetheless, in the first volume of *Modern Painters* Ruskin accuses Constable of a "want of veneration in the way he approaches nature," and in the fourth, he attacks a Constable tree as "wholly false in ramification, idle, and undefined in every respect": "we have arrived at the point of total worthlessness."[120] In *The Two Paths* he dismisses him once and for all as "nothing more than an industrious and innocent amateur blundering his way to a superficial expression of one or two popular aspects of common nature."[121]

Surely there are some extra-aesthetic reasons for such shrill denigration. Since Constable was Turner's sole major competitor, Ruskin must have made him a whipping boy in order to glorify Turner's talent the more. Also, Ruskin may have been offended by Constable's steadfast insularity. Not only did the painter refuse to travel outside Britain, but his favorite pastoral landscape settings were those of the lowest of lowland country, his native East Anglia. In *Modern Painters I* Ruskin points out (as he does with Turner and Shakespeare elsewhere) that Constable's "early education and associations were . . . against him; they induced in him a morbid preference of subjects of a low order"—then witheringly grants that the artist has been successful in "realizing certain motives of English scenery with perhaps as much affection as such scenery . . . is calculated to inspire."[122]

Probably Ruskin's main motive for devaluing Constable was, however, a disinterested one: he just did not believe the world looked the way Constable painted it. For Constable was preeminently an oil painter. Even his open-air sketches tended to be done in oil, usually on board or paper; prophetically modern as these studies seem to us today in themselves, they were nevertheless

119. App. 1 (*Works*, 5: 423). Actually, Ruskin is not exactly generous toward Constable in *Modern Painters I* either; there, he does praise his work as "thoroughly original, thoroughly honest, free from affectation, manly in manner, [and] frequently successful in cool colour"—but only after condemning his "unteachableness," his incapacity to draw, the want of "rest and refinement" in his work, and his regrettable preoccupation with "great-coat weather" (pt. 2, sec. 1, ch. 7, par. 18 [*Works*, 3]).

120. Vol. 1, pt. 2, sec. 1, ch. 7, par. 18 (*Works*, 3); vol. 4, pt. 5, ch. 5, par. 19, and Plate 27 (*Works*, 6, facing p. 98).

121. App. 1 (*Works*, 16: 415).

122. Pt. 2, sec. 1, ch. 7, par. 18 (*Works*, 3).

always intended to be the necessary first steps in producing larger, fully considered compositions; they were raw materials. Only in the closing eight years of his life did he turn seriously to watercolor, and his oils begin showing its influence.[123] Turner, by contrast, began as a watercolor painter, and experimenting with the medium for its own sake remained a source of pleasure to him throughout his career, despite his major work in oils; in fact, as Martin Hardie observes, "One feels that Turner got more real satisfaction and sheer enjoyment out of water-colour and that, however brilliantly he worked in oil, he preferred the qualities of the lighter medium to the more sticky and rebellious material of the oil-painter."[124] And although such sketches were rarely done as direct studies for his oils, he carried over into those paintings their qualities of luminosity and heightened color; in a late oil like "Norham Castle" (c. 1840–45), the distinction between the two media all but disappears, Turner floating his glazes over the white ground as if they were watercolor on paper.[125] Hardie claims that "it was because he *was* a water-colour painter that he liberated landscape painting in oil from its conventions and rejuvenated its spirit."[126]

It is a "paradox of development," Graham Reynolds comments, "that Turner should have carried over the essentials of his early water-colour technique into his finest oils, while Constable shows the effect of the more fluid medium in his very latest work alone."[127] This crucial difference between the two artists' visions and techniques becomes especially clear in their respective treatments of skies. Constable's skies are deep, often filled with billowy volumes of clouds modeled in bold brush strokes; Turner's are usually thin, multi-colored layers of hazy stratus clouds, like stains on the canvas:

> . . . Constable [is] always concerned with the structure of his landscape in depth, while Turner comes more and more to dissolve depth in the play of colour over his surfaces. . . . Turner is more concerned to note the colour nuances in veils of vapour than to emphasize the depth in the sky through which the clouds stretch. Constable is concerned with the clouds as almost sculptural three-dimensional entities. With Constable the sense of movement is attributed to the clouds as bodies; with Turner to the fine shades of tone and colour he notices with his incredibly sharp eye.[128]

Turner's world without depth was simply more *real* to Ruskin.

123. Graham Reynolds, *Constable: The Natural Painter* (London, 1965), pp. 89–90, 129–30.

124. Hardie, *Water-colour Painting in Britain*, 2: 31.

125. Martin Butlin, *Turner Watercolours* (London, 1962), p. 12.

126. Hardie, *Water-colour Painting in Britain*, 2: 30 (emphasis added).

127. Reynolds, *Constable*, p. 130.

128. Graham Reynolds, *Turner* (London, 1969), p. 174.

The most remarkable coalescence, however, of Turner's vision and Ruskin's is not optical at all, but philosophical. For Ruskin, Turner was "the painter of the loveliness of nature, with the worm at its root: Rose and cankerworm,— both with his utmost strength; the one *never* separate from the other. In which his work was the true image of his own mind."[129] At the close of *Modern Painters V* Ruskin movingly shows how Turner's early experiences imbued him with a tragic sense of isolation and a pessimism expressed not only in his art but in his epic poem on the frustration of human plans, *Fallacies of Hope,* excerpts from which he fixed to his exhibited paintings beginning in 1812 and continuing to the end of his life.[130]

> What was the distinctive effect of light which he introduced, such as no man had painted before? Brightness, indeed, he gave, . . . but in this he only perfected what others had attempted. His own favourite light is not Aeglé, but Hesperid Aeglé. Fading of the last rays of sunset. Faint breathing of the sorrow of night.
> And fading of sunset, note also, on ruin. . . . None of the great early painters draw ruins, except compulsorily. The shattered buildings introduced by them are shattered artificially, like models. There is no real sense of decay; whereas Turner only momentarily dwells on anything else than ruin.[131]

Hence Turner's preoccupation with scenes of natural disaster—avalanches, storms at sea—and the conscious analogy between the scarlet of his skies and the color of human blood. Turner was still more haunted by the fates of Carthage, Tyre, and Venice, fearing that modern England would meet the same end—an *idée fixe* his disciple transformed into the great underlying theme of *The Stones of Venice.*

Because Ruskin was similarly obsessed with decay. He felt not just a horror of it, as Rosenberg maintains;[132] rather, he had a seemingly masochistic *need* of it. In his first architectural effort, *The Poetry of Architecture,* Ruskin dwells lovingly on "the sadness of Italy's sweet cemetery shore," for, since "no real beauty can be obtained without a touch of sadness," it follows that "the principal glory" of Italy's landscape is "extreme melancholy": "she is

129. *Modern Painters V,* pt. 9, ch. 11, par. 13 (*Works,* 7).

130. Turner was always anxious to find literary parallels to his work; an excerpt from Langhorne's *Vision of Fancy* he chose to accompany a watercolor exhibited in 1799 is a chilling prediction of Ruskin's own terrible fate: it contrasts "life's morning landscape" with a "dark cloud gathering o'er the sky" (quoted in Reynolds, *Turner,* pp. 39–40).

131. *Modern Painters V,* pt. 9, ch. 11, pars. 27–28 (*Works,* 7). Ruskin's anti-English-ness must have been exacerbated by his conviction that England had destroyed Turner. (See, for example, ibid., par. 12).

132. Rosenberg, *The Darkening Glass,* p. 81.

but one wide sepulchre, and all her present life is like a shadow or a memory."[133] By contrast, England's lack of decay, her "border and order, and spikiness and spruceness," was probably an early incitement of his anti-Englishness. But this fascination with ruin soon became more than simply a romantic reflex or appetite for the picturesque. A striking emotional pattern emerges in Ruskin's impressions of Venice during his successive returns in the 1840s, following his initial 1835 visit. In 1841 he notes with disappointment: "the whole is not up to my recollection of it, and a little of my romance is going. The canals are I think shallower, and I am sure dirtier, than they were of old [It] is evident that the nature of the people is changed; and all that is now doing and erecting disagrees with things of old."[134] In 1845 he despairingly reports:

> When we entered the Grand Canal, I was yet more struck, if possible, by the fearful dilapidation which it has suffered in these last five years. . . . Of all the fearful changes I ever saw wrought in a given time, that on Venice since I was last here beats.[135]

> One only consolation I have—the finding among the wrecks of Venice, authority for all that Turner has done of her.[136]

In his 1881 "Castel-Franco Epilogue" to *Stones* Ruskin recalls that when he originally began the volumes more than thirty years earlier, "the city itself [was] even then, in my eyes, dead, in the sense of the death of Jerusalem, when yet her people could love her, dead, and say, 'Thy servants think upon her stones, and it pitieth them to see her in the dust.'" And he explains that he intended his title to mean "the history of Venice so far as it was written in her ruins."[137]

We are accustomed to associate Ruskin's horror at Venice's deterioration under the pressures of the nineteenth century with the later period of his increasingly serious mental instability—with the desperate ironies of *Fors* and the despairing querulousness of *St. Mark's Rest*. Given the political upheavals Venice had sustained since his early visits, plus the accumulative effects of rapid industrialization, growing numbers of tourists (for which his own books were partly responsible), and heavy-handed restorers, Ruskin's complaints of the seventies and eighties had considerable basis in reality. Yet the laments of these years are virtually the same as those of the forties. It scarcely seems

133. Pars. 23-24 (*Works*, 1).
134. May 9, 1841, *Diaries*, 1: 185.
135. To his father from Venice, September 10, 1845 (*Works*, 4: 41n).
136. To his father from Venice, September 14, 1845 (*Works*, 3: 251n).
137. Par. 1 (*Works*, 11).

204 Ruskin on Architecture

possible that Venice's disintegration in the single decade 1835–45 could be so rapid and so total. In his 1883 epilogue to the new edition of *Modern Painters II,* Ruskin refers back to his Italian journey of 1845: "And very solemnly I wish that I had gone straight home that summer, and never seen Venice" Then in a note he adds, "Seen her, that is to say, with man's eyes. My boyhood's first sight of her, when I was fourteen, could not have been brighter, and would not have been forgotten."[138]

We examined earlier how Ruskin believed that only the human eye in the perfect power of youth was the proper means of sight—but how he also argued that human sight is an absolutely spiritual phenomenon. The act of seeing was not just physical, but metaphysical: and therefore the awesome beauty and divine freshness of first wondering sight were by definition irrecoverable. Life's morning landscape is quickly eclipsed by the storm-cloud and plague-wind of experience—first figuratively, and later, for Ruskin, literally. "If my eyes were but as they used to be," he confides to his diary at the hoary age of twenty-eight, "what a different creature I should be."[139] Was this early figurative darkening of his vision a product of his "living in Turner," gazing daily, for example, at the fiery beauty of "The Slaver" and realizing that in its foreground detail was portrayed the cruelest possible exploitation of man by man? That sublimely powerful nature was forever being eroded by the gnawings of the barely visible cankerworm, just as in a corner of the painting the sick, dying slaves thrown overboard were being attacked by stealthy sharks and carnivorous birds?[140]

At all events, Ruskin was increasingly driven to see the world as ruined; he *had* to ignore the verdant settings of Salisbury and Wells in favor of viewing Amiens through rows of black industrial chimneys:

> But in the midst of these fifty tall things that smoke, [you] will see one, a little taller than any, and more delicate, that does not smoke; . . . *one* mass of wall—not blank, but strangely wrought by the hands of foolish men of long ago, for the purpose of enclosing or producing no manner of profitable work whatsoever, but one—

138. Par. 10 (*Works,* 4). Actually he was sixteen at the time of his first visit, though it is probably significant that he should err on the side of being younger.

139. Leamington, August 2, 1847, *Diaries,* 1: 355.

140. Reynolds gives a concise summary of the grisly scene's effect (*Turner,* p. 179): "There is no more majestic or terrifying instance of the wind and sea as elemental and destructive powers in all Turner's work. The red of the sunset reflected in the stormy waves becomes merged with and synthetized into the blood of the victims, and the ship itself, silhouetted against the storm, acquires something of the mythical quality of the ghost ships which haunt maritime imaginations." Ruskin sold the painting in 1869, frankly contending that it had become too distressing to live with (*Works,* 3: lv).

"This is the work of God; that ye should believe on Him whom He hath sent!"[141]

A terse 1866 diary entry becomes typical: "Saw the dead bones of Rouen— left her alive—twelve years ago. Always 'too late.'"[142] Significantly, in *Modern Painters IV* even the mountains are dying, only vestiges of what they once were:

> ... the more familiar any one becomes with the chain of the Alps, the more, whether voluntarily or not, the idea will force itself upon him of their being mere remnants of large masses,—splinters and fragments, as of a stranded wreck, the greater part of which has been removed by the waves
>
>
>
> For it is evident that, through all their ruin, some traces must still exist of the original contours ... like the obscure indications of the first frame of a war-worn tower, preserved, in some places, under the heap of its ruins, in others to be restored in imagination from the thin remnants of its tottering shell; while here and there, in some sheltered spot, a few unfallen stones retain their Gothic sculpture, and a few touches of the chisel, or stains of colour, inform us of the whole mind and perfect skill of the old designer. With this great difference, nevertheless, that in the human architecture the builder did not calculate upon ruin, nor appoint the course of impendent desolation; but that in the hand of the great Architect of the mountains, time and decay are as much the instruments of His purpose as the forces by which He first led forth the troops of hills in leaping flocks[143]

The destructive effects of political and industrial revolution throughout the nineteenth century should certainly in no way be underestimated: Ruskin's despairing obsession with decay and corruption had, as did all his preoccupations, ample foundation in observable fact. But at the same time, how clear in Ruskin is the necessity to his sense of mission, both as aesthetic and social reformer, of seeing a world in fragments—his need to fasten on shards of reality, preferably from an earlier, happier time, and then to reconstruct them "in imagination from the thin remnants of ... tottering shell." This is Ruskin's *real* architectural instinct: restoring to wholeness a world falling to pieces.

If for "the great Architect of the mountains," time and decay were instruments of purpose, so were they on a temporal level for John Ruskin. Here,

141. *Bible of Amiens*, ch. 1, par. 4 (*Works*, 33).
142. Rouen, July 9, 1866, *Diaries*, 2: 593.
143. Pt. 5, ch. 13, par. 18, ch. 12, par. 8 (*Works*, 6).

too, Ruskin's and Turner's lives overlap. Turner saw his works as forming a
universal statement; at an early point in his career he began methodically re-
purchasing the paintings he had sold; he hoarded sketchbooks, "Colour Be-
ginnings," loose drawings—regardless of their often deplorable condition. The
result was the stupendous Turner Bequest, with its almost twenty thousand
items. "'What is the use of them,' he said, 'but together?,'" Ruskin recalls.
"Turner appears never to have desired, from any one, care in favour of his
separate works. The only thing he would say sometimes was, 'Keep them to-
gether.' He seemed not to mind how much they were injured, if only the
record of the thought were left in them, and they were kept in the series
which would give the key to their meaning."[144] Turner wanted to be taken
whole, or not at all.

Turner's unremitting drive toward a universal statement was likewise Rus-
kin's. And therefore an appreciation of Ruskin's Messianic desire to put the
world back together is central to placing his architectural writing in a larger,
more significant context. The incompleteness of his examination of architec-
ture is in the broadest sense both explained by and the product of his urge to
incorporate the entire universe into his work. He was always seeing more to
do, more to promise his readers. In writing about Turner, he "undertook, not
a treatise on art or nature, but, as I thought, a small pamphlet defending a
noble artist against a strong current of erring public opinion. The thing
swelled under my hands . . ."[145]—and the five volumes of *Modern Painters* re-
sulted. Even so, he announced in the last chapter of the last volume: "Look-
ing back over what I have written, I find that I have only now the power of
ending this work;—it being time that it should end, but not of 'concluding' it;
for it has led me into fields of infinite inquiry, where it is only possible to
break off with such imperfect result as may, at any given moment, have been
attained."[146] He often noted that in writing *The Seven Lamps of Architecture*
he had great difficulty "keeping my Seven Lamps from becoming Eight—or
Nine—or even quite a vulgar row of foot-lights."[147] His letters to friends be-
came increasingly filled with evidence of his teeming mind and manic ambi-
tion;[148] in his later life he was sometimes working on six or seven different
projects at once. "I am sorry to pack my sentences together in this confused

144. *Modern Painters V*, pt. 9, ch. 11, par. 30, and accompanying note (*Works*, 7:
434n).
145. To H. G. Liddell, October 12, 1844 (*Works*, 3: 669). Here he is talking only
about *Modern Painters I*: "it was not till I had finished the volume that I had any idea to
what I might be led."
146. Pt. 9, ch. 12, par. 1 (*Works*, 7).
147. A note to the 1880 edition of *Seven Lamps* (*Works*, 8: 138n).
148. An especially fine example is his wryly encyclopaedic letter to Lady Trevelyan
from Paris, September 24, 1854 (*Works*, 36: 174–77).

way," he told readers of *Val d'Arno* (1874), "But I have much to say; and cannot always stop to polish or adjust it as I used to do." [149]

On the one hand, Ruskin's urge to inform the Victorian age was a fervor for imposing external order on the universe: he was forever passionately collecting, classifying, and ranging into hierarchies, as in a medieval *speculum*— rocks, coins, painters, etymologies, birds, plants, manuscripts, myths—though often in whimsically unmethodical and antiscientific ways. On the other hand, especially as he grew older, he was constantly seeking to impose internal order as well, developing a complexly allusive scheme of personal symbolism, reflected in the arcane titles he attached to his works. Here, too, he exhibits a deeply medieval quality of mind: he sees a world of infinite analogies, in which the eternal assumes and thereby spiritualizes endless temporal forms, and in which all things, great or small, are therefore related and mutually illustrative. The tiniest grain of sand, like the smallest carved flower on a Gothic capital, is necessary to the whole. Yet at the same time both the external and internal order he posits are rooted in an astonishingly literal insistence, very much of the nineteenth century, on the importance of microscopically observed fact.

But such contradictions disturbed Ruskin little—he seems even at times to have gloried in them. For he was convinced that truth was reached through the embracing of polarities. "They talk of my inconsistency," he assured his father in 1851, "because they cannot see two sides at once: all people are apparently inconsistent who have a wide range of thought—and can look alternately from opposite points." [150] At the end of his career in *The Bible of Amiens* he confessed with engaging insouciance:

> . . . I have lately observed with compunction, in re-reading some of my books for revised issue, that if ever I promise, in one number or chapter, careful consideration of any particular point in the next, the next *never does* touch upon the promised point at all, but is sure to fix itself passionately on some antithetic, antipathic, or antipodic, point in the opposite hemisphere. This manner of conducting a treatise I find extremely conducive to impartiality and largeness of view [151]

Truth itself seemed to Ruskin at once antithetic, antipathic, antipodic. A major reason for his obsession with Venice was that he considered the oppositions in her history archetypal: "For here in one city may be seen the effects of extreme aristocracy and extreme democracy—of the highest virtues and the worst sins—of the greatest arts and the most rude simplicities of humanity. It

149. Note to lec. 3, par. 63 (*Works*, 23: 42n).

150. From Venice, September 21, 1851, in *Ruskin's Letters from Venice*, ed. Bradley, p. 18.

151. Ch. 2, par. 39 (*Works*, 33).

is the history of all men, not 'in a nutshell,' but in a nautilus shell—my white nautilus that I painted so carefully is a lovely type of Venice." [152] And he viewed his own apparent contradictions in the same way. In later editions of *Modern Painters II* Ruskin added a note directly quoting Alexandre Rodolphe Vinet's *Vital Christianity* that perfectly, if inadvertently, defines his rationale: "the human race may be considered *as one man only*. . . . He receives, on his entrance into life, the heritage of all ages—he is the son of the whole human race." [153] Just as the history of all men was contained in that of a single city, Venice, so was the human race embodied in one isolated being, John Ruskin. He was not worried about his conflicts and shifts in opinion because they were all rooted in the same human soul and were thus resolved in its unity, as the convoluted, multichambered interior of the nautilus is harmonized in an exterior shell of opalescent grace.

Whatever his contradictions along the way, Ruskin was always striving toward a fixed, certain goal—to attain as nearly as possible, and convey, the breadth of vision permitted the human being by his creator.

> Not, indeed, that my work is free from mistakes; it admits many, and always must admit many, from its scattered range; but, in the long run, it will be found to enter sternly and searchingly into the nature of what it deals with, and the kind of mistake it admits is never dangerous—consisting, usually, in pressing the truth too far. It is quite easy, for instance, to take an accidental irregularity in a piece of architecture, which less careful examination would never have detected at all, for an intentional irregularity; quite possible to misinterpret an obscure passage in a picture, which a less earnest observer would never have tried to interpret. But mistakes of this kind—honest, enthusiastic mistakes—are never harmful; because they are always made in a true direction,—falls forward on the road, not into the ditch beside it [154]

> [S]ome men may be compared to careful travellers, who neither stumble at stones, nor slip in sloughs, but have, from the beginning of their journey to its close, chosen the wrong road; and others to those who, however slipping or stumbling at the wayside, have yet their eyes fixed on the true gate and goal (stumbling, perhaps, even the more because they have), and will not fail of reaching them. [155]

152. To his mother from Venice, August 8, 1869 (*Works*, 19: liv).

153. Note added after 1st ed. to pt. 3, sec. 1, ch. 14, par. 9 (*Works*, 4: 183n). The words "as one man only" were first emphasized by italics in the 1883 edition.

154. *The Two Paths*, app. 1 (*Works*, 16: 416).

155. Preface to *Modern Painters III*, par. 3 (*Works*, 5).

His sense that the medieval builders had their eyes fixed on the true gate and goal was doubtless what finally appealed to Ruskin most about the Gothic cathedral. As a lover of material beauty, compelled to "eat it all up into my mind, touch by touch," he saw the cathedral, of course, as a miraculous treasure-house. Here was a beautiful building filled with frescoes, glass, wood-carving, manuscripts, and goldsmith's work on which he could gaze endlessly—the products of an inspired creativity that overflowed formal aesthetic constrictions; to Ruskin, a Gothic cathedral *could* be "a vast illuminated missal . . . studded with porphyry pillars instead of jewels," and the illuminated missals it housed, "fairy cathedrals, full of painted windows." The infinite *richness* of Gothic beauty first inspired his architectural writings.

But concurrently, he began to fasten on the cathedral's unfinished, imperfect qualities as the noble expression over successive generations of all men of every level of talent, and hence as a metaphor for the human race, whose reach must always exceed its grasp. The striving, however, toward a goal unattainable on earth—heavenly perfection of accomplishment and vision—was in itself a legitimate form of wholeness, because it meant resolving to dedicate one's highest powers to a transcendental purpose. Its satisfaction with what he considered counterfeit wholeness, its readiness to accept attainable perfection of a limited order, caused Ruskin to reject Renaissance architecture and the world of "careful travellers" that approved it. The infinite *imperfections* of Gothic beauty led him into his social writings. From his cognizance of the affirmation in the Gothic cathedral not of God only, but the humanity He created, it was a simple logical extension to his social theory. What kind of society could make modern man whole and creative? This impulse expressed so fervently in his later works was implicit in his architectural theory. The surfaces, the details he emphasizes in his writings on architecture—and the vaults, the stately configurations of bays he does not—decline in importance in light of a larger view. Paul Frankl's description of Chartres might be a definition of Ruskin's *corpus:*

> As in so many other medieval buildings, part of the organic effect of Chartres Cathedral lies . . . in the fact that the cathedral has remained unfinished. . . . The church . . . is only a fragment of what had been visualized by its architect and his patron. One is tempted to imagine how it was intended to complete the church, and to wonder whether the total effect would have been improved. But when one considers the whole church, from the Romanesque crypt to the Late Gothic spire on the north-west tower, one is so filled with admiration that one hesitates to answer this question. The church is undoubtedly not as mature as, for instance, Amiens, and it undoubtedly contains details which are not harmonious,

but, paradoxically, because it contains so much irregularity and tension, the general effect is one of harmony; for harmony is the concordance of essentially different factors.[156]

We are back whence we began: Ruskin must be taken whole, or not at all.

156. Frankl, *Gothic Architecture*, p. 82.

Index

as conditioned by Turner, 196; Ruskin
sees as archetypal, 207–8. *See also*
Doge's Palace; Gothic, Venetian; Rus-
kin, John, works of; St. Mark's
Verona: Ruskin's love of, over Abbeville,
38–39; Ruskin's miscellaneous exam-
ples from, 47–48, 55, 85, 112; Rus-
kin's desire to "eat it up . . . touch by
touch," 57–58; Scaliger tombs at, 90,
94; Ruskin sees as destroyed, 139
Veronese, Paolo, 99, 140, 173, 177, 181,
185
Villafranca, Peace of, 139, 139n
Vinet, Alexandre Rodolphe: *Vital Christi-
anity,* 208
Viollet-le-Duc, E. E.: Ruskin's discovery of
Gothic structure through, 63n, 86–88;
influence on Frank Lloyd Wright, 152–
53, 154n
Vision. *See* Eyes, eyesight
"Visual functionalism," 75, 156–57

Walpole, Horace, 4, 5–9
Waterhouse, Alfred, 105, 119

Webb, Philip, 88
Wells Cathedral, 39, 204
Wetter, Johannes, 78n
Whewell, William, 167
Whistler, James Abbot McNeill, 156
White, John, 38
Wilberforce, Samuel, 133n
Wilenski, R. H., 35n, 107
Willis, Robert, 167, 191
Wiseman, Nicholas Patrick, Cardinal, 23
Woodward, Benjamin, 119, 124–27 passim,
129, 132, 137
Worcester Cathedral, 39, 171n
Wordsworth, William, 21, 102
Workingmen's College, 124–25
Wornum, Ralph, 125, 198
Wright, Frank Lloyd: and Viollet-le-Duc,
152–53, 154n; and Ruskin, 152–56,
153–54n; mentioned, 68, 150, 158,
159
Wright, John Lloyd, 154n
Wright, Lloyd, 154n

Young, G. M., 173

TEXT DESIGNED BY IRVING PERKINS
JACKET DESIGNED BY KAREN FOGET
COMPOSED BY HORNE ASSOCIATES, INC., HANOVER, NEW HAMPSHIRE
PRINTED AND BOUND BY GEORGE BANTA CO., INC., MENASHA, WISCONSIN
TEXT LINES ARE SET IN JOURNAL ROMAN MEDIUM,
DISPLAY LINES IN ELIZABETH AND JOURNAL ROMAN MEDIUM

Library of Congress Cataloging in Publication Data
Garrigan, Kristine Ottesen, 1939–
Ruskin on architecture.
Includes bibliographical references.
1. Gothic revival (Architecture) 2. Ruskin,
John, 1819–1900—Influence. 3. Architecture,
Victorian. I. Title.
NA610.G37 720'.9 73-2045
ISBN 0-299-06460-3